The Colour *of* Time

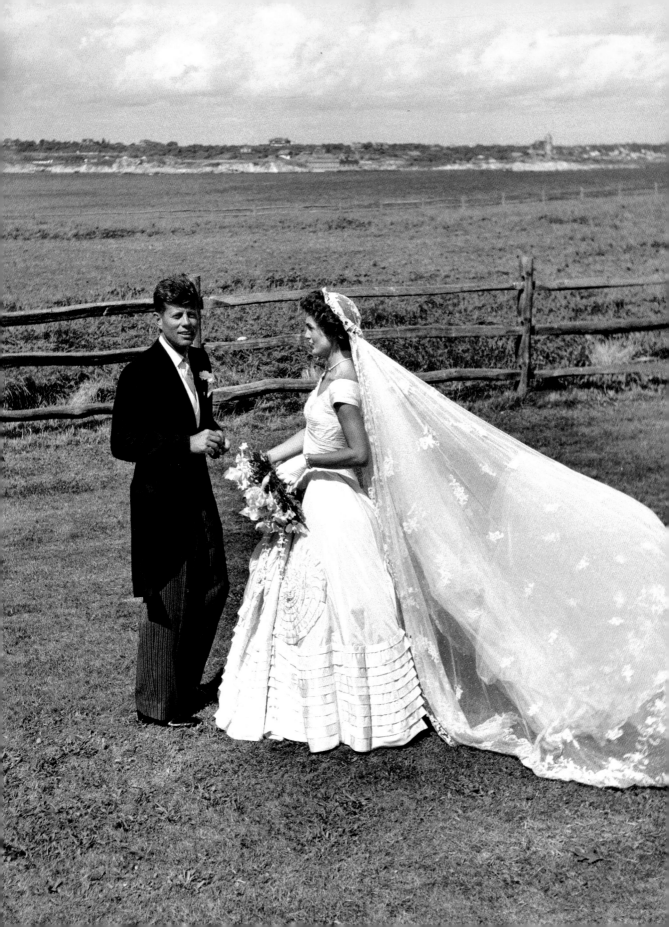

Dan Jones
&
Marina Amaral

The Colour of Time

A NEW HISTORY OF THE WORLD
1850 TO 1960

HEAD
of ZEUS

An Apollo Book

This is an Apollo book, first published in the UK in 2018
by Head of Zeus Ltd

Copyright © Marina Amaral & Dan Jones 2018

The moral right of Marina Amaral and Dan Jones
to be identified as the authors of this work has been asserted in accordance
with the Copyright, Designs and Patents Act of 1988.

3 5 7 9 10 8 6 4
A CIP catalogue record for this book is available from the British Library.
ISBN [HB] 9781786692689 ISBN [E] 9781786692672

Designed by Isambard Thomas
Colour separation by Flavio Milani
Printed in Italy by L.E.G.O. S.p.A.

Head of Zeus Ltd
First Floor East, 5–8 Hardwick Street, London EC1R 4RG
WWW.HEADOFZEUS.COM

Previous page
John Fitzgerald Kennedy and Jacqueline Bouvier
photographed by Toni Frissell at their wedding reception,
Hammersmith Farm, Newport, Rhode Island: 12 September 1953

Overleaf
The archaeologist Howard Carter examines the coffin
of the Egyptian pharaoh Tutankhamun (*c.*1332–1323 BC),
whose tomb he discovered (virtually intact) in the Valley of the Kings in 1922

PICTURE CREDITS

The photographs in this book are reproduced
by kind permission of Getty Images, with the exception of the following:
pp. 2, 14, 44, 50, 73–3, 204–5, 214–15 (Library of Congress)
pp. 16–17, 106, 236 (Wikimedia Commons)
p. 89 (Bibliothèque Nationale de France)

ACKNOWLEDGMENTS

The authors would like to thank the following for
their invaluable help in creating this book:

Charlotte Araya Moreland, Alastair Bruce, Georgina Capel and all at GCA,
Phil Curme, Ned Donovan, John Ford, James Holland, Dr Dan Jackson, Eloise Jones,
Mads Madsen, Professor Jonathan Parry, Dr. Fern Riddell, Andy Robertshaw, Saad Salman, Robin Schäfer,
Dr Gajendra Singh, Simon Sobolewski, Dr Phil Weir and Alex Winkworth.

Particular thanks to Anthony Cheetham and the whole team at Head of Zeus
including Georgina Blackwell, Dan Groenewald, Clémence Jacquinet, Claire Kennedy,
Richard Milbank, Suzanne Sangster and Isambard Thomas.

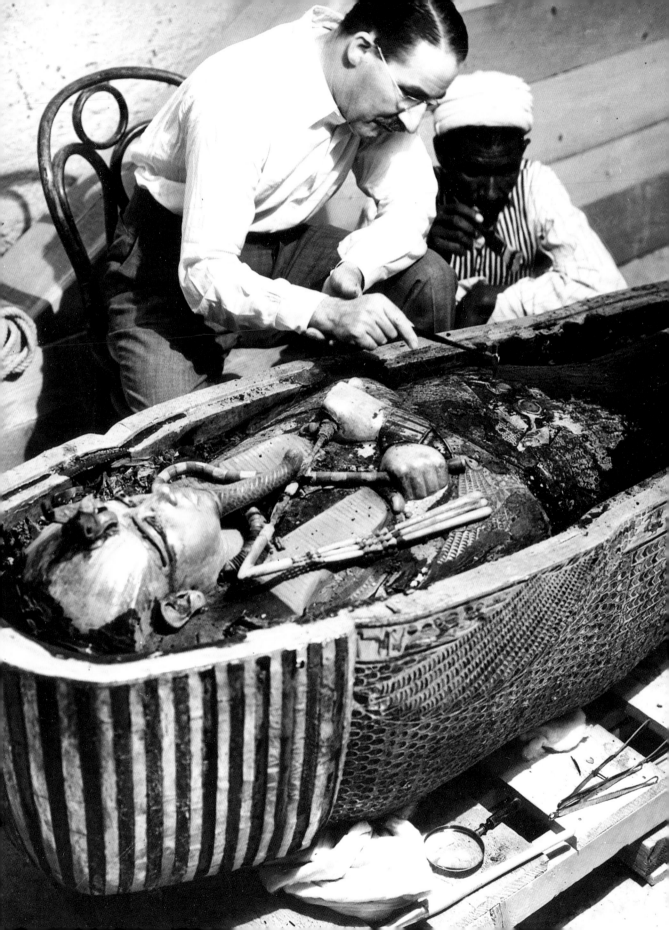

Introduction

Early in the 16th century Leonardo da Vinci jotted in his notebook a few lines about perspective. As objects get further away, he wrote, three things seem to happen. They get smaller. They become less distinct. And they lose colour.

Da Vinci was writing about painting, but his words can be applied literally to photography and metaphorically to history. We understand that the world has always been as vivid, immediate, colourful and 'real' as it seems to us today. Yet vivid and colourful is seldom the way we see the past now. Photography, which became part of the historical record with the popularisation of the Daguerreotype in 1839, was for its first century a medium that operated almost exclusively in black and white. The view behind us is partial and faded. We see history, to repurpose St Paul's phrase to the Corinthians, through a glass, darkly.

This book is an attempt to restore brilliance to a desaturated world. It is a history in colour. Among the following pages are collected 200 photographs taken between 1850 and 1960. All were originally monochrome, but they have been digitally colourized with the effect – we hope – of making us look afresh at a dramatic and formative age in human history.

Each picture included here is interesting in its own right. Together they have been selected and organized as a collection, accompanied by extended captions that flow one from another to form a continuous narrative: a story that takes us from the Crimean War to the Cold War and from the steam age to the space age. We begin in an age of empires and end in an age of superpowers. Here is a stage on which dance titans and tyrants, murderers and martyrs, geniuses, inventors and would-be destroyers of worlds.

The photographs come from a wide range of sources. Some were originally albumen prints, created through a complicated process involving long exposure-times, glass sheets and collodion, egg whites and silver nitrate. Others were shot on medium-format or even 35mm film roll. Some were created for private pleasure, others for sale as postcards or for publication in mass-market magazines. Some have an astonishing sharpness of definition; others bear the inevitable and irresistible patina of age. All ended up being preserved, digitized,

and made available through modern picture archives, from where they can now be downloaded in high resolution.

Conscience dictates that before you sit down to colourize a historical photograph, you must do your homework. A portrait of a soldier, say, will contain uniforms, medals, ribbons, patches, vehicles, skin, eye and hair colours. Where possible, each detail must be verified: traced via other visual or written sources. There is no way of knowing the original hues just by looking at the different shades of grey. The only course of action is the one familiar to every historian, whatever their speciality: dig, dig, dig.*

With as much information as possible to hand, you start to colourize. Although the canvas on which you work is a computer screen, every single part of the picture is coloured by hand. There's nothing algorithmic in the process. The tools may be digital, but the basic artist's technique has not changed since Leonardo's day: slowly starting to apply colours over colours, mixing them through hundreds of layers, trying to capture and reproduce a specific atmosphere that is (in this case) consistent with the photo itself. Lighting matters. So too texture. Tiny details

are of the utmost importance. Patience is a virtue. A single photograph can take anything between an hour and a month to colourize. And sometimes, after all that work, you must still accept that for a whole variety of reasons, the result is unsatisfactory. It just looks… wrong. Back to the archive with it. Some things must remain black and white.

This book is the product of two years' collaboration. In selecting the photographs we have tried to spread our gaze across continents and cultures, and to commingle the famous with the forgotten. We have tried to honour the dead and do justice to their times. We looked at perhaps 10,000 photographs. We agonized, and changed our minds. We tried to pack in as much as we could, knowing all the while that out of the 10,000 possible options 9,800 were destined for the cutting-room floor.

That ratio alone confirms that this is not a comprehensive history – how could it be? There are many more omissions than inclusions. But it is, we hope, a new way of looking at the world during a time of monumental change. It has been a privilege and a pleasure to create. We hope you enjoy reading it.

Marina Amaral & Dan Jones
April 2018

* Sometimes of course, digging proves fruitless. At this point the colourizer needs to make artistic choices, just as the historian uses his or her judgment. What might this have looked like? You follow your instinct and never pretend to know everything for sure.

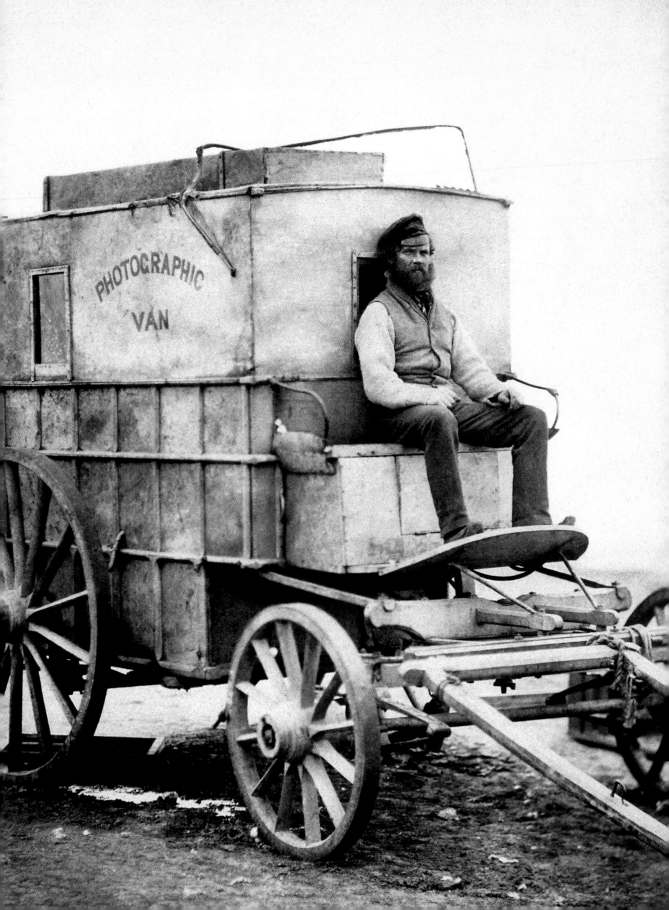

1850s

World of Empires

'The camera will present [artists] with the most
faithful transcript of nature, with detail and
breadth in equal perfection, while it will leave to
them the exercise of judgment, the play of fancy,
and the power of invention.'

Roger Fenton, 1852

On 8 March 1855 a 35-year-old English lawyer-turned-photographer named Roger Fenton arrived by ship at Balaclava on the Crimean Peninsula in the Black Sea, and unloaded his equipment. The Crimea was a war zone. Fenton and his two assistants came armed with five cameras, 700 glass plates, cooking tools, camping gear, three horses purchased in Gibraltar and a former wine-merchant's carriage converted into a mobile darkroom and sleeping quarters.

Fenton was an artistic pioneer and a political lightning rod. He was a founder-member of the Photographic Society, formed to promote a new and rapidly advancing art form. His trip was financed by the Manchester publisher Thomas Agnew & Sons, who wanted photographs for sale, and backed by the British monarch Queen Victoria and her husband and consort Prince Albert.

Fenton is rightly remembered today as one of the world's first war photographers, although the bloodless, straight-backed, heroic portraits he collected in the Crimea are what we would now call propaganda, not documentary. They were produced to justify the many thousands of British lives lost to violence and endemic disease in a wasteful, sapping struggle involving four of the great imperial powers of the 1850s: Britain, France and the Ottoman Empire on one side, and Russia on the other. Shocking reports of the terrible conditions in the Crimea had been printed in *The Times*; the British government was eager that Fenton provide a visual counterpoint to these bad news stories.

Be that as it may, Fenton's journey to the Crimea was still profoundly important as a historical moment. It marked the point at which great world events began to be documented extensively on film. Photography from this point becomes a rich seam in the mine of posterity, and the service men like Fenton did for their patrons is as nothing to the service they provided for then-unborn generations of historians seeking to narrate and explain the history of world events from *then* until *now*.

So what was the world of the 1850s, which Fenton went about photographing in all of its glory and so little of its distress? It was, in short, an age of empires. The dominant power was Britain, whose range of command and conquest included Canada, India, Burma, parts of southern Africa, Australia and New Zealand, along with many other smaller outposts dotted around the vast oceans which were commanded and explored by a navy that had done so much to make Britain a superpower.

1850

[Apr] Pope Pius IX is returned to Rome by French troops. He has been in exile since 1848

[May] Hippopotamus named Obaysch arrives in its new home at London zoo, having been captured in Egypt and sent to Britain as a gift

[Sep] Compromise of 1850 agreed by US Congress in an attempt to avoid conflict between pro- and anti-slavery states in the expanding Union

1851

[Jan] Taiping Rebellion breaks out in Tianjing, pitching China's ruling Qing dynasty against the Taiping Heavenly Kingdom, led by Hong Xiuquan

[May] Great Exhibition opens in the Crystal Palace, then located in Hyde Park, London

[Jul] Death of Louis Daguerre, pioneer and popularizer of photography

1852

[Mar] Serialization of Charles Dickens' novel *Bleak House* begins

[Dec] Charles-Louis Napoleon Bonaparte overthrows the French Second Republic and has himself crowned Emperor of France as Napoleon III

1853

[Jun] Georges-Eugène Haussmann appointed to begin radical rebuilding programme in Paris

[Jul] US Commodore Matthew C. Perry intimidates Japan with American gunships, leading to a trade treaty between Japan and the USA

[Oct] Crimean War begins when Ottoman Empire, supported and later joined by expeditionary forces from Britain and France, declares war on Russia

1854

[May] Kansas–Nebraska Act creates the US territories of Kansas and Nebraska, sparking violence known as 'Bleeding Kansas': a longrunning battle between pro- and anti-slavers

[Sep] John Snow traces a cholera epidemic in London to a single water-pump, proving the disease is water-borne

[Oct] Charge of the Light Brigade takes place during the Battle of Balaclava in the Crimean War

In Europe and the Middle East, Britain's competitors and rivals obviously included the French, Ottomans and Russians. The Chinese Qing dynasty and Indian Mughals provided competition for influence and resources in the East. South America was dominated by Brazil, while between the Gulf of Mexico and the Great Lakes marched the young United States. Born some 70 years earlier as an act of rebellious defiance against British rule, the USA had purchased territory from France and gobbled remnants of the once-mighty Spanish empire. Free white Americans, along with European and Chinese settlers, were now busily colonizing the vast North American vista between its Atlantic and Pacific seaboards. Yet as the United States expanded, so they divided ever-more bitterly among themselves, with consequences that would become horrifyingly apparent during the 1860s.

The other great moving forces of this imperial decade were technology and discovery. Rapid industrialization and new inventions were changing the way that people lived, worked, travelled, communicated, thought and dreamed. From telegraph cables laid beneath the sea to vast ocean liners above it; from ambitious plans to rebuild venerable old cities to wars deploying cannon that could reduce an ancient building to rubble in minutes; from the exploration of exotic faraway lands and scientific studies into the very origins of life, to the systematic destruction of ancient peoples through disease, forced resettlement and brute force: the 1850s was a time of extraordinary, near-unprecedented change which confused, delighted and killed people in roughly equal measure.

But as the world changed forever, so it was preserved forever by men like Fenton of the Crimea in his repurposed wine-wagon: capturing life through the shutter of his camera and ensuring, whether he meant it or not, that centuries later we could step into his time again, in black-and-white. Or, indeed, in colour.

1855	1856	1857	1858	1859
[Mar] Roger Fenton arrives in the Crimea with his photographic van to document the ongoing conflict	[Mar] Peak XV in the Himalayas measured as the world's highest mountain – later named Mount Everest	[May] Indian Mutiny begins with rebellion of sepoys in the East India Company's army near Delhi. Hostilities continue for more than a year	[Jan] Felice Orsini attempts to assassinate Napoleon III with a bomb. Orsini is later guillotined	[Apr] Work begins on the Suez Canal
[Mar] Tsar Nicholas I of Russia dies and is succeeded by his eldest son, Alexander II	[Mar] Crimean War ends with Treaty of Paris	[Sep] Financial panic in New York forces banks in the city to close and railroad companies across the USA to fold	[Aug] Government of India Act passed, effectively ending rule by the East India Company and passing power to the British crown	[Aug] SS *Great Eastern*, designed by Isambard Kingdom Brunel and at that date the largest ship ever built, sets out on her maiden voyage
[Sep] Sevastopol falls to a joint assault of French and British forces	[Oct] Second Opium War begins, pitching British and French forces against those of Qing-dynasty China	[Dec] Ottawa named as capital of the Province of Canada by Queen Victoria	[Aug] US President James Buchanan exchanges transatlantic telegraph messages with Queen Victoria – telegraph cable fails shortly afterwards	[Nov] Charles Darwin publishes *On the Origin of Species*, proposing a theory of evolution driven by natural selection

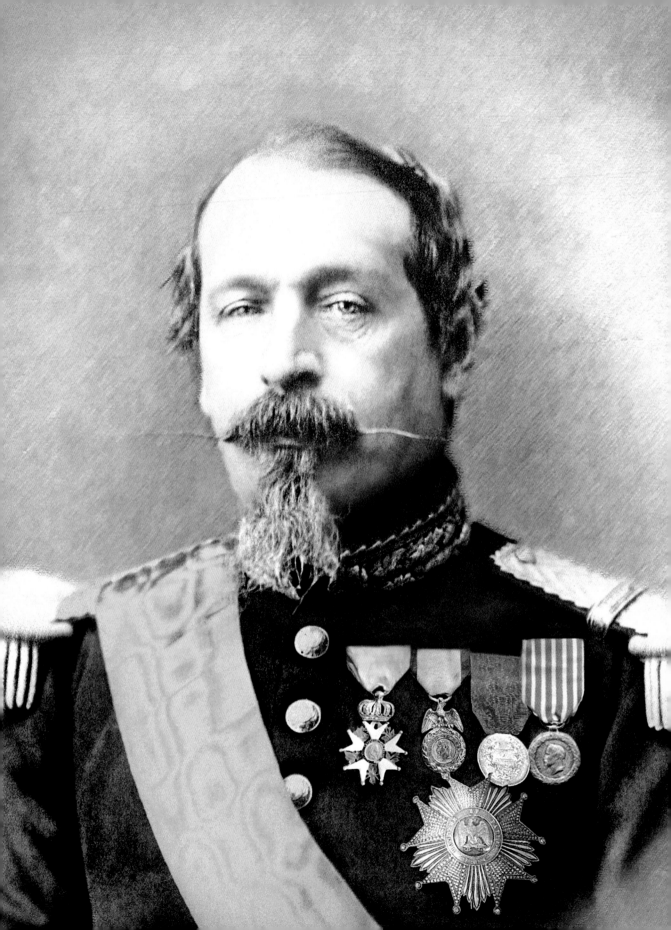

Napoleon III, Emperor of France

One man who bestrode this age of empire was Charles-Louis Napoleon Bonaparte, nephew and heir of Napoleon I, the charismatic general who had seized control of revolutionary France in 1799 and dominated the world.

The first Napoleon's reign ended in military humiliation at the Battle of Waterloo, and he died in exile on St Helena in 1821. His successor, known in his youth as Louis-Napoleon, also lived much of his life in exile, plotting to reclaim his uncle's crown and return France to imperial glory. His moment arrived in 1848. After a political revolution against the Bourbon monarchy, a Second French Republic was declared and Louis-Napoleon returned to be elected president.

Louis-Napoleon's mission of restoring France to its Bonapartist heyday involved a vigorous programme of modernization, which included banking reform, urban planning, railway- and shipbuilding and agricultural improvement. But it was all done under the shadow of autocracy. In 1852 the president overthrew his own Republic, and had himself crowned emperor. He took the name Napoleon III in deference to the first Bonaparte's son, another Napoleon, who was titular ruler of the French for a few days in the summer of 1815. On his coronation Napoleon III declared 'Some people say the Empire is war. I say the Empire is peace.'

These fine words turned out to be worthless. For the rest of the decade dissenters were exiled or imprisoned. France joined the Crimean War (1853–6) and invaded Italy (1859). During the 1860s (when this photograph was taken), repression was relaxed; but in the end Napoleon III proved himself a Bonaparte through and through. Following defeat in a war with Prussia, in 1870 he was overthrown and exiled. He died in England three years later.

Paris Rebuilt

One of Napoleon III's most striking achievements was the wholesale reconstruction of France's capital, Paris. In 1850 over one-third of Paris's rapidly growing population was crammed into a tiny area bounded by medieval walls, plagued by outbreaks of diseases like cholera and typhoid.

In exile in the 1840s Napoleon had declared his ambition to rebuild Paris as a magnificent city of marble, after the fashion of the first Roman emperor Augustus. In the 1850s that job was entrusted to Baron Georges-Eugène Haussmann, the energetic but abrasive prefect of the Seine. Twelve thousand buildings were demolished, many of them in the slums at the centre of the city. New sewers and aqueducts improved water sanitation, while wide tree-lined boulevards connected parks and public squares.

Haussmann's work cost 2.5 billion francs (perhaps 5bn euros today) and sharply divided opinion. The poets Victor Hugo and Charles Baudelaire thought the work had destroyed Paris's medieval charm, while many muttered that the newly widened streets were designed to make it easier to mobilize troops against future revolution. The writer Emile Zola called Haussmann's Paris 'an enormous hypocrisy, the falsehood of a colossal Jesuitism'.

Yet the city was transformed. Overleaf we see the first works beginning on the Rue de Constantine, looking towards the Palais de Justice, as pictured by Charles Marville, appointed Paris's official photographer in 1858. Almost all of the buildings in this photograph (except the Palais, under renovation when this photo was taken) have now vanished.

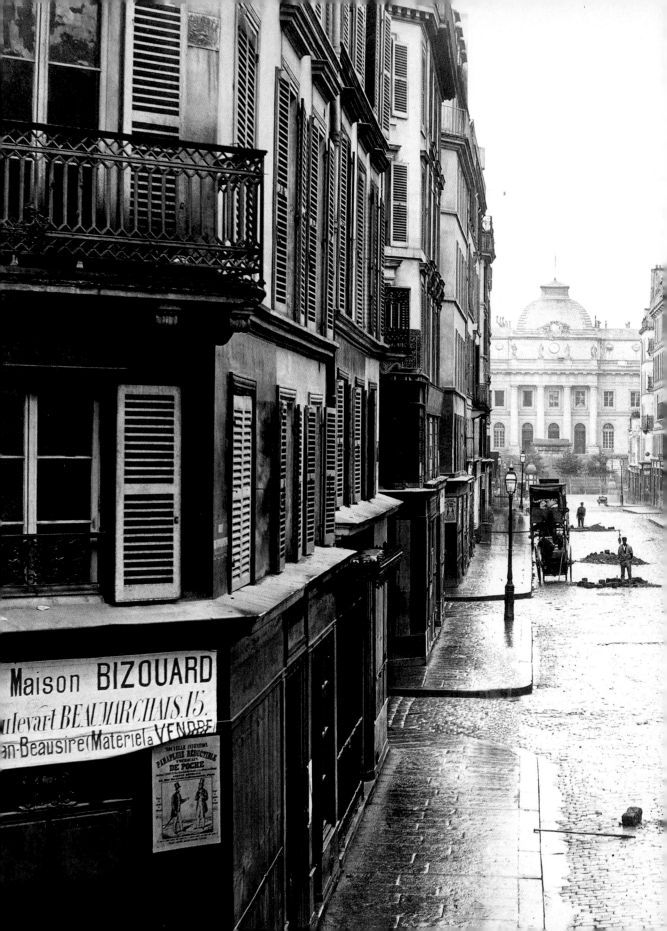

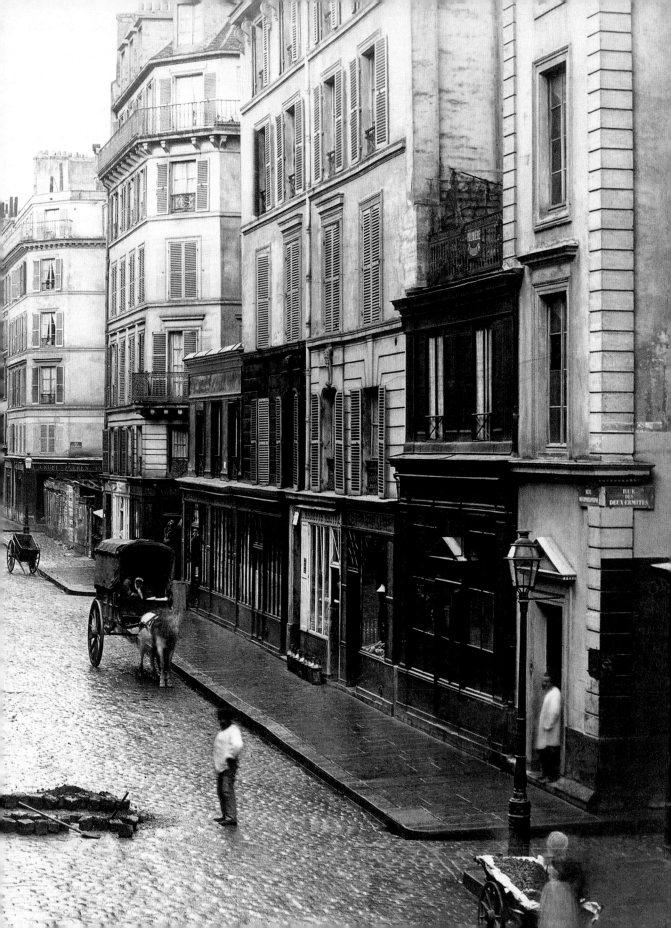

Queen Victoria

While Napoleon III reshaped France, across the Channel Britain was being reshaped under the rule of Queen Victoria. In 1854 she was 35 years old and had worn a crown for nearly half her life, since succeeding her uncle William IV in 1837. Described by one modern biographer as 'candid, stroppy and stubborn', Victoria understood the delicate constitutional position of the British monarchy, and reigned for six transformative decades: the 'Victorian' era, during which the British Empire expanded to cover one-fifth of the earth's surface. Driven by industrial and technological revolution and a booming national self-confidence encouraged by the Queen's sponsorship of great works celebrating her subjects' character and achievements, Britain became in equal measure the envy and the scourge of the world.

Victoria was photographed here by Roger Fenton on 30 June 1854, as part of a series of portraits commissioned by her husband, consort and love, Prince Albert. The couple had nine children, the youngest of whom, Princess Beatrice, was born in 1857; when Albert died in 1861, possibly of typhoid, Victoria was plunged into the deepest mourning.

Of this photograph, one of a set taken that day, Victoria noted in her diary that she was 'very successfully photographed, but it took a long time'. Her wistful gaze, cast deliberately away from camera, was a typical composition. Despite the queen's relatively low-key, domestic dress, the book on her lap and her partially uncovered hair, she remains somehow tantalizingly aloof.

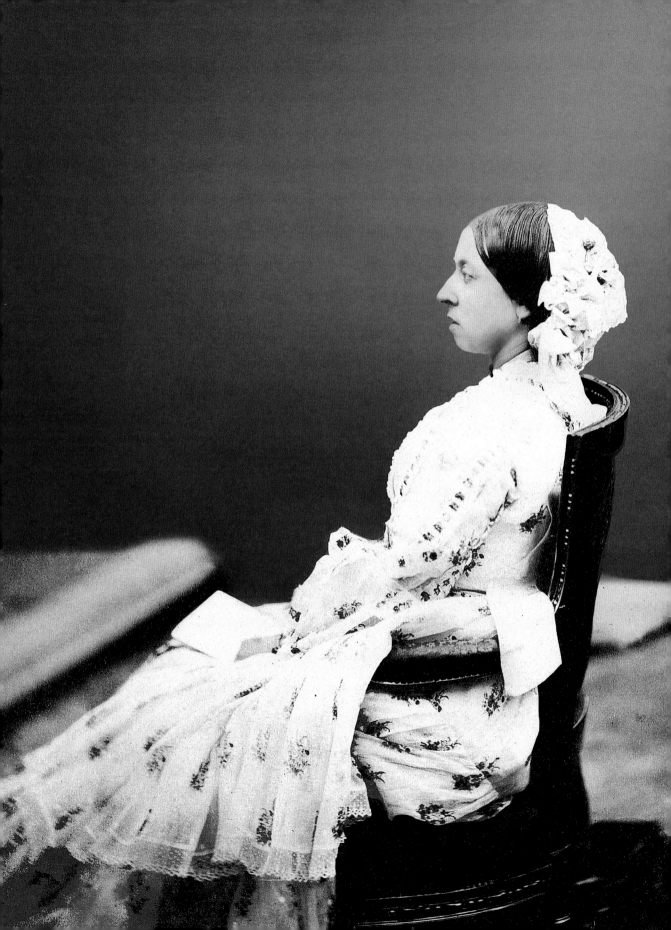

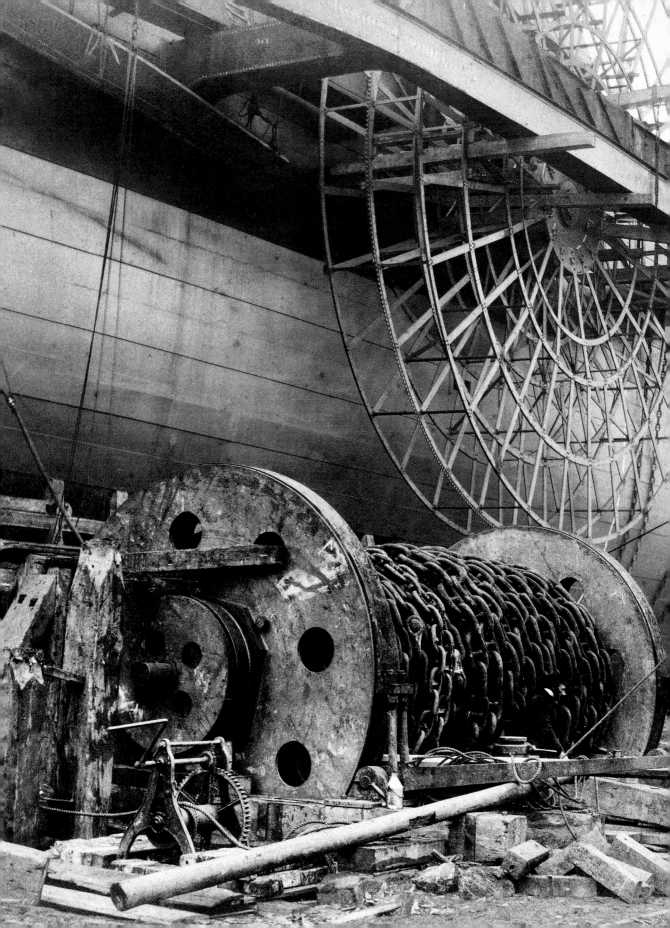

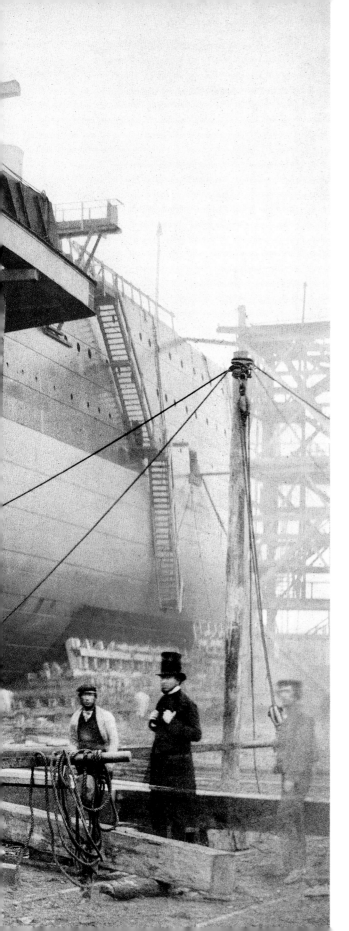

SS *Great Eastern*

Isambard Kingdom Brunel was not far from death when the largest ship that the world had ever seen was completed. Along with George Stephenson and Joseph Bazalgette, Brunel was one of the towering engineers of Queen Victoria's Britain. His trademark top hat and cigar were as recognizable as his great feats of building: the Clifton Suspension Bridge in Bristol, Paddington Station in London and the Great Western Railway. Brunel's work epitomized the spirit of adventure and invention that powered 19th-century Britain's imperial ambition.

The SS *Great Eastern*, pictured here, was Brunel's third ship and his last major project. Built at John Scott Russell's dockyards in Millwall, London, between 1854 and 1858, she was designed on a vast scale (32,000 tons of displacement). Brunel's intention was that she would be capable of making the long journey from Europe to Britain's trading posts in India or even to her colonies in Australia without the need to stop for refuelling.

Her maiden voyage took place in the autumn of 1859. Brunel, by then suffering kidney problems, had a stroke on deck shortly beforehand and died on 15 September. The SS *Great Eastern*'s greatest contribution to her age was laying telegraph cables across the Atlantic – but her size and expense proved unsustainable. In 1889 she was scrapped. Brunel, by that point, was long dead, memorialized with a window at Westminster Abbey, acknowledging his status as a titan of the Victorian age.

Hippomania

The strides taken in technology and transportation during the 19th century shrank the world, and Victorian Britain, with its industrializing society and connections to faraway lands, rapidly developed a taste for the exotic. Few things were more unusual than this hippopotamus, captured in Africa as a calf, sent by the viceroy of Egypt aboard a paddle-steamer to England, rehomed in London Zoo in 1850 and named Obaysch, after the island in the Nile where he was found.

Said to have been the first hippopotamus in Britain since Roman times, Obaysch sparked 'hippomania' in London. Thousands of people visited the zoo between 1pm and 6pm daily, during which time they could also see other exotic beasts including the (now extinct) quagga and a troupe of Arab snake charmers. Natural history was considered morally uplifting to the population at large, but the large crowds were also a boon for the zoo, which had opened to the public for the purpose of fundraising in 1847.

This 1852 photograph by the Spanish aristocrat Juan, Count of Montizón, seems to have been taken from inside Obaysch's cage. This was risky: Obaysch was highly attached to his Egyptian keeper but otherwise quite fierce. The sense of loneliness implied by both composition and subject is palpable. But two years later Obaysch was joined by a female, named Adhela, with whom he fathered a number of calves, including one born on 5 November 1872 and named 'Guy Fawkes'.

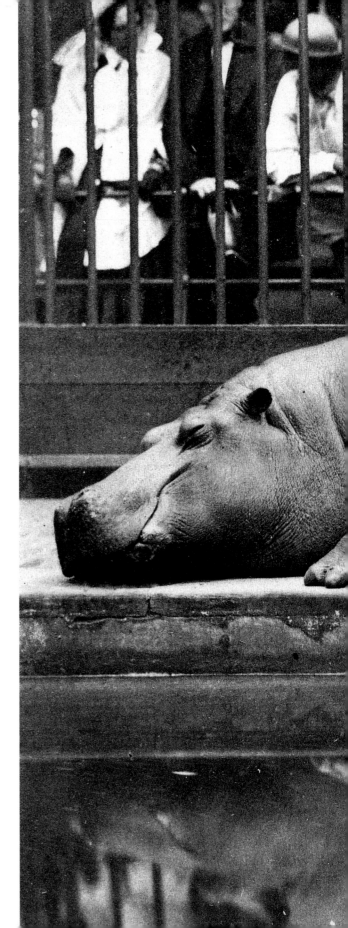

'Everybody is still running towards the Regent's Park, for the purpose of passing half an hour with the Hippopotamus. The animal itself repays public curiosity with a yawn of indifference.'

Punch magazine, 'Hip, Hip, Hip for the Hippopotamus', December 1850

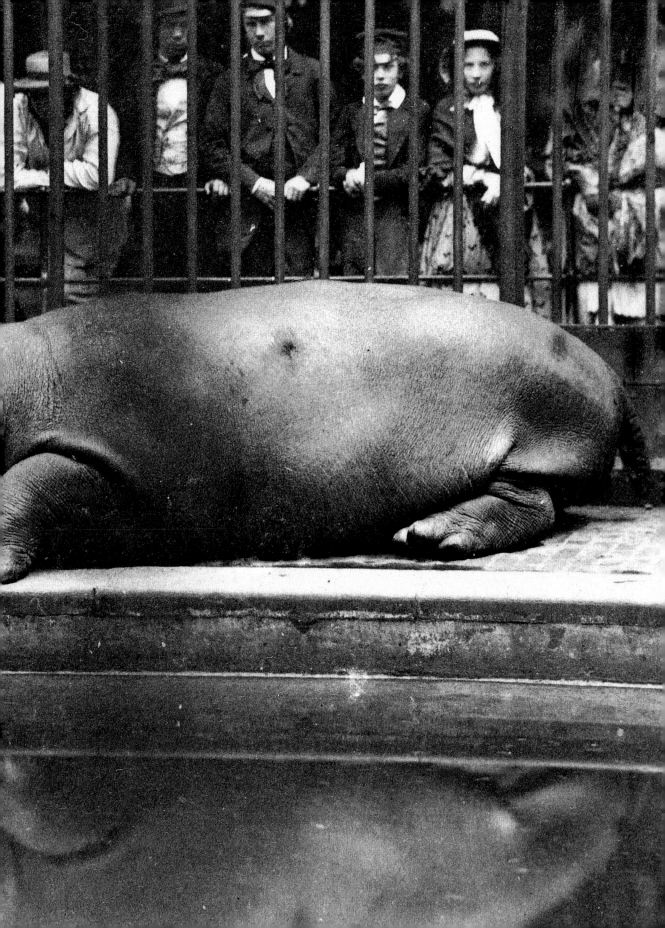

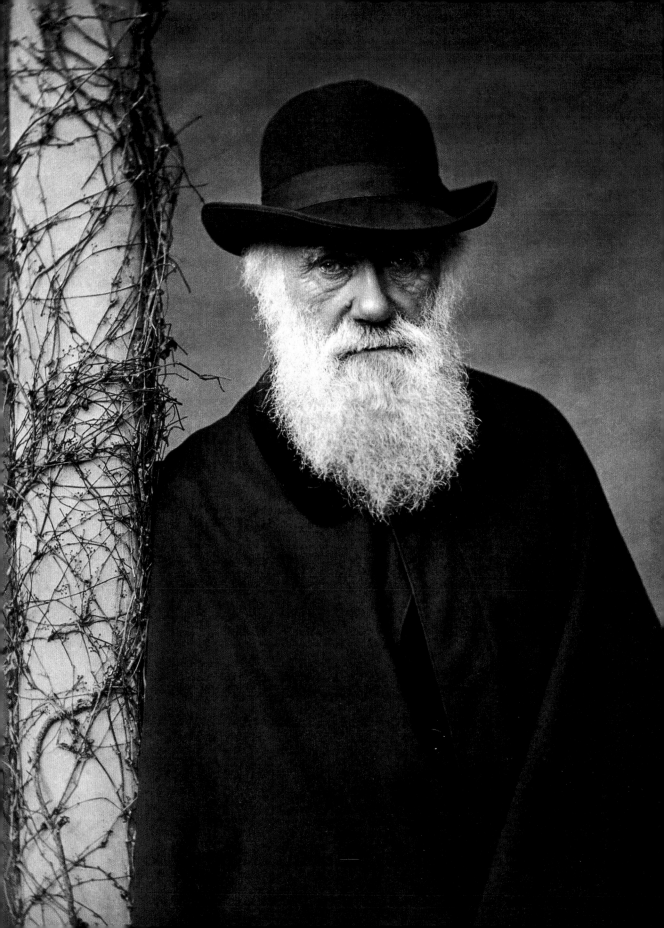

'Natural Selection… is a power incessantly ready for action, and is immeasurably superior to man's feeble efforts, as the works of Nature are to those of Art.'

Charles Darwin,
On the Origin of Species (1859)

Origin of Species

While public interest in zoology surged during the 1850s, natural history itself was also being transformed. In 1859 an Englishman named Charles Darwin published a book called *On the Origin of Species*. In it Darwin proposed a theory of natural selection, by which living things evolved over time according to their suitability to their environment.

The book was the product of Darwin's long field trips, including an epic five-year voyage during the 1830s aboard a ship called the *Beagle*. He studied the natural world in South America, Australia, New Zealand, southern Africa and the Galapagos Islands, collecting birds and animals, and analyzing their differences.

At one point during Darwin's youth his father had nudged him towards a career in the church. But *Origin of Species* put him squarely at odds with many Christian teachings, most obviously the story of God's creation. Darwin wrote that his work 'sets the priests at me and leaves me to their mercies', and that writing it was 'like confessing to murder'.

This did not stop Darwin's work from becoming profoundly influential. *Origin of Species* was regularly republished, and in 1871 Darwin released another, equally controversial work, *The Descent of Man*. He died, after a long period of ill health, in 1882. This image was taken by the famous studio Elliot & Fry towards the end of his life, and illustrates the 'venerable beard' Darwin had been cultivating at that point for nearly 20 years.

Exhibiting the World

The age of empire was an age of wonder – and plunder. As the imperial powers spread their global rule, they created a taste at home for novelties, new technologies and manufactured goods, and displays of extraordinary artefacts removed from their original settings.

In France a tradition of industrial expositions existed from the late 18th century onwards. In 1851 the British pilfered the idea and launched the first 'world's fair'. It was known as the Great Exhibition.

More than 100,000 objects from all over the world were displayed in a vast glass-and-iron structure erected in Hyde Park, nicknamed the Crystal Palace. Nearly six million visitors travelled to London to visit the exhibition, viewing objects that included railway locomotives, rare china, tapestries, porcelain and silks, jewels like the huge Koh-i-Noor diamond and a 50kg lump of gold mined in Chile, a steam hammer, a printing press, a Canadian fire engine, a folding piano and a set of Cossack armour from Russia.

After the show closed the Crystal Palace was dismantled then re-erected in 1854 in Sydenham, with many new displays. Pictured here are two plaster-of-Paris colossi made from casts taken at the temple of Abu Simbel in southern Egypt.

The Crystal Palace burned down in 1936, but it had served its monumental purpose, ushering in a global mania for world fairs and other displays of exotic treasures, a fashion which continues to this day.

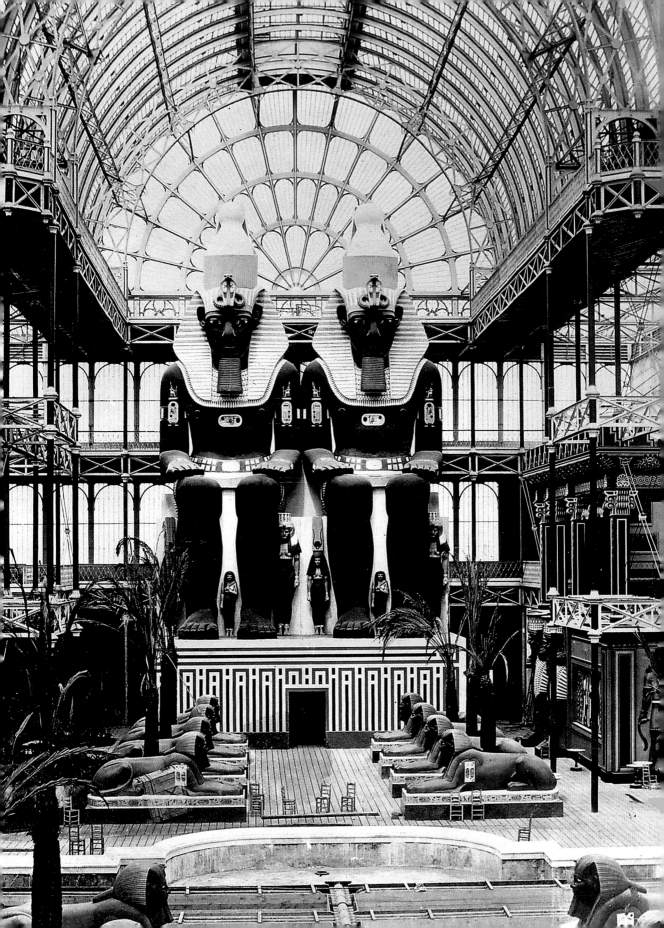

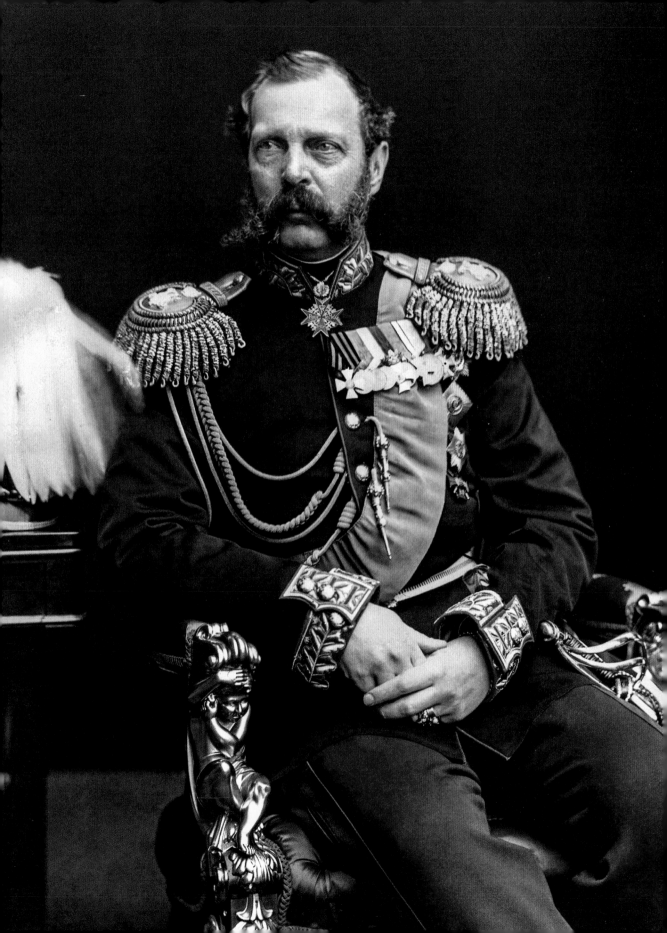

A Scandalous Tsar

When Alexander Nikolayevich stood at his father's deathbed on 2 March 1855, the older man wheezed some final words of advice. 'Serve Russia!' he said. Then, with his fist tightly clenched: 'Hold everything like this.' The 36-year-old Alexander II succeeded Nicholas I that night as Romanov tsar of Russia and for the next quarter of a century tried to put those often-contradictory pieces of advice into action.

Despite Russia's vast size and population, she lagged seriously behind Britain and France in industrial, political and cultural development. Indeed, Alexander's reign began amid a bitter war in the Crimea against those two superpowers, in which the inferiority of the Russian state was made shamefully obvious. Modernization and reform were essential if imperial Russia was to survive; yet in pursuing such policies Alexander naturally weakened his own autocracy and offended those who thought Westernization was a betrayal of Russia's history.

Alexander's most notable act of reform was the emancipation of the unfree peasants known as serfs in 1861, but he also loosened restrictions on the press, restructured local government and the military, and expanded the Russian railways. A man built in the sensuous Romanov tradition, he pursued a wildly passionate affair with Princess Ekaterina Dolgorukaya, whom he met when she was 11 and called his 'naughty minx'. He took her as his second wife in 1880, a few years after this photograph was taken in London. Alexander was killed in 1881 by three members of a revolutionary socialist organization called Narodnaya Volya ('People's Will'), who assassinated him with a bomb.

The 'Sick Man of Europe'

One of Russia's closest rivals was the Ottoman Empire, described by Tsar Nicholas I, during a meeting with a British diplomat in 1853, as 'a man who has fallen into a state of decrepitude'. Over the years this phrase has been wrongly repeated as 'the sick man of Europe'; nevertheless, the underlying idea was the same.

In the 1850s the once-mighty Islamic empire, which had began in Asia Minor during the 14th century and expanded to control territory from modern-day Iraq to Austria, was crumbling. Although since 1839 a sweeping programme of reform and modernization had been under way under Sultan Abdülmecid I, by the 1850s the empire's heyday was long past. As it decayed, the other great powers of the West vexed themselves with the Eastern Question: how to cope with the upheavals caused by the Ottomans' slow but steady collapse.

Constantinople, photographed here by the pioneering British war photographer James Robertson around 1855, had been the capital of the Ottoman Empire since its acquisition from the Byzantines 400 years earlier. The city was rich in history, multi-cultured and situated at a privileged position for trade, at the meeting point of Asia and Europe. Most significantly in the 1850s, it controlled access from the Mediterranean to the Black Sea, making it a place of special concern to Russia in particular, but also crucial to the imperial interests of Britain and France.

'If there was any intention on the part of Russia to invade and divide the Ottoman Empire… [would England] think she could dispense with intervention?… Would she not… protect her own interests and maintain the peace of the world?'

The Times of London predicts war, 26 March 1853

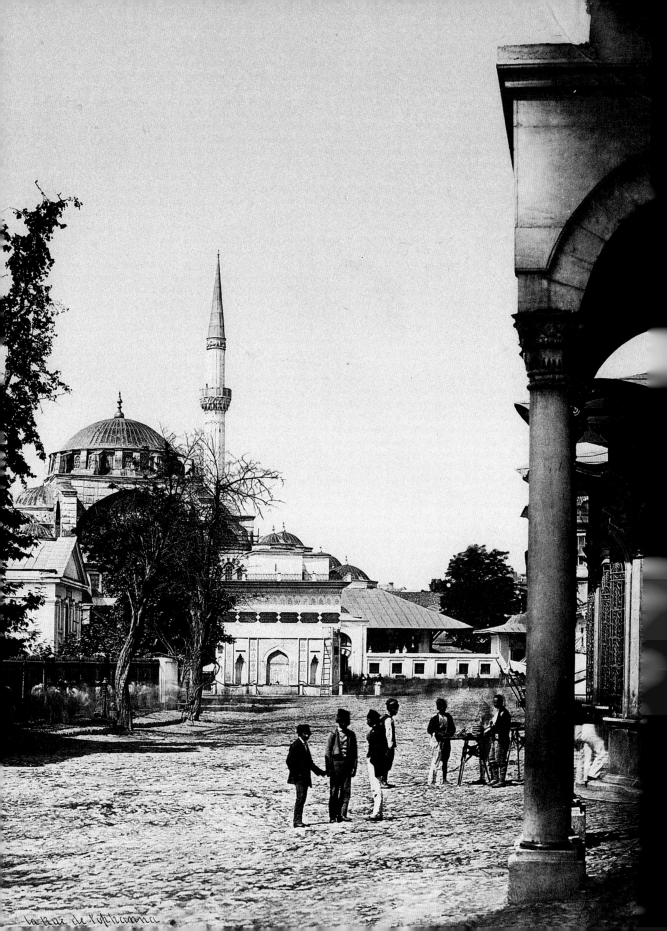

La Rue de l'Otmana

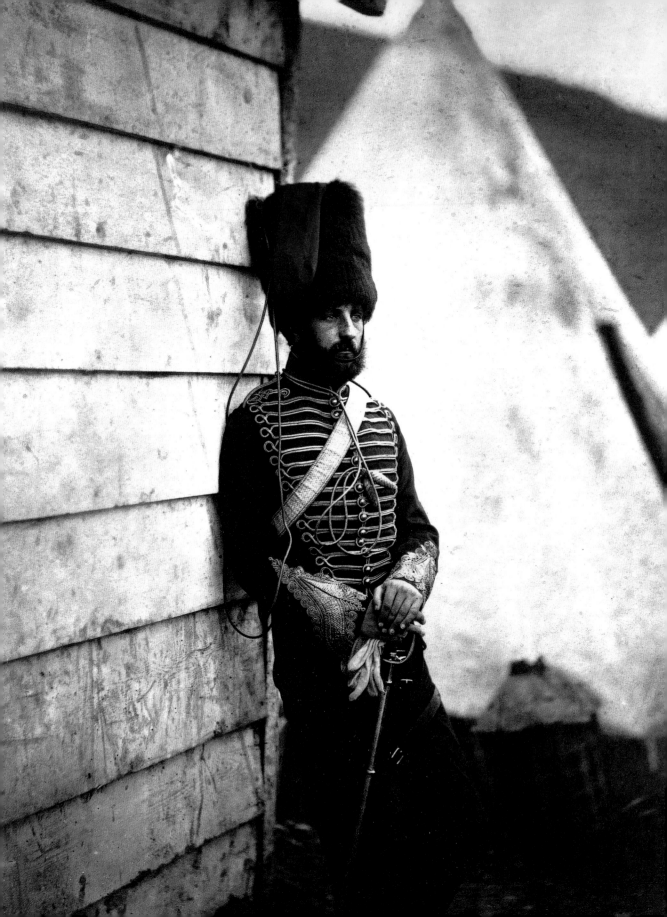

'As I went my night rounds among the newly wounded that first night there was not one murmur, not one groan... These poor fellows bear pain and mutilation with unshrinking heroism.'

British nurse Florence Nightingale, 5 November 1854

The Crimean War

The collapse of the Ottoman Empire was not merely the abstract concern of diplomats. In 1852 it became a *casus belli* when a group of Orthodox and Latin monks attacked one another with candlesticks at the Church of the Holy Sepulchre in Ottoman-ruled Jerusalem. This undignified spectacle was the flashpoint for a war eventually fought 2,400km away, which involved all of the great European powers and left around 600,000 people dead.

Following the disturbances in Jerusalem, Napoleon III of France and Nicholas I of Russia both demanded of the Ottoman rulers that they be recognized as protectors of the city's Christian holy places. The dispute was not settled, and escalated when Russia attacked Ottoman territory in modern Romania. Stung by the possibility of Russian aggression in areas of its own interest, Britain also intervened and declared war. In September 1854 British, French and Ottoman forces launched an attack at the heart of Russian military power in Sevastopol on the Crimean Peninsula in the Black Sea.

Conditions for all sides in the Crimean War were miserable. News reports telegraphed from the front to *The Times* of London spared no detail of the disease, hardship and waste. Captain Thomas Longworth Dames of the Royal Artillery, photographed here by Roger Fenton, is smartly presented in a deliberately sanitized view of the war, but the Irish war reporter William Howard Russell saw another reality. London beggars, he later wrote, 'led the life of a prince compared with the British soldiers who were fighting for their country'.

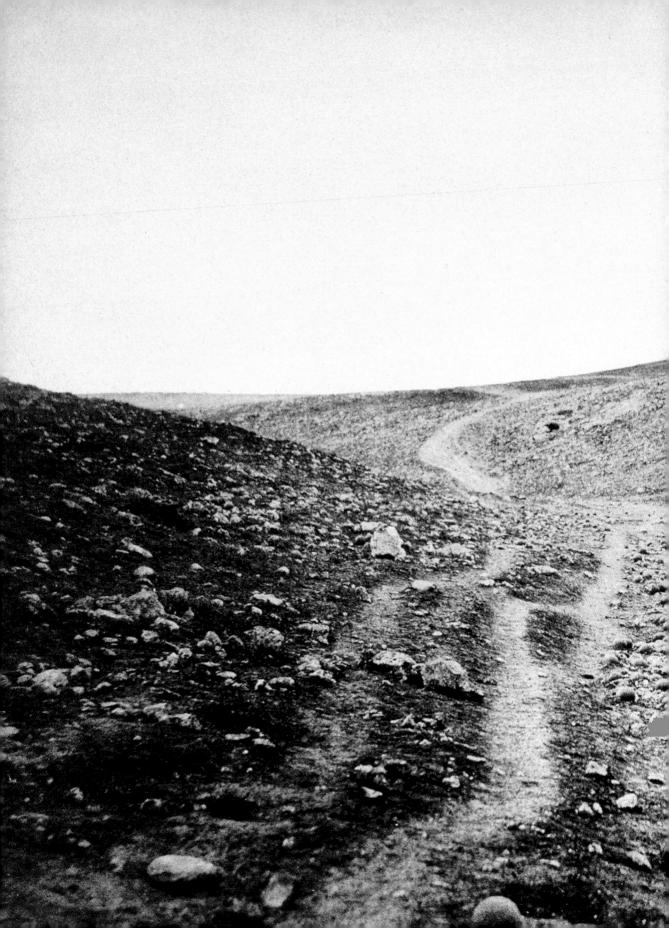

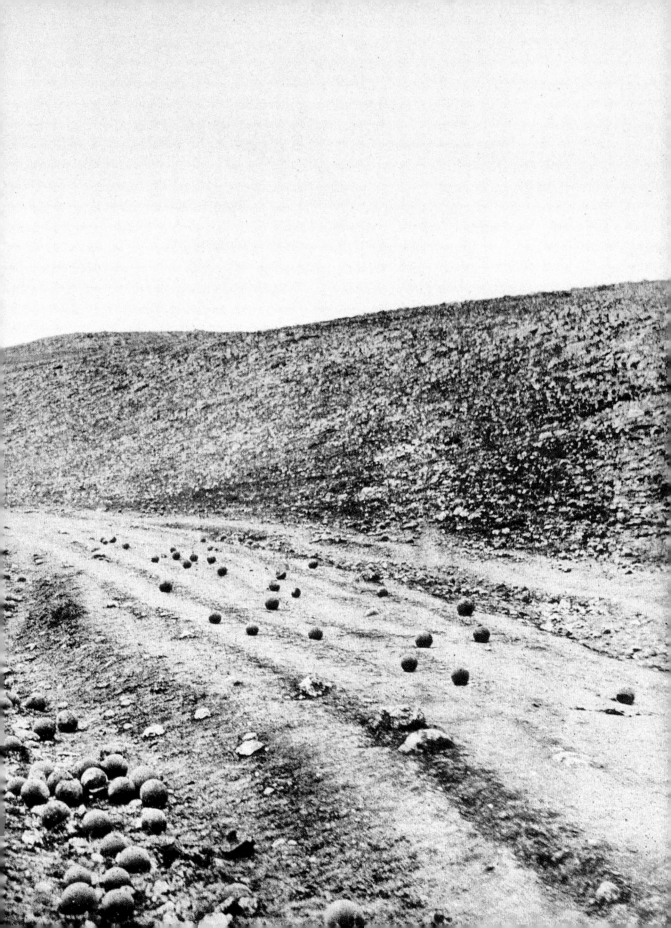

The Charge of the Light Brigade

Roger Fenton's photograph of the location of the
Battle of Balaclava, fought on 25 October 1854, shows
a landscape calm but for a littering of cannonballs.
(A debate still rages about whether Fenton placed the
cannonballs himself.) Yet the news reports from the
Crimea, which sped around Europe following the
battle, told a different story. 'A more fearful spectacle
was never witnessed than by those who, without the
power to aid, beheld their heroic countrymen rushing
to the arms of sudden death,' wrote William Howard
Russell. 'The plain was strewed with their bodies and
with the carcasses of horses.'

The Charge of the Light Brigade, immortalized
in poetry by Alfred Tennyson and on canvas by
Richard Caton Woodville, was only one action in that
battle. Yet it swiftly became emblematic of faltering
British leadership in the Crimean War and the awful
privations imposed on men and horses.

Six hundred and seventy-three British light
cavalrymen took part in a misdirected charge at
Russian gun emplacements, ordered on a death-ride
by inexperienced officers whose instructions were
incorrectly relayed. Around 110 were killed, but set
against the war's more general failings – a cholera
epidemic that killed thousands, inadequate winter
clothing and thin rations – the Charge of the Light
Brigade was an unforgivable disaster. It led directly
to the resignation of Lord Aberdeen's government in
London in January 1855.

Women at War

The wars of the mid-19th century may have been
fought overwhelmingly by men, but they were
facilitated to no small degree by women, who
supplied, provisioned and nursed the troops, and
endured many of the same harsh conditions in
the Crimea, where this unnamed photograph of a
cantinière was taken by Roger Fenton.

Women known as *cantinières* or *vivandières*
had travelled with French armies since the late 18th
century. As the wives of serving men, they wore
uniforms matching their husbands' and sold wine,
food, tobacco and other small provisions to the
soldiers from tents or carts. Napoleon III prized
cantinières and ensured that large numbers of such
women travelled with the French armies who fought
in Mexico, the Far East, Belgium, Italy, Russia and
elsewhere; they remained an integral part of the
French military until the early years of the 20th
century. The success of the system was mimicked by
others, notably during the American Civil War in the
1860s, where *cantinières* travelled with armies on both
sides of the conflict.

The life of a *cantinière* was by its very nature
difficult and dangerous. Yet it also allowed a rare form
of freedom, particularly for French women whose
general rights and freedom to move and work were
tightly circumscribed under France's 'Napoleonic
Code' of civil law. Perhaps inevitably, the highly
idealized image of the coquettish *cantinière* also
became a staple fantasy among British soldiers of
the day.

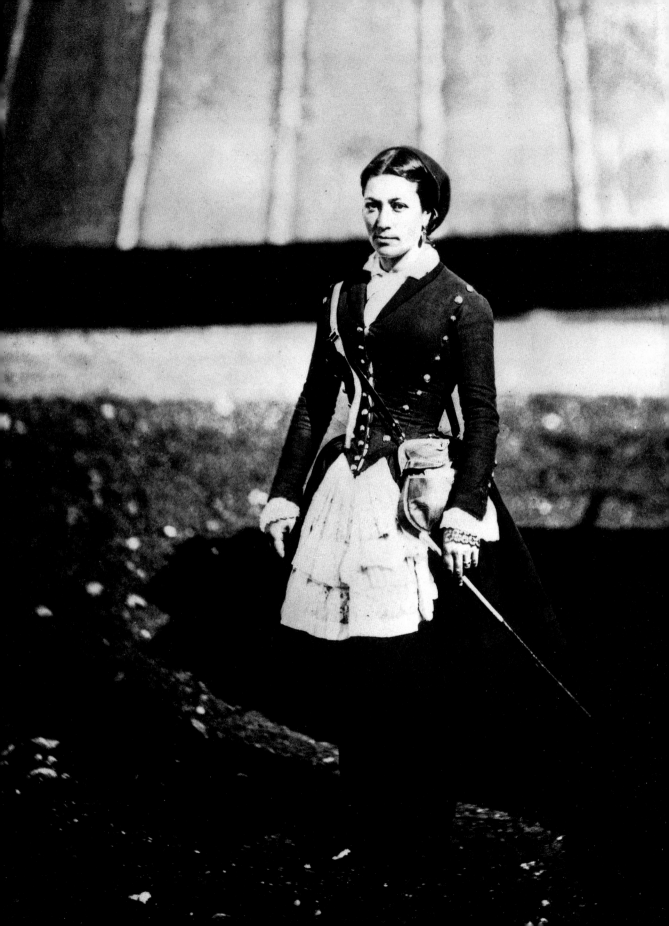

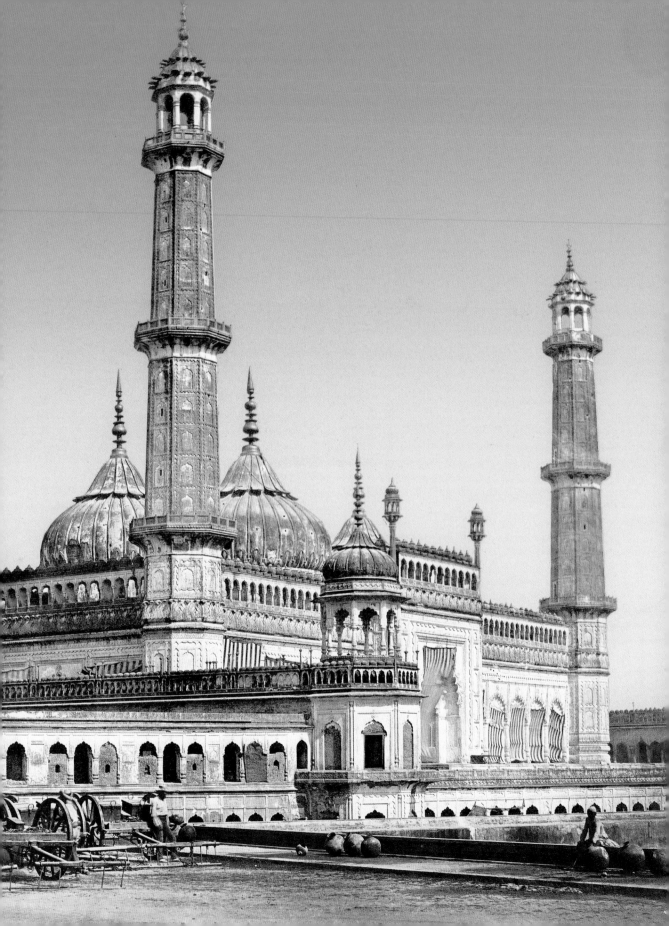

'The moment a mutiny is but threatened, which shall be no mere mutiny, but the expression of a universal feeling of nationality, at that moment all hope is at an end, as all desire should be at an end, of preserving our Empire.'

Victorian historian Sir John Seeley on the uprising of 1857–8

The Indian Mutiny

While the great powers fought in Europe, another struggle was taking place thousands of kilometres to the east. In India, British rule had been extended since the 1600s through the East India Company. Deploying royal patronage, political cunning and the might of its ferocious private armies, by the middle of the 19th century the Company ruled more than half of the Indian subcontinent, from the Himalayas to Madras, and from the borders of Afghanistan to Lower Burma.

Its officials were accused of interfering with social and religious traditions, economically exploiting the population and failing to provide justice. Religious tensions between Hindus, Muslims and Christians were further intensified in early 1857 by a rumour that new gunpowder cartridges issued by the Company to its Indian soldiers (sepoys) were greased with pig and cow fat – an insult to both Muslim and Hindu sensibilities.

On 10 May 1857 a major rebellion erupted in the garrison town of Meerut, led by mutinous sepoys. It spread rapidly to Delhi and Lucknow, regional capital of Awadh (or Oudh) province, which the East India Company had annexed in May 1856, and whose mosque is shown here shortly after the revolt. Other cities across Awadh rose during the following weeks and the governor's residence in Lucknow was besieged twice, for a total of more than 140 days. By the end of 1858 Lucknow and Delhi were in ruins and northern India had been in uproar for 18 months. The rebellion failed, but it would change India forever.

Birth of the Raj

Around 800,000 people were killed during the violence that swept through northern India in 1857–8. Atrocities and massacres were committed by both sides, including bayonetting civilians, rape, lynchings, child murder and the grotesque practice of strapping mutineers to cannon muzzles and blowing them to pieces. The people of India fought on both sides of the rebellion, with local history dictating allegiances. In the Punjab, Sikh soldiers fought alongside British units, such as the two cavalrymen pictured here in 1858 by Italian photographer Felice Beato.

The rebellion provoked an immediate spirit of vengeance among the British, manifested in merciless retaliatory executions applauded by a jingoistic press at home. Charles Dickens wrote: 'I wish I were commander-in-chief in India… I should do my utmost to exterminate the race.' Fortunately, he was not. In 1858 Queen Victoria issued a royal proclamation ending East India Company rule and imposing direct royal governance over India: the era of the British Raj.

Britain thereafter paid more attention to Indian culture and hierarchies, while also introducing railways and canals and encouraging schools and colleges: the basic structures of a modern India. This was all done, to be sure, with London's interests still in mind. Yet its ultimate effect, seen many decades later, was to seed an Indian nationalism that would eventually help tear the British Empire apart.

'We hold ourselves bound to the natives of our Indian territories by the same obligation of duty which bind us to all our other subjects.'

The Government of India Act 1858

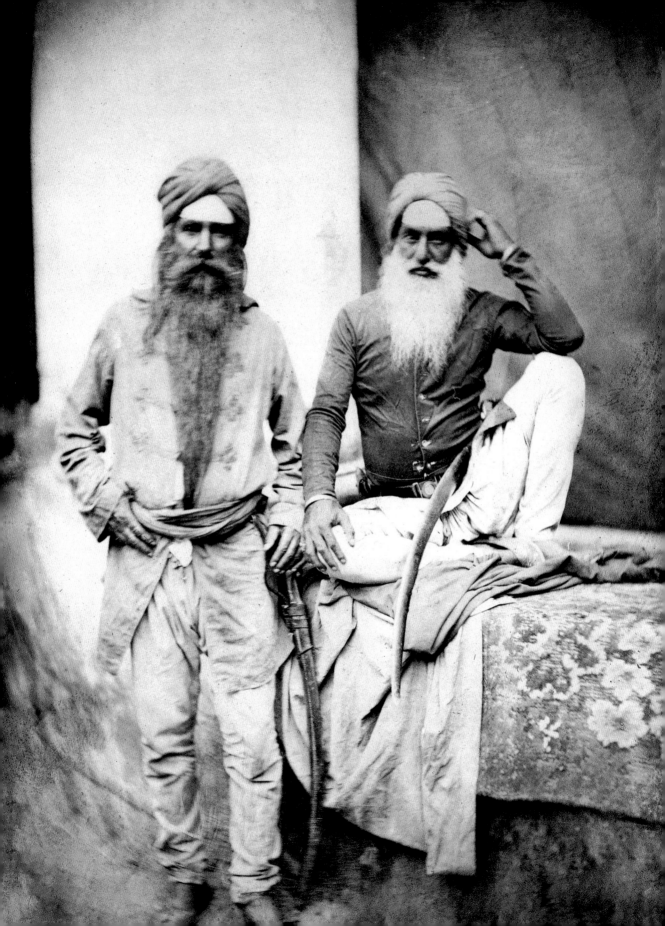

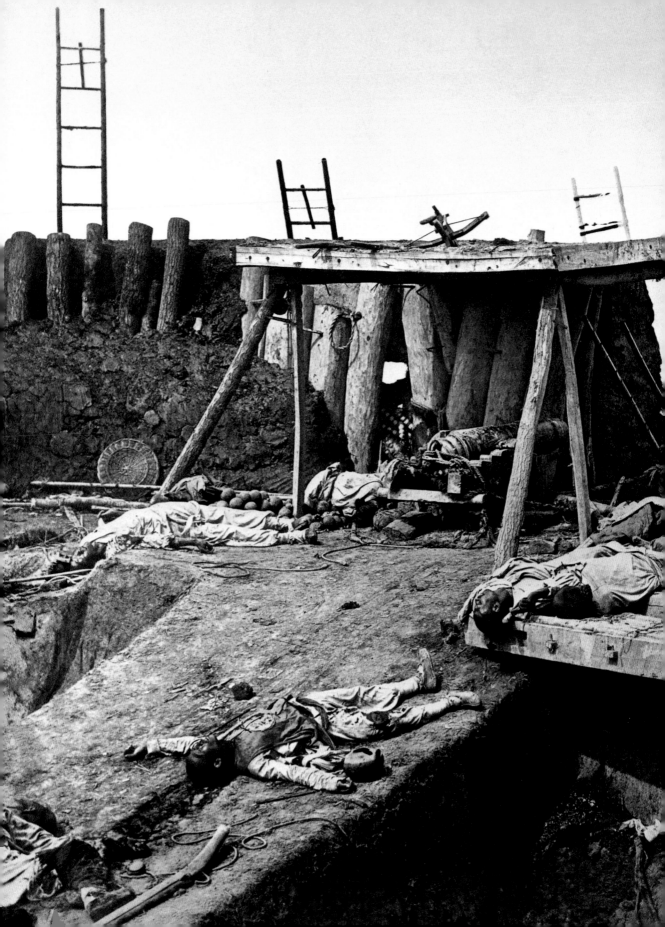

The Opium Wars

One of India's greatest attractions for the British
was opium. Poppies grown in British Bengal were
manufactured into this highly addictive drug, which
was then exported around the world, particularly to
China. There opium found an enthusiastic market
among a population who thought it aided sexual
performance. Opium dens, some full of skeletal
addicts, were a common sight in Chinese towns
and villages.

China's ruling Qing dynasty recognized the
social destruction caused by opioid addiction and
attempted to block sales by the British. The First
Opium War was fought between 1839 and 1842; in
1856 a second began. These wars pitted the naval
might of the British Empire and its French allies
against the Qing, and drew in many other issues of
contention between the powers, including general
rights of free trade with China, mistreatment of
foreign Christian missionaries, and the 'coolie' trade,
by which Chinese labourers were exported around the
world and put to work from Singapore and Australia
to Peru, Chile, the Caribbean and the United States.

This photograph by Felice Beato shows the
interior of one of the Taku forts that protected the
approach to Beijing, following a British and French
victory in August 1860. (The carnage shown here was
a departure from the bloodless war photography that
had characterized the Crimean War earlier in the
decade.) Two months later the British looted the city's
Yuan Ming Yuan (Old Summer Palace) of its priceless
porcelain and treasures, and then burned it. The
humiliated emperor fled and a punitive treaty was
imposed, highly favourable to Britain and France.

'The crimes of this guilty
land will never be purged
away but with blood.'

Abolitionist and freedom fighter John Brown

Expanding the USA

While the old world empires of Europe focused
on expanding eastwards, the young United States,
a nation forged by the revolutionary wars of the
18th century, was also growing. By the 1850s its
government was aggressively pursuing territory in
the modern Midwest, under the banner of 'manifest
destiny': the belief that the USA was destined to cover
all the land between the Atlantic and Pacific coasts.

Although manifest destiny eventually
underpinned the emergence of the USA as a world
superpower, it had dire consequences for Native
American peoples, such as the Pottawatomie tribes
of the Great Plains (two of whom are depicted here)
who had been removed by treaty from their original
homelands to new territories in Nebraska and Kansas.
As these regions were in turn claimed and settled by
the USA, so the Native Americans were moved again:
a relentless process of forced migration that saw whole
populations decline towards extinction.

For the settlers, meanwhile, the charge
westwards exposed severe political tensions between
the states. The issue was slavery; the question was
whether new states admitted to the Union should
permit slave labour. Kansas in the 1850s was the scene
of guerrilla warfare (known as 'Bleeding Kansas')
between those who thought slavery an inalienable
right under the Constitution, and those who thought
it a moral stain on the land of the free.

Eruptions of violence in the western territories
achieved no political solution, and by the end of the
decade it was clear to many that only a great war
between the states could resolve the issue.

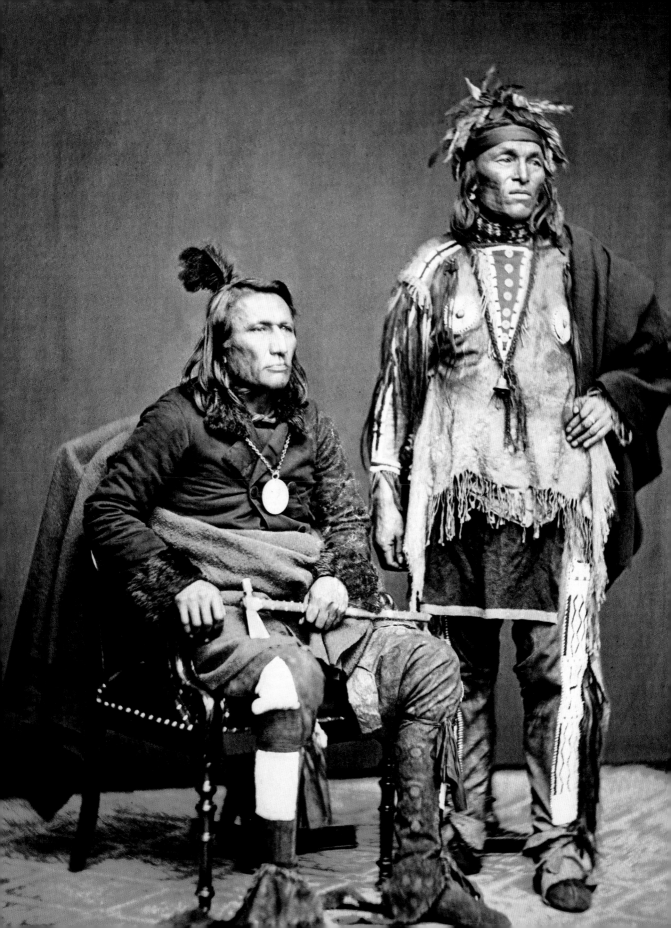

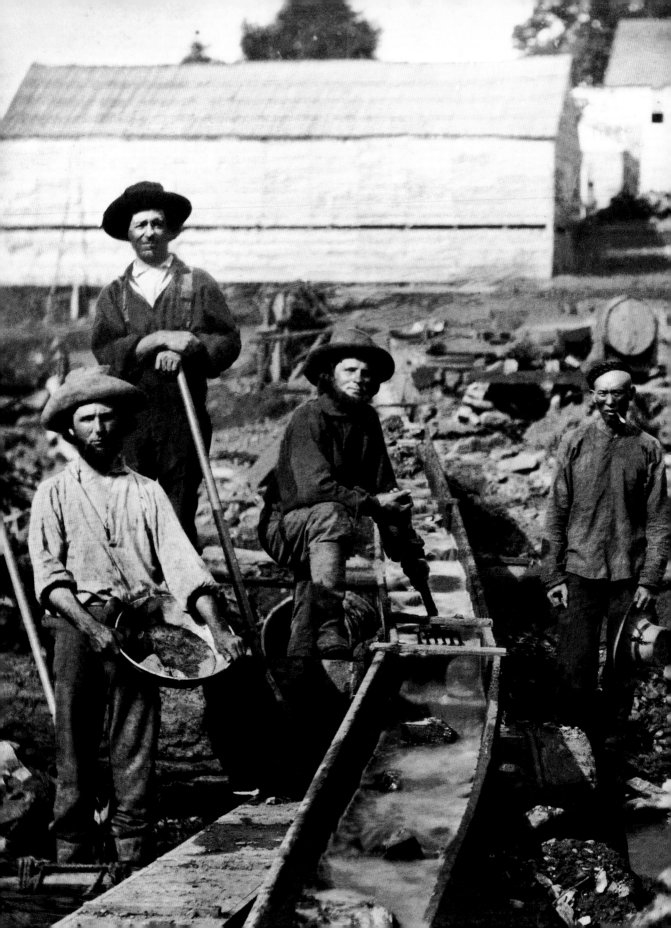

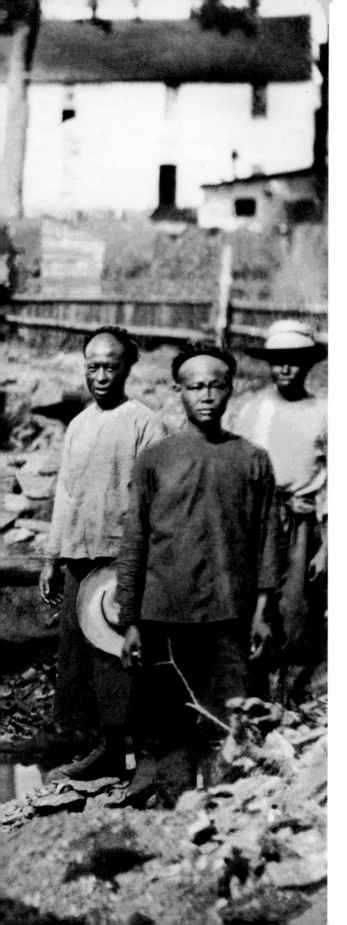

California Dreams

The American drive to the Pacific had brought California into the Union as the 31st state in 1848. That year gold was discovered in the Sierra Nevada mountains, beginning a rush of prospectors to the West, all with dreams of digging their way to a great fortune.

But it was not just Americans from the eastern states who arrived in California. During the 1850s thousands of workers arrived from China, fleeing from the turbulent rule of the Qing dynasty. Many of these went to the gold fields, although others settled in booming cities like San Francisco, where there was a high demand for basic services, ranging from laundry to prostitution, to support thriving new populations.

White and Chinese miners are shown here side by side, but tensions existed between the two, and California's state legislature ensured that in disputes the weight of the law came down on the side of the white man. Onerous monthly taxes and licensing fees were imposed on Chinese miners. A California Supreme Court decision of 1854 in the case of *The State of California vs George W. Hall* ruled that Chinese–Americans and immigrants should not be allowed to testify in legal cases against white citizens.

This basic denial of rights classified Chinese workers alongside black, mixed-race and Native American people, and tacitly reinforced white supremacy even in a so-called free state where slavery had been excluded from the constitution.

'…A race of people whom nature has marked as inferior, and who are incapable of progress or intellectual development beyond a certain point, as their history has shown…'

Racism is written into law,
The State of California vs George W. Hall, 1854

Connecting Canada

The settlement of North America was dragged along
by the railroad. Steam engines covering thousands of
kilometres of track allowed rapid overland links across
previously impossible distances. This was particularly
important in Canada and the northern United States,
where during the 1850s the Grand Trunk Railway
Company of Canada began to build a large network
of tracks connecting Montreal to Ontario, with rails
also running south to states including Vermont,
Massachusetts and Maine.

Canada's connection by rail mirrored its
increasing political unity. Although split between
French- and English-speaking regions, a unified,
British-ruled Province of Canada had been created
out of Lower and Upper Canada in 1840. (In 1867
these would be joined by two neighbouring British
territories, Nova Scotia and New Brunswick.) Yet
this political entity was nothing like as expansive as
the Canada we know today: all lands west of Lake
Superior remained unsettled and largely unexplored.

Over the second half of the 19th century
Canadian settlement increased and its independence
advanced, although the nation only achieved
complete freedom from British oversight in 1982. This
photograph speaks to Canada's history as an imperial
dominion: it was one of many such scenes captured
by the Scotsman William Notman, who emigrated
to Canada in 1856 and four years later attended the
future king Edward VII during a royal tour.

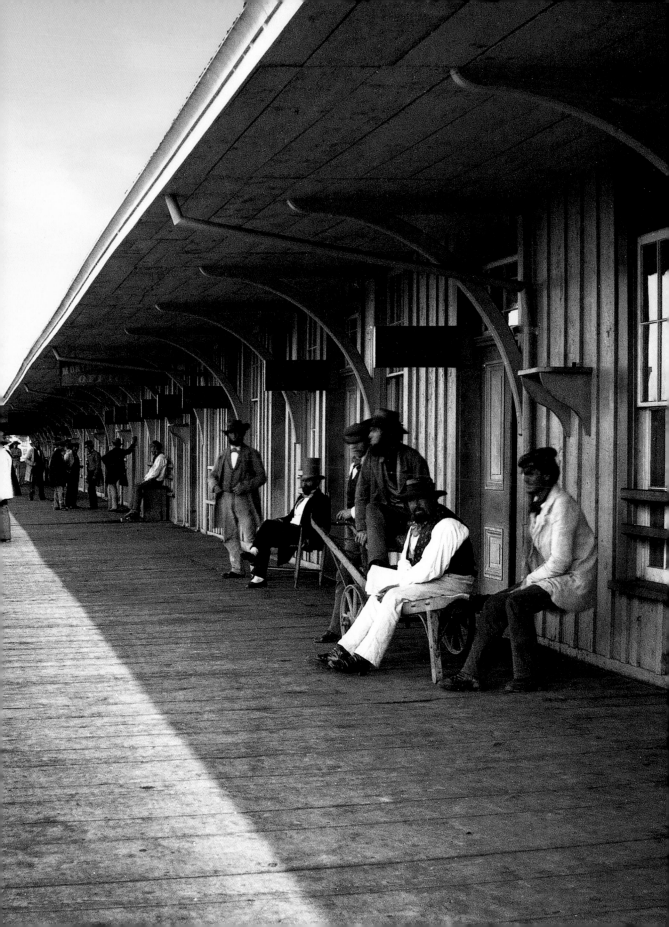

Insurrection

1860s

'The heart of this nation was stirred yesterday
as it has never been stirred before.
The news… carried with it a sensation
of horror and of agony which no other event in
our history has ever excited.'

New York Times, 16 April 1865,
two days after the shooting of Abraham Lincoln

'm mad! I'm mad!' With these words 21-year-old Lewis Powell fled the house of US Secretary of State William H. Seward and ran into the street, throwing a bloodied knife into the gutter. It was nearing midnight in Washington DC on 14 April 1865, a doleful date in American history.

Behind him Powell left Seward lying critically injured: stabbed half to death in his bed. Elsewhere even worse was afoot. A few streets away, at Ford's Theatre, the 16th president, Abraham Lincoln, was also in a grievous state. He had been shot in the head by the famous actor John Wilkes Booth, while watching a performance of the comic play *Our American Cousin*. Seward survived, but Lincoln died the following morning. An attempt on the life of Vice President Andrew Johnson failed, and he was sworn in as Lincoln's successor the same day. It was the first time a US president had been assassinated, but it would not be the last.

Powell was arrested three days later, after being apprehended at a boarding house, and most of his co-conspirators were also captured. (Booth was shot dead.) Their motives quickly became plain. All were disaffected supporters of the Confederacy, the southern bloc of states which had seceded from the Union in 1861 in protest at Lincoln's election on an anti-slavery platform. The secession of the South had begun a bloody civil war that killed 620,000 Americans in four years and ended in Confederate defeat. Powell, an Alabaman, was a veteran of the vicious Battle of Gettysburg, fought in July 1863.

This portrait was taken when Powell was a captive awaiting trial on the USS *Saugus*, anchored in the Anacostia River. The photographer was Alexander Gardner, a Scotsman who had emigrated to the United States, where he documented many of the most significant battles and characters of that time.

The rawness of Gardner's compositions and his unblinking eye for death and violence can obscure the fact that, like Roger Fenton, he often heavily manipulated the scenes he captured. Here Powell looks callous and insouciant; in reality he was in a tortured state of mind. He was being kept in miserable conditions, and few days earlier had banged his head repeatedly against the bars of his cell in a likely suicide attempt. Gardner presented a very different image of a would-be murderer. This photograph here is a study in icy defiance, which today reminds us of the affected carelessness of a

1860

[May] Giuseppe Garibaldi leads an invasion of Sicily in an event known as the Expedition of the Thousand, part of the *Risorgimento*

[Oct] Beijing's Summer Palace burned to the ground during the Second Opium War

[Nov] Abraham Lincoln elected 16th president of the USA

1861

[Feb] Southern states secede from the Union, forming the Confederate States of America, led by President Jefferson Davis

[Feb/Mar] Emancipation of the serfs proclaimed by Russian tsar Alexander II

[Apr] US Civil War begins

[Aug] Xianfeng Emperor dies; power in Qing China is seized by a faction controlled by Empress Dowager Cixi

1862

[May] French defeated in Mexico at battle of Puebla – the anniversary now marked on *Cinco de Mayo*

[Jun/Jul] US Civil War – Seven Days Battles

[Sep] Otto von Bismarck appointed minister president of Prussia by King Wilhelm I

1863

[Jul] Battle of Gettysburg: bloodiest conflict of the US Civil War, in which 165,000 men took part, around a third of whom were killed or maimed

1864

[Feb] Prussia invades Denmark

[Dec] Isambard Kingdom Brunel's Clifton Suspension Bridge opens in Bristol, England – seven years after its designer's death

rock star on the cover of some fashion magazine. Gardner's photographs, and therefore his version of the story, informed a world hungry for news of the agonies that gripped the disunited States. And he saw the story through. A few months later he was the only photographer present at the hanging of Powell and three of his fellow plotters, who died at the Washington Arsenal on 7 July 1865.

The American Civil War was one of the defining events of the 1860s, but elsewhere the world was moved by other major upheavals. The kingdom of Prussia under the formidable political leadership of Otto von Bismarck crushed its neighbours in Denmark and Austria to emerge as the dominant power in central Europe. Italy was unified under the rule of King Victor Emmanuel II. These two concurrent (and connected) waves of nation-building at gunpoint were part of a long history of upheaval in central Europe that stretched back to the heyday of the Holy Roman Empire; their effects would be felt across the world during the global wars of the 20th century. Meanwhile, Russia entered a 50-year period of social and political revolution as Tsar Alexander II liberated the empire's unfree peasant class before struggling to contain a series of revolts in its western

territories. Japan was gripped by revolution and the spirit of reform and China entered a long period of modernization under a pair of charismatic dowager empresses.

All the while, technological progress marched on, as the building of thousands of kilometres of new railroads and telegraph cables further connected the world, canals were dug and new vehicles like the submarine were created. Scientists discovered new elements and created technologies that would alter man's experience of the world in radical and unexpected ways. Some, like antisepsis, prevented disease and prolonged life. Others, such as dynamite, highlighted humankind's growing ability to harness science for the purpose of destruction.

1865

[Apr] US Civil War ends with General Lee's surrender at Appomattox. Lincoln is subsequently assassinated by John Wilkes Booth and accomplices including Lewis Powell

1866

[Mar/Apr] US Congress passes first Civil Rights Act, offering legal protections to African Americans: an important measure in the early years of Reconstruction

[Jul] SS *Great Eastern* succeeds in laying the first working transatlantic telegraph cable

1867

[May] Alfred Nobel patents dynamite in London

[Jun] Emperor Maximilian of Mexico shot dead by a firing squad

[Sep] Karl Marx publishes first volume of *Das Kapital*

[Nov] 14-year old Mutsuhito succeeds his father as Emperor Meiji of Japan. The 'Meiji Restoration' heralds rapid change in Japanese society

1868

[Jan] Last-ever convict ship arrives in Australia from Britain, bringing to an end the era of penal transportation

[Oct] Thomas Edison applies for his first patent

1869

[May] National Women's Suffrage Association formed in New York to lobby for the right for American women to vote

[Nov] Suez Canal is officially opened with the sailing of a ceremonial armada

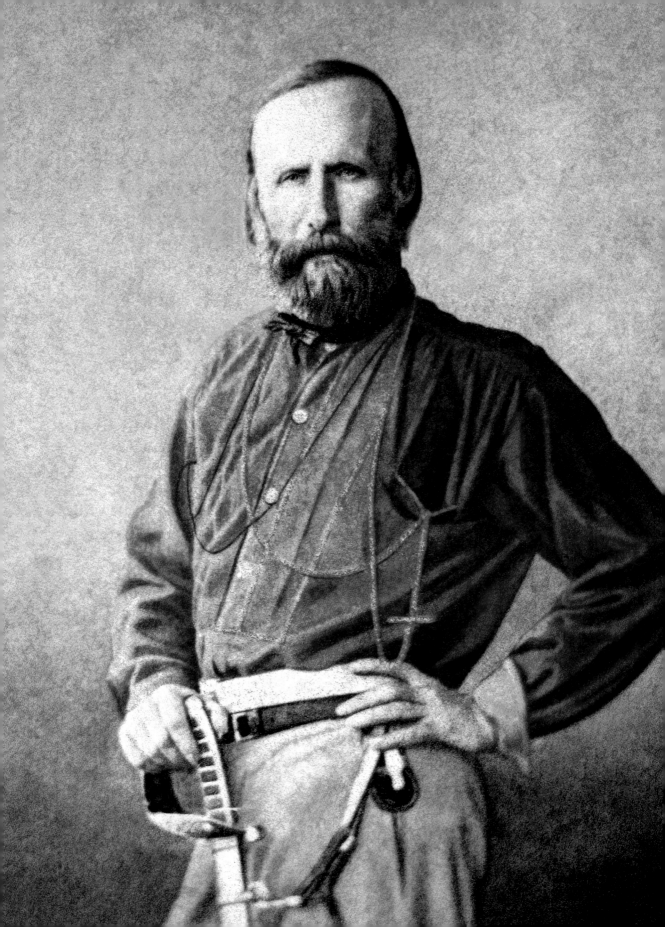

Garibaldi

The red-shirted army known as *I Mille* (the Thousand) poured off their ships in western Sicily on 11 May 1860, armed and impassioned by the leadership of one of the most famous and daring soldiers of the century: Giuseppe Garibaldi. They aimed to liberate Sicily from rule by the Bourbon monarchy and join it to the nascent kingdom of Italy.

Italian unification was the latest of the grand causes to which Garibaldi had devoted his life. Born in 1807, he was attracted to revolution from a young age, and was duly exiled from Italy aged 26. He then found his way to South America and hitched his fortunes to a succession of insurgent movements, taking part in the Ragamuffin War against the Brazilian Empire and a civil war in Uruguay.

Garibaldi was a master of guerrilla warfare and a highly capable naval commander. During the 1850s he operated merchant ships between the Americas and Britain. But Italy and the politics of Italian unification always called him back home. His arrival in Sicily in 1860 marked the beginning of a campaign that would end in triumph with Italy united in 1871.

Garibaldi's legend was as impressive as his achievements. Here he is pictured in 1864, wearing his signature red shirt. This uniform, together with his reputation as a romantic expeditionary and adventurer combined to lend him iconic status across the world – nowhere more so than in his beloved Italy, whose eventual unification he did so much to ensure.

'I offer neither pay, nor quarters, nor food; I offer only hunger, thirst, forced marches, battles and death. Let him who loves his country with his heart, and not merely with his lips, follow me.'

Giuseppe Garibaldi, 2 July 1849

Italy United

By the 1860s the Ponte Salario, on the outskirts of Rome, had survived the collapse of the Roman Empire, the depredations of conquering barbarians and a bombardment by Napoleon I's armies. In 1867, however, the famous 25m stone arch at the centre of the bridge finally came crashing down into the river below, destroyed by papal and French troops attempting to delay the progress of forces led by Garibaldi.

It was a casualty of the long-running series of political and military campaigns known as the *Risorgimento* – literally, the resurgence – by which the disparate states of the Italian peninsula were united. Italian nationalists had been struggling to consolidate a nation state free of foreign domination for much of the 19th century, and by 1867 the dream was tantalizingly near. Almost all of Italy was in their hands: the exception was the Papal State, centred on Rome, which had been declared capital of a united Italy in 1861 but remained unconquered. In 1867 Garibaldi's men attempted to capture the city, only to be beaten back by papal troops supported by French allies. It was during the course of this battle that the Ponte Salario was reduced to rubble.

Rome eventually fell to the Italian army on 20 September 1870 and Italy was united under King Victor Emmanuel II the next year. The bridge was rebuilt in 1874 and later widened to accommodate 20th-century motor traffic. Today it is a rather unprepossessing part of the state highway SS4.

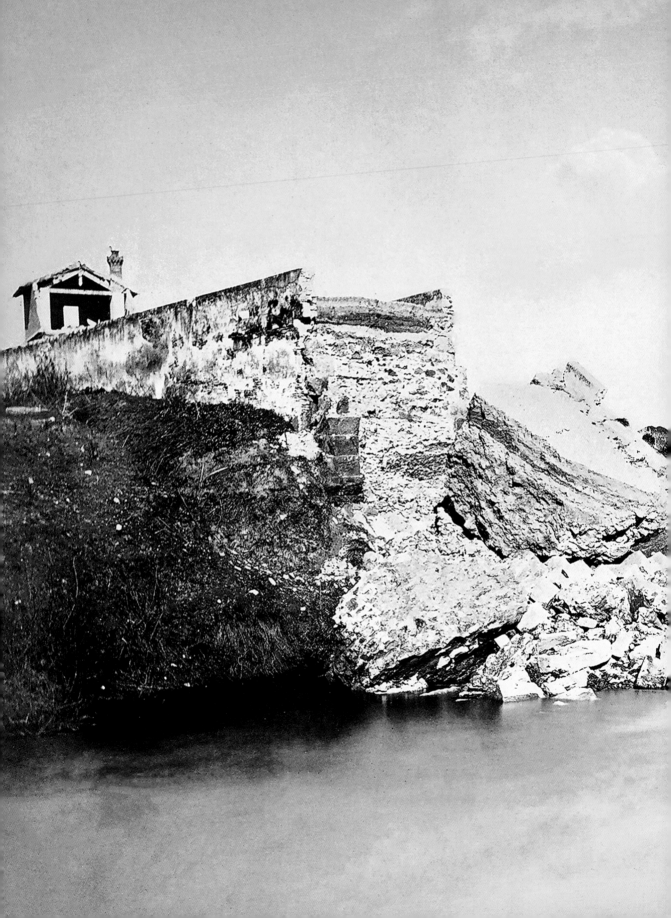

'It is not by speeches and
majority resolutions that
the great questions of
the time are decided...
but by iron and blood.

Otto von Bismarck, September 1862

Bismarck

War in Italy, combined with the aftermath of the
Crimean War of the 1850s, smashed and recast
relations between the great powers in Europe. By the
1860s, one of the clearest winners was the kingdom
of Prussia, and its talismanic statesman Otto von
Bismarck, nicknamed 'the Iron Chancellor'.

As in Italy, the direction of politics among
the loose coalition of states comprising the ancient
kingdom of Germany was towards national
unification. A series of revolutions in 1848–9 had
failed to bring this about, but when the Prussian king
Wilhelm I made the experienced diplomat Bismarck
his chief minister in 1862, his highest goal was to
create a federal, united Germany with Prussia at
its heart.

A brilliant diplomat, flexible politician and
aggressive military leader, Bismarck stormed Europe
during the next decade, overseeing wars in which the
Prussian army secured rapid and near-total victories
over her neighbours. In 1866 Prussia defeated Austria
in battle at Sadowa (now in the Czech Republic), and
annexed a number of smaller German states. In the
same year Bismarck survived an assassination attempt
in which he was shot five times.

In 1870–1 Prussia destroyed France in war,
and the stage was set for full German unification in
which Wilhelm became emperor and Bismarck his
chancellor. Pictured here in old age, Bismarck was
the pre-eminent politician of his generation, whose
career would last until the 1890s and whose legend
for a good deal longer.

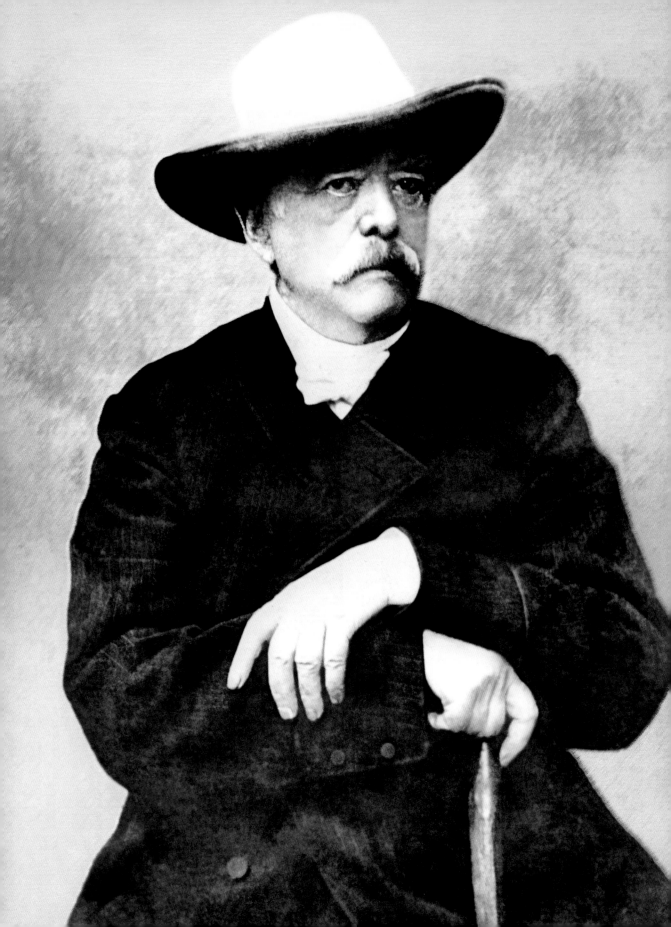

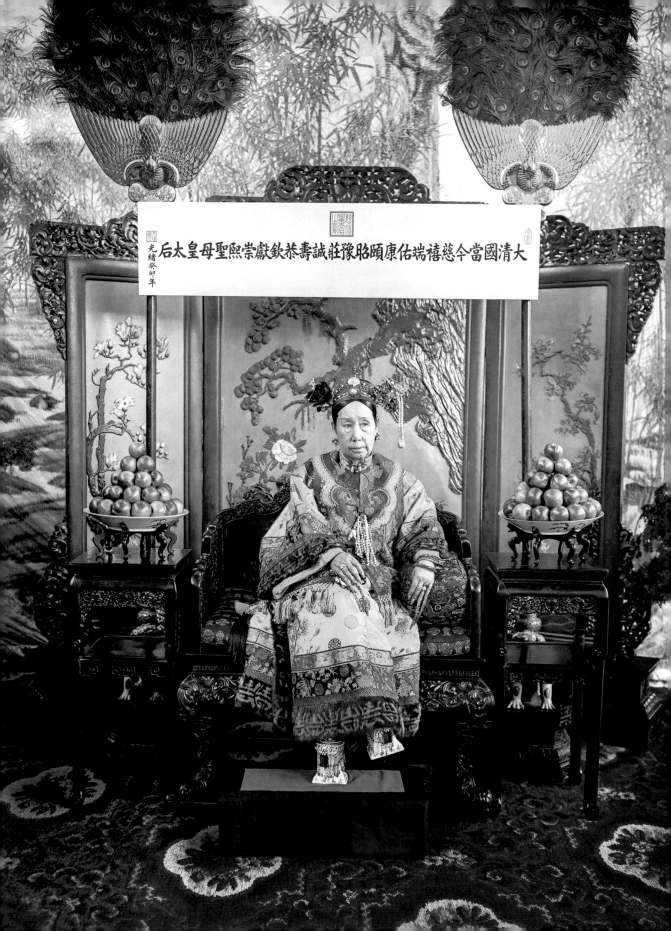

The Last Empress

In China another canny politician was manoeuvring her own way into power, at the war-battered court of Qing-dynasty China. She was the Empress Dowager Cixi: a woman from Beijing who was a senior concubine to the Xianfeng Emperor and birth mother of his son and heir.

After humiliation in the Second Opium War, the Xianfeng Emperor fled Beijing. He died in August 1861 and Cixi and the emperor's most senior consort, known as Ci'an, carried out a joint coup supported by various members of the old ruler's family. They seized control of the imperial court, ruling in the name of the five-year-old Tongzhi Emperor (r.1861–75), and later the Guangxu Emperor (r.1875–1908).

Cixi and Ci'an ruled 'from behind the curtain': a literal fact of government, since convention did not allow women to appear at meetings of male officials. Despite this inconvenience, Cixi showed a natural aptitude for rule, which notably outstripped that of Ci'an. In the 1860s and at several other critical moments afterwards she encouraged a policy of openness towards Western technologies and education. Yet this often conflicted with her natural conservative instincts, while her authoritarian approach to rule brought her into dispute with those around her.

This image of Cixi was captured five years before her death in 1908 by a diplomat's son and amateur photographer called Xunling. Although the photograph dates from some four decades after Cixi first took control of China, her majesty was plainly undimmed by age.

'I like to meet any distinguished foreigners who may be visiting in China, but I do not want any common people at my Court.'

Cixi, according to Xunling's sister Der Ling, an imperial lady-in-waiting

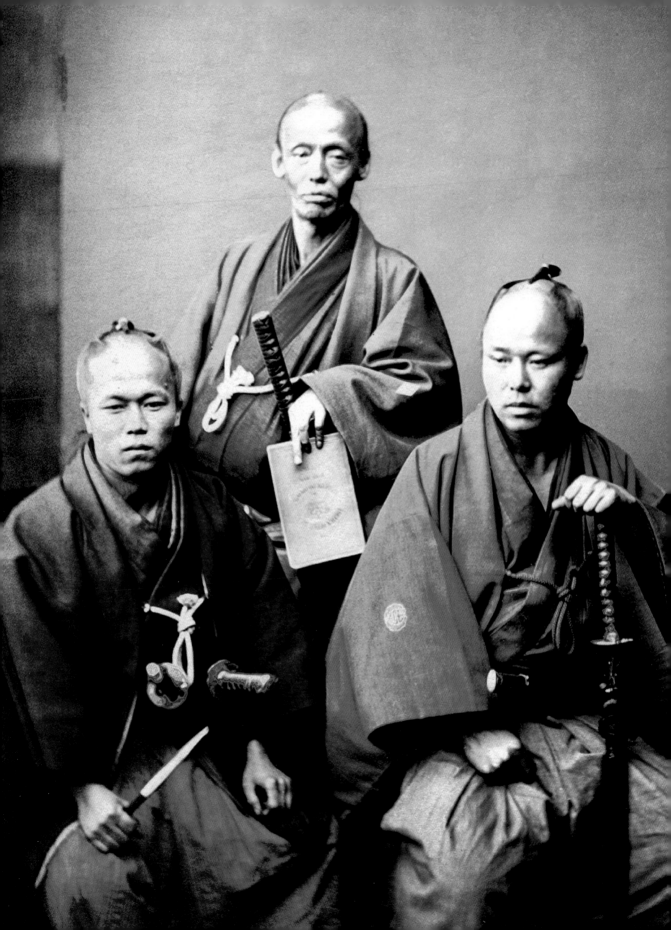

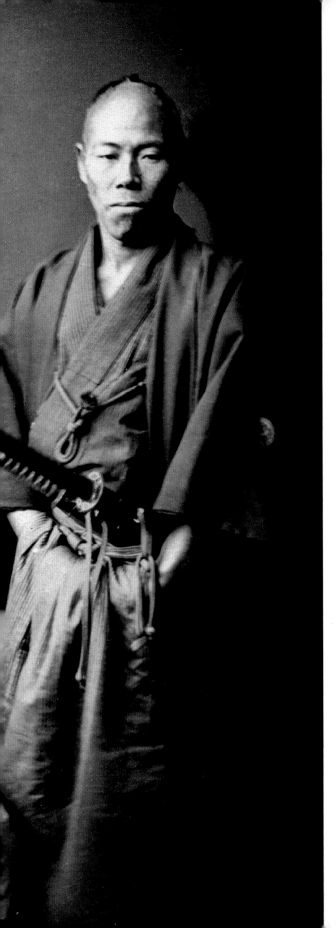

Rising Sun

Like China, Japan was ruled by an emperor – but he had long been a cypher. Since the late 16th century, emperors had lived hidden away in the imperial palace in Kyoto, leaving government to shoguns: feudal military dictators drawn from the Tokugawa clan, who delegated authority throughout Japan via *daimyō*, or lords who controlled their own provinces.

By the 1860s the Tokugawa shogunate (or *bakufu*) was losing its grip on power, and Japan's traditional policy of isolation from foreign relations was crumbling. In 1854, gunships under United States Commodore Matthew C. Perry had imposed a treaty on the Japanese which forcibly opened the country up to trade.

This picture of 1863, one of many beautiful scenes from Japanese life captured by Felice Beato, shows samurai warriors from Satsuma province in southwestern Japan. In 1867 leading clans from Satsuma and its neighbouring district of Chōshū led a rebellion against the shogun, Tokugawa Yoshinobu, forcing a revolution.

On the death of the Emperor Kōmei that November, his 14-year-old son Mutsuhito acceded. It was announced that power in Japan would be transferred from the shoguns back to the emperors, and the centre of power in Japan transferred to Edo, renamed as Tokyo. This was known as the Meiji ('enlightened rule') restoration, in which Japanese policy turned towards openness, limited democracy, industrialization and the adoption of Western technology – allied to Eastern social values.

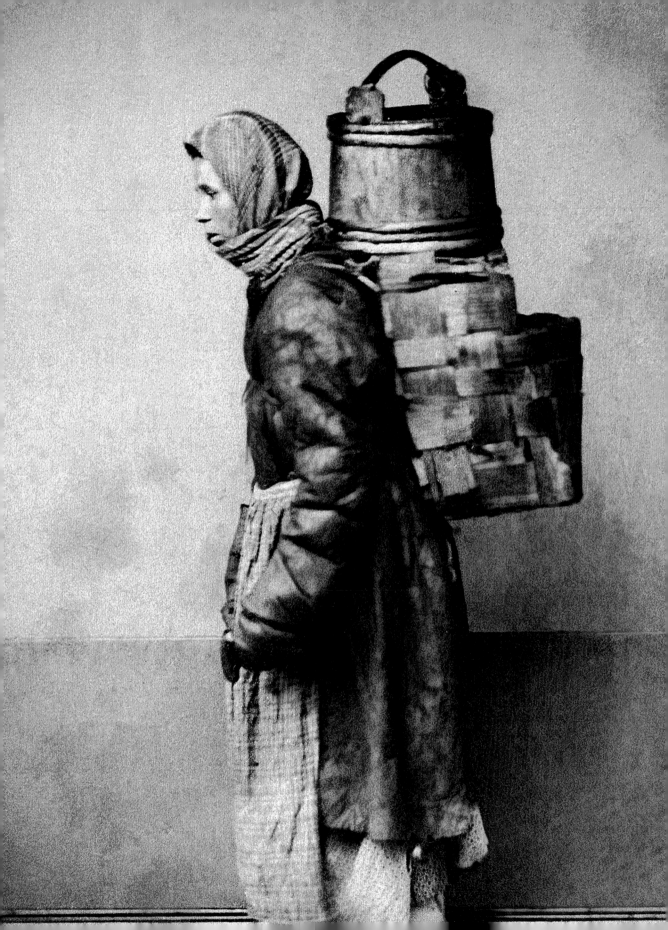

Emancipation

'It is better to abolish serfdom from above,' Tsar Alexander II of Russia had said in 1856, 'than to wait for it to abolish itself from below.' He was referring to the feudal organization of Russian society, by which millions of peasants living throughout the empire existed in a form of legal slavery: bound to the land on which they lived and compelled to labour for a landlord who owned their bodies and their souls; forbidden to own land, marry according to their choice, plead in court or vote.

Serfdom had existed in Russia since 1649, but by the 1860s many – including the tsar – saw it as indefensible, both morally and economically. In 1861, therefore, Alexander issued a long and detailed emancipation statute, which freed more than 20 million Russian serfs from their shackles and granted ex-serfs property and legal rights.

This apparently generous act earned Alexander the nickname 'the Liberator'. Yet it was not an entirely bright new dawn. The land made available for peasants to buy was scarce and often substandard and in place of feudal lordship came a new system of local government, which effectively tied people to their local village (*mir*). Emancipation was certainly an astonishing achievement, passed without civil war, major disorder or anarchy. Yet these reforms were not joined to a full raft of sweeping changes that would genuinely improve the lot of the Russian people. The consequences of Alexander's incomplete revolution would soon become clear.

'I did more for the Russian serf in giving him land as well as personal liberty, than America did for the negro slave set free by the proclamation of President Lincoln.'

Tsar Alexander II, 17 August 1879

Das Kapital

The revolutionary lurches that shook the world during the 19th century provided inspiration for one of the most idolized and despised writers in modern history: the German social scientist, journalist, economist and socialist, Karl Marx.

In the 1860s Marx lived in London, writing for newspapers and working on a monumental study of economics and history that would be published under the title *Das Kapital* (*Capital*). The first volume appeared in 1867, and it built on Marx's international reputation as a radical – and dangerous – thinker, which had been first established by an earlier, much shorter book called *The Communist Manifesto* (1848), co-written with his friend Friedrich Engels.

Underpinning Marx and Engels' analysis was a belief that human society progressed through struggle between the classes; built into that struggle was an inevitable revolutionary endgame, when workers would become conscious of their common plight, rise up, seize control of the means of production and establish an ideal communist society.

Marx died in 1883, with his communist paradise unrealized and the tyrannical revolutions inspired by his works several decades distant. This photograph was taken in London in 1875, when Marx visited the Regent Street studio of John Mayall and sat for a number of pictures taken in quick succession. Marx was only one of a number of Mayall's high-profile subjects: a well-known name in photography since the 1850s, his successful series included a set of pictures of the British royal family.

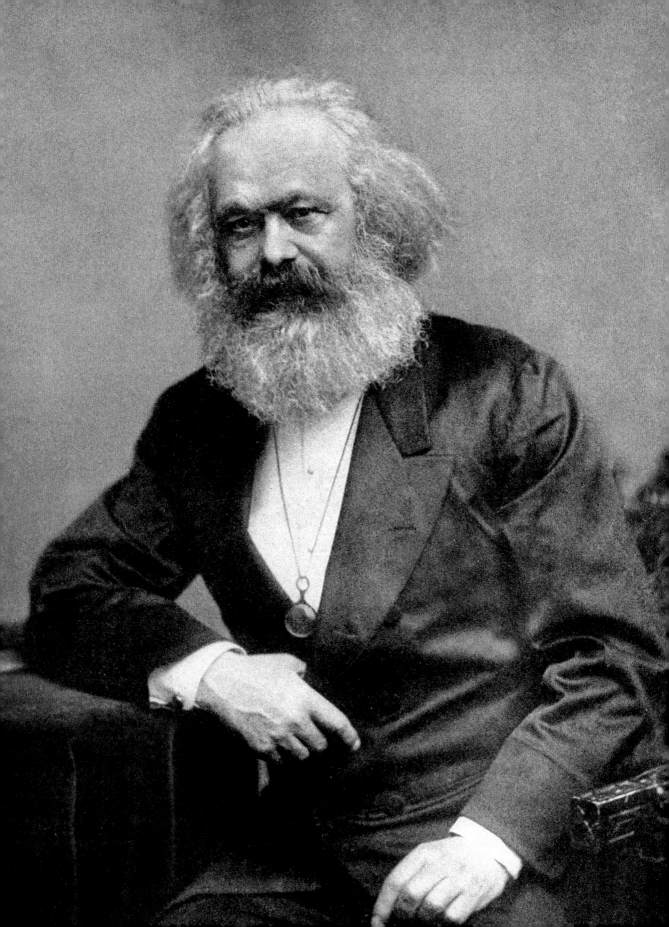

Freedom and Slavery

Karl Marx wrote dozens of newspaper columns about the conflict that ripped apart the United States between 1861 and 1865: a war between the states that left hundreds of thousands dead.

Slavery lay at the heart of the Civil War. There were other factors, certainly, related to disparities between the industrialized, mercantile states of the North and those in the conservative South, where agriculture and the cotton trade drove the economy and the way of life.

Slavery, however, focused all these into the form of a question that by the 1860s had come to dominate all others. Was the right to own black slaves an inalienable freedom of US citizens, enshrined in the Constitution? Or was it the opposite of freedom?

Following the election of Abraham Lincoln as the 16th president of the USA on an avowedly anti-slavery platform, in 1861 seven Southern states left the Union and established the Confederate States of America, led by President Jefferson Davis from a capital in Richmond, Virginia. By April, the states were at war.

This famous photograph shows a slave auction house in Atlanta, Georgia, being guarded by a black soldier wearing the blue Union uniform. It seems at first glance to be an image of life in the South. In fact, it was taken in 1864, when Confederate defeat was assured. The photographer, George N. Bernard, composed it as a commentary on the outcome of a war in which the fundamental rights of African Americans had been, first and foremost, at stake.

'With us, all of the white race, however high or low, rich or poor, are equal in the eye of the law. Not so with the negro. Subordination is his place. He, by nature… is fitted for that condition which he occupies in our system.'

Confederate Vice President Alexander Stephens,
21 March 1861

Honest Abe

Abraham Lincoln was an unlikely president and
a singular man. He was ungainly but charismatic;
spiritual but a religious sceptic; and highly educated,
but mostly by himself. Born in a log cabin in Illinois
in 1809, he sought political office during the 1830s,
a process which by 1861 had led him to the White
House and the threshold of a civil war. By the time
he took office his personal probity and plain speech
had earned him the nickname 'Honest Abe'.

The war profoundly changed Lincoln
(photographed here by Alexander Hesler in 1860).
It became painfully obvious to him that victory
could only come through wholesale destruction of
the Southern lands and way of life. It also crystallized
his views on slavery. In his first inaugural address on
4 March 1861 he declared: 'I have no purpose, directly
or indirectly, to interfere with the institution of
slavery in the States where it exists.' Yet less than two
years later he issued the Emancipation Proclamation,
declaring the three million slaves in the South to be
'thenceforward, and forever free'.

Lincoln is now recognized by most Americans as
the greatest president beside George Washington. Yet
during his time in office he was often fiercely derided.
He was lampooned as 'the original gorilla' by his
leading general, George B. McClellan. *The Times* of
London dismissed a speech given by Lincoln in 1863
as 'dull and commonplace'. This was, in fact, the
Gettysburg Address, which is today learned by rote
by almost every American schoolchild.

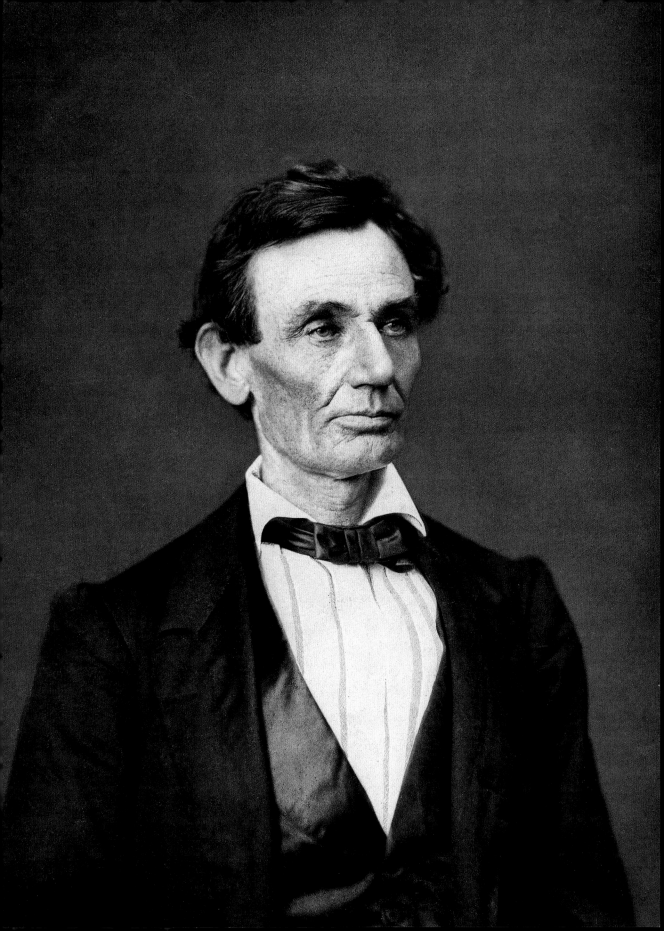

Gettysburg

On 5 July 1863 Alexander Gardner and his assistant Timothy O'Sullivan roamed the fields and hills around the crossroads town of Gettysburg, Pennsylvania, cataloguing a landscape littered with the bodies of thousands of Americans who had fallen during the costliest battle of the Civil War.

On the first three days of July a Confederate invading army led by General Robert E. Lee had been overcome by a huge Union force under General George G. Meade. Action had been concentrated at various ominously named points, including Cemetery Ridge and Devil's Den. More than 165,000 men took part in the battle. By the time Gardner and O'Sullivan took this photograph, nearly one-third were dead, dying, maimed or missing.

Gettysburg was a pivotal moment in the war. It effectively halted Lee's invasion of the North, and prevented any forced negotiation by which the Confederacy would have secured independence or a permanent commitment to slavery. Buoyed by victory, Union armies led by generals including Meade, William T. Sherman and Ulysses S. Grant ground their way towards a final victory, achieved with Lee's final surrender at Appomattox Courthouse in Virginia in April 1865.

The staunchly Unionist Gardner travelled with Northern armies and the photographs he and O'Sullivan captured emphasized the righteousness of the federal cause and the monstrous pity of war. Several of their most famous pictures were staged: bodies moved and items introduced from a prop store the two men kept in their mobile studio.

'A battle has been often the subject of elaborate description; but it can be described in one simple word, devilish!'

Alexander Gardner, 1866

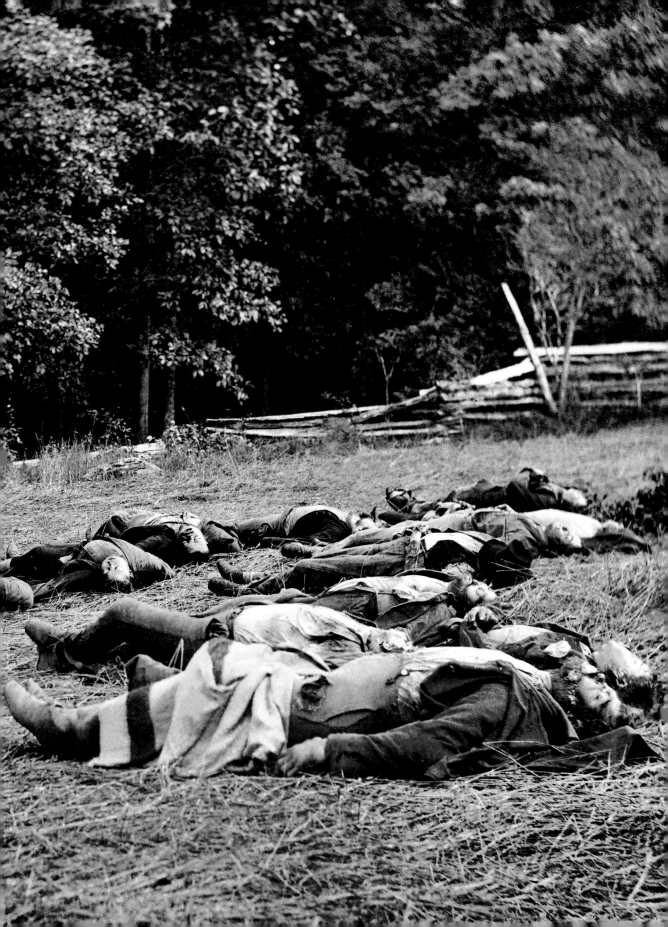

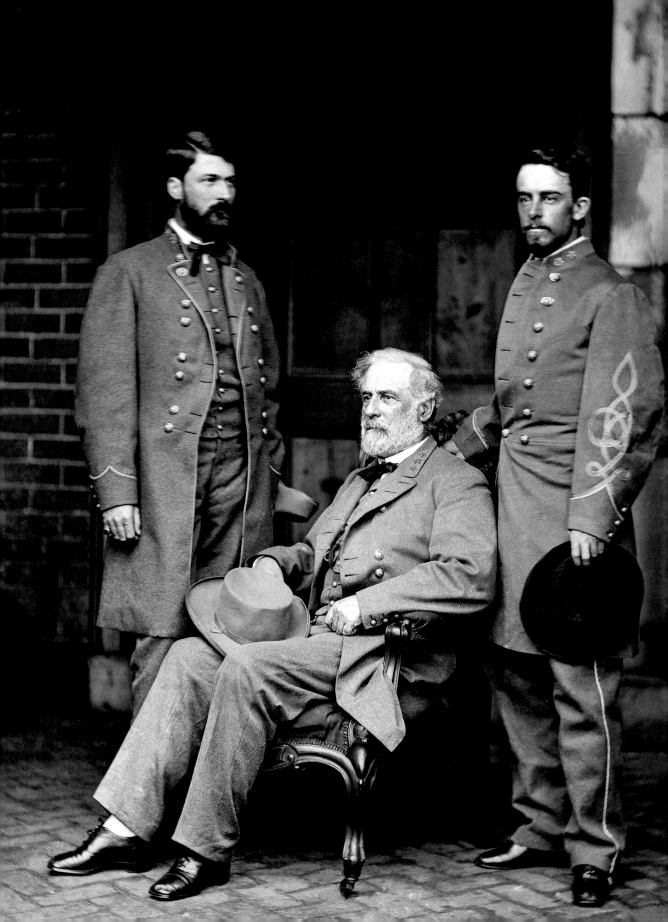

> 'I felt like anything rather than rejoicing at the downfall of a foe who had fought so long and valiantly, and had suffered so much for a cause, though that cause was, I believe, one of the worst for which a people ever fought.'

Ulysses S. Grant remembers
Appomattox in 1865

Surrender

Richmond, Virginia, had been the capital of the Confederacy. It was also home to the South's most illustrious soldier, General Robert E. Lee. A brilliant strategist, Lee was the man on whom Southerners had pinned their hopes throughout the war, his status exceeding even that of the Confederate president, Jefferson Davis.

Lee was a lifelong warrior: a star at West Point, veteran of the Mexican War of the 1840s (by which the United States had annexed Texas), and relentlessly aggressive general, who had won a string of victories against the odds, besting Union commanders at the Seven Days Battles (1862), the Second Battle of Bull Run (1862), Fredericksburg (1862), Chancellorsville (1863) and Cold Harbor (1864).

This image of Lee was taken by Mathew Brady, the Washington-based photographer for whom Alexander Gardner and others worked during the war. Brady visited Lee at his house on 16 April 1865 and found him in the company of his son G. W. C. 'Custis' Lee (left) and trusted aide Walter H. Taylor (right). The sombre mood of the portrait captures the terrible times. Seven days earlier Lee had surrendered his Army of Northern Virginia to the Union general Ulysses S. Grant at Appomattox Courthouse. Two days earlier President Lincoln had been fatally shot.

Lee once famously said 'it is good that war is terrible, otherwise men would grow fond of it'. With 620,000 Americans dead, the terrible war in which he had played a leading role was over.

Colonization

Most of the slaves whose rights lay at the heart of the American Civil War were descended from people transported from West Africa. Since the 1810s, some Americans had been arguing for a reversal of the process. During the 1820s and 1830s a group called the American Colonization Society sent ships carrying freed African Americans to establish colonies on the so-called Pepper Coast. This policy – in equal part well-meaning and racist – led to the establishment of Liberia, in which a mixed-race, Protestant ruling class held power over indigenous Africans.

One of these new Liberians was the Presbyterian minister and journalist Edward Wilmot Blyden (top row, far right), who was born on the Caribbean island of St Thomas in 1832 and emigrated to Liberia in 1850. Blyden became deeply involved in the intellectual life of Liberia, working as a diplomat, newspaper columnist and academic. In 1861 he became professor of Latin and Greek at Liberia College; his works included extensive writings on Ethiopianism, which argued that black Africans scattered about the globe would be best served by returning 'home'.

This portrait of Blyden was taken in middle age, by which time he had left Liberia for Sierra Leone. The flag behind his shoulder advertises the Young People's Society of Christian Endeavor (YPSCE), an American missionary organization that aimed to spread Protestantism and the gospel. How committed to this idea Blyden was is uncertain; he grew convinced as his life went on that Islam was better suited than Christianity to sub-Saharan Africans.

'This seems to be the period of race organization and race consolidation. The races in Europe are striving to group themselves together according to their natural affinities.'

Edward Wilmot Blyden,
Christianity, Islam and the Negro Race (1888)

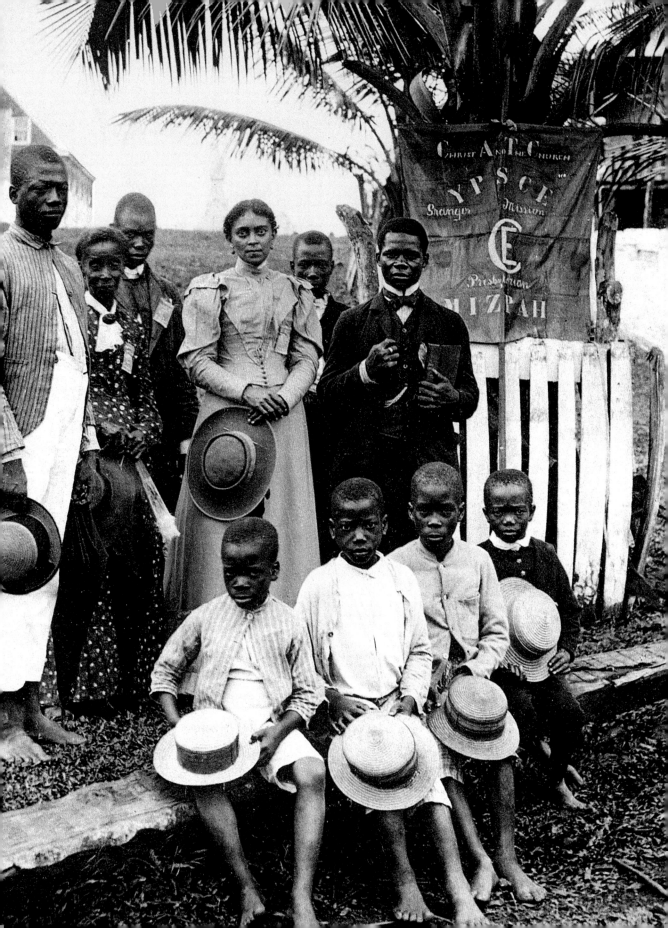

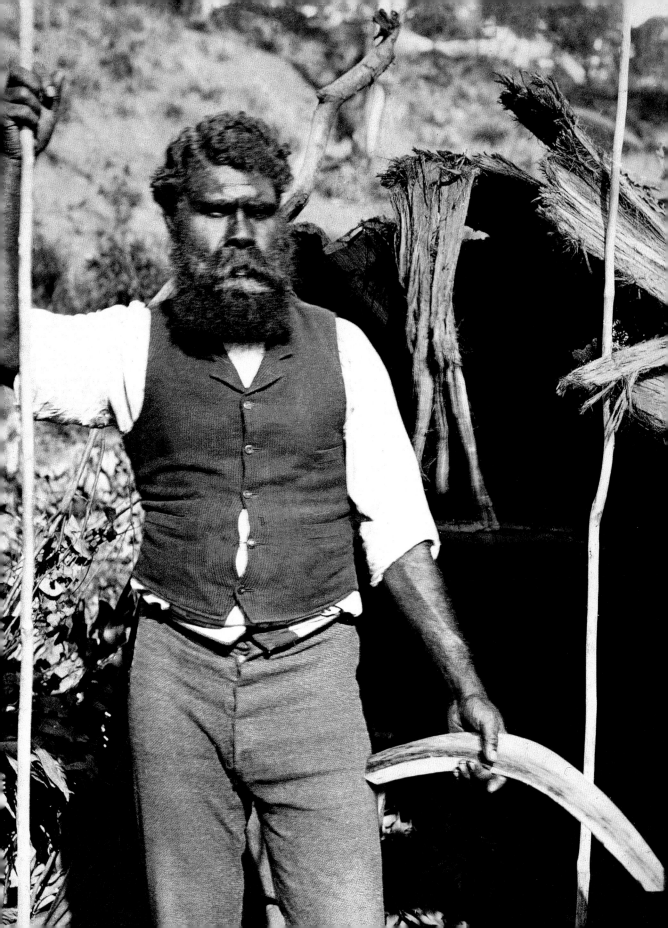

Australia Fair

Far from the Atlantic, another region of imperial expansion was undergoing sweeping changes during the 1860s. The east coast of Australia had been identified as a suitable location for a penal colony by the British in the late 18th century; by the 1860s large tracts of territory had been claimed for the British crown to be settled by farmers, gold miners and other settlers, who built cities, exploited the land and imported foreign labourers.

Some of these workers were forcibly taken as slaves from the islands of the South Pacific, Torres Straits and Papua New Guinea. Others arrived voluntarily from areas including China, India and Iran, while workers from Egypt and Turkey came to drive camel trains across the Australian wilderness.

Just as had happened in North America, colonization in Australia brought about vicious conflict with indigenous peoples who had inhabited the Australian continent and surrounding islands for the previous 40,000 to 80,000 years. This photo, typical of a genre of staged images of Aboriginal Australians taken between the 1860s and 1900s, is intended to illustrate the juxtaposition of traditional ways of life with imported European dress and manners.

The reality was very much harsher than changing fashions. During the 1860s, for example, lawmakers in Melbourne established the Aboriginal Protection Act, which gave the governor of the colony of Victoria the power to decide where Aboriginal Australians lived and how much they earned, and to separate children from their parents.

'It was in this paradise that the yellow-liveried convicts were landed, and the Corps-bandits quartered, and the wanton slaughter of the kangaroo-chasing black innocents consummated… in the brutish old time.'

Mark Twain describes 19th-century Australia, 1895

The Suez Canal

The Suez Canal – a 120-mile manmade waterway dug through the Egyptian desert at the Suez Isthmus – was the brainchild of a French diplomat called Ferdinand de Lesseps. Its purpose was to link the Mediterranean and Red Seas, creating a shorter trade route from Western Europe to the Far East; at the time, merchants had to sail around the Horn of Africa. De Lesseps used his influence with the *wali* (viceroy) of Egypt, Muhammad Said Pasha, to realize this long-held dream, and in 1869 the canal formally opened to ships of all nations. Its inauguration took place on 16–17 November, with a day of religious celebration followed by a ceremonial entry to the canal of ships officially supposed to be led by the French imperial yacht *L'Aigle* (The Eagle).

The Suez Canal was controversial, not least for the British, who worried about its potential to disrupt their trade with India. Unable to stop its construction, they instead decided to embarrass the French during the opening ceremonies. Although *L'Aigle* was supposed to be the first ship to pass through the canal, the British Navy's HMS *Newport* overtook the French yacht as she waited to enter the waterway.

The Suez Canal would have a profound effect on world affairs for the century to come. It allowed for much more rapid global transit, and ushered in a period of increased European interest in Africa, whose importance to global trade – and therefore its vulnerability to colonial conquest and plunder – was about to explode.

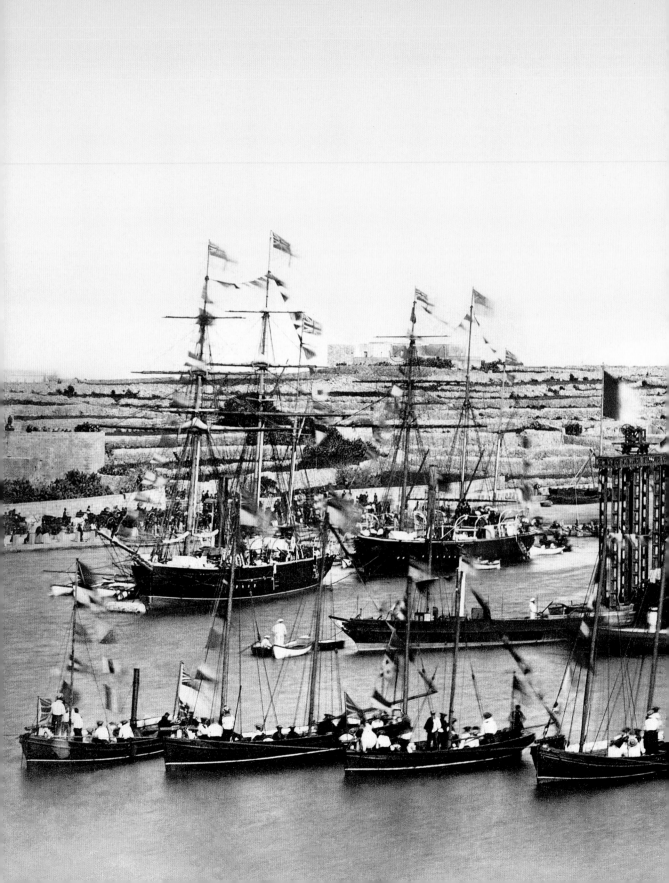

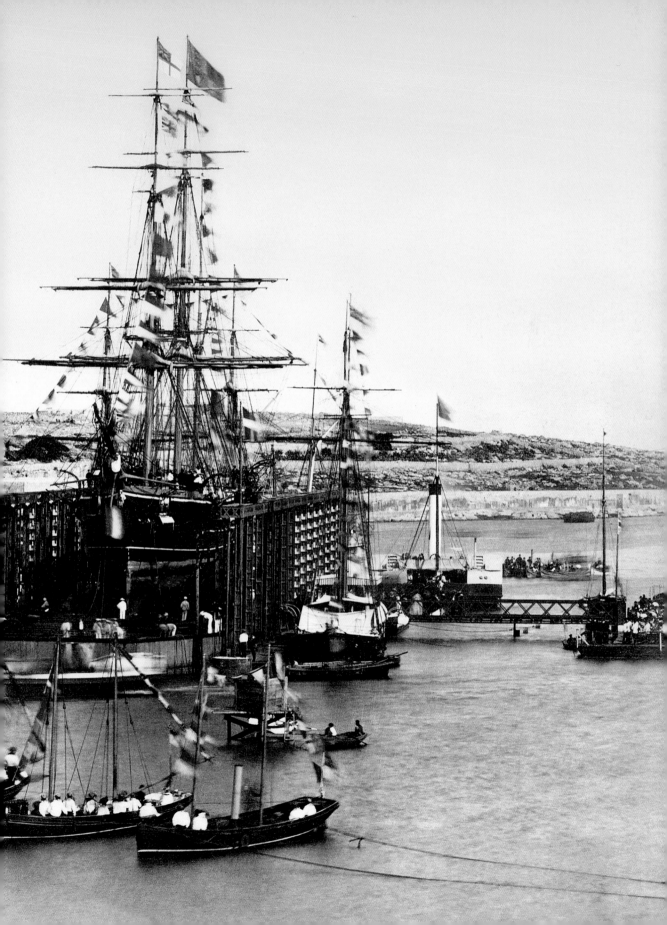

1870s

Age of Troubles

'I longed to arrest all beauty that came before me,
and at last the longing has been satisfied.'

Julia Margaret Cameron, 1874

The house in Freshwater on the Isle of Wight was known as Dimbola Lodge, after its owners' estate in Ceylon (modern Sri Lanka). Next door lived Britain's poet laureate, Alfred Tennyson. Outside in a converted henhouse was a photographic studio, where the lady of the house, Julia Margaret Cameron, first began her experiments with a camera.

Born to Anglo-Indian high society in 1815 and a latecomer to photography at the age of 48, Cameron was nevertheless one of the discipline's most significant early practitioners. In her hands the photographic plate became a vehicle for portraits that did not so much document as emote. She was an artist whose work was shot through with the sensibilities of the Pre-Raphaelite movement (founded in the late 1840s); whose interests were as far from the sharp worldliness of Roger Fenton or Alexander Gardner as was imaginable.

Julia Margaret Cameron (*née* Pattle) worked in tight frames and soft focus, with her mind turning as often as not to themes of romance, historicism, fantasy and myth. Even when her subjects were world-famous, high-collared, long-bearded men like Charles Darwin, Cameron managed to locate in them something spiritualistic. Her goal, she once stated, was to discover 'the

greatness of the inner as well as the features of the outer man'. She loved to pose and even dress sitters as characters or archetypes from the imagined past, such as the age of King Arthur or the Roman goddess Diana. In her hands Tennyson (a reluctant sitter for any portrait) became a bushy-bearded, distinctly medieval scholar in a photograph entitled *The Dirty Monk*.

Cameron's career was short but influential. She began taking photographs after receiving a camera as a present from her children in 1863 and quit in around 1875 when she and her husband, Charles Hay Cameron (20 years her senior), left the Isle of Wight and moved back to Ceylon. But by the time she died in 1879 she had made an indelible impression on her field. Along with a small group of other likeminded souls – Oscar Gustave Rejlander was one, the *Alice In Wonderland* author Lewis Carroll was another – she pioneered the deployment of the photograph as a bona fide art form.

Two of Cameron's favourite sitters, whom she photographed repeatedly during the 1860s and 1870s, were her nieces Julia Jackson (later the mother of the author Virginia Woolf) and May Prinsep. The latter is seen here (p. 82) posing in the role of Beatrice Cenci, a tragic young noblewoman from late 16th-century Rome, famous for murdering her abusive father –

for which crime she and several of her siblings were beheaded on the order of Pope Clement VIII.

Although this image was first printed by Cameron in 1866, the gothic history of Beatrice Cenci as seen through the eye of the lens and printed in a process using silver nitrate and egg-white was a tale well suited to the 1870s: a decade in which the monstrous and wonderful freely commingled.

Some events of the decade seemed positively medieval. In Rome Pope Pius IX was nearing the end of an exceptionally long and defiantly retrograde reign, which had been characterized by wars with secular rulers and the affirmation of a doctrine of papal infallibility. In Spain, a pretender line of Carlist kings took to the battlefield in an attempt to win back the crown they felt had been snatched unfairly from them. In Paris, after France's defeat in an ill-starred war with Prussia, the rebellious citizenry took up arms and declared a municipal commune which ended in a massacre on a scale to match the bloodiest events in the city's history.

Many other of the decade's developments, however, were intrinsically modern. The world's economy, ever-more closely connected by the invisible threads of industrial capitalism, suffered the worst collective downturn in history – an event known as the Long Depression. In the United States,

the Civil War had left huge swathes of the country ruined. In the South, the administrations of Andrew Johnson, Ulysses S. Grant and Rutherford B. Hayes faced the immense challenges of Reconstruction, while in the West, the government set about surveying the mineral wealth and topography of the American wilderness. This investigation and exploitation of the landscape would exacerbate violent tensions with its Native American inhabitants.

In Africa, Britain's explorers, including Dr David Livingstone and Henry Morton Stanley, set out to chart the continent's interior, although their intrepid voyages of enquiry could scarcely be separated from the process by which the major European powers were starting crudely to appropriate the lands and wealth of Africa for their own use. In Kabul, capital of Afghanistan, the 'Great Game' between Britain and Russia bathed the streets in blood. From the Balkans to the Dardanelles the Russo-Turkish war did likewise.

All the while, artists continued to try to make sense of it all – from grand old poets like Tennyson to novelists like Count Leo Tolstoy, to portraitists like Cameron, a photographer of imperial background, modern means and medieval sensibilities, capturing the world in delicate poise from the sanctum of her henhouse on an island in the English Channel.

1875

[Nov] Britain purchases Egypt's share in the Suez Canal

1876

[Mar] Alexander Graham Bell makes the first-ever telephone call, asking his assistant Mr Watson to come and see him

[Jun] Battle of Little Bighorn – victory for Lakota Sioux and Cheyenne fighters over US cavalry, during which George Armstrong Custer is killed

[Nov] Porfirio Díaz elected president of Mexico

1877

[Apr] War breaks out between Russia and Turkey

[Apr] Leo Tolstoy's *Anna Karenina* is published in full, following a four-year serialization

1878

[Feb] Edison patents his phonograph

[Feb] Pope Pius IX dies – his 31-year reign makes him the longest-serving pontiff since St Peter

[Nov] Second Anglo-Afghan War begins with a conflict in the Khyber Pass

1879

[Jan] Anglo-Zulu War begins, and the Battle of Rorke's Drift is fought

[Oct] Edison demonstrates and later patents his electric lightbulb

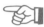

The Paris Commune

In July 1870 a war, long-threatened, erupted between
Prussia and France. It was plain within days that the
Prussian military, primed by Chancellor Otto von
Bismarck, was vastly superior to the French. Old,
ill and confused, Napoleon III was captured and
imprisoned in Germany, and the French Second
Empire collapsed. A new government – the Third
Republic – was formed to continue the war, but
by January 1871 Paris had been under winter siege
by Prussian troops for four months. The French
surrendered and were forced to endure the sight of the
Prussian king Wilhelm I being crowned emperor of a
newly unified Germany in the Palace of Versailles.

During the siege Paris had been defended by
the National Guard, a militia of increasingly
radical hue. By March, with German troops still
stationed around Paris, the mood inside the city
had turned mutinous. On 18 March an attempt
by the government to remove cannon from Paris's
defences was met with armed resistance. Eight days
later city elections resulted in the establishment of a
Commune: a revolutionary, socialist administration
that barricaded the streets, defended by the reservists
of the expanded National Guard. The Communards
held on for two months, until the regular army
stormed Paris on 21 May. In *la semaine sanglante*
('Bloody Week'), the Commune was crushed
and order restored – against a grim backdrop of
burning buildings and mass executions. This famous
photograph (pp. 86–7), attributed to André-Adolphe-
Eugène Disdéri, shows just a dozen of the estimated
6,000–10,000 Communards who were killed and
buried in mass graves.

The Carlist Wars

While the Franco-Prussian war was ending the
Second French Empire, in Spain a dispute over the
crown was dragging the country to the battlefield.

In 1833 a dispute over the successor to the
Bourbon King Ferdinand VII had created rival
Spanish royal houses. On one side was Ferdinand's
daughter, Queen Isabella II. On the other were
descendants of Ferdinand's brother Carlos. The
Carlists refused to recognize female monarchy; they
stood for traditional, conservative values and insisted
they were the rightful kings of Spain.

This photograph shows Carlos, Duke of
Madrid, the official Carlist claimant during the
1870s. He came tantalizingly close to making good
his claim. In 1870 Isabella was forced to abdicate her
throne after a liberal uprising. In her place came an
unpopular Italian prince, who was elected Amadeo I
by the Spanish parliament but abdicated in early
1873. There followed a 22-month period of republican
government, until finally, in late December 1874,
the Bourbon monarchy was restored in the shape of
Isabella's son, Alfonso XII.

During all of this turmoil the would-be Carlos
VII made as much nuisance as possible, whipping
up separatist sentiment in Catalonia and the Basque
Country and maintaining a volunteer army and
guerrilla movement. In 1873–5 the Carlists were
capable of putting thousands, and even tens of
thousands, of troops in the field.

Yet despite several major battles and sieges,
by 1876 Carlos admitted defeat to superior
government forces and went into exile in France.
From 1881, he also claimed to be rightful king of the
French, as Charles XI. He died, having never worn
either crown, in 1909. The Carlists continued to
pursue their claim, however, and would later throw
in their lot with the nationalist forces of General
Franco during the Spanish Civil War.

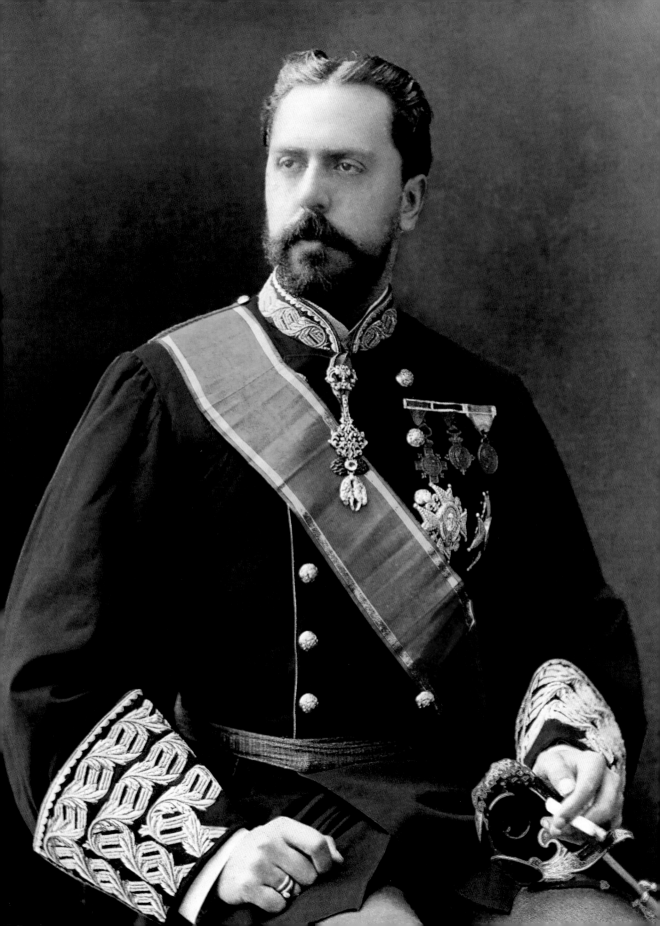

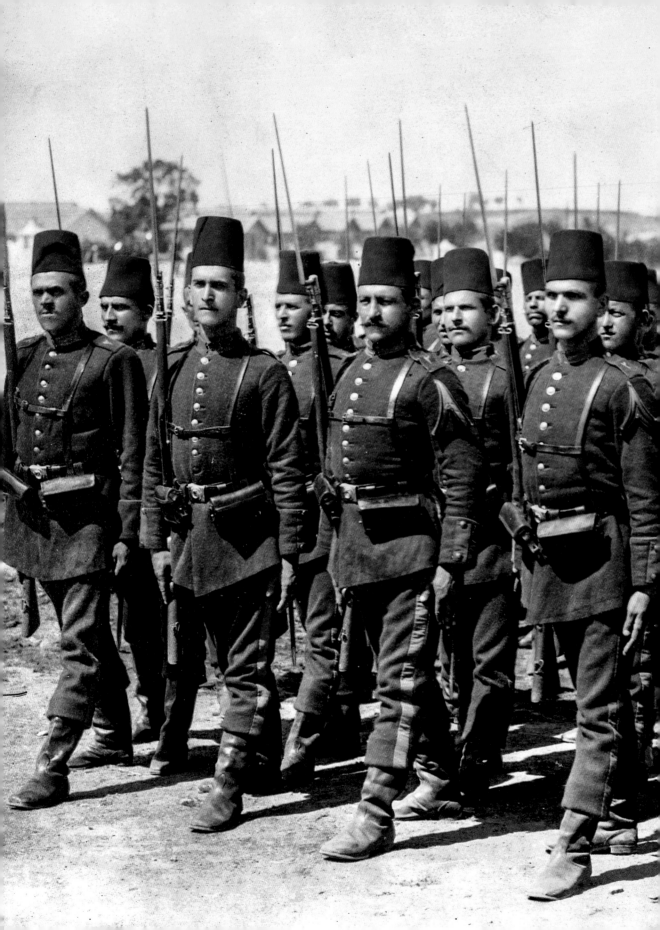

The Russo-Turkish War

While Spain was riven with internal conflict and France struggled against Prussian aggression, Eastern Europe was tormented by the long-running rivalry between the Russian and Ottoman Empires.

Tensions in the 1870s were concentrated on the Balkans. In 1875–6 a wave of rebellions and localized wars broke out in Ottoman-ruled Bulgaria, Romania, Serbia, Montenegro, Bosnia and Herzegovina, and were harshly put down.

The Balkan rebels elicited much sympathy across Europe, especially after reports circulated of widespread atrocities and massacres perpetrated against civilians in Bulgaria. Russia saw this as an opportunity. Feeling increasingly assured that (unlike the Crimean War) no other major European power would spring to the Ottomans' aid, in 1877 Tsar Alexander II declared war and sent troops to advance on Turkey across the Danube in the west and through the Caucasus in the east.

This photograph shows members of the Turkish Imperial Guard, who were tasked with defending the Ottoman heartlands. In the war of 1877–8 they ended up on the losing side: by March 1878 Russian troops were threatening Constantinople and the Ottomans were forced to agree the Treaty of San Stefano, by which Romania, Serbia, Montenegro and Bosnia were all freed from Ottoman control, and a vast Principality of Bulgaria was created under Russian protection.

The Balkan rebellions and Russian victory against the Ottomans had radically altered the balance of power in the region; the consequences of this shift would not be fully obvious until the start of the next century.

'All happy families resemble one another, each unhappy family is unhappy in its own way.'

Leo Tolstoy,
Anna Karenina (1875–7)

Leo Tolstoy

Russia's wars against the Turks loom large in the final pages of *Anna Karenina*, the novel by Count Lev Nikolayevitch ('Leo') Tolstoy, serialized in the *Russian Herald* between 1875 and 1877 and subsequently regarded as one of the masterpieces of modern literature.

Anna Karenina explores the life, adultery and death of its eponymous heroine, but as with many of Tolstoy's other works its range is vast and the real subject matter is Russia itself: its people, its politics, its dilemmas and its soul. ('My hero is truth,' he once wrote.) Ten years previously Tolstoy had published in the same magazine *War and Peace* (1865–7), a panoptic chronicle of Russian aristocracy during the Napoleonic Wars; before that he had written about the Crimean War in *Sevastopol Sketches* (1855).

These works account for only a fraction of Tolstoy's voluminous output. Born in 1828, he had become famous by his twenties and remained so throughout his long life: this photograph of him telling his grandchildren Ilya and Sonia a story about a garden full of cucumbers was taken shortly before his death in 1910.

Tolstoy lived in an age of literary greatness. In Russia, his contemporaries included Ivan Turgenev, Fyodor Dostoevsky and Anton Chekhov; outside Russia, such writers as George Eliot, Thomas Hardy, Victor Hugo, Gustave Flaubert, Emile Zola, Henrik Ibsen, Herman Melville, Mark Twain and Henry James. Each in their own way took their experience of the middle and latter part of the 19th century and immortalized it on the page.

'It was better that a little
blood should be shed that
much blood should be saved.'

Porfirio Díaz, interview, 1908

Porfirio Díaz

Had Porfirio Díaz been Russian, he was just the sort of character whom Tolstoy might have included in one of his novels.

Born in Mexico in 1830, Díaz trained for the priesthood as a boy, but in the 1840s abandoned the church, first for the law and then for the army. He fought in the Mexican civil conflict known as the War of Reform between 1857 and 1860, and again in 1861–7, when Napoleon III of France installed a puppet ruler in Mexico and turned the country into an empire subservient to the French state.

By the time the French were run out of Mexico, Díaz had risen to the rank of general. But he was to rise higher still. In the 1870s he led the opposition to the presidency of Sebastián Lerdo de Tejada, whom he forced into exile after defeating him on the battlefield at Tecoac in 1876. The following year Díaz was officially elected president of Mexico. He went on to serve seven terms between 1876 and 1880 and 1884 and 1911, known collectively as the *Porfiriato*.

As president, Díaz opened Mexico to foreign investment, kept the peace between church and state and modernized Mexico's economy. However, his administrations were authoritarian in character, and their high levels of corruption and nepotism benefited only a small group of Mexicans. When he manufactured an eighth presidential term for himself in 1910 the result was revolution and Díaz found himself brought down by his own methods.

The Long Depression

The stable, if unevenly shared, economic development of Mexico under the *Porfiriato* was all the more remarkable since it took place during a worldwide economic downturn that came to be known as the Long Depression.

Often described as the first truly international economic crisis, and known as the Great Depression until superseded by the global collapse of the 1930s, the Long Depression sprang from a series of financial crashes known as the Panic of 1873, which began on 9 May with a day of huge losses on the Vienna stock exchange.

Losses in Vienna spread quickly to financial markets abroad, providing a stark illustration of the interdependence of national economies linked by industrial capital. Market panics caused bank failures and railroad company bankruptcies. Britain and the United States were particularly hard hit, although from 1873 onwards many countries experienced plunging prices and wages and increased unemployment. While a worldwide recovery began in 1878–9, the effects of the Depression were still felt in many countries in the 1890s.

This photograph, summoning the troubles of the age, is by the Swedish-born, British-based photographer Oscar Gustave Rejlander, who died in 1875. Its original title was *Hard Times*, after the Charles Dickens novel of 1854, although Rejlander later changed its title to *A Spiritistical Photo*. It shows an unemployed carpenter worrying over his wife and child. Rejlander pioneered artistic methods of photography, often creating montages of several exposures in a single frame. In the original version of this photograph, Rejlander superimposed a second, faint image of the carpenter placing his hand on his wife's head while their child prays at his feet.

'I would be willing, yes glad,
to see a battle every day
during my life...'

George Armstrong Custer

Custer's Last Stand

The Long Depression and the difficulties of postbellum Reconstruction made the 1870s a difficult decade in the United States. This was complicated further by an ongoing war between Native American tribes and the US government. In the 1870s this conflict flared dramatically in a series of clashes known as the Great Sioux Wars, fought in 1876–7 around the Black Hills of South Dakota and Wyoming, where gold had been discovered in 1874.

One of the most famous casualties was Lieutenant-Colonel George Armstrong Custer of the 7th US Cavalry: a Civil War veteran pictured here in the uniform showing his wartime rank of brevet major-general. Custer was an almost impossibly flamboyant character, nationally famous for his romantic appearance, cavalier attitude to danger and appetite for women.

Black Hills gold had been discovered on an expedition led by Custer, and the belligerent officer was prominent in the military campaigns to push Native Americans out of the way of white miners, driving Lakota and Dakota Sioux, Cheyenne and Arapaho Native Americans from the Black Hills onto reservations. Although his campaign was ultimately successful in that respect, Custer paid for it with his life. At the Battle of Little Bighorn in Montana on 25 June 1876, Custer and his men were overwhelmed by a large army of Sioux and Cheyenne warriors led by famous chiefs including Sitting Bull and Crazy Horse. Custer's entire battalion was surrounded on a hill and killed in an action known as 'Custer's Last Stand'. The only survivor was a horse called Comanche, which lived to old age and died in 1891.

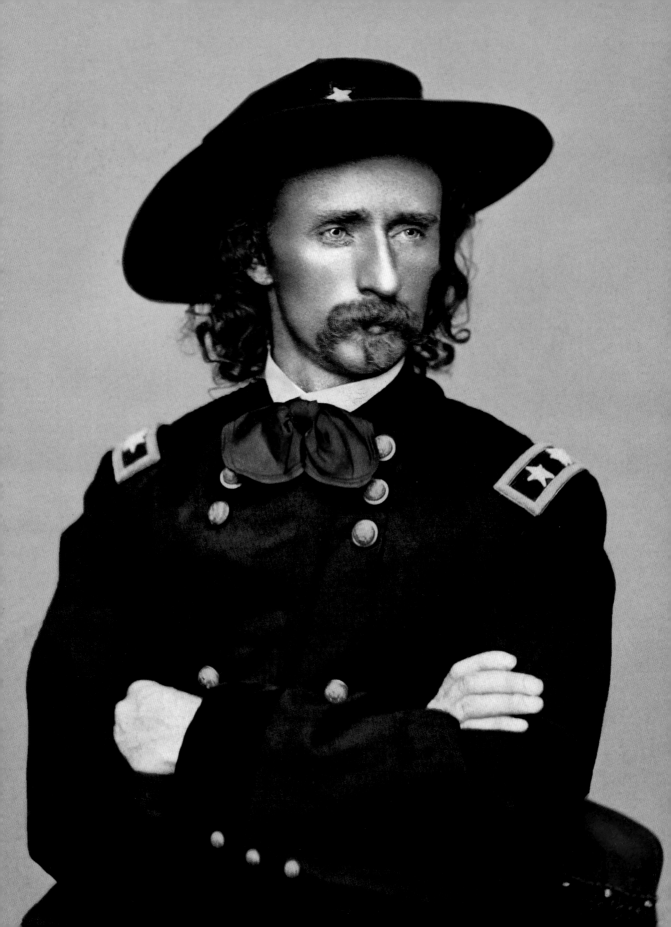

Reconstruction

Rebuilding the United States after the calamities of the Civil War was not simply a matter of burying the dead and rebuilding bombarded cities and swathes of shattered landscape. There were also enormous legal, political and cultural tasks to be undertaken in piecing back together the broken Union.

The Reconstruction Era is usually dated between 1863, when President Abraham Lincoln began the process of readmitting rebel states into the Union in an attempt to hasten a peaceful end to the war, and 1877, when a deal to secure the election of President Rutherford B. Hayes saw federal troops withdrawn from Southern states.

One of the most pressing questions asked during Reconstruction was of how to accommodate the millions of former slaves who were freed by the passage of the 13th Amendment to the US Constitution (which abolished slavery except as punishment for a crime), granted equal rights as citizens by the 14th Amendment and extended the (male) franchise by the 15th. The law had changed, but attitudes towards race and equality had in many places been hardened by the experience of the war. Reconstruction was thus a struggle between Americans who strove for a reconciled nation and those who clung to more radical and divisive ideas of the future.

This photograph of freed slaves during or shortly after the Reconstruction era was taken in the town of Belton, South Carolina: a town which had been built on cotton processing in the state where the first shots of the Civil War had been fired.

I know why the caged bird sings,
 ah me
When his wing is bruised and
 his bossom sore… '

Paul Laurence Dunbar, 'Sympathy' (1895)

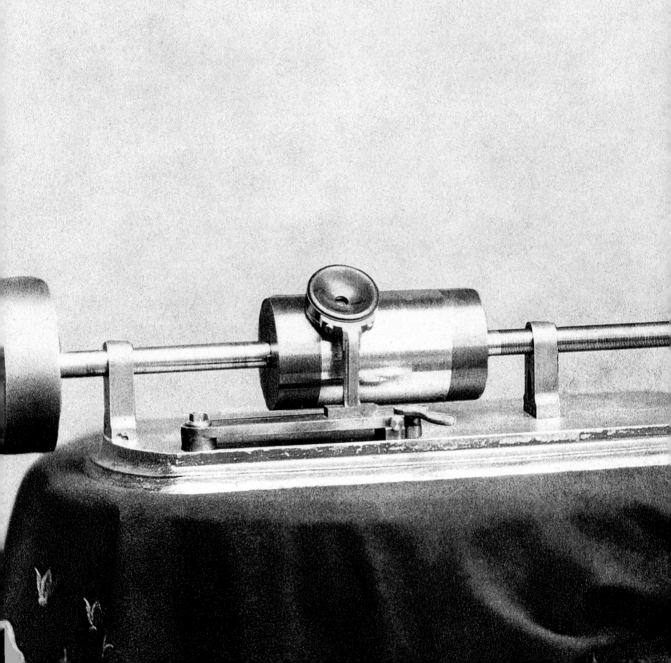

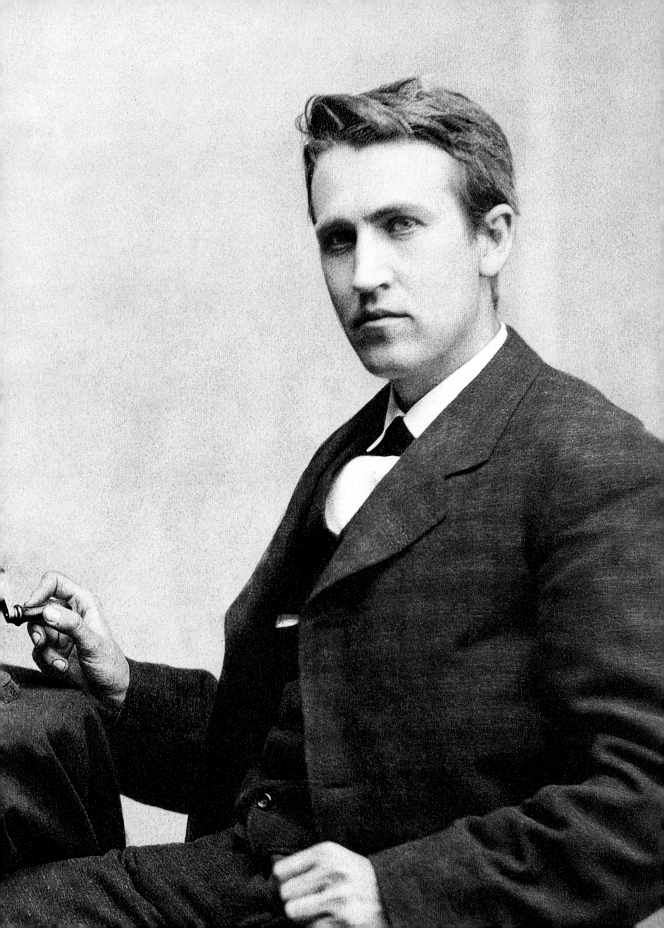

Thomas Edison

Few people embodied the entrepreneurial spirit
of the postbellum United States so completely as
Thomas Alva Edison, inventor extraordinaire, whose
youthful fascination with telegraph machines and the
technology of communication led him into a career
of seemingly boundless innovation.

Edison was born in Ohio in 1847 and although
he received only a very basic formal education he
grew up an inquisitive and enterprising child. In
his teens he started working as a telegraph operator,
and was often in trouble for experimenting on the
equipment without permission.

Experimentation soon gave way to creation:
Edison would acquire more than 1,000 patents
during his lifetime. He is credited with having created
the first lightbulb, motion-picture camera (the
Kinetoscope), alkaline battery and phonograph – one
of which he is pictured with here (pp. 102–3) in 1878,
in an image taken by Mathew Brady.

The phonograph developed from Edison's
designs for a long-distance telephone system. It
recorded sound onto a cylinder, from which it
could be played back. The machine captured the
imagination of his country and the world beyond,
bringing Edison the fame, financial investment
and confidence to follow his numerous interests,
which ranged from industrial methods for metal-
ore processing to X-ray technology, to the movie
business. When he died in 1931, his mind as inquiring
as it ever had been, he was remembered as a giant of
American ingenuity.

Stanley and 'Kalulu'

If Edison was one of the greatest technical minds
of his age, then Henry Morton Stanley was one
of the most adventurous and eccentric. Born into
poverty and illegitimacy in Wales in 1841, he went to
sea and ended up in America, fighting first for the
Confederacy then for the Union army during the
Civil War.

After deserting the navy at the end of the war,
he began to work as a journalist, and within a few
years had landed the story that would make his name,
when James Gordon Bennett of the *New York Herald*
assigned him to go to Africa to locate the missing
missionary and explorer Dr David Livingstone.

Against all odds Stanley tracked Livingstone
down near Lake Tanganyika in 1871, supposedly
greeting him with the words 'Dr Livingstone, I
presume?' This photograph was taken soon after
Stanley returned to Britain to announce his success –
which was initially disbelieved and ridiculed. He was
pictured by the London Stereoscopic Company with
a young boy called Ndugu M'hali, whom he named
Kalulu and adopted as his servant and companion for
several years.

Stanley returned to Africa repeatedly over the
years. During an exploratory expedition in 1877
Kalulu was drowned when he fell into the Congo
River at a waterfall, subsequently named by Stanley
as 'Kalulu Falls'. During the 1880s Stanley left
newspaper work and worked for King Leopold II
of Belgium, securing for him vast tracts of land in
the Congo Basin of equatorial Africa. In this way he
became a critical player in the early history of the
'Scramble for Africa'.

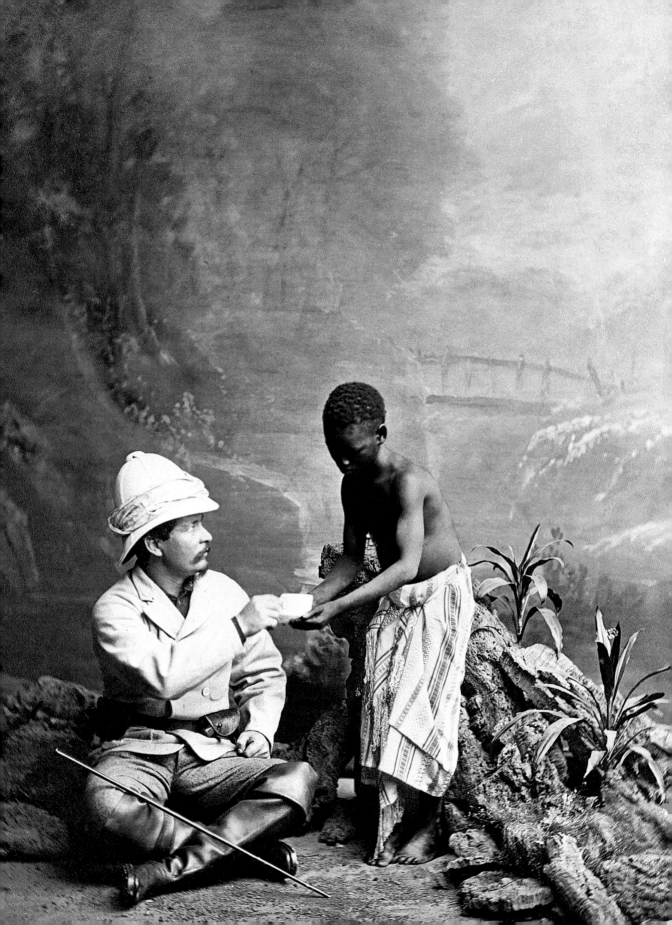

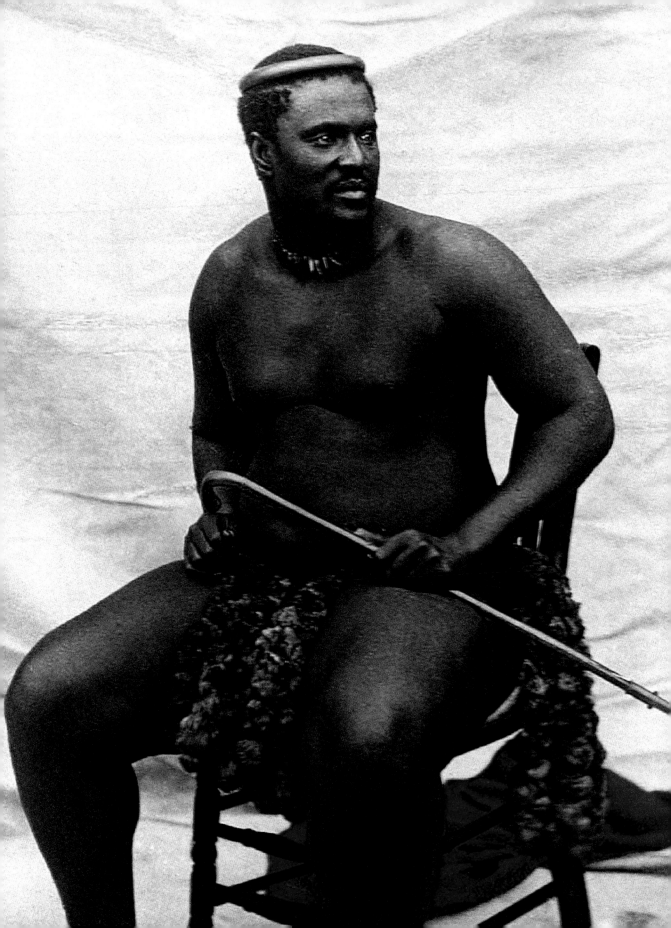

King Cetshwayo

Far south of the Congo the Zulu king, Cetshwayo kaMpande, was fighting for his life and his kingdom, both of which were gravely threatened. The danger came from the British, who wished forcibly to federate areas of southern Africa they ruled as colonies, including the Cape Colony and the Boer province of the Transvaal, both of which bordered Zulu lands.

The chief warmonger in the Cape was the colonial administrator Sir Henry Bartle Frere, who regarded the destruction of the Zulu kingdom as a prerequisite for British security. In January 1879 he deliberately manufactured a pretext for war and sent thousands of British troops into Zululand.

Cetshwayo's men led a fierce resistance to this initial invasion, crushing a heavily armed British column at the Battle of Isandlwana on 22 January, before attacking the tiny British garrison at the mission station of Rorke's Drift, where they were repelled after a soon-legendary 11-hour stand by the defenders.

Sadly for Cetshwayo, pictured here in the mid-1870s, this was the high point of his successes. By July 1879, British reinforcements had reached and burned Ulundi, the capital of Zululand. Cetshwayo was captured and exiled to Cape Town; his kingdom was partitioned between his political enemies and the British.

In 1882 Cetshwayo travelled to Britain to negotiate his restoration as king, but too much damage had been done. Returning to Zululand the following year, he found his realm divided by civil war. He was forced to flee once more and when he died in 1884, many Zulus believed he had been poisoned.

'I have gazed upon the face of Agamemnon…'

Heinrich Schliemann, 1876

Mycenae

Wars of the ancient, and not the modern, world were what interested Heinrich Schliemann. The energetic and ambitious German archaeologist spent much of the early 1870s digging at Hisarlik in what is now northwestern Turkey, where he believed he had found the remains of the city of Troy, dating back to the time of Homer.

In the mid-1870s Schliemann found himself tied up in legal disputes with the Ottoman government, after smuggling out of Hisarlik a stash of ancient gold artefacts known as Priam's Treasure. So between 1874 and 1876 the German turned his attentions to the ruins pictured here, at Mycenae in Greece. Again the object of his search was Homeric: he sought the tombs of Agamemnon and his wife Clytemnestra, whose deeds and affairs were described in the *Iliad*.

What Schliemann discovered was a series of Bronze Age fortifications and royal graves containing spectacular treasure, including one particularly exquisite hammered gold death-mask. He was convinced that this was Agamemnon's, but the treasures he found have been shown to predate by several centuries the era – the 12th or 11th centuries BC – to which scholars have assigned the Trojan War.

In 1878 Schliemann returned to digging at Hisarlik, and later, before his death in 1890, he excavated at Tiryns in the Peloponnese. His methods – sometimes destructive, sometimes deceptive and almost always self-aggrandizing – were frequently criticized, but his ability to popularize his work earned him worldwide renown. He was a forerunner of the archaeologist-adventurer type Hollywood would later reinvent as Indiana Jones.

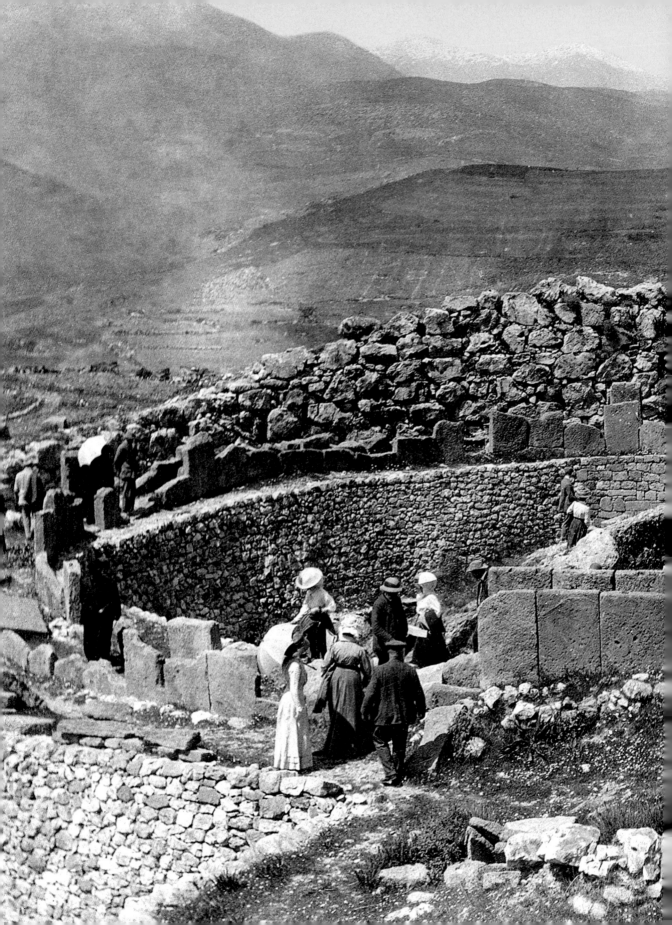

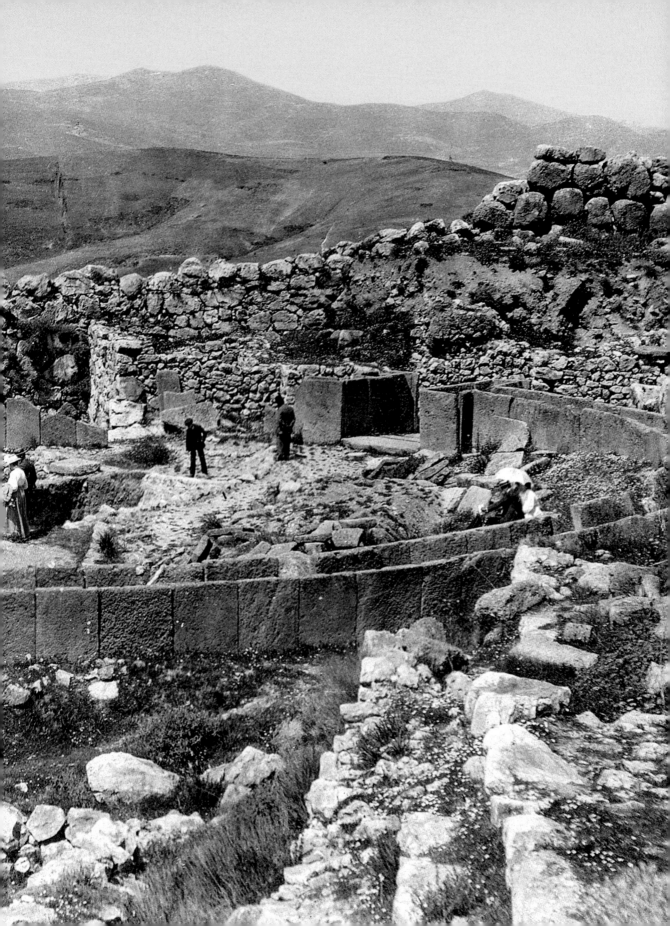

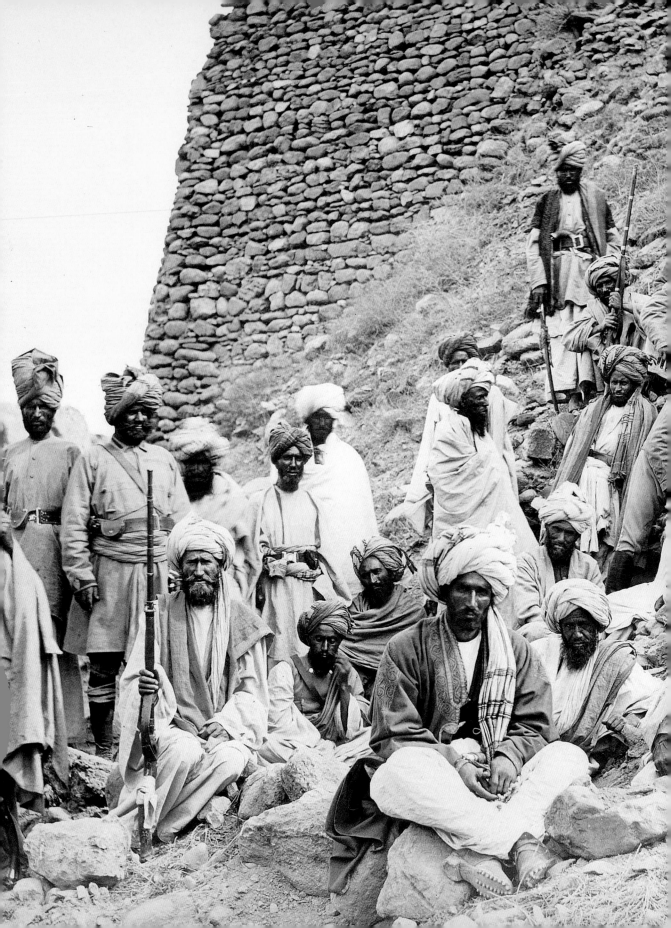

The Anglo-Afghan Wars

In Central Asia British-led armies were involved in a colonial war fought in quite different terrain. Afghanistan bordered British India, providing a buffer and a border with the Russian Empire, whose struggles with the British for influence in the region were known as the 'Great Game'.

Between 1839 and 1842 British and Indian troops had tried and failed to enforce regime change in the Afghan capital Kabul, at the cost of thousands of lives. From 1878 until 1880 a second Anglo-Afghan war was fought, during which this picture was taken by John Burke: an Irish-born photographer who travelled with the British-Indian army as it marched again on Kabul, once more with the intention of replacing the Afghan ruler.

Burke captured this image outside the walls of Jamrud Fort, at the mouth of the Khyber Pass, at the beginning of the war. It shows a British officer, Captain Tucker (seated, centre), surrounded by Afghan chiefs.

As British forces approached Kabul in early 1879, the emir Sher Ali Khan fled north, seeking Russian protection. In May, the British extracted from his successor the lopsided Treaty of Gandamak, which allowed a British Mission to reside in Kabul. Three months later, however, the British envoy was killed by mutinous Afghan troops, following which an army under General Frederick Roberts occupied Kabul. A rebellion led by Sher Ali Khan's son was crushed in September 1880, and a new emir, Abdur Rahman Khan, accepted British control of his country's foreign policy, bringing a brief but bloody war to a conclusion.

'An earthen pipkin
between two metal pots.'

Robert Bulwer-Lytton, Viceroy of India,
describes Afghanistan in 1878

Pope Nono

While archaeologists in Greece sought to dig up larger-than-life historical characters, so the faithful in Rome were laying one to rest. Giovanni Maria Mastai-Ferretti, known in Rome as Pio Nono and beyond as Pius IX, was the longest-serving pope in history after Saint Peter. He was a political firebrand: a pope in the medieval tradition rather than the modern. He cast himself (often with good reason) as a victim of Italian nationalists such as Giuseppe Garibaldi, who tried to conquer the Papal States during his reign.

Among the many positions, usually conservative and often controversial, taken during his 31-year papacy, Pius was best known for pronouncing on the dogma of the Immaculate Conception (confirming that the Virgin Mary was entirely free from Original Sin at the time she was conceived and the doctrine of papal infallibility (defined at the First Vatican Council of 1869–70 and holding that the teachings of the pope on issues of morality and faith could not, by definition, be wrong). He was an enthusiast for trains, an appeaser of revolutionaries, an intolerant anti-modernist and a reactionary whose illiberal measures included the reinstituting of Rome's Jewish ghetto.

Pius was the first pope to be photographed both in life and afterwards: here he lies on his deathbed after expiring, aged 85, on 7 February 1878. When his white stone tomb was opened on 4 April 2000 ahead of his beatification, his corpse was found to be near-perfectly preserved, with the hint of a smile playing on its lips.

'Give me an army saying the rosary, and I will conquer the world.'

Pope Pius IX

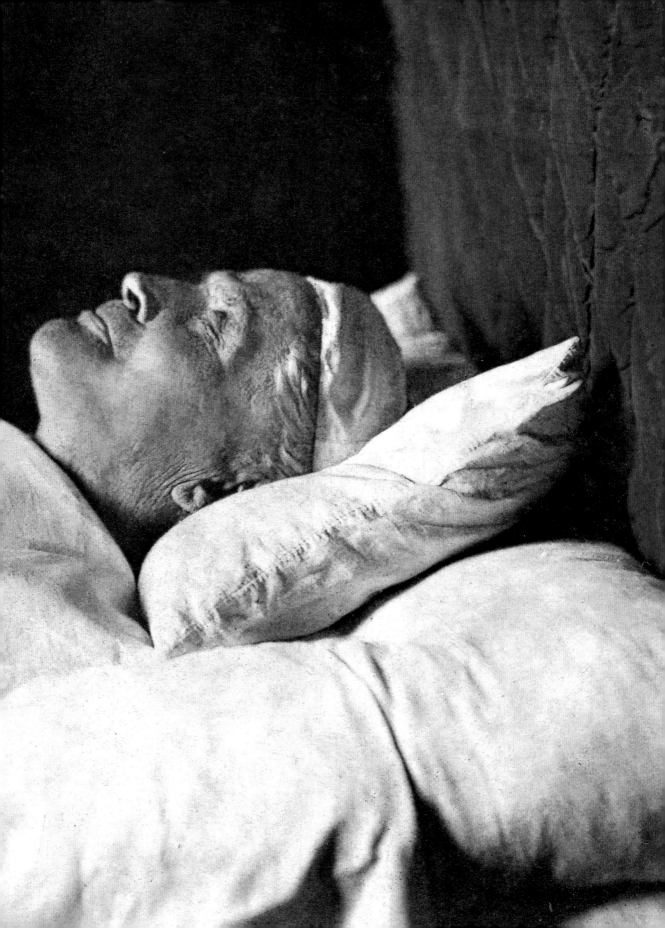

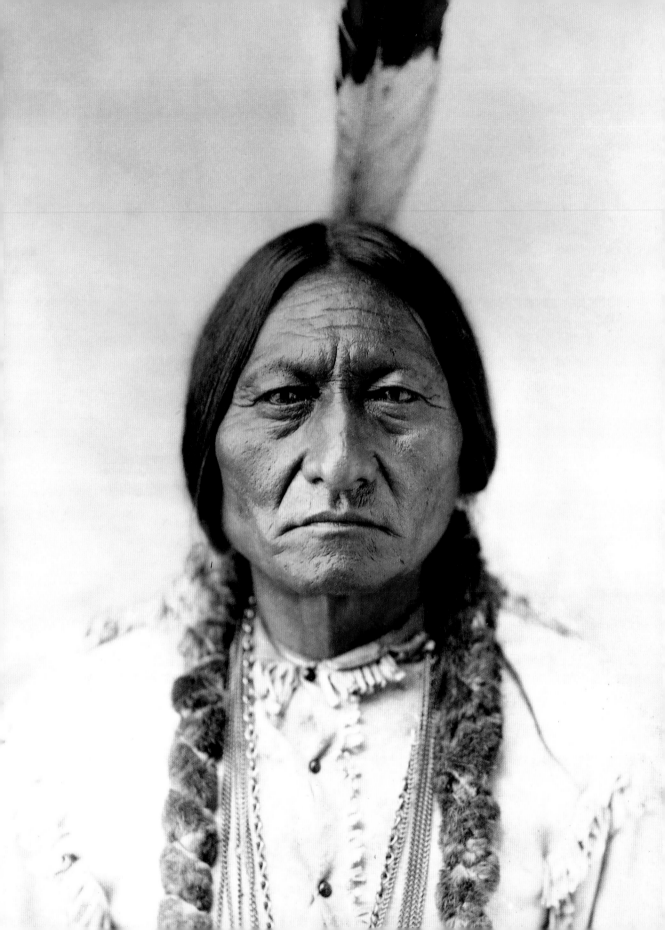

1880s

Age of Marvels

'The life my people want is a life of freedom.
I have seen nothing that a white man has,
houses or railways or clothing or food,
that is as good as the right to move
in the open country, and live
in our own fashion.'

Sitting Bull, interview, 1882

n the summer of 1885 the Hunkpapa Native American chief Sitting Bull toured the United States and Canada with a circus. *Buffalo Bill's Wild West* featured animal tricks and rodeo, feats of daredevil marksmanship and battle re-enactments: all purportedly based on the nerve-jangling experiences of its founder William Frederick 'Buffalo Bill' Cody, a frontiersman who played up enthusiastically to his public image as king of the border men.

For Cody, the 54-year-old Sitting Bull's recruitment to the *Wild West* show was quite a coup. The Hunkpapa were a tribe of the Lakota or Western Sioux, and Sitting Bull had been foremost among the warriors who humiliated and slaughtered Lieutenant-Colonel George Custer and his men at Little Bighorn in 1876. The chief's reputation among his people was as an exemplar of courage and wisdom. To the great white American public he was an embodiment of the noble savage: inscrutable, exotic and dangerous.

This picture of Sitting Bull with a single eagle-feather in his hair was taken in that same year of 1885. The man behind the camera was David Francis Barry, a Dakota-based photographer friendly with Cody, whose favourite subject was the American West, and whose subjects included Native Americans such as Red Cloud, American Horse and Gall, as well as

Cody's other star attraction, the sharpshooter Annie Oakley. Sitting Bull's people knew Barry as 'Little Shadow Catcher', in reference both to his stature (he stood at just 1.65m) and his skill at creating vivid portraits on little oblongs of photographic paper.

Sitting Bull worked only a single season with Cody. In 1886 he returned to the Standing Rock reservation in the Dakota Territory, where his people had been corralled, and lived for several years as a farmer in a cabin-village north of the Grand River. Then, in 1890, trouble flared again, as the reservations of the northern plains rose in thrall to the 'Ghost Dance' movement. This was a messianic religious craze begun by a deluded medicine man called Wovoka (aka Jack Wilson) who fused Christian millenarianism with Native American ritual, and told his followers that if they performed the Ghost Dance and wore garments called Ghost Shirts then the white man would miraculously disappear from the earth.

Against the background of disputes over food rations to the reservations, this cruel fantasy, founded on desperation and puffed up with false hope, found a willing audience among Native Americans of numerous tribes – including the Hunkpapas, whom Sitting Bull encouraged in their ghostly contortions. The US government, convinced the ground was being

1880

[Jun] Australian bank robber Ned Kelly apprehended by police. He is hanged in November

[Dec] Outbreak of the First Boer War in southern Africa

1881

[Mar] Alexander II of Russia assassinated by a bomb and succeeded by Alexander III

[May] First electric tram opens for business, connecting Prussian military academy with a train station near Berlin

[May] American Red Cross founded by Clara Barton and associates

1882

[Jan] Standard Oil Trust created in secret by John D. Rockefeller to control numerous interconnected businesses

[May] Triple Alliance pact formed between Germany, Austria-Hungary and Italy

[Jun] Death of Giuseppe Garibaldi

[Aug] Wagner's opera *Parsifal* and Tchaikovsky's *1812 Overture* receive their first public performances in Bayreuth and Moscow respectively

1883

[Mar] Death of Karl Marx

[Aug] Eruption of Krakatoa volcanic island in the Dutch East Indies kills at least 40,000 people in the initial blast

1884

[Oct] International Meridian Conference sets Greenwich Mean Time as worldwide standard for zero degrees longitude

[Nov] Berlin Conference opens under Bismarck's supervision, with the aim of regulating European colonization in the 'Scramble for Africa'

[Dec] Mark Twain publishes *Adventures of Huckleberry Finn*

laid for a new round of war, decided to strike first, and sent Indian agency police into the reservations. On 15 December they tried to arrest Sitting Bull at his cabin. A gunfight broke out, during which Sitting Bull was shot dead.

Two weeks later, on 29 December 1890, one of the most notorious massacres of the Indian Wars took place at Wounded Knee Creek in South Dakota, where more than 150 men, women and children of the Hunkpapa and Miniconjou Lakota were slaughtered by the US 7th Cavalry. Although conflict between Native American peoples and settlers dragged on into the 1920s, the bison that had sustained the Plains Indians' ancient way of life had been driven almost to extinction. Resistance was growing ever-more feeble – and futile.

This cheerless endgame to a war of greed, vengeance and cultural extermination was by no means unique to the USA in the 1880s. In Africa the decade saw a new round of brutal colonialism, as European powers carved up the continent in the 'Scramble for Africa'. Some of the worst atrocities were committed in the Congo Free State, personal fiefdom of Leopold II, king of the Belgians, which became the scene of almost unimaginable cruelty and inhumanity. The writer Arthur Conan Doyle would

later call Belgian crimes in the Congo 'the greatest to be ever known'.

In an era before instant global transmission of news, the citizens of the USA and Europe were not yet aware of these horrors. For them, the 1880s was an age of architectural marvels, such as the Statue of Liberty in New York and the Eiffel Tower in Paris, and of a new breed of multi-storey 'skyscrapers'. This was also a decade during which astronomers gained new insights into the workings of the heavens, and international sporting rivalries began.

And people like Clara Barton, founder of the American Red Cross, showed that while some human beings were capable of doing the most terrible things to one another, others possessed fathomless reserves of generosity, and were prepared to fight for good and not for evil.

1885

[Feb] Leopold II, king of the Belgians, establishes the Congo Free State

[Jun] Muhammad Ahmad bin Abd Allah, better known as the Mahdi, dies of typhus during a war in Sudan against Egyptian and British forces

1886

[Jan] Karl Benz patents his Motorwagen, a car with a four-stroke engine

[May] Coca-Cola first goes on sale in the USA

[Oct] Statue of Liberty officially unveiled in New York harbor

1887

[Jun] Queen Victoria and her loyal subjects of the British Empire celebrate her Golden Jubilee

[Sep] Yellow River flood kills hundreds of thousands of people in China

1888

[Mar] Great Blizzard of 1888 hits the eastern seaboard of the USA

[Jun] Wilhelm II becomes German emperor following the deaths of his grandfather Wilhelm I and father Frederick III

[Aug] Body of Mary Ann Nichols discovered in London – the first victim of 'Jack the Ripper'

1889

[Jan] Rudolf, crown prince of Austria, commits suicide

[May] *Exposition Universelle* opens in Paris, marking the centenary of the French Revolution. Its monumental showpiece is the new Eiffel Tower

[May] Johnstown Flood causes widespread destruction in Pennsylvania

Electric Trams

The history of the tram long predated electrification: mules, horses, cable pulleys and steam engines had all been used to pull streetcars around towns and cities since the world's first passenger tram began operating in South Wales in 1807, and by the late 19th century trams could be found in cities across the world – a popular and widespread means of mass transit.

From the 1880s, however, electric trams began their rise to the pre-eminence they would hold until they were swept aside to make way for motor cars and buses in the first half of the 20th century. The first, pictured here, appeared in Lichterfelde, near Berlin, opening for business on 16 May 1881. It connected the local train station with the newly built Prussian Military Academy, known as the *Hauptkadettenanstalt*, two and a half kilometres away. It could carry up to 20 people at a time, drawing a direct current from its rails and, later, from a wire overhead. The tram was built by Werner von Siemens, whose company had also, the previous year, produced the world's first electric elevator.

Besides elevators and trams, electrical power was also being used to create magnets, lightbulbs, telephones, and even boats. In the autumn of 1881 many of these new inventions were showcased in Paris at the International Exposition of Electricity, where scientific papers were also presented, defining many now-common technical aspects of measuring and using electricity, including units of measurement (amps, volts and ohms). A future in which everyday things were connected and charged through wires was rapidly being realized.

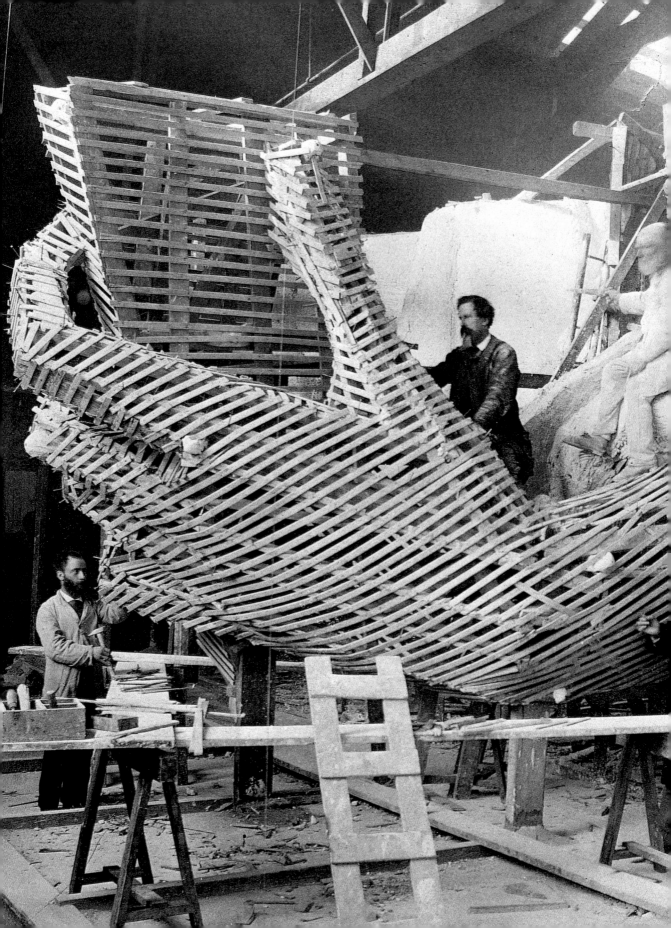

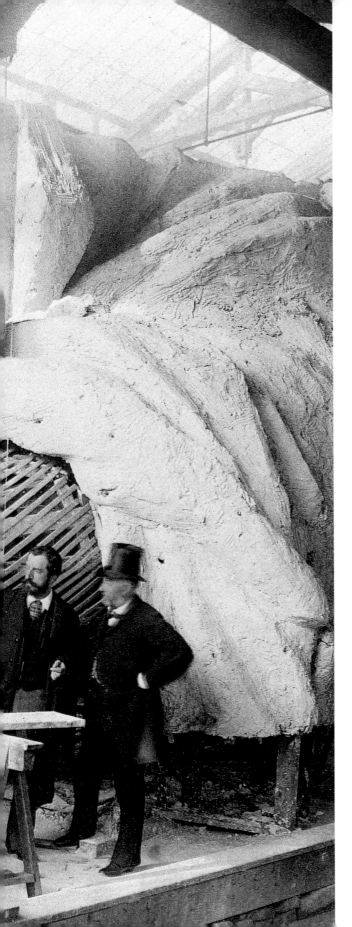

'Give me your tired,
your poor,
Your huddled masses
yearning to breathe free...'

Emma Lazarus, 'The New Colossus', 1883

The Statue of Liberty

It was not electricity but liberty that would enlighten the world, said US President Grover Cleveland on 28 October 1886 as a massive new landmark was unveiled in New York Harbor. The Statue of Liberty (*Liberty Enlightening the World*), rising 93m from its base to the tip of its blazing torch, was a joint enterprise between French and American citizens, first conceived in 1865.

The towering statue of the Roman goddess Libertas was built in France, and in parts. This photograph, taken at the workshops of Gaget, Gauthier & Co. in Paris in 1881, shows artists at work on the statue's left hand, which carries a tablet bearing the date of the US Declaration of Independence (4 July 1776). The sculptor working on the thumb is Frédéric Auguste Bartholdi, who had previously designed (but never built) a massive female figure to stand at the entrance of the newly dug Suez Canal.

The long gap between conception and delivery of the Statue of Liberty was partly due to the monumental scale of the work itself and partly due to the effects of the Long Depression of the 1870s. Funding for the pedestal came from American subscribers, whose goodwill was encouraged by the newspaper publisher Joseph Pulitzer and by the writing of Emma Lazarus's now-famous sonnet 'The New Colossus'.

When the statue was first erected its copper exterior caught the sunlight, but within a couple of decades the metal had oxidized and Libertas had adopted her now familiar shade of green.

John D. Rockefeller

The advances in transport and technology that transformed the world in the 19th century depended on new forms of energy. Few were so important as oil. Vast profits were available to those who could master the oil business and its associated industries – most notably the railroads. That is how John D. Rockefeller became the richest man in modern history.

Rockefeller's organization, Standard Oil, had been incorporated in Ohio in 1870, but by the 1880s was a complex trust in which dozens of companies spread across the United States were controlled via a small group of shareholders. Rockefeller's ambition, deep understanding of the oil and transport industries, and penchant for sharp and secretive business practices had set the organization on its way to monopolization of American oil refinement and distribution.

In 1881 a long article in *Atlantic Monthly* magazine decrying the corruption of the railroads in particular and American industry in general complained that 'Nobody knows how many millions Rockefeller is worth… Just who the Standard Oil Company are, exactly what their capital is, and what are their relations to the railroads, nobody knows except in part.' In 1911 Standard Oil was found to be in breach of antitrust legislation and broken up, but two years later Rockefeller's personal fortune was estimated at $900m. This compared, historically, to the stupendous riches of King Croesus of ancient Lydia or Jakob Fugger, and Rockefeller was widely loathed for his wealth. Yet he gave much of his money away, funding philanthropic causes that included biomedical research, public health and education.

'I believe it is a religious duty to get all the money you can, fairly and honestly; to keep all you can, and to give away all you can.'

John D. Rockefeller, speech, c.1899

'I ought to be jealous of the tower. It is much more famous than I am. People seem to think it is my only work…'

Gustave Eiffel (attributed)

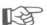

The Eiffel Tower

The French did not only construct landmarks for other nations during the 1880s. This was also the decade during which the Eiffel Tower rose in stages over Paris, the totemic creation of Gustave Eiffel, who had been the lead engineer on the Statue of Liberty.

Eiffel was no stranger to monumental, international projects. He had previously built a prefabricated metal church for a town in Chile, a Hungarian railway station and a Portuguese viaduct when, in 1886, he won the right to create the central showpiece of the *Exposition Universelle*: a huge world's fair to be held in Paris in 1889.

Work began on the site, on the Champ de Mars in Paris's 7th arrondissement, in the early summer of 1887. The six photographs here, dated between 14 July 1888 and 12 March 1889, show the speed with which the tower – at more than 300m the world's then-tallest structure – was erected. Originally painted a vivid red at odds with its now familiar rusty brown, it was not to everyone's taste: indeed, the design was bitterly criticized in a petition signed by a group of French artists, including the author Guy de Maupassant, which called it a 'ghastly dream' and a 'hateful column of bolted sheet metal'.

Their protests, in the end, came to nothing. The tower long outlived its original 20-year lease, becoming as much a part of the Paris skyline as the Statue of Liberty did of Manhattan's.

14 Juin 1888 10 Juillet 1888 14 Octobre 1888

14 Novembre 1888 12 Fevrier 1889 12 Mara 1889

The *Exposition Universelle*

All the wonders of human activity, said the official guidebook, were gathered in Paris between 6 May and 31 October 1889. The Eiffel Tower reached up to the heavens, while below it on the Champ de Mars were more than 60,000 exhibitors from South America to the Far East, displaying art, crafts, music, furniture, textiles, metalwork, food, wine, technology, historical re-enactments and the fruits of industry, all gathered in custom-built spaces such as the 8-hectare glass-and-steel pavilion known as the 'Galerie des machines'.

This photograph from 1889 shows one of the most celebrated groups of exhibitors at the *Exposition Universelle*: dancers wearing traditional Javanese costume. Java was at this time part of the Dutch East Indies; their *Exposition* space mimicked a kampong, or traditional village, in which Javanese natives exhibited their hat-making skills and agricultural practices, and performed religious ceremonies. Perhaps their most influential demonstration was of gamelan music, in which players struck gongs, kettledrums, cymbals and xylophone-style instruments. The young French composer Claude Debussy, who was watching, went on to incorporate elements of gamelan composition into his own work.

The *Exposition* (which included a re-enactment of the storming of the Bastille) marked a century since the French Revolution of 1789 – a perfect time to celebrate the republican dream. It was handsomely attended and profitable; it also demonstrated that, even if French politics remained perpetually turbulent, the capital had at least physically recovered from the depredations of the Franco-Prussian War and the Commune of the previous decade.

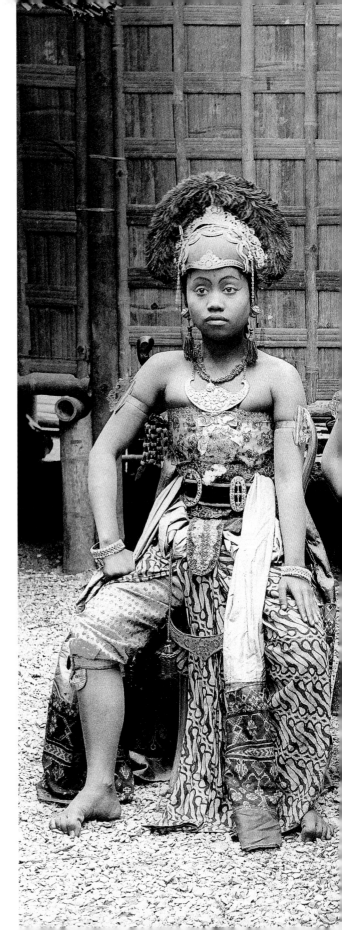

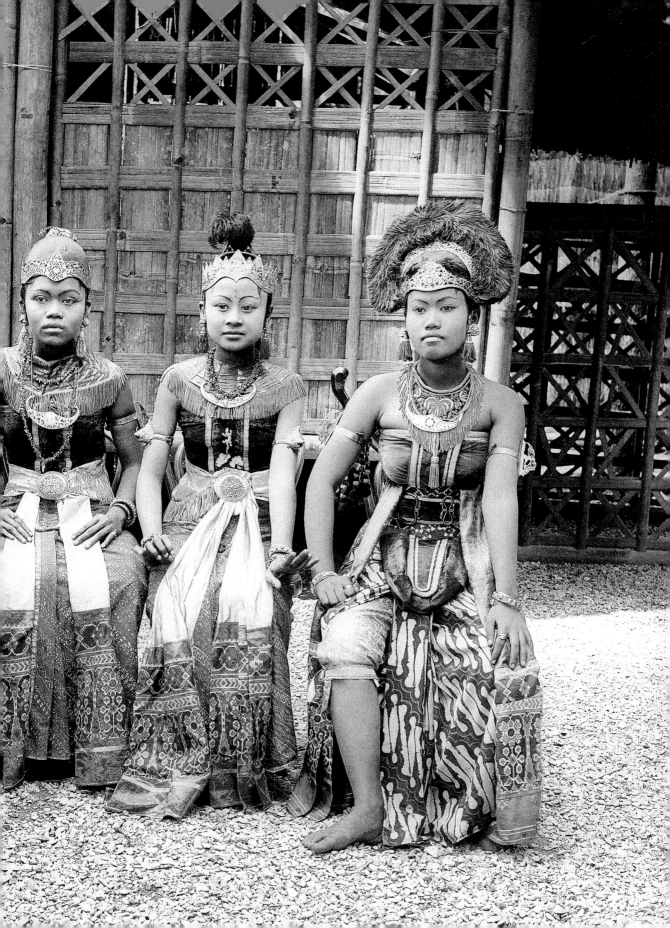

The First Skyscraper

One of John D. Rockefeller's most notable bequests was to a new university in Chicago – a city being transformed during the 1880s. This picture shows the Home Insurance Building, built on the corner of LaSalle and Adams Streets. After its completion in 1885 it rose to a then-mighty 10 storeys, to which a further two had been added by the time this photograph was taken in the early years of the 20th century.

The architect responsible for the building was William Le Baron Jenney, who learned his trade during the 1850s in Paris, where he was a classmate of Gustave Eiffel. He was given his opportunity in Chicago as a result of a catastrophic fire in 1871, which began (according to city lore) when a cow kicked over a kerosene lamp in a barn on DeKoven Street, and destroyed 9 sq km of the city centre, killing 300 and leaving some 100,000 homeless.

Jenney realized it was possible to add height to buildings by constructing them around load-bearing steel and wrought-iron frames, and his work earned him the name 'Father of the Skyscraper'. Architectural historians still debate whether the Home Insurance Building was truly the world's first skyscraper, but Jenney's insights certainly influenced all the high-rise buildings that followed, permanently changing the skylines of cities across the world.

Jenney's 12-storey experiment was soon superseded by other, taller structures (not least the one next door to it here). It was torn down in 1931 to make way for the Field Building, which rose to a magnificent 45 storeys and 163m in height.

Leopold II of Belgium

Leopold II, king of the Belgians from 1865 until 1909, was interested less in tall buildings than in far-off places. During the 1880s he sponsored efforts to explore, 'civilize' and annex sub-Saharan Africa. He claimed a large colony in the Congo Basin – known as the Congo Free State, later as the Belgian Congo – then cruelly forced its people to co-operate in plundering its natural resources for his own gain.

In 1880 Leopold (seen here in a portrait by the Chichester-based photographer Russell & Sons) hired the explorer Henry Morton Stanley to work as his agent in the Congo River Basin, establishing trading posts and inducing native chiefs to agree treaties that turned the region into a royal fiefdom. At first Leopold's men raided the territory for ivory before turning in the 1890s to rubber: a substance much in demand for its use in vehicle tyres and electrical cables. Leopold's private military, the *Force Publique*, satisfied the king's demand for rubber quotas by using forced labour backed with threats, kidnap, flogging, torture, mutilation and murder. Millions of Congolese people died; starvation and disease became rife.

Belgium was by no means alone in this atrocious colonial misrule. Leopold's seizure of the Congo was part of the 'Scramble for Africa', the process by which the African continent was brought under the rule of Britain, France, Portugal, Germany and other European imperial powers between the 1870s and 1880s. This rush for African spoils was given the patina of legitimacy at a great-power conference held in Berlin in 1884. By 1902, 90% of African territory was under European control.

'All the crimes perpetrated in the Congo have been done in your name, and you must answer at the bar of Public Sentiment for the misgovernment of a people...'

George Washington Williams,
open letter to Leopold II, 18 July 1890

The Sultan of Zanzibar

Barghash bin Said (seen sitting here, centre, among his ministers) was the second sultan of Zanzibar, in East Africa, ruling between 1870 and his death on 26 March 1888. Like so many other rulers of his time, he was faced with the onerous task of defending his realm against European powers intent on carving up the continent during the 'Scramble for Africa'.

Zanzibar's convenient location, centred on an archipelago in the western Indian Ocean, just below the Horn of Africa, meant it was a historically lucrative trading spot: useful to slave traders from Arabia as well as to merchants carrying gold, spices and coffee.

By the 1870s Britain had a longstanding influence within Zanzibar, thanks to the presence of merchants from the East India Company and British India; their soft power was demonstrated in 1876, when the British pressured Barghash to abolish the slave trade. During the 1880s, however, Britain failed to stand up for Zanzibar's interests when Tanganyika, the territory on the African mainland facing Zanzibar, was overrun by Germany. Piece by piece the colonial powers picked off almost all of Zanzibar's possessions in East Africa, under the guise of agreements to provide 'protection'.

In 1890, two years after Barghash died, Zanzibar itself – much depleted territorially – was officially declared a British protectorate, a status that lasted until the country joined the British Commonwealth as an independent nation in 1963. The following year, Zanzibar unified with Tanganyika to form modern-day Tanzania.

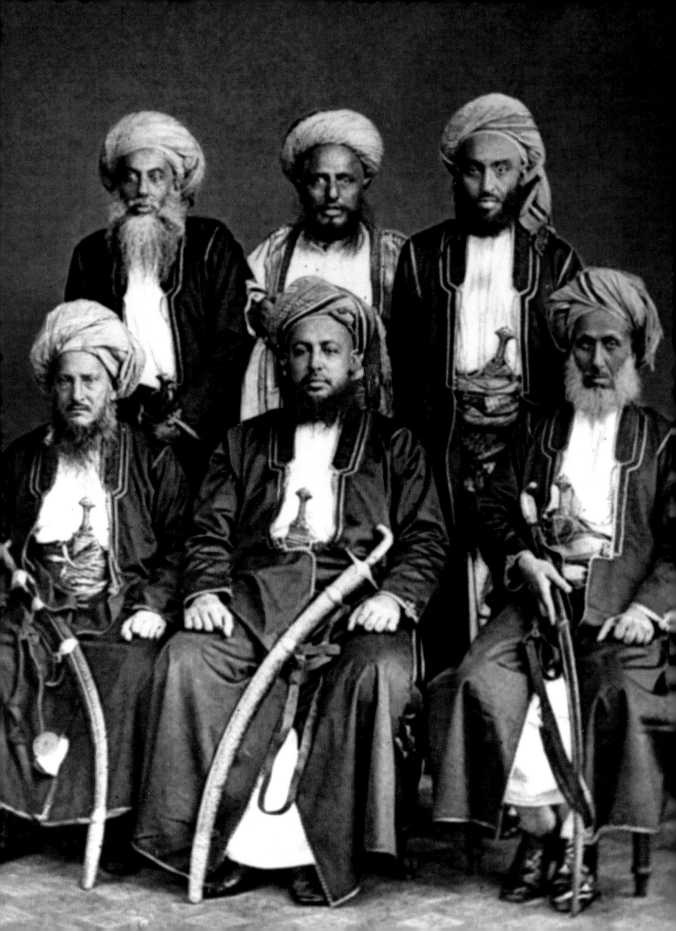

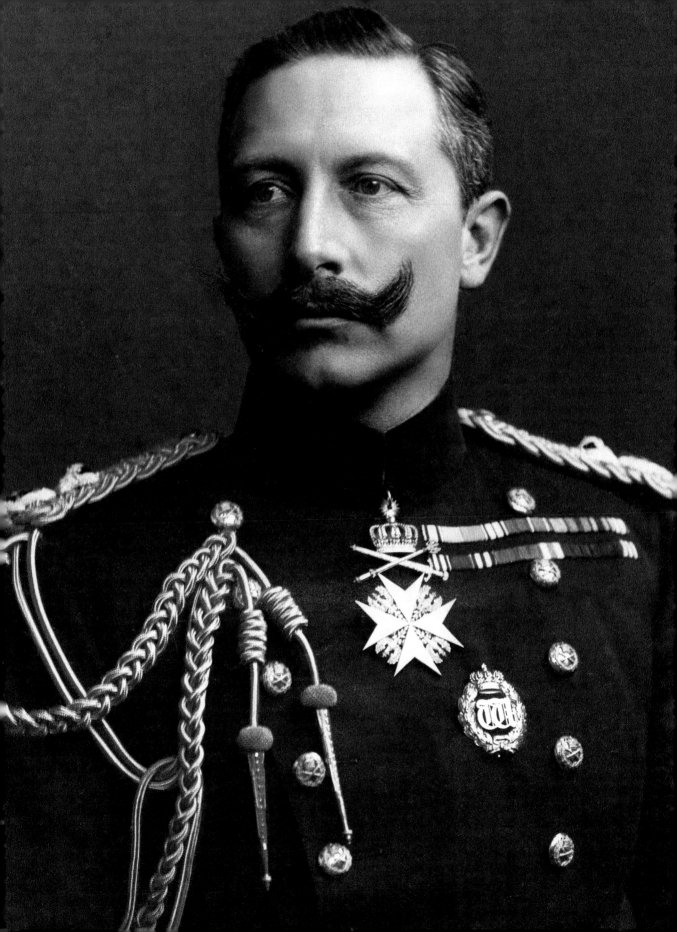

Kaiser Wilhelm II

As Germany joined the 'Scramble for Africa', the empire was experiencing a change of ruler at home. Kaiser Wilhelm II, a 29-year-old grandson of Queen Victoria of England, acceded to the imperial throne on 15 June 1888 following the deaths, in close succession, of his grandfather Wilhelm I and father Frederick III.

Wilhelm II proved a volatile and destructive emperor. One of his earliest significant actions was to dismiss his elderly chancellor Otto von Bismarck. Although he is pictured here wearing British military uniform in a portrait by the photographer Thomas Voigt, Wilhelm maintained fractious relations with his relatives in England, and was similarly unpopular with his cousin Tsar Nicholas II of Russia.

Prone to gaffes, abrasive, insecure and aggressive to a fault in foreign policy, Wilhelm made enemies as easily as friends. His anti-Semitism and racism were pronounced even for an illiberal age, while his glib reading of German history – which in 1900 led him to liken German troops fighting in China to the hordes led by Attila the Hun – often backfired.

Wilhelm's belligerence played a role in the many complex events that led to the outbreak of a world war in 1914; he abdicated following German defeat in 1918 and lived out a long life in exile in the Netherlands, where he occupied himself with growing an impressive beard, chopping wood and hunting animals. He detested Adolf Hitler and the feeling was mutual; it was with some ambivalence that the Führer allowed the Kaiser to be buried with military honours following his death in 1941.

'There is only one person who is master in this Empire and I am not going to tolerate any other.'

Kaiser Wilhelm II, speech in Düsseldorf, 1891

The Big Freeze

This chilly winter scene, taken in eastern England as part of a collection called *Life and Landscape on the Norfolk Broads* by Peter Henry Emerson and the artist Thomas Frederick Goodall, shows the first frost of 1886 (overleaf). It is a quiet, pastoral image, but its depiction of frozen countryside was appropriate, for the 1880s experienced a sharp drop in global temperatures.

Exceptionally harsh winters were recorded in 1880–1. In the northern hemisphere the summer of 1884 was on average 1.2°C colder than the one preceding, and the cooldown continued until 1888, when the eastern United States and Canada were buried by severe snowstorms known collectively as the Great Blizzard. The chillier climate coincided with crop failures and strange atmospheric changes, most notably dazzlingly colourful sunsets. (It has been suggested that one such sunset is memorialized in the vivid orange sky of the 1893 Expressionist painting *The Scream*, by Norwegian artist Edvard Munch.)

One major contributor to this climatic disruption was the cloud from a gargantuan volcanic eruption between Java and Sumatra in the Dutch East Indies, which took place on 26–27 August 1883. The three-peaked volcanic island Krakatoa (or Krakatau) erupted with a violence that exceeded anything in recorded history, blasting 25 cubic miles km of debris 80km through the air, emitting a roar heard 4,800km away in Australia, sending a tsunami rolling through the oceans and pumping tons of dust and ash into the earth's atmosphere. At least 40,000 people died in the blast, and many more shivered thereafter beneath the world's newly darkened skies.

The Johnstown Flood

Extreme weather caused widespread destruction and
the deaths of more than 2,000 people in Johnstown,
Pennsylvania, on 31 May 1889. Days of relentless
and torrential rainfall exerted unbearable pressure
on the poorly maintained South Fork Dam at Lake
Conemaugh, around 23km from the town, but
despite repeated warnings that the defences were
about to burst, no evacuation was ordered.

When floodwater duly overwhelmed the dam
shortly before 3pm on 31 May, more than 14 million
cubic metres of water was released into the Little
Conemaugh River, racing downstream and engulfing
several villages before crashing into Johnstown in
a surge that reached 18m in height. Many people
caught in its path were crushed by debris or drowned.
Those who survived often lost everything: this photo
is one of many that were taken of a house belonging
to Johnstown resident John Schultz, which was
speared by a tree, turned over, washed through
the town and deposited on its roof several streets
away from its original address. (Somehow Schultz
survived.) Schultz's house was described as a 'freak of
the flood'; it was certainly a monument to the power
of the raging waters.

The Johnstown calamity paled by comparison
with the Yellow River flood of 1887, which killed
around 900,000 Chinese people. Nevertheless, at
the time it was the most lethal civilian disaster in US
history: a humanitarian crisis that stirred the pity and
charity of citizens all over the world.

Clara Barton

The editors of the *Johnstown Daily Tribune* had no doubt about the contribution Clara Barton and the nurses of the American Red Cross (ARC) had made to relieving the Johnstown disaster of 1889: 'Hunt the dictionaries of all languages through and you will not find the signs to express our appreciation of her and her work.'

Born in Massachusetts in 1821, Barton was a painfully shy child, but found her calling first as a schoolteacher and later as a volunteer nurse at some of the bloodiest battles of the American Civil War, including Antietam, Fredericksburg and the Wilderness Campaign. After the war she embarked on a speaking tour in which she stunned audiences with her vivid and impassioned accounts of her experiences.

Despite her own poor health she devoted the rest of her life to nursing: working on the front line of the Franco-Prussian War in the 1870s; lobbying for the US Senate to ratify the 1864 Geneva Convention, which obliged combatant armies to protect and treat the wounded; and setting up the ARC in 1881, with financial support from John D. Rockefeller and moral support from the abolitionist Frederick Douglass. She was also an energetic campaigner for the rights of disenfranchised black people and women's suffrage.

This photo of Barton was taken by James E. Purdy, a fellow New Englander and a prolific portraitist; Barton sat for him in 1904, the year she turned 83, when she stepped down as president of the ARC and retired. She died eight years later on 12 April 1912.

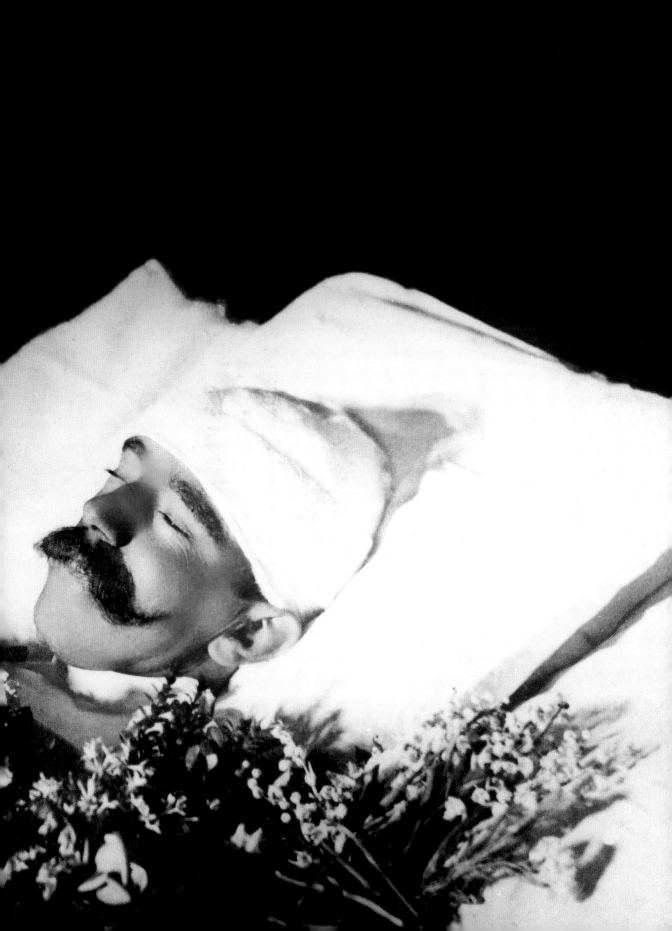

Rudolf, Crown Prince of Austria

The troubles of Archduke Rudolf, crown prince of Austria, were not the sort the Red Cross could solve. Rudolf, pictured here after his suicide on 30 January 1889 (pp. 142–3), had been a frustrated, and eventually a miserably depressed, heir to the Austro-Hungarian imperial throne.

As his father Franz Joseph I's only son, Rudolf was destined for rule from the day of his birth in 1851. However, he grew up with profoundly different political ideas from the emperor and his ministers: liberal, anti-clerical and anti-Russian, he was frozen out of a significant role in government.

To compound Rudolf's unhappiness, he was compelled in 1881 to wed the second daughter of Leopold II, king of the Belgians. Her name was Stéphanie and although she was a distant enough cousin to make their union permissible under canon law, the marriage proved to be ill-transacted. Other than a single daughter, all Rudolf managed to give Stéphanie was a sexually transmitted disease, and within a few years divorce was under consideration.

Impetuous and despairing, in 1889 Rudolf shot himself. His body was found alongside that of the impressionable 17-year-old Baroness Mary Vetsera, one of his several mistresses. The apparent murder-suicide took place in a hunting lodge at Mayerling, in woods near Vienna. It had consequences no one could have imagined: by diverting the line of the Austro-Hungarian succession, Rudolf ensured that by 1914 the heir was his cousin Archduke Franz Ferdinand, whose murder in Sarajevo sparked the First World War.

'Small though [the] photographs are, they give us much valuable information; and they can be relied upon as accurate.'

The Observatory journal, editorial, 1880

Gibbous Moon

Far above the troubles of the earth, the moon looked down unchanging on the dramas of the late 19th century. This extraordinary image of it was captured by Andrew Ainslie Common, a pioneering English astronomer-photographer whose day job was sanitary engineering, but whose abiding passion in life was looking at the heavens. In 1886 Common was elected a Fellow of the Royal Astronomical Society; he had taken this high-resolution picture of the moon with a 910mm reflecting telescope at his home in the London suburb of Ealing some six years earlier, on 20 January 1880. His notes on the image read: 'Exposure, quick. Enlarged about 10 times.'

Technically what Common saw with his telescope on that day was known as a waxing gibbous moon: the portion visible from earth was greater than a semi-circle but smaller than a circle. This image was particularly notable for showing clearly the dark patches on the surface known as the lunar maria or 'seas'. However, the image Common printed, and which is displayed faithfully here, is upside down: this is the moon as it appears from the southern and not the northern hemisphere. Nevertheless, it is easy to make sense of it: the small dark round patch in the bottom left of the moon is the Mare Crisium (Sea of Crises); its larger neighbours are the Mare Serenitatis (Sea of Serenity) and Mare Tranquillitatis (Sea of Tranquillity) – the future site of the first manned landing on the moon, 89 years later.

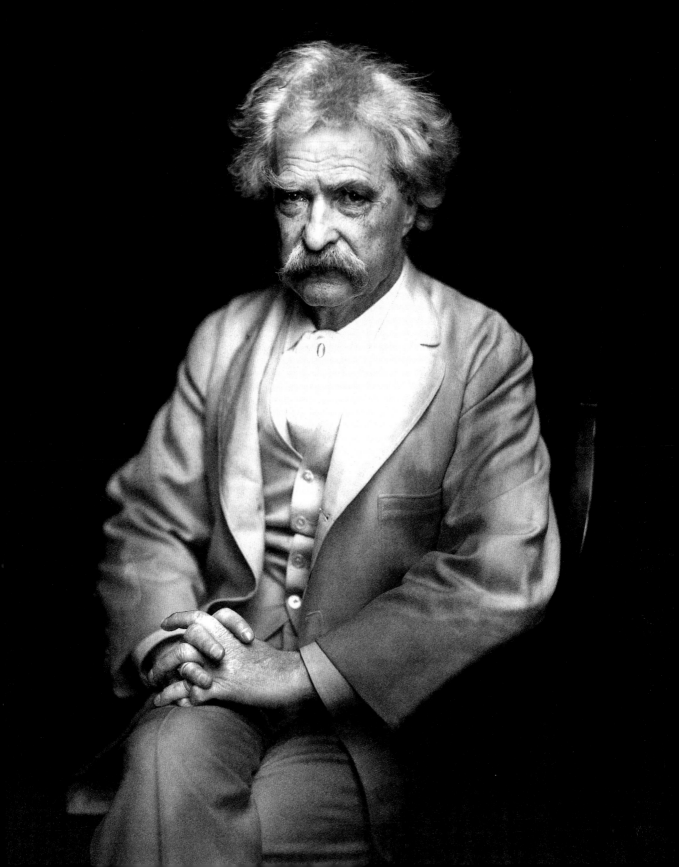

1890s

Century's Twilight

'Humour is the great thing, the saving thing.
The minute it crops up, all our hardnesses yield.'

Mark Twain, essay, 1897

n 1894 the American humourist, novelist, publisher, riverboat pilot, speaker and wit Mark Twain declared himself bankrupt and set out to travel the world. In each of the two previous decades he had written a masterpiece: *The Adventures of Tom Sawyer* (1876) and *Adventures of Huckleberry Finn* (1885). The 1890s were strange times: although his writings were much in demand, his publishing company was a failing concern.

Mark Twain was born in Missouri in 1835 and grew up in the South in a family sliding rapidly from wealth into poverty. His name at birth was Samuel Langhorne Clemens; he ditched this for his famous pen-name in 1863, a time in his life when he was making a living by piloting steamboats. ('Mark Twain' was a joke: it was a riverboat call by the leadsman, measuring depth, confirming that the water was safe to navigate.) Once he abandoned the river for a full-time life of letters, he built his reputation as a writer able to conjure out of personal experience the character of the homespun American 'old boy' of the Mississippi.

Yet despite his ingrained American-ness, Twain – pictured here towards the end of his life by the great photographer Frances Benjamin Johnston – would spend most of the 1890s travelling the wider world. He visited Australia and New Zealand, India and South Africa, London and Vienna, everywhere beguiling audiences and charming potentates with his spirited speech and trove of entertaining anecdotes from a long life well lived, and tailoring his stage shows deftly to suit the sensibilities of each place he visited. Since the death of Charles Dickens in 1870 there had been no writer alive better in tune with the spirit of his times.

In 1873 Twain had defined those times as 'the Gilded Age'. He did so by co-authoring a popular novel of that exact title: a work that skewered a historical moment defined by the collision of rapid technological advance, population growth, industrial wealth and American Reconstruction with the ageless human failings of over-optimism and corruption. As Twain globetrotted his way through the 1890s, he was able to see at first hand a world that still met his diagnosis.

At home in the United States, the population was still rapidly expanding, the economy was as unpredictable as it had been in the 1870s and life for many Americans remained dangerous and hard. But the USA was also entering a new phase of its life, in which the young nation born out of rejecting colonial rule appeared to be turning itself into an

1890

[Mar] Kaiser Wilhelm II dismisses Otto von Bismarck as German chancellor

[Jul] Britain takes control of the sultanate of Zanzibar, trading it with Germany for the Heligoland islands in the North Sea

[Dec] Hunkpapa Lakota chief Sitting Bull shot dead; a fortnight later more than 150 Lakota are massacred at Wounded Knee in South Dakota

1891

[Feb] Death of William T. Sherman, lauded US Civil War general and pioneering advocate of 'total war'

[Apr] London–Paris telephone line opened for public use

1892

[Jan] Ellis Island opens as a clearing point for immigrants arriving in the USA

[Apr] General Electric company formed from the merger of Edison's General Electric Company and the Thomson-Houston Company

1893

[Jan] Hawaiian monarchy overthrown, leading to abdication of Queen Liliʻuokalani and eventual annexation by the USA

[May] Financial crisis and a credit crunch in the USA trigger an acute period of economic depression known as the Panic of 1893

[Sep] New Zealand grants women the right to vote – the first country in the world to do so

1894

[May] Jacob Coxey arrested in Washington DC after leading a protest march from Ohio to petition the government for a recession-busting public works programme

[Aug] First Sino-Japanese war begins

[Nov] Nicholas II succeeds Alexander III as Russian tsar

imperial power. War with Spain in 1898 brought Cuba, the Philippines, Puerto Rico and Guam under US control; Hawaii was annexed at the same time. The conflict between those who supported American imperialism and American isolationism would dominate the decades to come, and is in many senses still alive today, in the second decade of the 21st century.

Across the Pacific Ocean, imperialism brought a different set of problems. The 1890s saw a rolling succession of conflicts between China, Japan, Korea and the numerous European powers who held commercial and political interests in and around the Sea of Japan and the Yellow Sea. Likewise in Africa, where British, French, German, Italian and Belgian colonial powers continued to subjugate native peoples and scheme for control of a continent that they had so recently and roughly divided between them.

In Europe there were moments of high pageantry during the 1890s – the 1896 Olympic Games and the Diamond Jubilee of Queen Victoria in 1897. But there were also notorious cases of low depravity, such as the Dreyfus affair, which exposed a French establishment rotten at its core. And all the while, the world moved on: steam trains continued

to puff, the first modern cars rolled out of factories and the stars of the stage began to contemplate a new technology: moving pictures.

This, then, was the world through which Mark Twain travelled: writing all the while of his own adventures and carefully building his prestige until he returned to New York in October 1900, announcing that he was back, that he would never leave again, and that he had learned, the more he saw of the world, to hate imperialism with a passion.

1895

[Jan] Jewish army captain Alfred Dreyfus formally stripped of his rank in the French army, having been wrongly convicted of selling military secrets to Germany

[Feb] The Lumière brothers patent their Cinematograph, a moving-picture player that rivals Edison's Kinetoscope

[Oct] Queen Min of Korea murdered by Japanese assassins in the Gyeongbok Palace in Seoul

1896

[Mar] Ethiopian army loyal to King Menelik II trounces Italian troops at the Battle of Adwa

[Apr] 1896 Summer Olympics held in Athens: the first modern Olympic Games

[May] US Supreme Court upholds racial segregation in the landmark Plessy v Ferguson case

1897

[May] Irish playwright Oscar Wilde released from prison after a two-year sentence for gross indecency

[Jun] British Empire celebrates Queen Victoria's Diamond Jubilee

[Jul] Gold rush on the Klondike begins, with 100,000 people travelling to the Canadian/Alaskan border to seek their fortunes

1898

[Feb] USS *Maine* blown up in Havana harbour, sparking war between the USA and Spain

[Sep] British victory over Mahdists in Sudan at the Battle of Omdurman

[Oct] Attacks on foreigners in China by members of the 'Boxer' movement, beginning a three-year uprising known as the Boxer Rebellion

1899

[Jan] Théâtre Sarah Bernhardt opens in Paris with its namesake and patron starring in a revival of Victorien Sardou's *La Tosca*

[Feb] War breaks out between the Philippines and USA

[Oct] Second Boer War begins in southern Africa

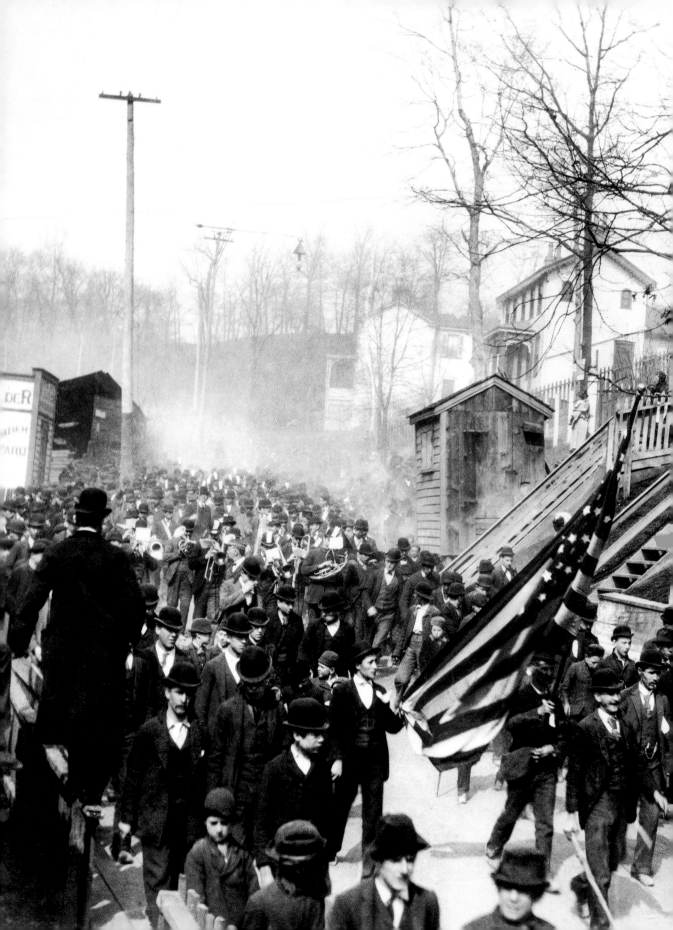

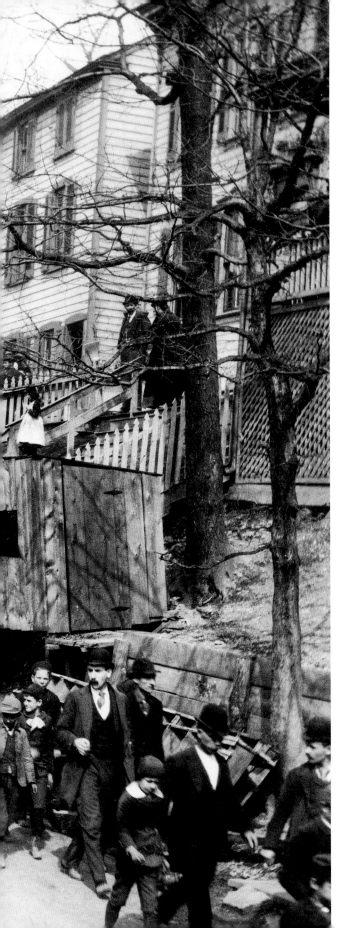

Coxey's Army

The perfect illustration of Twain's 'Gilded Age' was the crisis that gripped the United States from 1893: a four-year economic meltdown worse than any that the nation had experienced to that point, brought about by a run on gold reserves held by the US Treasury.

Since the US dollar was backed by actual deposits of gold, its credibility came into sharp doubt in April 1893 when it appeared that federal reserves were falling to a dangerously low level. A run on the Treasury began, as investors sold everything they could and converted their wealth into gold dollars or bullion.

Panic spread quickly through the financial system, leading to a series of bank runs and collapses, followed inevitably by business bankruptcies, particularly in railroad and steel production. Within the year one in five Americans was jobless and demonstrations had begun.

This photo shows 'Coxey's Army' on the march in 1894. Led by the Ohio businessman Jacob S. Coxey, who advocated abandoning gold-backed dollars and stimulating the economy with a federal road-building programme, hundreds of people – their numbers boosted along the route – marched from Massillon, Ohio, to Washington DC to petition the government. When they got there on 1 May, however, Coxey was arrested for trespassing on the Capitol lawn before he could make any public pronouncements.

It took until 1897 for the economic turbulence to subside. By that time, it had ended the unpopular second term of President Grover Cleveland; bankers such as J. P. Morgan and the Rothschilds had become wealthy through making high-interest bailout loans to the US government; and a plentiful new supply of gold had been discovered in the Klondike.

'We are here to petition for legislation which will furnish employment for every man able and willing to work...'

Jacob S. Coxey, undelivered speech of 1894

Gold Rush

Since gold underpinned the US economy, finding new sources was a lucrative business. And in the summer of 1896 prospectors exploring the Yukon in western Canada, close to the Alaskan border, found a trove of nuggets in the waters of a tributary of the Klondike River. They named the tributary Bonanza Creek, and the name was apt. Striking rich was the aim of every prospector: the dream that had drawn white settlers west to California in the 1840s, and which now sparked one of the most famous gold rushes in history.

In July 1897, once the ice had thawed and news of the riches of Bonanza Creek had reached the outside world, around 100,000 people scrambled to join the treasure hunt, picking their way along perilous mountain trails or paying huge fees to be taken to Alaska by sea and riverboat from San Francisco. The Hän people of the Yukon were moved to reservations to make room for the new arrivals.

There was, truly, a vast amount of gold in the Klondike. But demand nevertheless far outstripped supply and many more people lost a fortune there than made one. Hundreds died trekking to the goldfields, and conditions in prospecting camps were rough, as this photo by the Seattle-based photographer Frank La Roche illustrates. In boom towns like Dawson City, known for high-stakes gambling and champagne-fuelled excess, disease, lawlessness, fires, prostitution and violence were rife.

The Klondike remained irresistible to many Americans until the summer of 1899. Then even more gold was found in Nome, close to the mouth of the Yukon, and the bounty-crazed gold-diggers moved on.

'In an incredibly short period of time the inhabitants of the coast cities were beside themselves with excitement … A stampede unequalled in history was on.'

Edwin Tappan Adney,
The Klondike Stampede (1900)

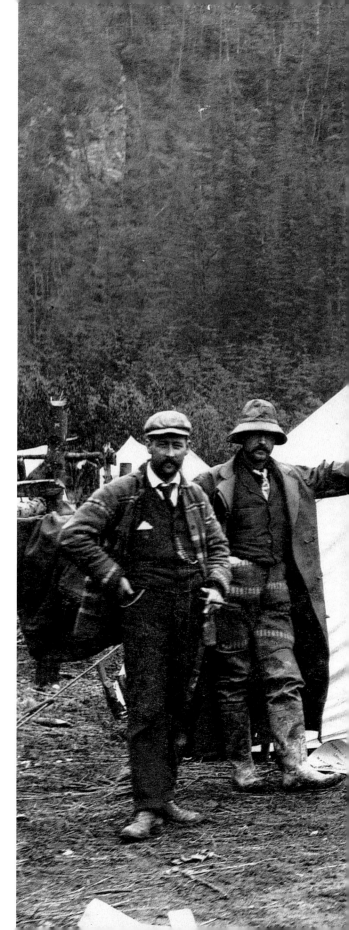

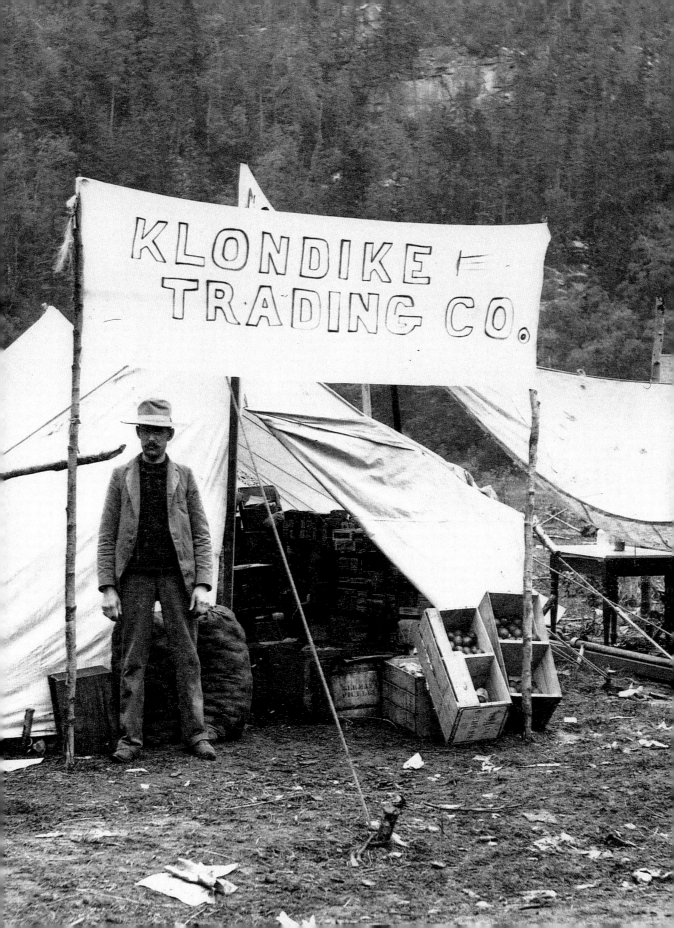

Sarah Bernhardt

As gold fever seized the American northwest, elsewhere the country was in thrall to a treasure of the stage. The French actress Sarah Bernhardt travelled from Paris to tour the United States three times in the 1890s (1891, 1896 and 1900), wowing audiences in the latest works by fashionable French playwrights, including Victorien Sardou's *La Tosca* and *Cléopâtre* and Edmond Rostand's *Cyrano de Bergerac*.

The illegitimate daughter of a Dutch-Jewish courtesan, Bernhardt's career began slowly, but from the 1870s her magnetic stage presence and unforgettable voice had earned her an international reputation, as well as a queue of celebrity suitors including the novelist and dramatist Victor Hugo and Queen Victoria's son Albert Edward, the future Edward VII.

Bernhardt also played male roles, notably Shakespeare's Hamlet and the role of Napoleon's son in Rostand's *L'Aiglon*. For many years she was also the manager of Paris's Théâtre Sarah Bernhardt (renamed from the Théâtre des Nations).

By 1890, when this photograph was taken by W. & D. Downey, showing Bernhardt in the lead role of Sardou's *Théodora*, she was the most famous actress in the world. The 'divine Sarah' was also known for her fiery temper: she once broke an umbrella over a doorman's head, and, at a show in San Francisco in 1891, threatened to shoot a stagehand with a revolver. In 1915, a longstanding and painful injury to Bernhardt's knee was found to be infected, and her right leg was amputated. She continued to work regardless. At the time of her death in 1923, she was acting in a film that was being shot in her own house in Paris.

'In Sarah Bernhardt's voice there was more than gold: there was thunder and lightning; there was heaven and hell.'

Lytton Strachey, essay on Bernhardt's career, 1925

The Lumière Brothers

Since she had dominated the stage for 30 years, it was little surprise that Sarah Bernhardt became one of the early stars of motion pictures, which were first created by her compatriots Auguste and Louis Lumière when Bernhardt was at the height of her fame.

The Lumière brothers, shown here in middle age, inherited a profitable photographic factory and an inquisitive temperament from their father. On 13 February 1895 they patented their Cinematograph, a movie camera that also projected images, which could be watched by audiences of many people at once. In this respect it differed from Thomas Edison's Kinetoscope, designed for use by a single viewer at a time. The Lumières' first film – a 46-second shot showing workers leaving their factory in Lyon – premiered with several others at the Grand Café on the Boulevard des Capucines in Paris on 28 December of the same year. It is today considered the first motion picture.

As inventions like the Cinematograph and Kinetoscope reached the market, the potential of moving pictures was quickly realized, and noted stage actors began to appear in early short films. Bernhardt performed as Hamlet duelling with Laertes in 1900. But the Lumières' interest in the movie business was relatively short-lived. After compiling a library of several thousand documentary-style short films, their focus shifted to developing an early colour-photographic process called autochrome and investigating 3D imaging or 'stereoscopy'. Auguste also spent many years researching diseases such as cancer and tuberculosis. Louis died in 1948, and Auguste in 1954.

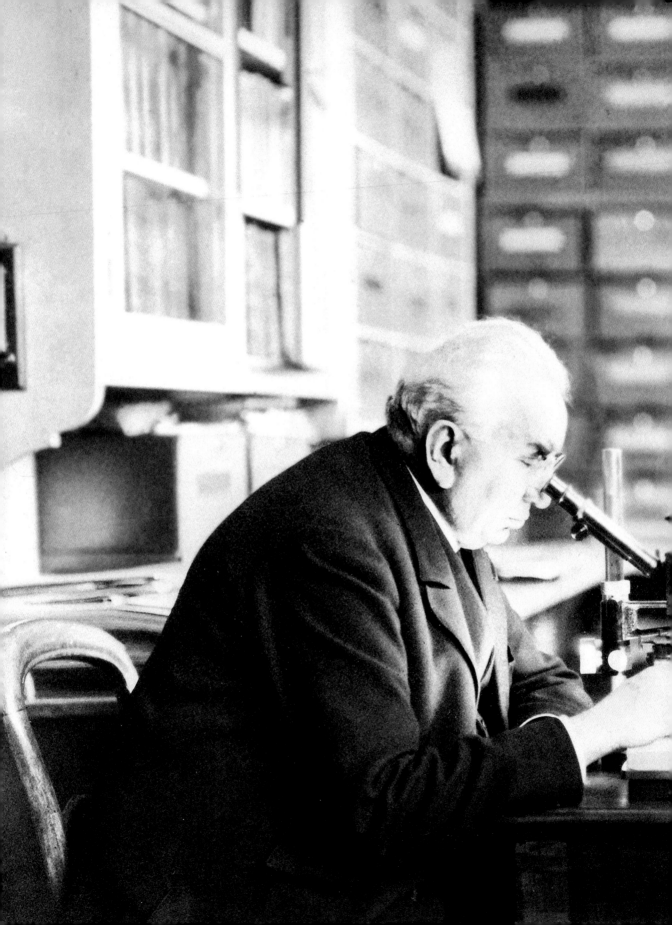

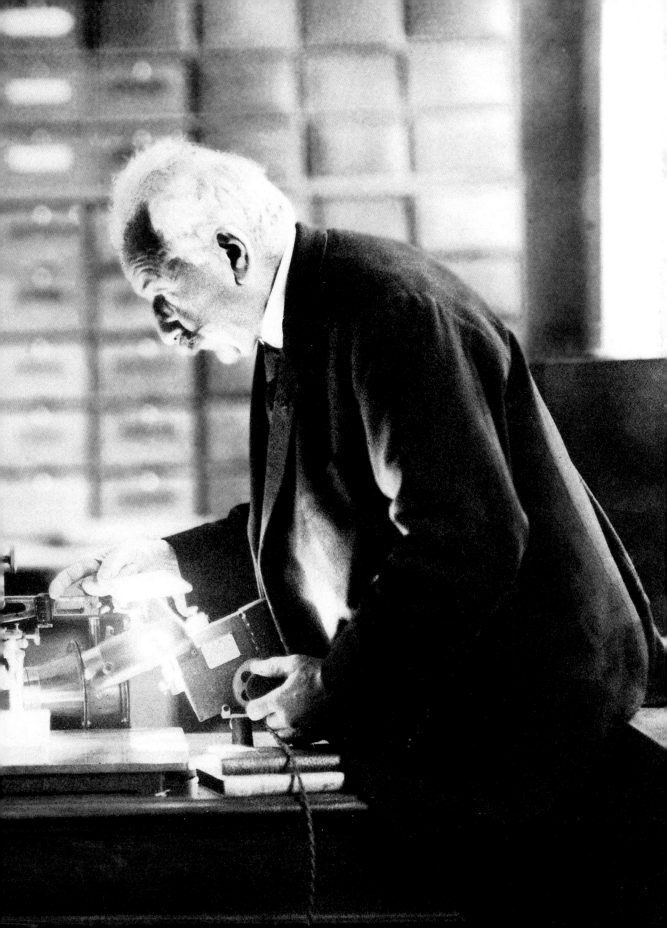

New Olympians

Strange to say, there were no gold medals at the 1896 Athens Olympic Games – the first modern Olympiad to be held under the supervision of the International Olympic Committee. Winners of the featured events – including athletics, wrestling, gymnastics, rowing, tennis and a swimming race only open to sailors – were awarded silver medals. The runners-up took bronze or copper.

This photograph shows the starters in the 100m final, which was won in 12 seconds by the American Thomas Burke – seen here demonstrating his then-unusual 'crouch' start in the second lane from the left. Burke won in a good, but not exceptional time; he had stormed his heat in 11.8 seconds. Still, this was impressive enough, considering Burke was better known as a 400m specialist. (He won that race, too.)

Other revivals of the ancient Greek athletics contests had been attempted in the years before 1896: most notably a series of Olympics held between 1859 and 1888, originally organized by the philanthropist-businessman Evangelos Zappas, who excavated and restored the Panathenaic Stadium first developed in the 4th century BC for the purpose. By 1896 Zappas had been dead for more than 30 years and the organizational mantle had passed to a Frenchman called Pierre de Coubertin.

Although small-scale and amateurish by today's standards, the Athens Games successfully revived the classical concept, launching a sequence of summer and (from 1924) winter Games broken only by the two world wars.

Automobiles

Since the 1830s inventors had been striving to produce a vehicle that could run under its own power without the need for iron rails to guide it. In the 1890s their dreams were finally realized when the first gasoline-driven cars began to appear on roads. The Germans Karl Friedrich Benz and Gottlieb Daimler had demonstrated gasoline-powered carriages in Europe in the 1880s. In the United States Charles and Frank Duryea drove their own creation – the Duryea Motor Wagon – around Springfield, Massachusetts in the autumn of 1893. (Motor cars made by the Duryea brothers claimed the honours of winning America's first road-race and being involved in its first traffic accident.)

This car is a French-built six-horsepower Panhard et Levassor, photographed in 1898, when it was the property of Charles Stewart Rolls, a Welsh baron's son and engineering enthusiast who collected early aircraft and cars – an interest that he would develop into a business, in partnership with Henry Royce, in the early 20th century. Their company, Rolls-Royce, was formed in 1906 and built a reputation for producing quiet, smooth and luxurious cars. The company survived Rolls's death in 1910, which occurred when he crashed a *Wright Flyer* at an airshow.

Although the cars of the 1890s were experimental and in many cases impractical, the age of the automobile had clearly begun. During the course of the next decade vehicles such as the Oldsmobile Curved Dash and Model T Ford would be mass-produced on factory assembly lines. The way that people travelled would never be the same again.

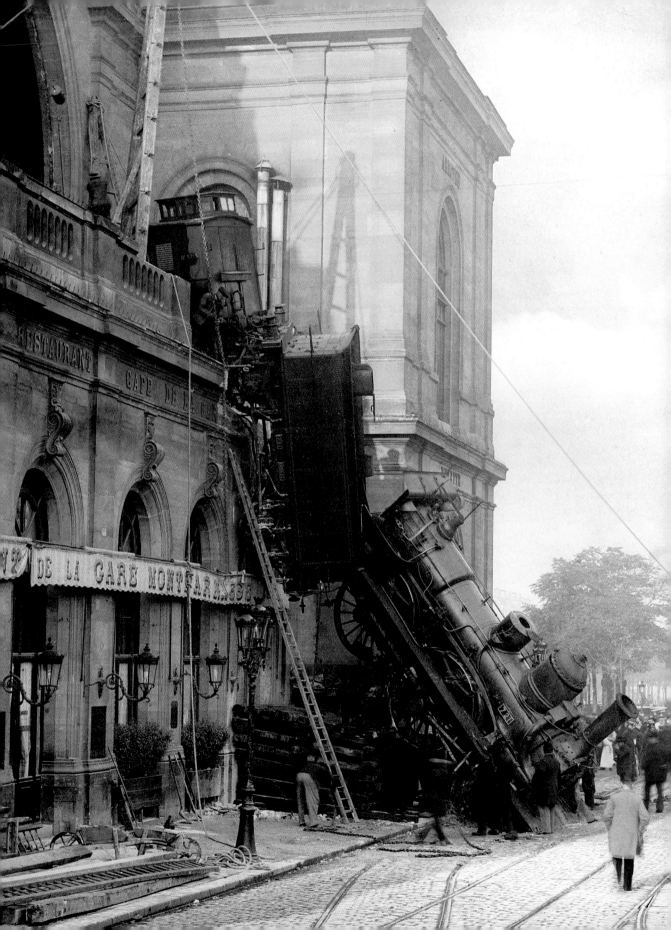

The Montparnasse Rail Crash

As transport evolved, so did the potential for spectacular and sometimes deadly accidents. One of the most famous – and photogenic – rail crashes in history took place at the Gare Montparnasse in Paris on 22 October 1895 when the Granville to Paris service, arriving towards the end of the afternoon, careered through its buffers, through the station wall and out into the Place de Rennes, coming to a rest with the engine's nose in the street below.

In the hours that followed, Paris's leading photographers flocked to capture this extraordinary scene. This image was published by the Léon & Lévy printing agency, which specialized in picture postcards; another famous view of the same scene was taken by the eccentric photographer and inventor Henri Roger (later known as Henri Roger-Viollet).

Remarkably, the derailment at Gare Montparnasse caused only one fatality: Marie-Augustine Aguillard, a newspaper vendor, who was killed by falling masonry when the train erupted through the station wall. But the locomotive era exacted a heavy toll in human lives, whether through engines leaving the tracks, crashing into one another or exploding due to faulty boilers. Notable calamities of the decade included the Münchenstein disaster of 1891, when a train plummeted from a bridge in Switzerland with the loss of over 70 lives, and the Atlantic City rail crash of 1896, in which 50 people were killed. Improving safety for passengers was, it seemed, an endless task.

'One can imagine the stupefaction of travellers... as the train approached the barrier at a crazy pace. Their stupefaction changed rapidly to terror...'

Le Petit Journal, 23 October 1895

'J'Accuse!...I accuse the first council of war of violating the law by condemning a defendant with unrevealed evidence...'

Emile Zola, L'Aurore, 13 January 1898

The Dreyfus Affair

The biggest scandal in France during the 1890s was not a train wreck but a court case. In 1894 the Jewish army captain Alfred Dreyfus was convicted of treasonably selling military intelligence to the Germans. The ensuing 'Dreyfus affair', lasting more than a decade, became a *cause célèbre*.

Dreyfus is photographed here on 5 January 1895, following his formal degradation. He had been publicly stripped of his rank and military insignia and had his sword broken; his penal sentence was life imprisonment on Devil's Island in French Guiana.

As he was degraded, Dreyfus protested his innocence, and he was right. It soon became clear that he was the victim of erroneous prosecution, faked evidence and virulent anti-Semitism. Attempts by pro-Dreyfus journalists to exonerate him focused first on proving the guilt of another officer, Ferdinand Walsin-Esterhazy. When a court martial in 1898 exonerated Esterhazy, the newspaper *L'Aurore* published 'J'Accuse', an open letter by the novelist Emile Zola addressed to the president of the Republic, denouncing the verdict and alleging a cover-up.

Zola was later convicted of libel (he fled to England to avoid jail), while the Dreyfus affair split France into opposing camps: those on the republican, anti-clerical left who supported Dreyfus (known as *Dreyfusards*) and Catholic nationalists who thought his defenders were anti-French. Dreyfus was court-martialled for a second time in 1899 and reconvicted, but seven years later, with *Dreyfusards* in control of government, a civilian court cleared his name. Dreyfus served with distinction during the First World War and died in 1935.

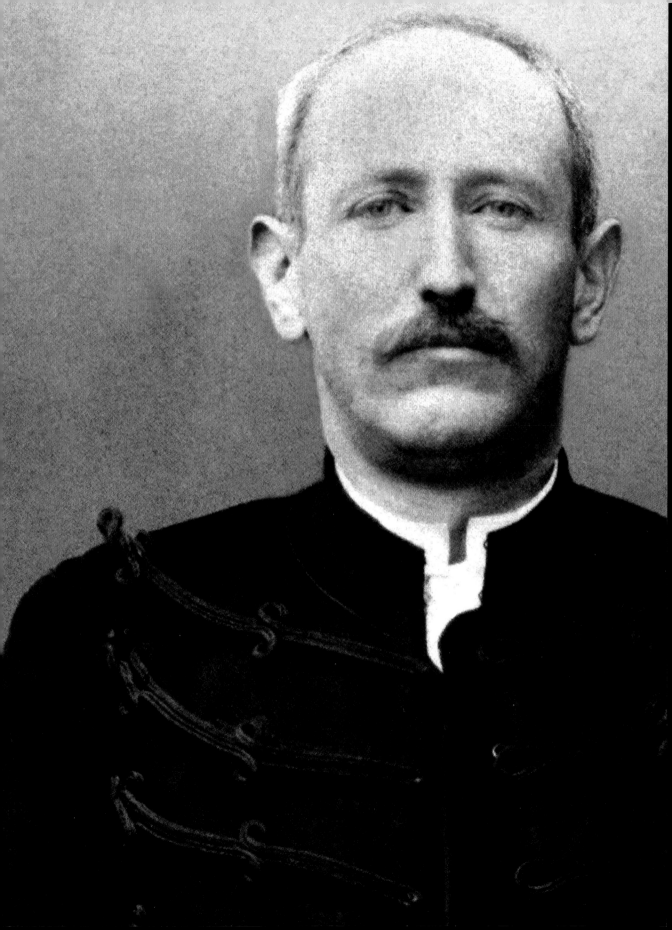

The Wreck of the *Maine*

While the Dreyfus affair divided France, across
the Atlantic a violent clash was brewing in Cuba.
It began, quite literally, with a bang, when on 15
February 1898 the armoured cruiser the USS *Maine*
was blown up in Havana harbour. A huge explosion
ripped through the front of the ship, leading to the
deaths of 260 sailors – nearly three-quarters of the
men on the ship.

No one has ever satisfactorily established how
the explosion occurred, but the consequences were
distressingly clear: it began an all-out war between
the United States and Spain.

The *Maine*, whose wreck is shown here, had
been in Havana as part of a long-running drive
to protect US citizens and interests in Cuba. An
insurgent war for independence from Spanish rule
had been under way for four years, and abuses against
prisoners herded into concentration camps were
widely reported in the American press.

War declarations between Spain and the USA
were exchanged on 22 and 25 April 1898, after which
American expeditionary forces were despatched to
Cuba and the Philippines – another Spanish colony.
Overwhelming military power ensured that the
USA prevailed in the 10-week war. By August Spain
had agreed armistice terms. Under the Treaty of
Paris, signed on 10 December 1899, Cuba was given
independence under US supervision, while the USA
also took control of the Philippines, Puerto Rico and
Guam. The US was now unarguably a global power,
while Spain, its once-mighty empire now greatly
reduced, was left to lick its wounds.

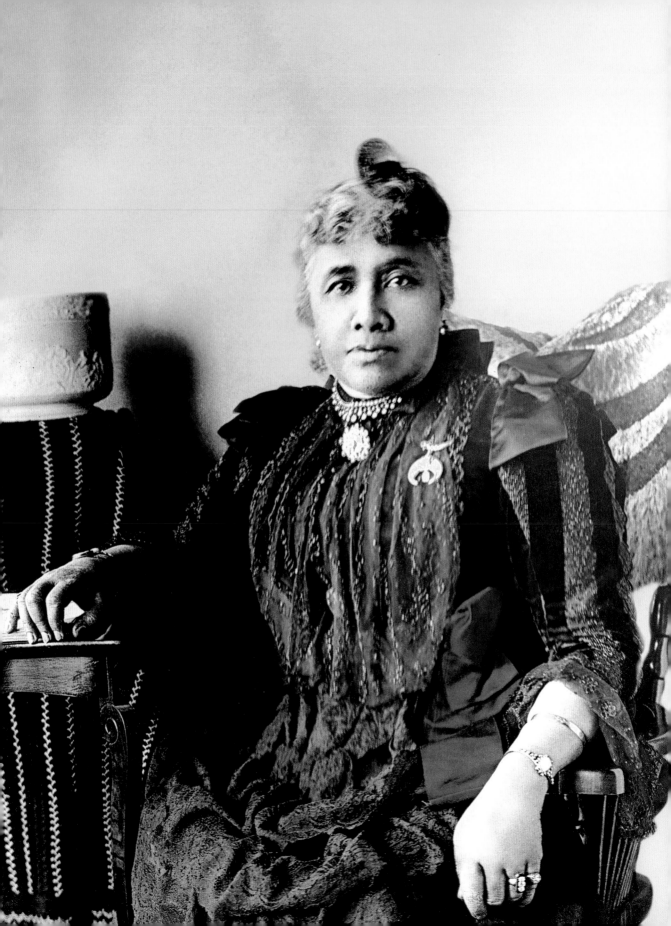

'Oh honest Americans… hear me
for my down-trodden people! Their
form of government is as dear to
them as yours is precious to you.'

Lili'uokalani, *Hawaii's Story
by Hawaii's Queen* (1898)

Hawaii's Last Queen

Lili'uokalani was a woman of firsts and lasts. She was
both the first woman ever to rule over the Hawaiian
Islands and the last monarch Hawaii had before it was
taken over by the United States in 1898.

Lili'uokalani was born Lydia Kamaka'eha in
1838, and she inherited her throne at the age of 52,
following the death of her brother King Kalākaua.
But her reign was troubled and short. She attempted
to stall a process by which Hawaii had developed
close and reciprocal economic arrangements with
the USA, which included the establishment of a
naval base at Pearl Harbor. This brought the queen
directly into conflict with a political group led by the
Hawaiian-born missionaries' son Sanford B. Dole,
who favoured a process by which close ties could be
gradually transformed into US annexation.

In 1893 Lili'uokalani was forced to abdicate and
placed under arrest in her own palace. Dole became
president of the Republic of Hawaii in 1894 and, four
years later, at the height of the Spanish-American
War, President William McKinley approved its
annexation, to become a US Territory and, from 1959,
the 50th State.

Lili'uokalani, photographed here by Barnett
M. Clinedinst, remained in Honolulu after her state
was taken from her, and attempted via a succession of
lawsuits to reclaim crown lands that had been taken
from her. She died at her home, Washington Place,
on 11 November 1917.

War in the East

Trouble was also brewing in the western Pacific, as Japan – confident, modernized and aggressive following the Meiji Restoration – clashed with the Chinese Qing dynasty over Korea.

Korea was in theory ruled by King Gojong of the Joseon dynasty and his wife, Queen Min. However, China regarded it as a vassal state, while Japan actively sought to force the kingdom to trade on favourable terms, opening up its plentiful coal and iron deposits to Japanese exploitation. This caused political turmoil within Korea as both sides sponsored factions in the Korean government and military, which clashed bloodily and often.

In March 1894 a pro-Japanese reformer called Kim Ok-Kyun was murdered in Shanghai; in June, as Sino-Japanese tensions escalated, Japan sent an 8,000-strong expeditionary force to Korea which captured King Gojong and installed a pro-Japanese government. The result was all-out war between China and Japan, declared on 1 August and ultimately decided by Japan's vastly superior naval power, modelled on that of the British navy.

This photograph shows Japanese sailors aboard the *Hiei* – a Welsh-built ironclad corvette, whose crew took her into battle in the Yellow Sea, near the mouth of the Yalu River, in September 1894, where she was badly but not fatally damaged.

By the spring of 1895 successive resounding Japanese victories forced the Chinese to seek peace terms. The Treaty of Shimonoseki was agreed on 17 April, ceding Taiwan and parts of Manchuria to Japan and recognizing Korea as independent of Chinese rule. Japanese victory hastened the end of the Qing dynasty, and had deadly consequences inside Korea.

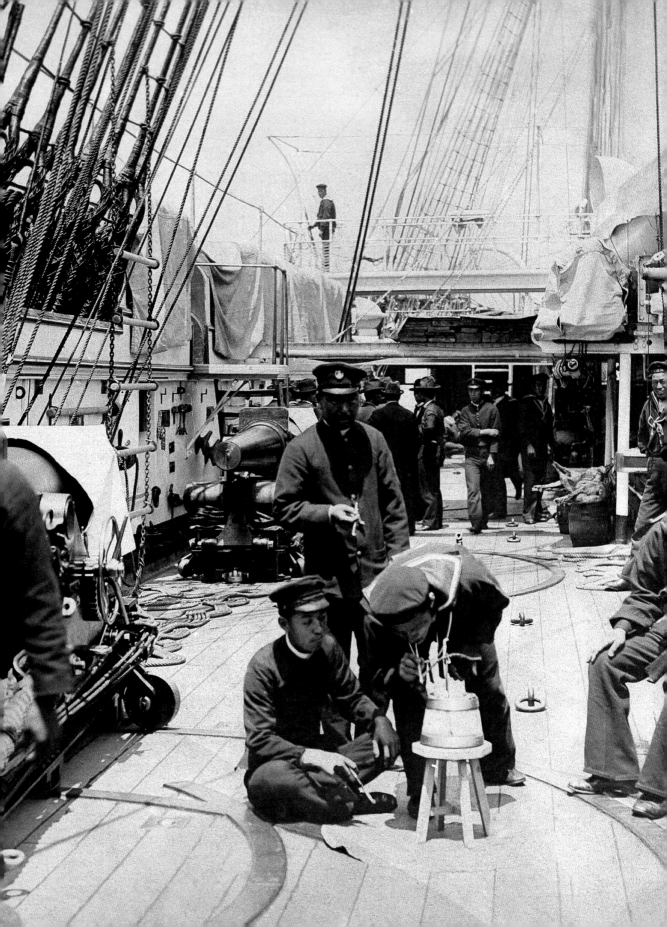

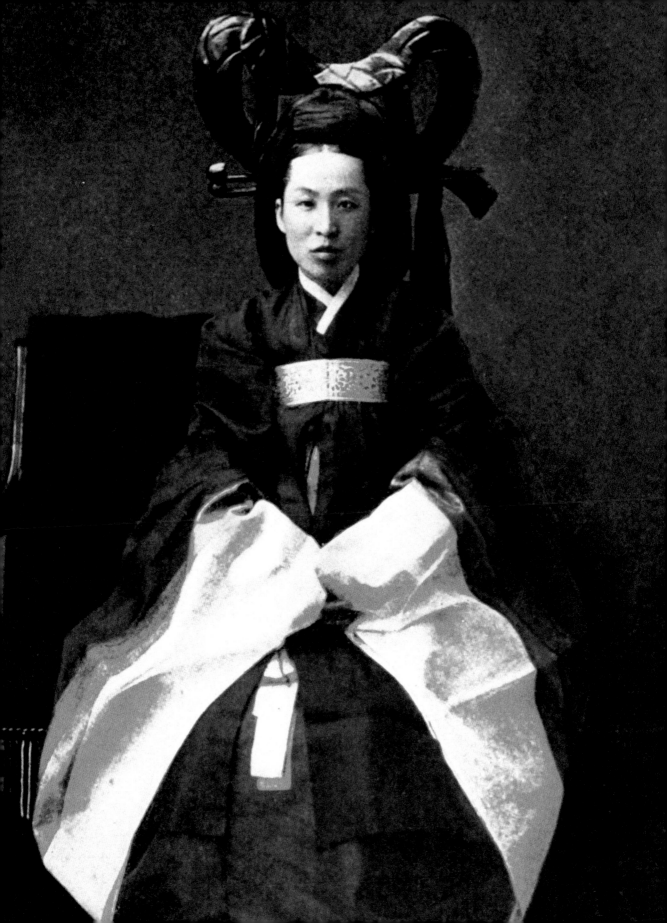

'Queen Min'

The outcome of the Sino-Japanese War of 1894–5 weighed heavily on Korea's King Gojong, who was now obliged to follow policies in line with Japanese interests. This particularly displeased his wife and consort, Queen Myeongseong, known according to her family's dynastic name as Queen Min.

Ever since her marriage to Gojong in 1866, when she was 14, Queen Min had ruffled feathers. She sought an active role in politics within the royal palace and showed little regard for the subservient position of women suggested by traditional Confucian values. She led her own political faction, advocating policies that included military reform, sweeping modernization and proactive cultural and economic contact with the West. After the Sino-Japanese War she argued for closer Korean links with Russia in order to stall Japanese dominance.

Images of Queen Min were rare. The identity of the woman in this photograph is hotly disputed: some say it depicts Queen Min; others that its subject is a lady's maid from the Korean court – as a security measure they were often dressed much like her.

One thing is certain, however. On 8 October 1895 Queen Min, aged 43, was cut to pieces with swords by Japanese assassins who had infiltrated the Gyeongbok Palace in Seoul. After her murder Min's body was burned, and Gojong fled to the Russian legation. On returning to his palace in 1896, he honoured Min's remains with a magnificent funeral.

Gojong declared his kingdom an empire in 1897, but 10 years later he was forced to abdicate by his Japanese overlords. In 1910 Korea was annexed and ruled from Tokyo until 1945.

'The extinction of our nation is
imminent… If we must perish,
why not fight to the death?'

Empress Dowager Cixi,
council meeting, 17 June 1900

The Boxer Rebellion

The aftermath of the Sino-Japanese War also brought
dramatic upheaval in China. Between 1898 and 1901
a popular uprising, stirred by widespread famine and
drought, and supported from 1900 by the Empress
Dowager Cixi, attacked foreigners and Chinese
Christians, whom its adherents blamed for leading
China into ruin.

The uprising was fomented by a secret society
called the Yihequan, or 'Righteous and Harmonious
Fists', whose 'shadow-boxing' gave the movement its
Western name of Boxer. Members of the Yihequan
practised a martial art system they believed made
them immune to Western weapons and bullets.
They were eventually disabused of the notion, but
not before they had killed numerous Christians and
missionaries in northeast China, burned churches
and foreigners' homes and laid Beijing under siege.

The siege, which began on 20 June 1900,
provoked a massive armed retaliation from an alliance
of eight nations with Chinese interests: Japan, Russia,
France, Britain, the United States, Austria-Hungary,
Germany and Italy. Nearly 20,000 coalition troops
marched on Beijing and relieved the siege. Cixi and
the Guangxu Emperor fled, and on 7 September 1901
Qing ministers agreed a humiliating peace which
required China to pay vast reparations to the Western
powers. Boxers and ministers who had backed their
uprising were executed and foreign troops were to be
stationed in and around Beijing.

This was a heavy blow to Chinese prestige and a
fatal one to the Qing dynasty, whose centuries of rule
in China would very soon be over.

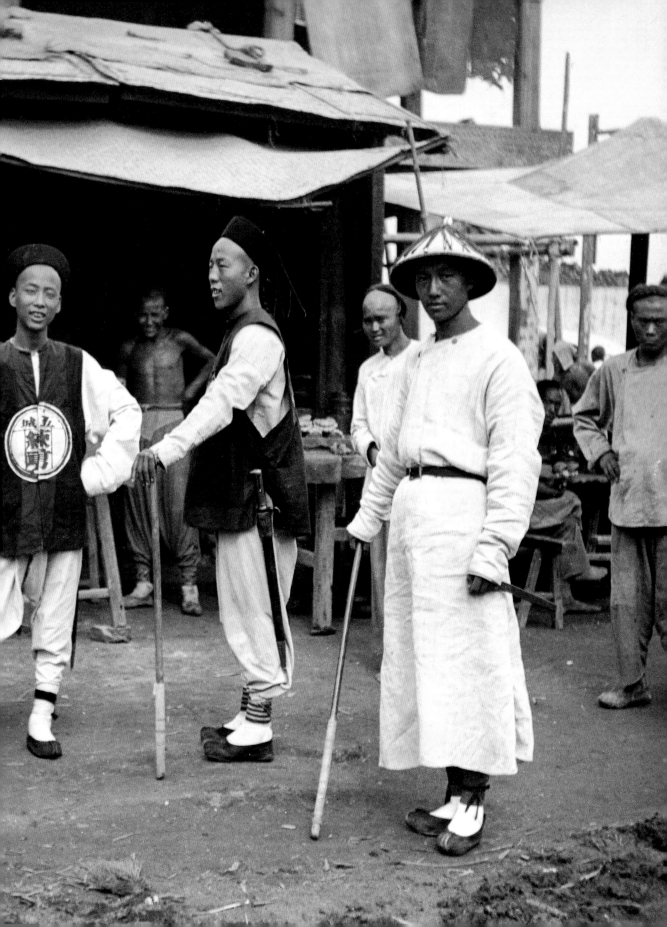

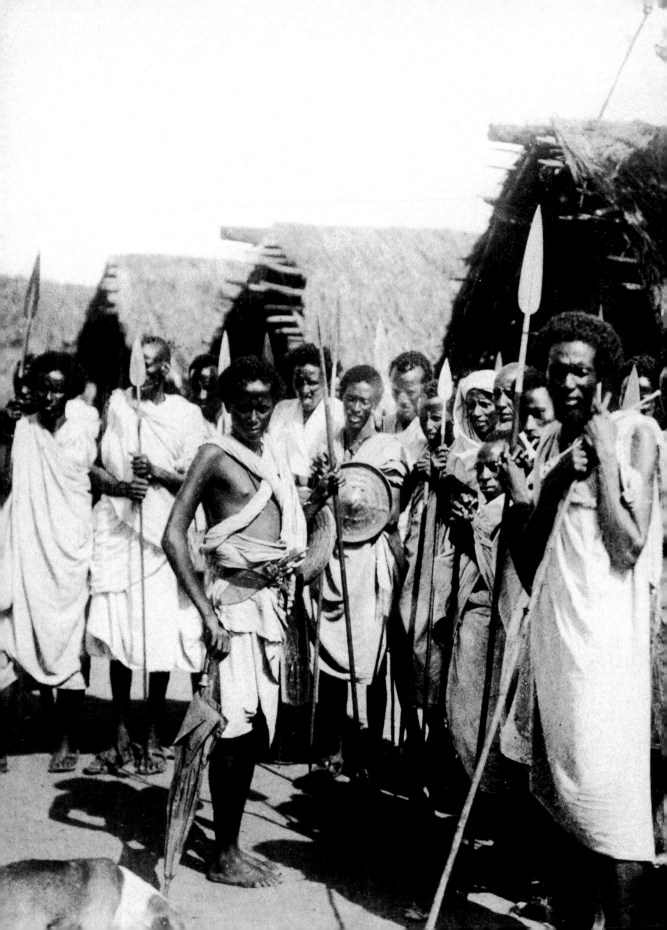

The Italo-Ethiopian War

Italian troops helped put down the Boxer Rebellion in China. However, attempts to impose Italy's will in Africa around the same time met with a radically different outcome.

The Empire of Ethiopia (known in Europe as Abyssinia) was one of the very few parts of Africa that had not been colonized by European powers during the 'Scramble for Africa' of the 1880s. But in 1895 its resilience was fully tested as the Italian government of Prime Minister Francesco Crispi attempted to turn Ethiopia into a protectorate.

The Italian claim rested on a deliberately ambiguous provision within an 1889 treaty between the two realms. It succeeded only in provoking the Ethiopian emperor Menelik II to denounce Crispi's colonial arrogance and tear up the treaty altogether. Italy, with the secret backing of Britain, marched off to war in 1895, fully expecting the usual outcome of a conflict between a technologically advanced Western state and non-European belligerents armed with far more basic weapons, such as those seen in this image, taken outside a hospital in the coastal town of Massaua.

Instead, the Italians were roundly beaten by a well-armed and highly motivated enemy. Disparate and traditionally hostile Ethiopian tribes rallied to Menelik's side, and at the decisive Battle of Adwa on 1 March 1896 a heavily outnumbered Italian army was routed by 100,000 men loyal to Menelik. Italy was forced into an climbdown so embarrassing that it abandoned its colonial ambitions for several decades. Crispi resigned. Menelik, meanwhile, was triumphant: he could claim the unique status of having driven an encroaching European power out of Africa and secured his empire's independence.

'Enemies have now come upon us to ruin our country and to change our religion… With the help of God, I will not deliver my country to them.'

Menelik II, proclamation to Ethiopians, September 1895

Lord Kitchener

One of Britain's chief strategic goals during the apogee of African colonialism was to keep the French out of Sudan – positioned between Ethiopia to the south and Egypt to the north, and ruled since 1885 by the followers of a messianic Islamic leader known as the Mahdi. The upheaval in Ethiopia provided a pretext for intervention in Sudan, so in 1898 Britain summoned military support from their client-state of Egypt and invaded. The job of conquest was entrusted to a tall, foul-tempered, Irish-born army officer by the name of Horatio Herbert Kitchener, pictured here.

Widely disliked but supremely talented in the field, Kitchener won a string of victories in Sudan, culminating on 2 September 1898 in the Battle of Omdurman. At this battle (later notable for the presence of a young British officer called Winston Churchill), British and Egyptian forces crushed an army commanded by Abdullah ibn Muhammad. The British described their opponents as Dervishes, but they called themselves the *Ansar*, and were devoted to the memory of the Mahdi.

After Omdurman Kitchener won another conclusive victory, at the battle of Umm Diwaykarat in late November 1899. As a result, Sudan became a joint Egyptian–British protectorate and Kitchener became an earl. During the Boer War of 1899–1902, he was second-in-command of British forces under Lord Roberts but became commander-in-chief in November 1900. He went on to serve as secretary for war during the First World War, when his heavily moustachioed image was used in army recruitment posters.

Kitchener died aboard HMS *Hampshire* in June 1916, when the cruiser hit a German mine west of Orkney and sank with the loss of 737 lives. His death was described by King George V as 'a great loss to the nation'.

'A rather bloated purplish face and glaring but somehow jellied eyes.'

The novelist and playwright J. B. Priestley remembers Lord Kitchener

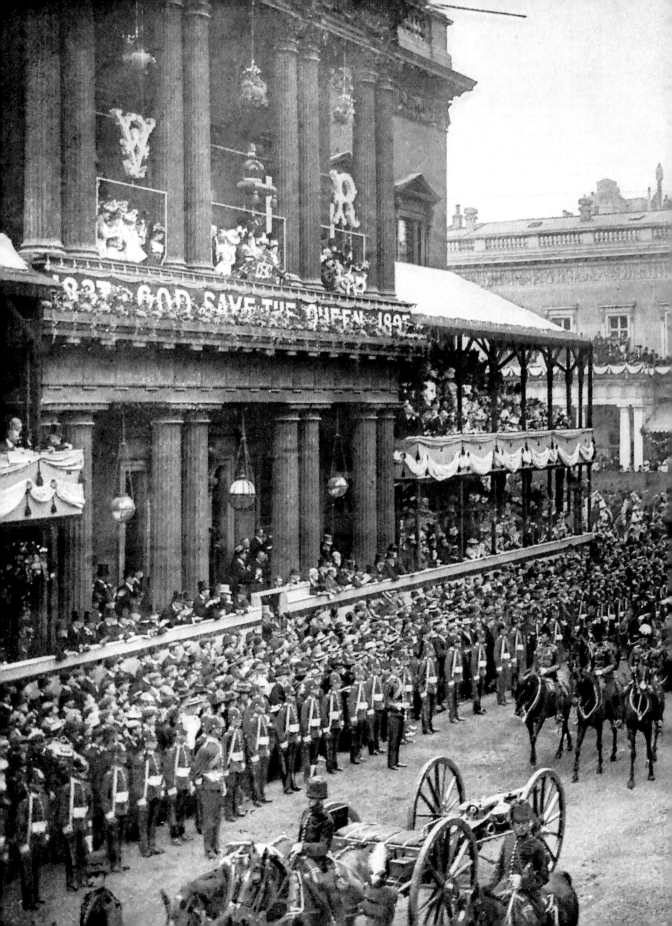

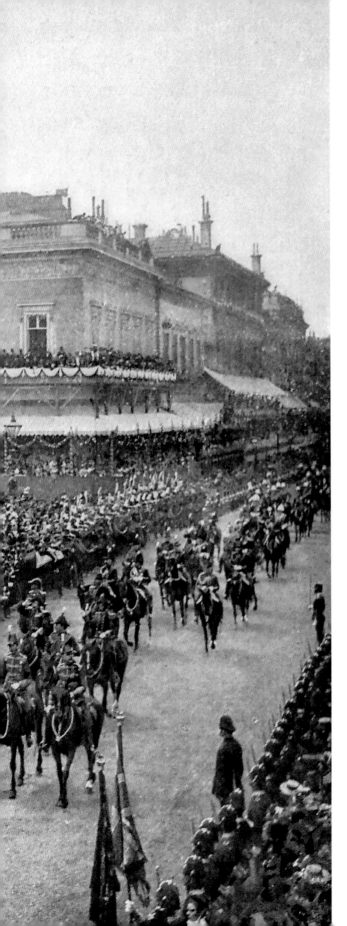

Diamond Jubilee

While Kitchener's armies charged across the sands of Sudan, a great imperial pageant was unfolding throughout the British Empire. On 22 June 1897 Queen Victoria marked her 60th year on the throne – then an unparalleled achievement in British history.

The Diamond Jubilee was celebrated in London with a vast parade (pictured here), at which governors and military delegations from Britain's numerous colonies, protectorates and dominions turned out to walk the streets in colourful obeisance to their seemingly eternal monarch. During a long day of parades, the queen, 78 years old and arthritic, remained for the most part in her carriage, dressed in her now-customary black to mourn the many family members she had outlived.

In honour of the occasion, Victoria had composed a short telegraph message, sent to the furthest reaches of the empire. It read: 'From my heart I thank my beloved people. May God bless them.' Her text may not have been expansive – but the fact that Victoria was able to communicate instantly with places as distant as India, Canada and Australia was a reminder of the many technological advances that had taken place between the beginning of her reign in the 1830s and its twilight years.

Britain, the British Empire and the world beyond had been profoundly changed by the inventions and upheavals of those six decades; the Queen's person was one of the very few constants. What now lay beyond, as the 20th century dawned and the Victorian age finally drew to a close, was anyone's guess.

Darkness at Dawn

1900s

'Death is nothing,
nor life either, for that matter.
To die, to sleep, to pass into nothingness,
what does it matter?
Everything is an illusion.'

Mata Hari's last words

Some of the world's most famous and beautiful women had stepped in front of 'Walery's' camera. But few of them left such an impression on the lens – or the world – as Mata Hari. Erotic dancer, circus performer, mistress and courtesan, her real name was Margaretha Geertruida Zelle. But her stage name spoke to the air of cultivated mystery and sexual availability that trailed her, made her a star of the Parisian stage and ultimately led her to a castle courtyard in Vincennes where twelve French infantrymen shot her with their rifles before their officer blew her brains out with a revolver.

Born in Leeuwarden in the Netherlands on 7 August 1876, Zelle was 29 or 30 years old when she appeared at 'Walery's' studio on the rue de Londres in Paris in 1906. Walery, like Mata Hari, was a pseudonym: the byline of Stanislaw Julian Ignacy, Count Ostroróg, who inherited his title, name and talent for portraiture from his Lithuanian father, and had photographed everyone from French prostitues to the Shah of Persia.

All of them had a story. Few were quite as dramatic as Mata Hari's. By this early point in her life she had already lost her mother, started and abandoned a career as a teacher, married a syphilitic, abusive and drunk Dutch soldier called Rudolf Macleod, borne him two children, lost one of them and left him. She was now embarking upon an exciting new phase of her life, performing titillating dance routines to Parisian *sophistiqués* in the achingly fashionable Orientalist style.

She claimed to be a Hindu princess steeped in the art of dance from childhood. In truth she was an upmarket stripper, but her act was a good one. Her faux-Indonesian name (meaning 'sun' or literally 'eye of the day') together with her penchant for performing in bejewelled headgear, nude bodystockings and little else, garnered the attention of numerous wealthy men. Early in her career these included Emile Etienne Guimet, in whose museum she first performed; later she came to the attention of politicians and army officers across Europe, some of whom admired her performances, others of whom saw her potential as a *femme fatale* who might be employed in seducing and spying on the powerful.

The Walery photograph here shows Mata Hari at her most glamorous and seductive. She had just 11 years left to live. After the excitement and glamour of the *Belle Epoque* waned towards the end of the decade, so did Mata Hari's star. In time she, like so

1900	1901	1902	1903	1904
[Jul] Assassination of King Umberto I of Italy by the anarchist Gaetano Bresci	[Jan] Death of Queen Victoria. She is succeeded by her son Albert Edward, who takes the name Edward VII	[May] Second Boer War ends with agreement of the Treaty of Vereeniging	[Nov] Panama declares independence from Colombia, backed by the US government who wish to see a canal built across the isthmus	[Feb] War breaks out between Russia and Japan
[Nov] Horatio Herbert Kitchener becomes commander-in-chief of British forces in South Africa and deploys scorched-earth tactics in the ongoing Second Boer War	[Jan] Commonwealth of Australia established by the federation of six British colonies	[May] Cuba achieves independence from US rule	[Dec] Wright Brothers successfully test the *Wright Flyer* biplane at Kitty Hawk, North Carolina	[Jul] Trans-Siberian railway connects Moscow with Vladivostok in eastern Russia
	[Sep] US President William McKinley fatally shot while visiting the Pan-American Exposition in Buffalo, NY		[Dec] Marie S. Curie awarded the Nobel Prize in Physics, jointly with her husband Pierre Curie and Henri Becquerel	[Aug] Battle of Waterberg prompts a genocide of the Herero and Nama people in German South West Africa

many of her generation, would eventually be lost to the guns of the First World War: after a string of compromising affairs with military officers of various nationalities, Mata Hari was arrested in Paris in 1917 and accused of being a traitor who had used her sexual wiles to spy on the French for Germany. She was convicted on thin evidence, and executed on 15 October.

The strange story of Mata Hari – exotic, dangerous and destined for disaster – captured much of the mood of the 1900s. The old world was giving way, but to what, no one quite knew. Old empires were being tested by rebellion at home and insurrection in their colonies. In Britain, Queen Victoria was dead, succeeded by her son, whose large extended family included an increasingly erratic and belligerent Kaiser of Germany. In Russia, the tsars still ruled, but war with Japan and revolution in the streets were testing monarchy's grip. In the United States, an unprecedented wave of migration poured into a country shaken by banditry, earthquakes and the assassination of a third president.

From the islands of the Pacific to the Horn of Africa, violence flared and armies collided, deploying ever-deadlier means of corralling and intimidating civilian populations. In the fields of science and technology, unimaginable new feats were being achieved: human flight, railroads and canals that bisected entire continents, and the fundamental reordering of Newtonian physics. But advancing technology often brought new menaces, either by provoking wars or providing appallingly efficient new ways to fight them. Human beings were racing towards the future, but the closer one looked at what was coming, the less appealing it seemed.

1905

[Jan] Bloody Sunday massacre in St Petersburg in which hundreds of protestors are killed and wounded. Starts a year of constitutional reform and a limited revolution

[Mar] Albert Einstein publishes the first of his four *annus mirabilis* papers, which include the theory of special relativity

[Mar] Mata Hari debuts her exotic dance routine at the Musée Guimet in Paris

1906

[Mar] Death of Susan B. Anthony, suffrage campaigner and Red Cross founder

[Apr] San Francisco earthquake destroys much of the Bay Area of northern California

[Dec] Premiere of *The Story of the Kelly Gang* in Melbourne, Australia – the first feature film in cinema history

1907

[Jul] Japan–Korea Treaty places Korea firmly under Japanese supervision

[Aug] International alliance known as the Triple Entente created, linking Britain, France and Russia

1908

[Jan] Robert Baden-Powell publishes *Scouting for Boys*, sets up the international Boy Scout movement

[Jul] Young Turk Revolution restores the 1876 constitution and electoral politics in the Ottoman Empire

[Sep] First Model T Ford produced in Detroit, Michigan

1909

[Jan] Panama achieves official independence from Colombia

[Oct] Japanese statesman and four-time prime minister Ito Hirobumi assassinated in Manchuria

[Dec] Death of Leopold II of Belgium

Funeral Train

Queen Victoria died in her bed at Osborne House on the Isle of Wight, an hour or so after dusk on 22 January 1901. She was surrounded by dogs and family, and expired after muttering 'Bertie', the name of her son and successor, Albert Edward. The prince was duly crowned Edward VII, ushering in the 'Edwardian' era – the British label for what was elsewhere considered the tail end of the *Belle Epoque*.

Once dead, Victoria had to be buried. It was 64 years since Britain had interred a monarch, but Victoria had left clear instructions for a military ceremony with the unusual colour scheme of white and gold. She was to be laid to rest beside her mother and her husband, Prince Albert, on the Frogmore Estate in Windsor, around 145km from the Isle of Wight.

The journey was an appropriately Victorian affair, in which the grand and old commingled with the brave and newfangled. The coffin of oak and lead was taken by horse-drawn carriage, royal yacht and locomotive to her resting place, guarded all the way by ostentatious deputations of the mighty British military and cheered along its route by crowds of people, most of whom had known no other king or queen. This photograph shows Victoria's funeral carriage awaiting the coffin.

Large numbers of foreign nobles attended the funeral at St George's Chapel in Windsor on 2 February, including Kaiser Wilhelm II of Germany and Archduke Franz Ferdinand of Austria-Hungary. Little did they know that within the decade many of them would be back there again.

'Most priceless of all will be the memory of the events of Saturday left in the minds of the little children… taken in the early morning to gaze upon a black London…'

The Times of London, editorial,
4 February 1901

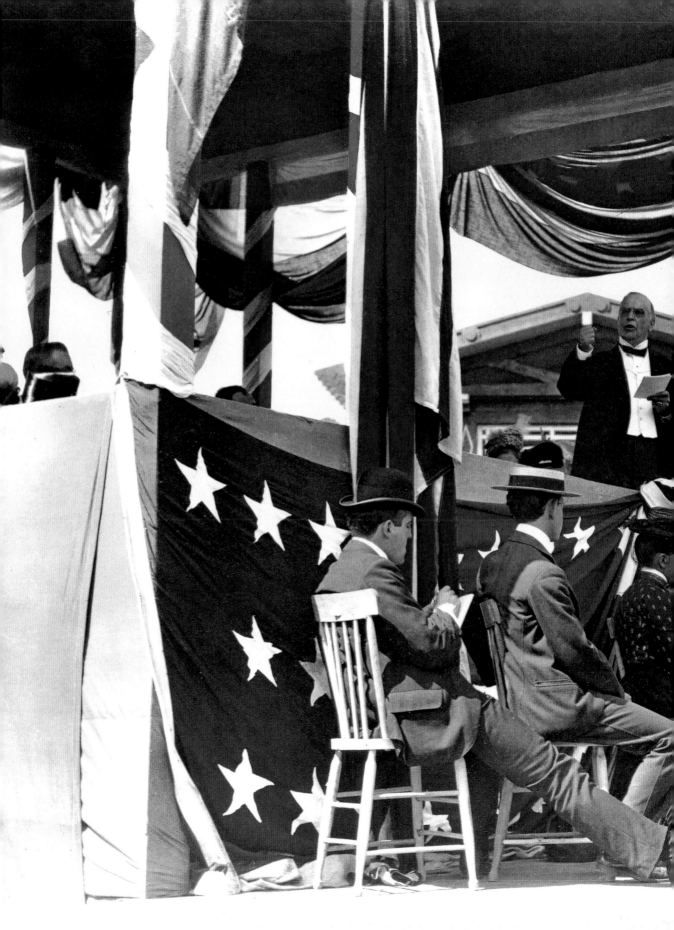

William McKinley

Britain was not the only nation to bury a head of state
in 1901. On 6 September William McKinley, 25th
president of the United States, was attending the Pan-
American Exposition in Buffalo, New York when,
just hours after this image was taken (by renowned
Washington photographer Frances Benjamin
Johnston), he was twice shot in the stomach at close
range. The assassin was a Polish-American anarchist
called Leon Czolgosz, who had been obsessed with
the idea of killing the president since he had heard
about the murder of the Italian king Umberto I, also
by gunshot, the previous year.

After waiting in line with well-wishers, Czolgosz
fired at McKinley at close range with a revolver
concealed beneath a handkerchief. The president
was rushed to hospital but died eight days later from
blood poisoning. He was succeeded by Vice President
Theodore Roosevelt, and Czolgosz went to the
electric chair. The execution at Auburn Correctional
Facility, New York on 29 October was re-enacted
and filmed as a silent movie by Thomas Edison's film
studio and rushed out to theatres within a week.

McKinley's Republican presidency had been
quietly transformative: economic growth was
accompanied by successful resolution of the Spanish–
American War and the annexation of Hawaii. He
was the last US president to have served in the Civil
War, and the third (after Abraham Lincoln and James
Garfield) to have been shot dead in 36 years. His
tenure marked the start of a new phase in American
politics, now called the Progressive Era.

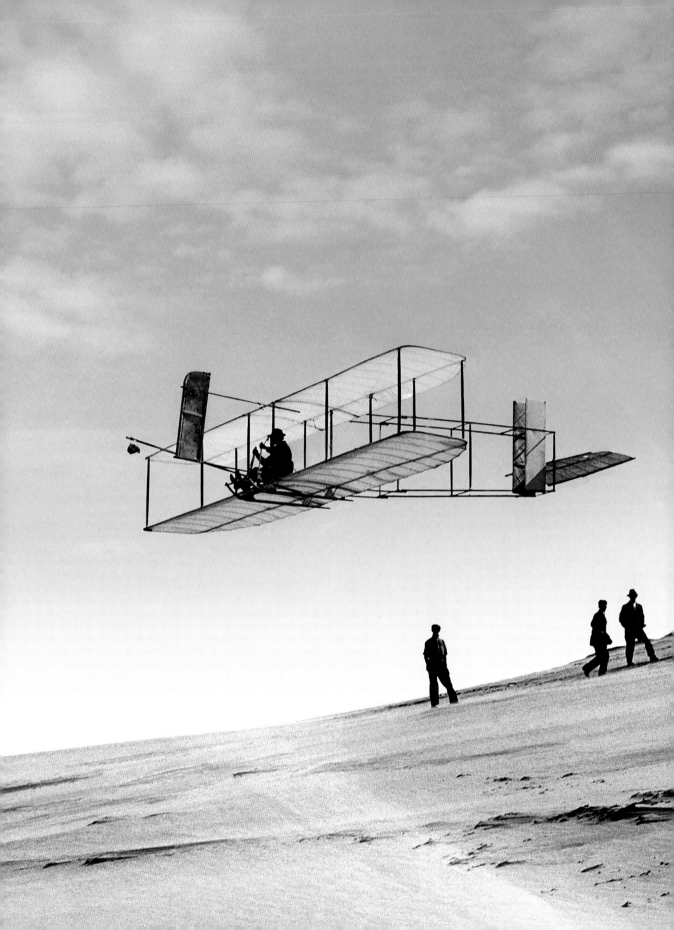

The Wright Brothers

Kill Devil Hills, near Kitty Hawk, was where man first flew. Or, to be more precise, these breezy dunes in North Carolina were where American brothers Orville and Wilbur Wright made 700-odd glider flights (such as the one pictured here) before completing, on 17 December 1903, the first successful demonstration of a powered, heavier-than-air machine.

They called it the *Wright Flyer*: a sprucewood biplane in which the pilot lay facing forward. It was skeletal, hard to control and broke beyond repair when it was caught by a strong gust of breeze after four short flights. Still, it flew.

After their momentous first flight the Wrights worked to improve their flying machines; by 1908 they had a flyer that could stay aloft for over an hour. Public demonstrations in Europe and America made the Wrights famous. They opened a pilot school at Huffman Prairie in Ohio and sold factory-produced versions of the *Flyer* to customers including the US army.

By the end of the decade, however, others were catching up, and the Wrights were bogged down in legal wars to secure patents and protect their designs. In 1912 Wilbur Wright died young, from typhoid; Orville sold the family company but remained involved in aeronautics until his own death in 1948, by which time aircraft had crossed oceans, broken the sound barrier and dropped atomic bombs that killed tens of thousands of people at a stroke.

'For some years I have been afflicted with the belief that flight is possible to man… I feel that it will soon cost me an increased amount of money if not my life.'

Wilbur Wright, letter to businessman Octave Chanute, May 1900

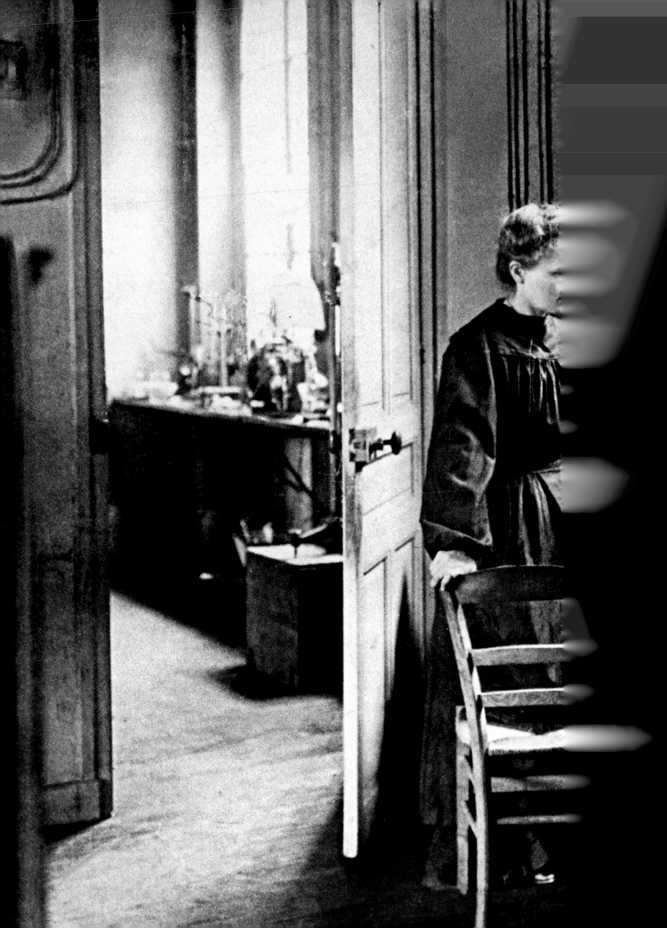

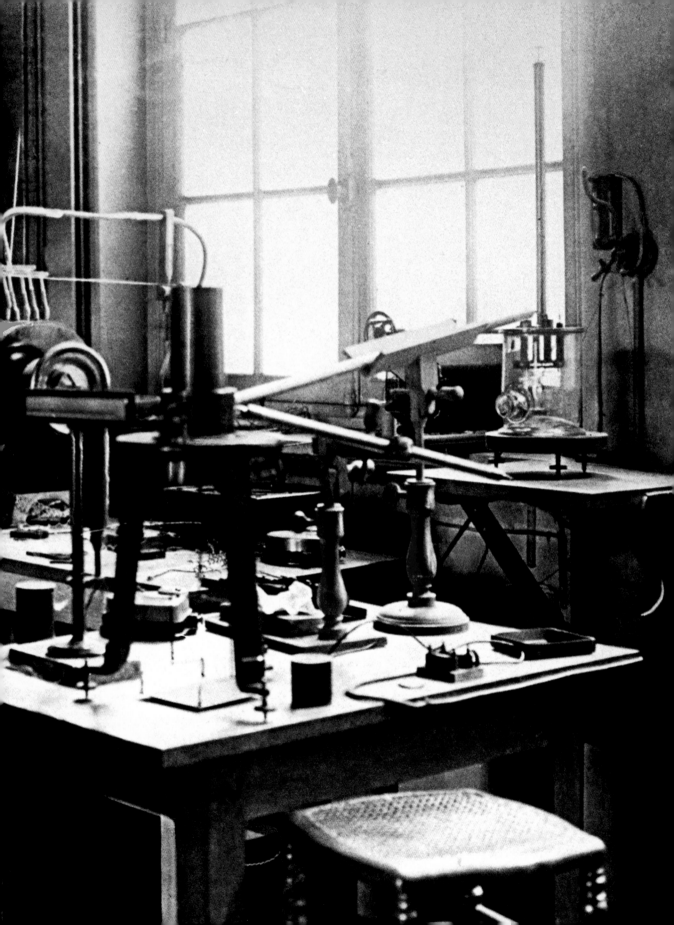

Marie S. Curie

Marie Salomea Skłodowska was educated in Warsaw's so-called 'Flying University', but she was no aviator. Rather, she was the most brilliant physical scientist of her age: a double-Nobel Prize-winning researcher into radioactivity, who was better known by her married name of Marie Curie.

Born in 1867, Marie Curie left Poland at the age of 24, and although she clung to her Polish identity all her life, she conducted most of her research in Paris alongside her husband Pierre Curie, until his death in a road accident in 1906. The couple shared a laboratory and discovered two new atoms with peculiar qualities: polonium (named for Poland) and radium (named for the 'rays' it appeared to emit). This research earned them the Nobel Prize (in physics) in 1903, received jointly with her doctoral supervisor, Henri Becquerel.

After Pierre's death, Marie inherited his professorial seat at the University of Paris and opened the Radium Institute, a superlative laboratory (pictured here pp. 192–3) where her work on atomic energy and radioactivity continued: she succeeded in isolating radium in 1910 and won a second Nobel Prize (in chemistry) in 1911. During the First World War she worked with the Red Cross deploying radiology in the form of mobile X-ray units for wounded soldiers.

Before the war Curie was regularly scorned and sidelined in France for being a woman, a foreigner and a suspected Jew. After the war, however, she was lauded, and although she disdained financial reward there was no escaping the fame her huge scientific contribution had earned her. She was a titan of science – in an age that did not lack for them.

'When you sit with a nice girl for two hours you think it's only a minute, but when you sit on a hot stove for a minute you think it's two hours. That's relativity.'

Attributed to Einstein
by the New York Times, 1929

Albert Einstein

Two years after Marie Curie was awarded her first Nobel Prize, a 26-year-old German patent office examiner working in Bern, Switzerland was busy revolutionizing the way that scientists understood the building blocks of the universe.

Albert Einstein – photographed here in middle age, still sporting the black moustache and unkempt hair he favoured from his youth – was an obscure candidate to overturn three centuries of Newtonian thought about time, space, energy and mass. But that is precisely what he did with a series of articles published in the journal Annalen der Physik in 1905, written partly on the basis of 'thought experiments' – raw theoretical calculations performed without the luxuries of laboratory equipment.

One of the essays Einstein produced in 1905, 'On the Electrodynamics of Moving Bodies', proposed his most famous theory: special relativity. This reconciled longstanding but conflicting ideas about the relationship between space and time, and made sense of the strange behaviour of objects moving close to the speed of light. Special relativity contained an equation describing the relationship between mass and energy which became among the most readily quoted pieces of scientific shorthand of all time: $E=mc^2$.

Ten years later, in 1915, Einstein proposed a second theory: 'general relativity', which extended his arguments to describe gravity as an expression of spacetime. He won the Nobel Prize (in physics) in 1922 and emigrated to the United States when Europe sank into war in the 1930s. Einstein was still reconfiguring conceptions of the universe when he died in 1955.

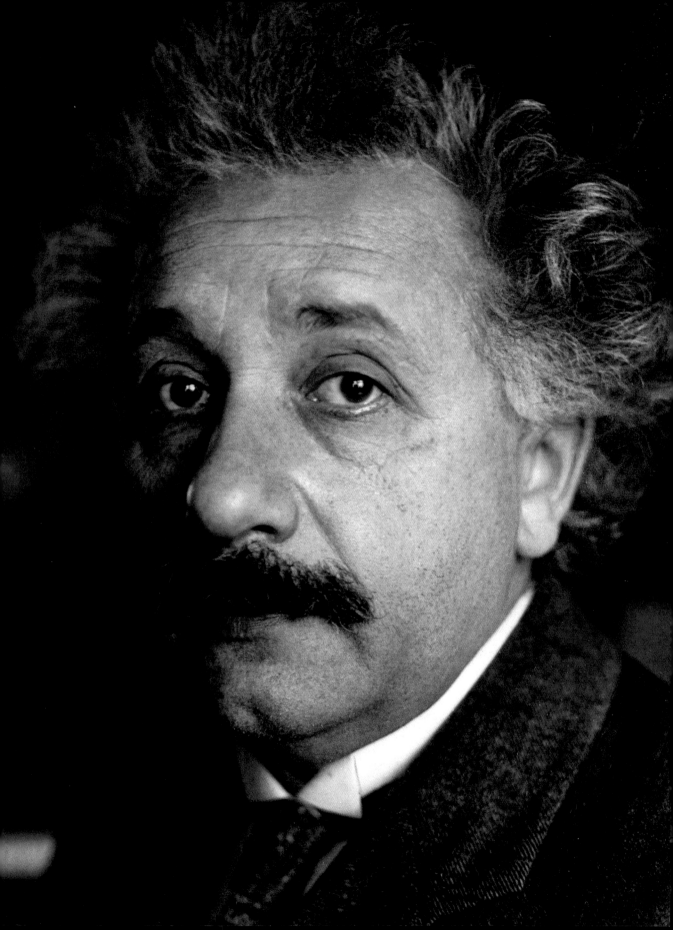

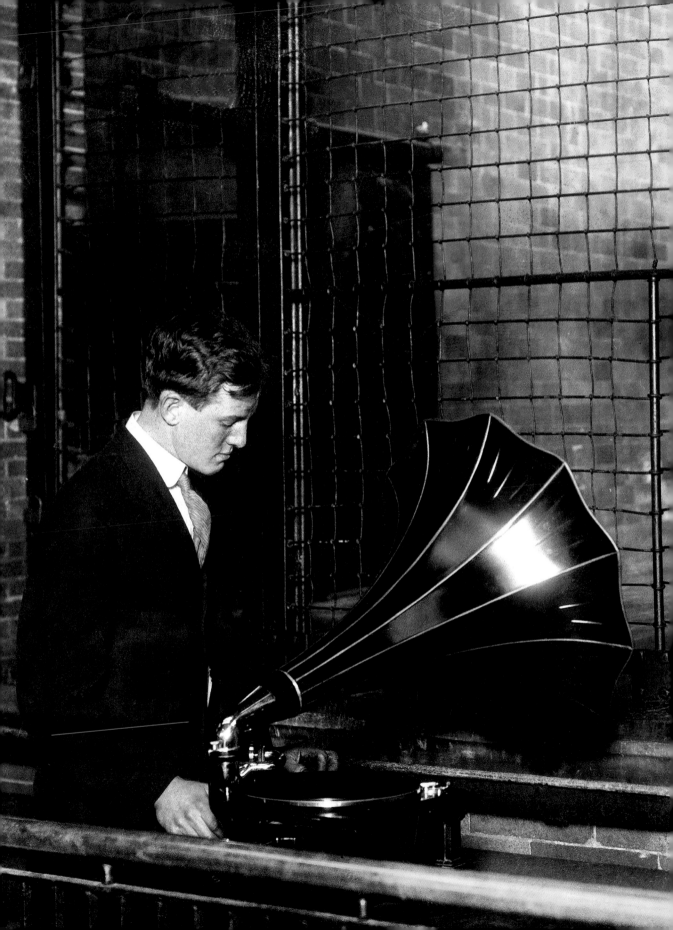

The Gramophone

As scientific geniuses and ambitious inventors stretched the bounds of human knowledge, so the technology available to ordinary people also advanced. In 1877 Thomas Edison had invented the phonograph; a quarter of a century later the Gramophone (originally a brand name rather than a generic term) was in production.

Created by the German-born businessman Emile Berliner (whose other interests included designing helicopter prototypes) the device played flat, pressed discs, decorated from 1909 with a famous label featuring a dog called Nipper listening to his master's voice. This unusual photograph of a lion performing a similar task was taken by the German photojournalist Philipp Kester, who also pictured the Gramophone being played to a camel, giraffe, elephant, brown bear, llama and stag.

The Gramophone was far from the only strange new device to excite consumers in the 1900s. Families could consider buying a petrol-powered car made by Benz or Daimler, a kitchen toaster from General Electric, a razor from the Gillette Safety Razor Company, Corn Flakes from William Kellogg's Battle Creek Toasted Corn Flake Company or a Kodak Brownie camera.

Vacuum cleaners, lie detectors, windscreen wipers, air-conditioning units, Bakelite and cellophane were all invented around this time, and in the years that followed each would slowly come to be part of the fabric of everyday life, particularly in the United States – one reason why many people across the world were so keen to move there.

'I don't like to be close to them [i.e. Gramophones] when they're talking through their teeth. They never really represent the human voice...'

Mark Twain, a Gramophone sceptic,
The London Chronicle, 1907

Ellis Island

The year 1907 set a record in American history that would not be broken for nearly 90 years: 1,285,349 immigrants arrived in the United States, more than in the two centuries between the establishment of the Jamestown settlement and the War of 1812.

The federal government had taken over immigration policy from the individual states in 1890, and a processing centre for new migrants was built on Ellis Island in New York Harbor. This burned down, but on 17 December 1900 a new, fireproof replacement opened and on its first day 2,251 people passed through its doors. The influx did not abate for many years, with large numbers of people arriving from southern and eastern Europe, fleeing poverty, war, scarcity or persecution (particularly Jewish pogroms in the Russian Empire).

This photograph shows children undergoing routine medical examination at Ellis Island. Inspecting for disease – including respiratory problems, bacterial ailments like typhus, fungal infections and mental impairment – was a central part of the process of entry. Those found to be ill were either treated at the on-site hospital or sent home.

Ellis Island continued to be America's frontier post until its closure in 1954, but it operated against a backdrop of growing anti-immigrant sentiment. In 1921 and 1924 the federal government passed laws curtailing migrant numbers – and so the lid was slammed back on the great American melting pot.

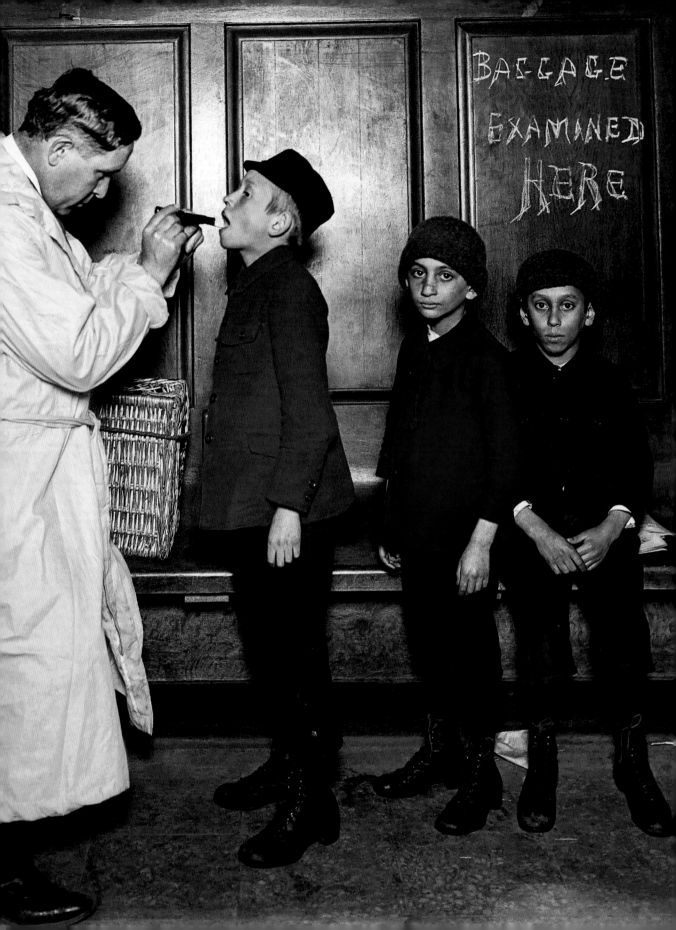

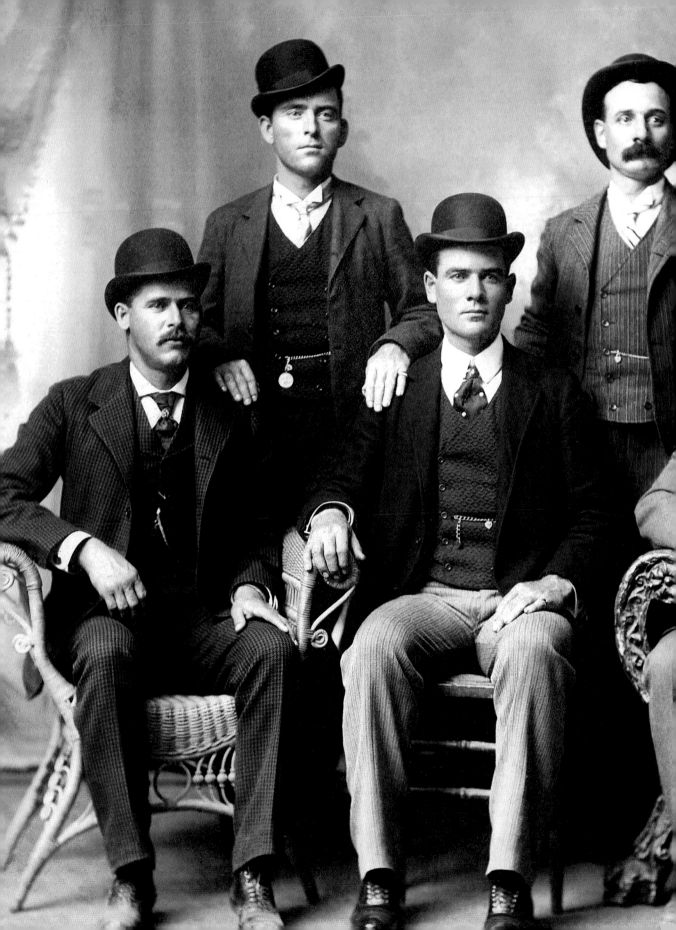

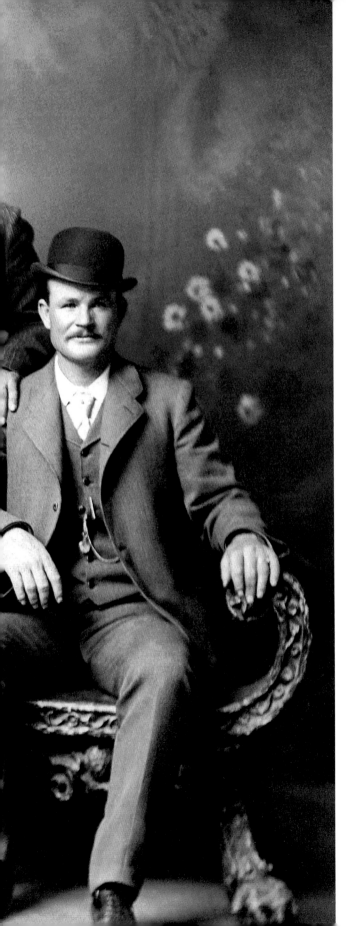

Butch Cassidy

The outlaw Butch Cassidy (seated, far right) was himself the son of immigrants: his parents left Britain to settle in Utah as Mormon ranchers in the mid-19th century.

Cassidy was the eldest of their 13 children. Born Robert LeRoy Parker in 1866, he owed his famous pseudonym 'Butch' to a brief stint working in a butcher's shop. Cassidy became notorious after robbing a bank in Colorado in 1889 and subsequently assembling a band of Wyoming-based, livestock-rustling horseback bandits known variously as the Wild Bunch and the Hole-in-the-Wall Gang.

The gang members pictured here, around the year 1900, are (standing, left to right) Bill Carver and Kid Curry and (seated) Harry Longabaugh (aka 'The Sundance Kid'), Ben Kilpatrick and Cassidy himself.

By the time this photograph was taken, these men and their associates were wanted in several states for robbing banks and trains, evading (and often taunting) sheriffs' posses and agents of the famous Pinkerton Detective Agency.

Not long after they were photographed, Cassidy and Longabaugh used their loot to buy into a ranch in Patagonia, apparently meaning to retire. Soon enough, though, they were robbing again. Then, between 1908 and 1911, they simply disappeared.

Reports later circulated that they had been killed in a shootout with Bolivian cavalry, but one of Cassidy's sisters claimed that he had returned to the USA and lived incognito until his natural death in 1937. Whatever his true fate, his life – and legend – has become an origin story of the American West.

'Death and destruction have
been the fate of San Francisco
...the city is a mass of
smouldering ruins.'

San Francisco Call-Chronicle-Examiner
joint edition, 19 April 1906

The San Francisco Earthquake

The San Andreas Fault runs for 1,200km below the state of California, marking the turbulent join between two of the earth's tectonic plates. It has produced some spectacular earthquakes, but few so terrible as that which destroyed much of San Francisco, the surrounding Bay Area and settlements all along a 476km stretch of the fault when the ground began to shake at 5.13am on 18 April 1906.

The earthquake lasted 42 seconds, and its magnitude – roughly 7.9 on the Richter Scale – together with the location of its epicentre almost directly underneath a large and densely populated city meant it was deadly. Three thousand people lost their lives and nearly a quarter of a million were left homeless as some 28,000 buildings were destroyed.

Most of the damage was done not by the initial tectonic shift, but by three days of fires, pictured here, that broke out when gas mains ruptured and caught light. San Francisco's fire chief, Dennis T. Sullivan, had been crushed to death by a collapsing building on 18 April, and in his absence inept attempts to create fireblocks by dynamiting houses worsened the blazes. The US army and navy were called in and the mayor declared martial law, ordering that looters should be shot on sight.

Although its short-term effects were grave, the earthquake presented an opportunity for sweeping civic regeneration. Slums were cleared, cable cars swiftly repaired and public areas remodelled. Around the Bay, new settlements sprang up to accommodate those who left the city following the disaster. Within a decade, San Francisco was the powerhouse of northern California once again.

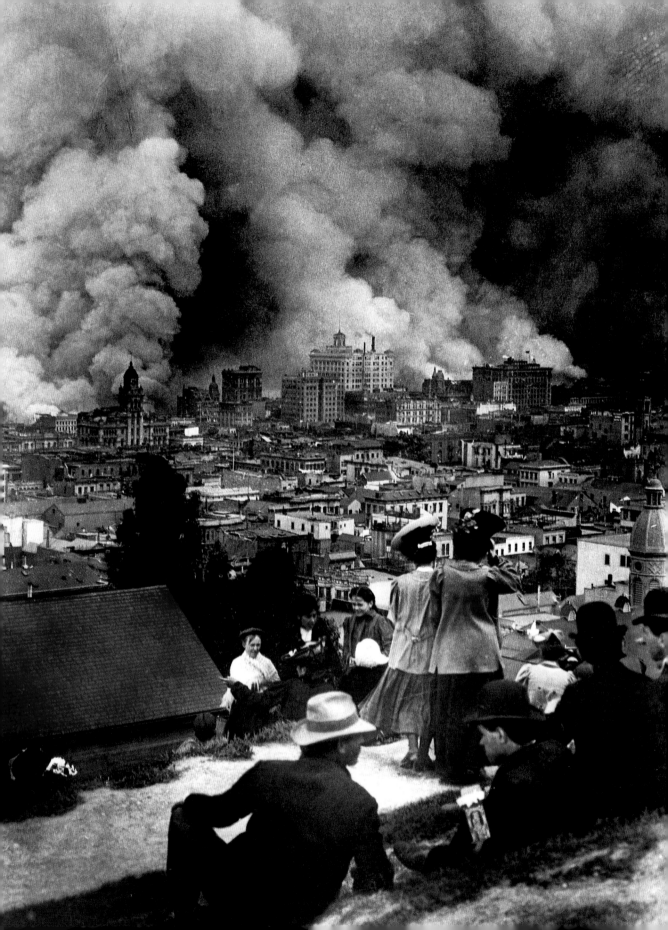

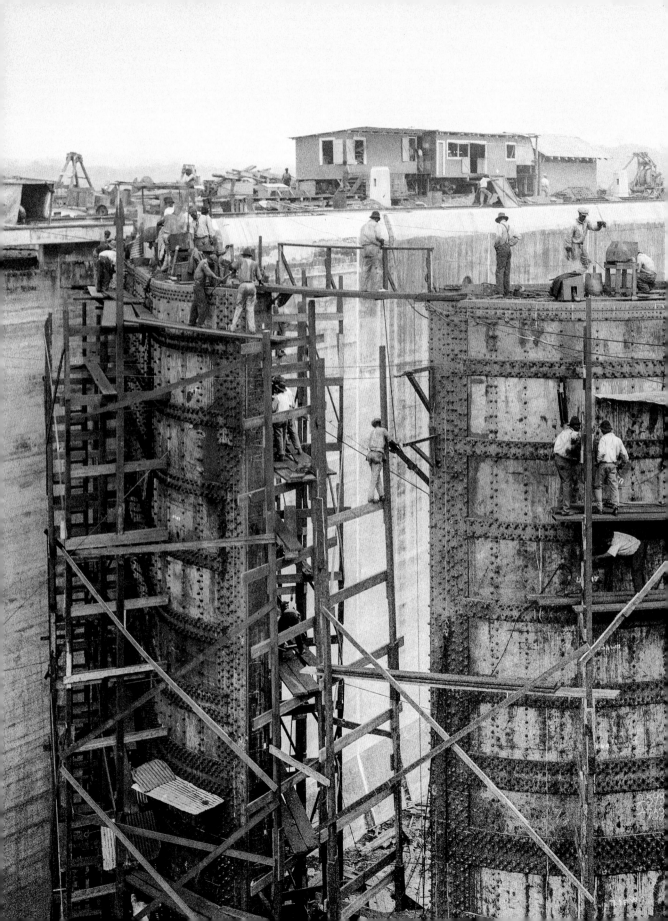

The Panama Canal

Rebuilding San Francisco was a big job, but not the most challenging task that faced US engineers in the 1900s. Four thousand miles southeast, a wonder of the modern world was being forged: the Panama Canal, a waterway cutting a path through the isthmus connecting North and South America, linking the Caribbean Sea with the Pacific Ocean and reducing shipping times from the east to west coast of the United States by weeks.

The possibility of a Panama Canal had been considered since the days of the *conquistadors*, and workers first broke ground in the 1880s under the direction of Ferdinand de Lesseps, who had masterminded the Suez Canal. But humid, malarial conditions and the vast cost of building a canal that had to rise more than 25m above sea level had defeated the French.

Taking over the project demanded the diabolical cunning of US President Theodore Roosevelt. Since Panama was part of Colombia, in 1903 he encouraged, funded and armed Panamanian rebels in a successful bid to secede; then he leased the canal land from the new government and extracted the right for the USA to build the waterway and manage it indefinitely.

This photograph shows construction on one of the canal's three massive locks. From 1907 work was overseen by General George Washington Goethals of the US army, who brought the extraordinary project to completion two years ahead of schedule. The biggest engineering task then undertaken by the USA opened for business on 15 August 1914: a bold symbol of a world superpower in the making.

'No single great material work which remains to be undertaken on this continent is as of such consequence to the American people.'

Theodore Roosevelt,
speech to Congress, 1902

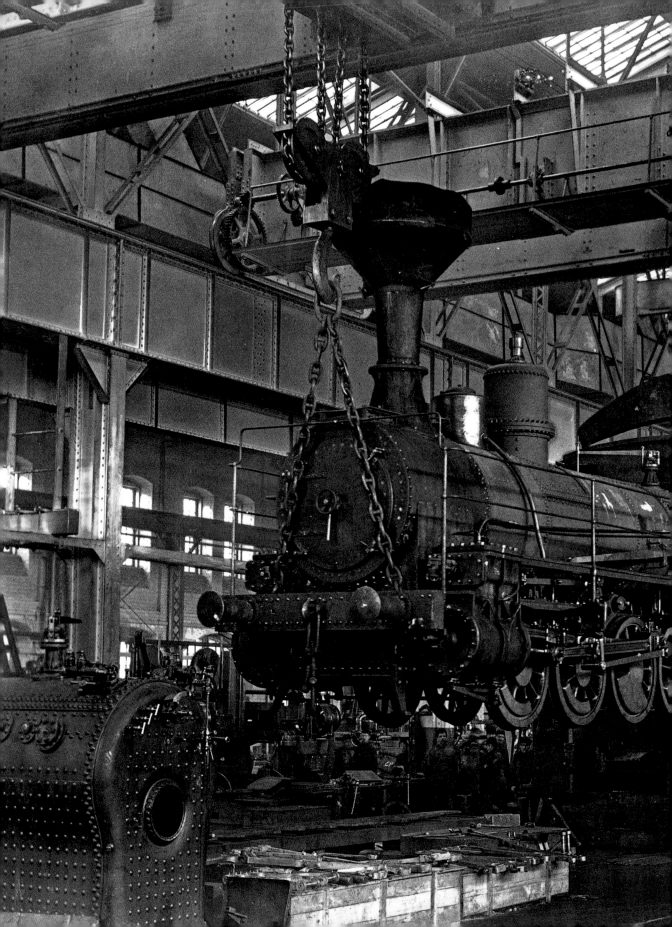

The Trans-Siberian Railway

While the United States dug the Panama Canal, on the other side of the Pacific Ocean a similarly ambitious marvel of modern infrastructure was nearing completion. The Trans-Siberian Railway – a single track linking Moscow with Vladivostok on the eastern fringes of the Russian Empire, was completed on 21 July 1904.

Construction of the Far Eastern section of the project was inaugurated by the tsarevitch (the future Nicholas II) in 1890, but the real brains behind the railway belonged to the Georgian-born Count Sergei Witte, Russian finance minister for the duration of the project (who would become prime minister the year after its completion). The railway covered over 9,000km, broken only at Lake Baikal where ferries took passengers and freight across the water. A journey that once took six weeks could by 1914 be completed in less than ten days.

The Trans-Siberian was the catalyst for change within Russian society. Some four million peasants from the west migrated to Siberia, travelling in cramped third-class carriages to seek work in newly accessible lands.

The massive increase in rail capacity at the turn of the century was also a spur to Russian industry, as a boom in track-laying between 1860 and 1917 increased the total network from 1,600km to 72,000km. Factories such as the Sormovo Iron Works in Nizhny Novgorod, pictured here, began producing thousands of steam engines. These were not merely for leisure and trade. The year after the Trans-Siberian Railway opened, engines chugged east from Moscow pulling men and matériel for war.

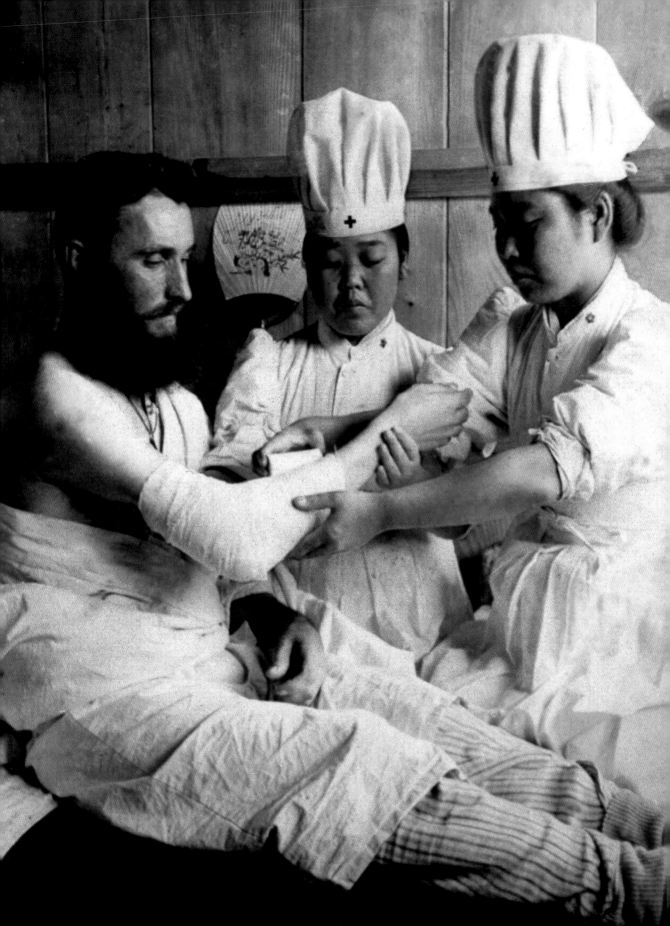

The Russo-Japanese War

In 1905 Russian railways helped provoke a war. While laying the Trans-Siberian, the tsarist government also built tracks in Manchuria in northeastern China, where they had a military outpost in Port Arthur (modern Lüshunkou District): a warm-water harbour in the Yellow Sea leased from China's Qing dynasty. From 1897 a Russian fleet was anchored at Port Arthur, and after the Boxer Rebellion of 1899–1901 tens of thousands of Russian soldiers were stationed in Manchuria.

This build-up was viewed with concern in Japan, whose leaders saw Russia's eastern ambitions as an explicit threat to their own regional influence. Nicholas II had been encouraged to dominate Manchuria (and the neighbouring Korean peninsula) by Kaiser Wilhelm II of Germany, who bombarded him with letters arguing that only Russia could prevent Japanese dominance in the Pacific – a phenomenon he described in racist terms as the 'Yellow Peril'.

On 8 February 1904 war broke out. The Japanese torpedoed battleships in Port Arthur, beginning an 11-month siege which ended with the port's surrender. Fighting on land was vicious: at the Battle of Mukden (20 February–10 March 1905) combined casualties totalled more than 150,000. This photograph shows Japanese nurses of the International Red Cross helping a wounded Russian soldier; with one million members in 1905, the Japanese branch of the Red Cross was the largest in the world.

Japan won every significant battle of the war, and her people were therefore disappointed by an even-handed peace brokered by US President Theodore Roosevelt and signed in Portsmouth, New Hampshire, on 8 September 1905. In Russia, meanwhile, the dismal war effort allowed a serious rebellion to erupt in 1905, following which the beleaguered Tsar Nicholas II bowed to the need for major reforms, multi-party politics and a new constitution.

'The Russians were not so much outgeneralled as they were outfought, and they were outfought because they were lukewarm…'

The New York Sun, 'Why the Russians Lost in the Recent War', August 1906

The Boer War

While Indian independence was a contentious issue within the British Empire, it had not yet erupted into open conflict on the scale of that which took place in southern Africa at the turn of the century.

The Boer War was fought between a British imperial army from the Cape Colony and Afrikaans-speaking farmers ('Boers') of the Transvaal and Orange Free State, both self-governing republics. Their complex dispute boiled down to Britain's desire to rule over a federated South Africa and stake a claim to its valuable gold and diamond mines, and the Boers' wish to resist.

War broke out on 11 October 1899, and after a year of heavy fighting the much larger British imperial army secured several important victories, seizing the Boer capitals of Bloemfontein and Pretoria and relieving a long siege at Mafeking (the defence of which was organized by Robert Baden-Powell, founder of the Boy Scouts and Girl Guides).

From the autumn of 1900, however, the war took a vicious turn. The new British commander-in-chief, Lord Kitchener, dealt with Boer guerrilla warfare by deploying scorched-earth tactics against Boer farms and imprisoning their inhabitants (as well as black labourers) in concentration camps like the one pictured here.

The camps were incompetently and cruelly run. By the time the war was settled with Boer capitulation on 31 May 1902, around 28,000 Boers and 20,000 black Africans had died in them, either through starvation or disease. These wasteful deaths foreshadowed a grim new type of warfare that would characterize the dawning century.

'The tragedy is over. The curtain falls over the Boers as British subjects, and the plucky little Republics are no more.'

Boer General Jan Smuts,
letter to his wife, 1 June 1902

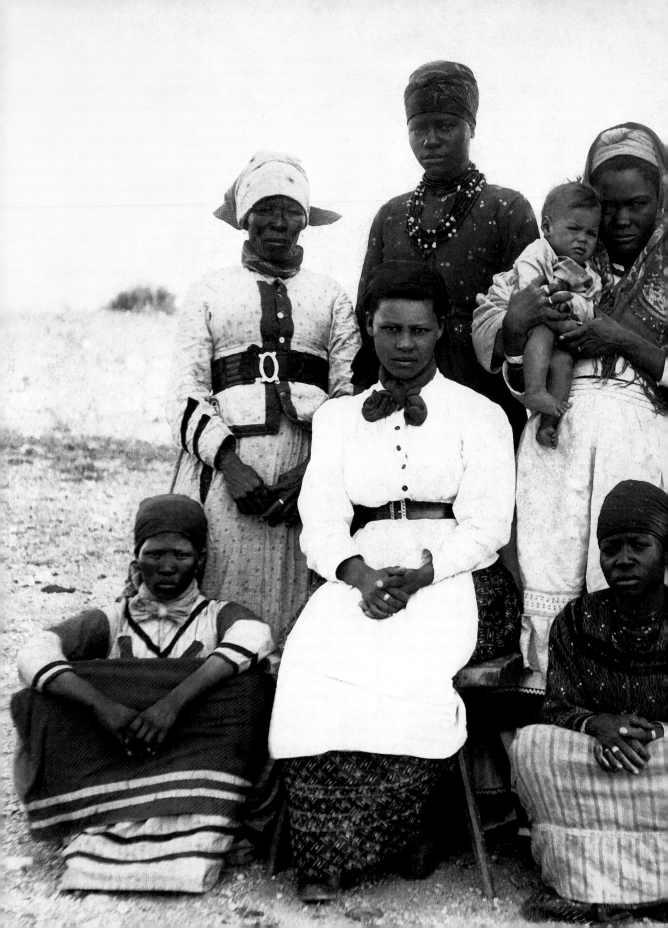

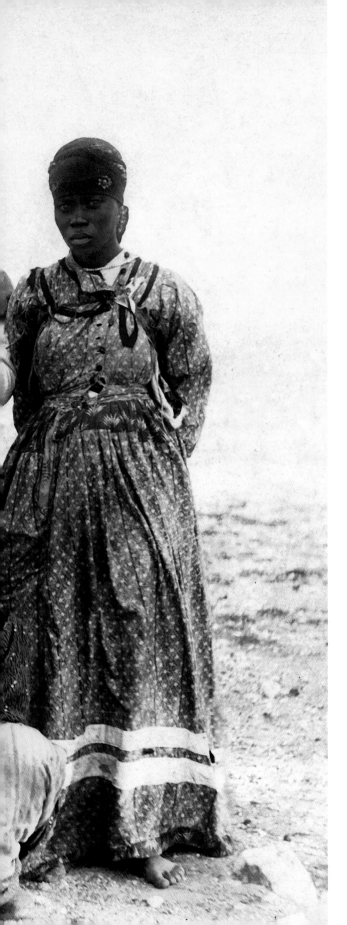

The Herero Wars

While the British herded Boers and black Africans into concentration camps, further atrocities were taking place to the north, where German South West Africa (now Namibia) spiralled into rebellion and atrocious colonial reprisals.

German imperial rule in southwest Africa had caused regular clashes with the native Herero and Nama tribes ever since the Germans colonized the area during the 'Scramble for Africa' in the 1880s. In 1903 the Herero chief Samuel Maharero led a rebellion of warriors armed with *kirie*, or wooden clubs, but was defeated the following year at the Battle of Waterberg by a small German force equipped with modern rifles and machine guns. Following his battlefield triumph the German military leader Lieutenant-General Lothar von Trotha deliberately drove the vanquished Herero into Omaheke Desert, shooting those they encountered and ensuring that many of the rest died, agonizingly, of thirst.

Those who survived were imprisoned in concentration camps, the most notorious of which was Shark Island: a slave-labour facility riddled with disease where inmates were starved, beaten and worked to death. By the end of the ordeal around 65,000 Herero were dead. This sanitized image of Herero women in Western clothes was originally published in the German weekly news magazine *Berliner Illustrirte Zeitung*. It tells very little of the horrifying real story of a people whose collective fate was recognized by Germany as a genocide in 2004.

'Let us die fighting rather than die as a result of maltreatment, imprisonment and some other calamity...'

Samuel Maherero, letter to Nama chief Hendrik Witbooi, 1904

The Philippine–American War

In the former Spanish colony of the Philippines another long-running revolt was under way. This one was fought between the United States military, who had occupied the Philippine islands following the 1898 Treaty of Paris, which ended the Spanish–American War, and Filipinos who insisted that the First Philippine Republic was the legitimate, independent government of the archipelago.

Tensions between the two groups were already high in early 1899 when, on 4 February, shots were fired by an American private in the village of Santa Mesa, near Manila. The result was the two-day Battle of Manila in which several thousand Filipinos died for the cost of several hundred American lives. It marked the beginning of a war fought (as with the Cuban, Boer and Herero conflicts) between the well-armed conventional forces of an occupying nation and ill-equipped but tenacious guerrilla soldiers.

Both sides were accused of atrocities. American troops killed, raped and cruelly abused civilians, looted houses and interned large numbers of Filipinos (such as those photographed here) in squalid concentration camps. The insurgents tortured captives with methods including crucifixion, live burial and death by exposure to biting ants.

This grotesque violence did not entirely end with the agreement of peace on 1 July 1902, by which US President William McKinley granted limited self-government to the Philippines. Determined veteran insurgents proclaimed a 'Tagalog Republic' (Tagalog referred to ethnic Filipinos who spoke the language of the same name) and fought on until 1906; the last outposts of rebellion were crushed only in 1913.

'If the honest American patriots could understand the sad truth of this declaration, we are sure they would, without the least delay, stop this unspeakable horror.'

Emilio Aguinaldo, president of the
First Philippine Republic, 1900

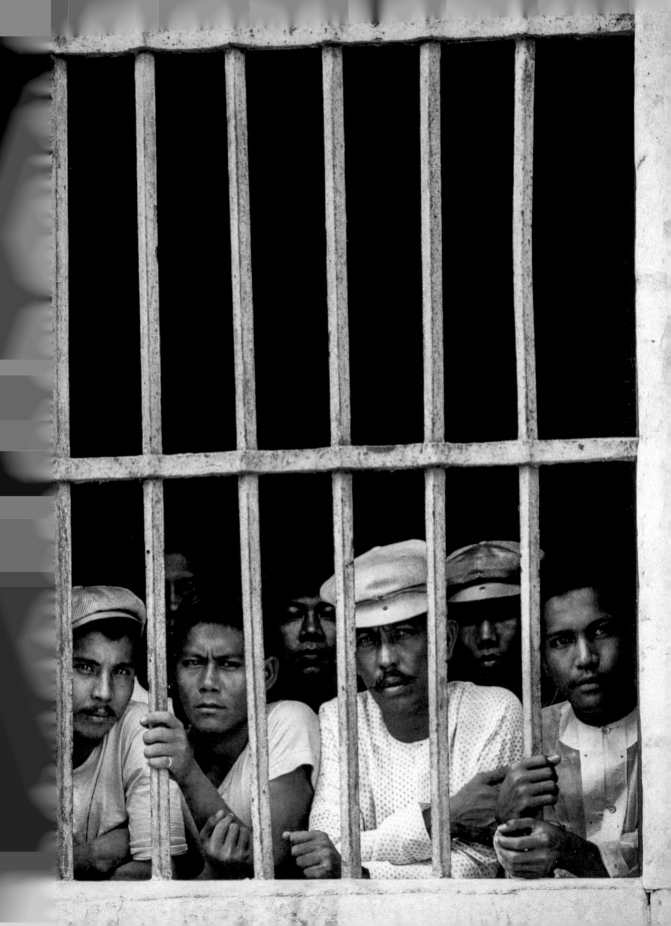

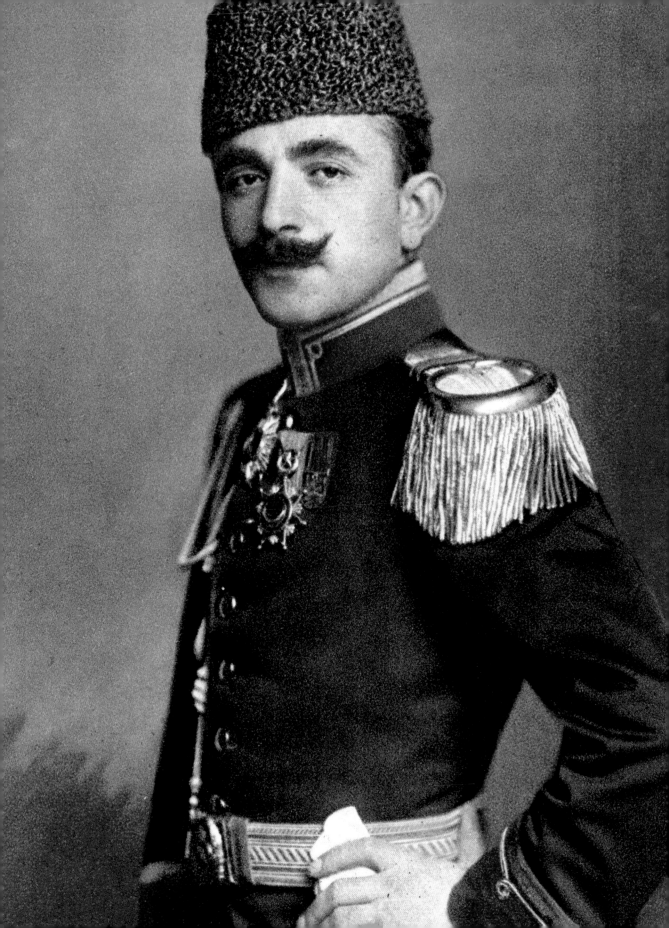

Young Turks

Revolution was the goal of the Young Turks, a political movement that came to prominence in the Ottoman Empire between 1906 and 1908 with the aim of overturning the absolute monarchy of Sultan Abdul Hamid II and re-establishing a constitutional government.

Abdul Hamid's 30 years as sultan since his accession in 1876 had not been gloriously spent: his drive to modernize Turkey's economy and infrastructure was sullied by repeated rebellion, foreign war, a massacre of Armenians and brutal, illiberal measures against internal opponents.

The sultan narrowly escaped murder by an Armenian assassin in 1905; his fate was instead decided in the summer of 1908 when disaffected members of the Young Turk movement – a coalition of army officers and opposition liberals – rose up against provincial authorities. Disobedience spread across the Empire. The sultan calculated that the only way to save his position was to reissue a parliamentary constitution that he himself had suspended in 1878.

Thus began the Second Constitutional Era in the Ottoman Empire – and the pre-eminence of Young Turks, including the army officer Enver Pasha, captured here by the German photographer Nicola Perscheid.

Despite the reforms of 1908, Abdul Hamid was deposed the next year and replaced with his brother, Murad V. Ironically, under Murad's command and Enver Pasha's control, the collapse and disgrace of the Ottoman Empire was assured. In 1914 Enver Pasha (as minister for war) argued successfully for Turkey to join the First World War on the side of Germany; in 1915 he was largely responsible for the Armenian genocide, in which up to 1.5 million perished. Enver Pasha died fighting in the Russian Civil War in 1922.

'The peculiar treasure of Kings
was his for the taking:
All that men come to in dreams
he inherited waking . . .'

Rudyard Kipling, 'The Dead King', 1910

Nine Kings

In Britain the 1900s ended as it began: with a royal funeral. On 20 May 1910 the royal train was once more on its way to Windsor bearing a monarch's corpse: this time that of the 68-year-old Edward VII, whose 122cm waistline and near-constant consumption of cigarettes and cigars had resulted in his death from a series of heart attacks a fortnight earlier.

Representatives of more than 70 states and dozens of European royals gathered to mourn him. This photograph, taken during the ceremonies, is a very rare – perhaps unique – depiction of nine kings gathered together in a single room.

From left to right they are: (back row) Haakon VII of Norway, Tsar Ferdinand I of the Bulgarians, Manuel II of Portugal, Kaiser Wilhelm II of Germany, George I of the Hellenes, Albert I, king of the Belgians; and (front row) Alfonso XIII of Spain, Edward's son and successor George V, and Frederick VIII of Denmark.

Some of these men were closely related to one another: Haakon VII was Frederick VIII's son and George V's brother-in-law; the German Kaiser was George V's first cousin. Many of them would soon be facing an existential crisis. Within ten years of this photo being taken, King Ferdinand and Kaiser Wilhelm had been forced to abdicate, Manuel was deposed and George I assassinated. The German and Portuguese monarchies were abolished and the powers of others severely curtailed.

A monarchical era was drawing to a close, soon to be swept away, like much else, by the horrors of the First World War.

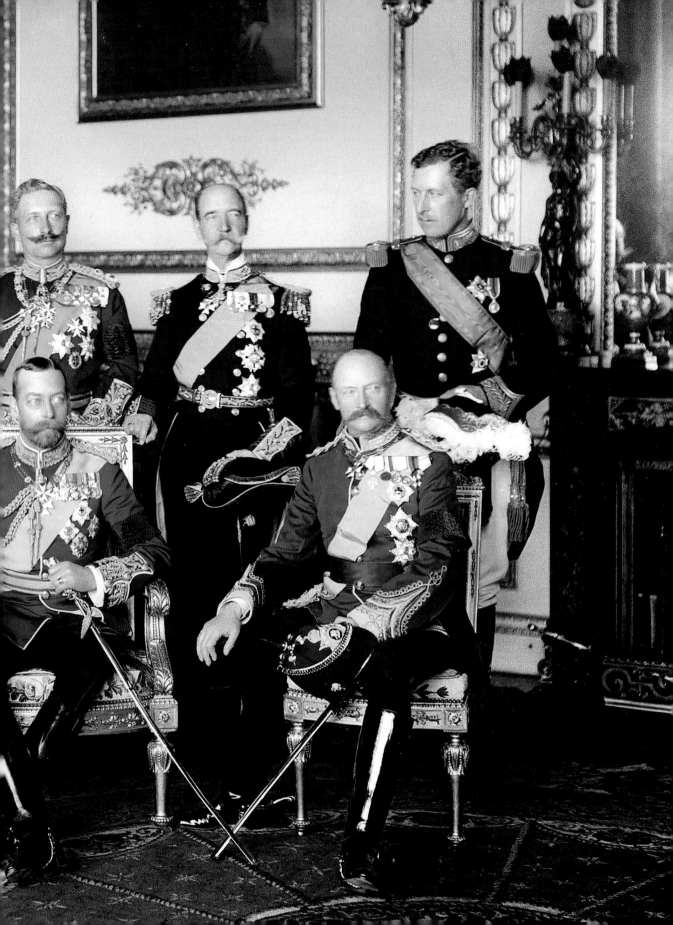

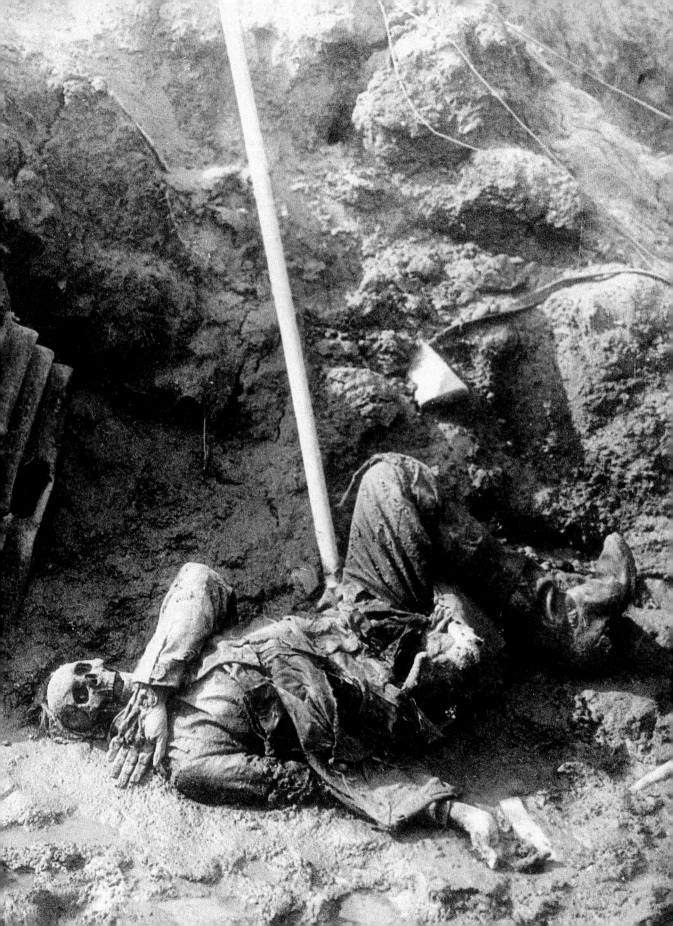

War & Revolution

1910s

'We are the Dead. Short day ago
We lived, felt dawn, saw sunset glow,
Loved and were loved, and now we lie,
In Flanders fields.'

John McCrae, 'In Flanders Fields', 1915

Second Lieutenant Ernest Brooks had learned to take photographs in gilded surroundings. Since buying his first camera as a young man, he had snapped European princesses on their wedding days and British kings shooting tigers while travelling in the entourage of the British royal family to South Africa and India. His London studio stood a stone's throw from Buckingham Palace, and he liked to call himself the official royal photographer.

All that was now a world away, as in November 1916 he stood in a blasted, muddy trench in Beaumont Hamel, near the banks of the River Somme in northern France, and trained his lens on the rotten corpse and exposed skull of a dead German: a human being killed like nearly one million others in one of the most hellish battles mankind had yet devised.

For four and a half months in 1916 the Somme Valley had juddered to the sound of howitzers, mines, warplanes screaming in the skies and tanks rolling over sucking mud to crush lines of barbed wire 45m thick. The air had blown thick with rain and the hay-like stench of invisible phosgene poison gas. The first day of the battle alone (1 July) had produced upwards of 60,000 casualties on the Allied side: young men sent to their deaths walking bayonets-fixed into a spray of machine-gun fire. One British captain who fought at the Somme wrote an account describing corpses 'stretched out… one on top of each other six-feet high. I thought at the time I should never get the peculiar disgusting smell of warm human blood heated by sun out of my nostrils.'

The Welsh poet David Jones wrote of his own experience as an infantryman at the Somme in a lyrical re-imagining of war's terror entitled 'In Parenthesis'. 'Sweet sister death has gone debauched today and stalks on this high ground with strumpet confidence, makes no coy veiling of her appetite but leers from you to me with all her parts discovered,' he wrote. Jones was among the many combatants in the war who responded through poetry (others included Wilfred Owen and Siegfried Sassoon). He was also one of the many people so traumatized by their experiences on the Somme that they suffered recurrent and devastating nervous collapse: Jones had numerous breakdowns of the sort that would in the 21st century be diagnosed as symptomatic of post-traumatic stress disorder.

And this had been only one bloodbath among many. The names of the campaigns and battles of the Great War – the First World War – would echo down the years: the Marne and Verdun, Tannenberg and

1910

[Jan] First public radio broadcast, made from the Metropolitan Opera House in New York

[May] British king Edward VII dies, and is succeeded by his son George V

[Nov] Revolutionary war begins in Mexico, sparked by the corrupt re-election of longtime president Porfirio Díaz

1911

[May] Porfirio Díaz leaves Mexico for exile in France

[Oct] Violence spreads through China following the accession of the two-year old Puyi as emperor. Republic of China proclaimed the following year

1912

[Jan] Robert Falcon Scott and colleagues reach the South Pole to find they have been beaten there by Roald Amundsen; they die of exposure and starvation on the way back to their base camp

[Apr] RMS *Titanic* collides with an iceberg and sinks. More than 1,000 passengers and crew drown

[Aug] Chinese nationalist party the Kuomintang is formed

1913

[Mar] King George I of Greece assassinated

[May] Igor Stravinsky's modernist ballet *The Rite of Spring* opens in Paris and causes popular uproar

[Jun] Suffragette activist Emily Davison throws herself under the king's horse at the Epsom Derby and is fatally trampled

1914

[Feb] First Charlie Chaplin films released, introducing his 'Little Tramp' character

[Jun] Assassination of Archduke Franz Ferdinand in Sarajevo triggers international mobilization that leads to the First World War

[Sep] Battle of the Marne and Race to the Sea establish the Western Front in Flanders and France

Ypres, Gallipoli and Jutland, the Spring Offensive and the Hundred Days Offensive. Europe, Africa and the Middle East had been turned upside down by a war that pitched 19th-century military strategy against 20th-century military technology: a catastrophic combination that sent a generation to their graves.

Very few inventions brought to the trenches of the Great War were as benign or as useful as the camera. Lieutenant Brooks was the British army's first official photographer and during his time in the Dardanelles and on the Western Front he took more than 4,000 images, cataloguing inhumanity on an unprecedented scale with his lightweight Goerz Anschütz folding plate camera, which was small enough to fit in a satchel. Brooks was adamantly opposed to staging war photographs, which makes doubly horrifying the raw documentary evidence he recorded of a conflict that was sadly mislabelled by the writer H. G. Wells as 'the war that will end war'.

This deathly collision between international blocs known as the Triple Entente (or Allied Powers) and Central Powers dominated the 1910s, from its beginning in 1914 until its conclusion, by way of armistice and a series of deeply flawed peace treaties in 1919–20. But, beyond the killing fields of Flanders and East Prussia, this was also a decade of polar exploration, ocean liner launches and riotous experimentation in art, music and dance. It was a time of revolution – in China, Mexico and Russia – and of pandemic disease that asked terrible new questions of medical science. War, pestilence, conquest and death – it was as though the horsemen of the apocalypse had come thundering across the earth. A wasted skeleton at the bottom of a trench was only the start of it.

1915

[Feb] D.W. Griffith's innovative film *Birth of a Nation* released; its blatant racism boosts the reborn Ku Klux Klan

[Apr] Gallipoli campaign begins in the Dardanelles, ending with massive failure and Allied retreat

[May] German U-boat sinks the British liner RMS *Lusitania*

[Aug] Tsar Nicholas II takes personal command of Russian military effort on the Eastern Front

1916

[Apr] Nationalist Easter Rising in Dublin suppressed by British

[May] Battle of Jutland begins – involving 250 combat ships

[May] Sykes–Picot agreement secretly carves up the Middle East between British and French control

[Jul] Battle of the Somme begins, with more than 60,000 casualties in a single day

[Dec] Mystic and royal favourite Grigori Rasputin murdered in St Petersburg

1917

[Feb] Zimmermann Telegram reveals German attempt to induce Mexico to invade the USA

[Apr] USA enters First World War on the side of Britain and France

[Oct] Bolshevik Revolution completes destruction of the Romanov monarchy and creates a socialist state in Russia

[Nov] Balfour Declaration states that Britain views 'with favour' the establishing of a 'national home for the Jewish people' in Palestine

1918

[Mar] First recorded case of 'Spanish flu' detected in Kansas, USA; it will become a worldwide pandemic

[Apr] Death in combat of fighter pilot ace Manfred von Richthofen, aka the Red Baron

[Nov] Armistice signed by German military leaders ends First World War. Kaiser Wilhelm II abdicates

1919

[Jan] Paris Peace Conference opens, leading to the Treaty of Versailles, heavily punishing Germany for actions in the First World War

[Jan] Prohibition legislation ratified in the USA, leading to federal ban on alcohol

The Mexican Revolution

Since the 1870s Mexican government had been dominated by the old war hero Porfirio Díaz, whose time as president was known as the *Porfiriato*: a period of autocratic rule, which delivered modernization and national wealth at the cost of corruption, oppression and pork-barrel politics. In 1910, however, Díaz was an old man, and Mexico was seeking new leadership. When the 80-year-old was returned for another term in plainly rigged elections, the country erupted into rebellion and civil war.

One of the most famous revolutionaries was the guerrilla warrior General Francisco 'Pancho' Villa, pictured here in January 1914 with his longsuffering wife Doña Luz Corral. Villa joined the fight against Díaz in the northern state of Chihuahua and quickly showed a gift for leadership and an unnatural ability to cheat death: in 1912 he talked his way out of a firing squad as his executioners were lining up to shoot.

A talented robber, enthusiastic philanderer and charismatic bandit-cum-freedom fighter, Villa deliberately courted Hollywood newsreel companies, who paid him for the right to shoot silent movies covering his wartime exploits. But his relationship with the United States was sorely tested in 1916 when Villa invaded New Mexico, then evaded a 5,000-strong detachment of the US Army for more than a year.

The Mexican Revolution was largely settled in 1917 with the promulgation of a new constitution, but the following years saw a bloodbath of revolutionary leaders. In July 1923 Pancho Villa was assassinated: shot dead in his car in the city of Parral after collecting a consignment of gold from a local bank.

'After making a very poor show as emperor for three years I made a very poor show of abdicating...'

Puyi, *From Emperor to Citizen* (1964)

Revolution in China

In China another revolution was afoot, as 2,000 years of imperial rule came to an end with a couple of pieces of paperwork and a harvest of severed heads.

In 1908 the Guangxu Emperor died suddenly, probably poisoned, aged 37. The likely hand behind his death was the ailing Dowager Cixi, China's real ruler, who herself expired the following day. On her deathbed Cixi named as her successor a two-year-old child called Puyi, who became the twelfth and, it soon transpired, final Qing dynasty emperor.

Puyi was in no position to rule, and within three years of his accession a series of revolutionary uprisings gripped the realm, beginning in October 1911 in the southern city of Wuchang. This picture shows decapitated prisoners lying in the street after one bout of revolutionary violence. By 1912 calls for an end to imperial rule were irresistible: in February Puyi's advisors were persuaded to issue an edict of abdication.

China became, in theory, a republic, although in reality the country was thrown into several decades of turbulence, with power contested between republicans, nationalists, imperialists, communists and warlords.

Amid all this the young emperor's safety was guaranteed by a document called The Articles of Favourable Treatment of the Great Qing Emperor after his Abdication. Puyi flirted with power for the rest of his life: he was briefly restored as emperor in 1917 and installed by the Japanese as puppet ruler of Manchuria (Manchukuo) between 1932 and 1945. The last emperor of China died in hospital in 1967.

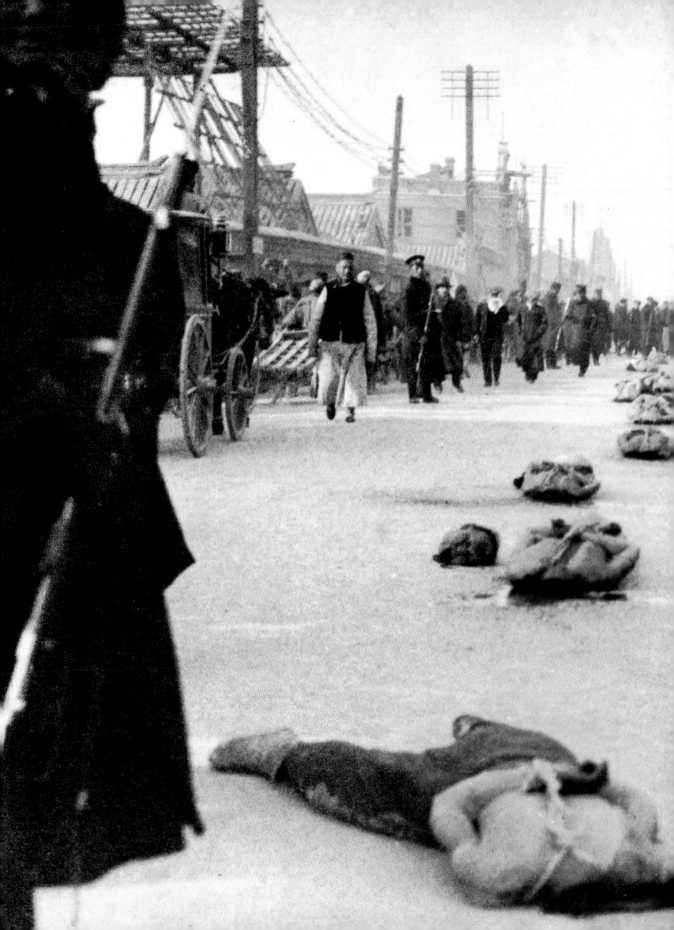

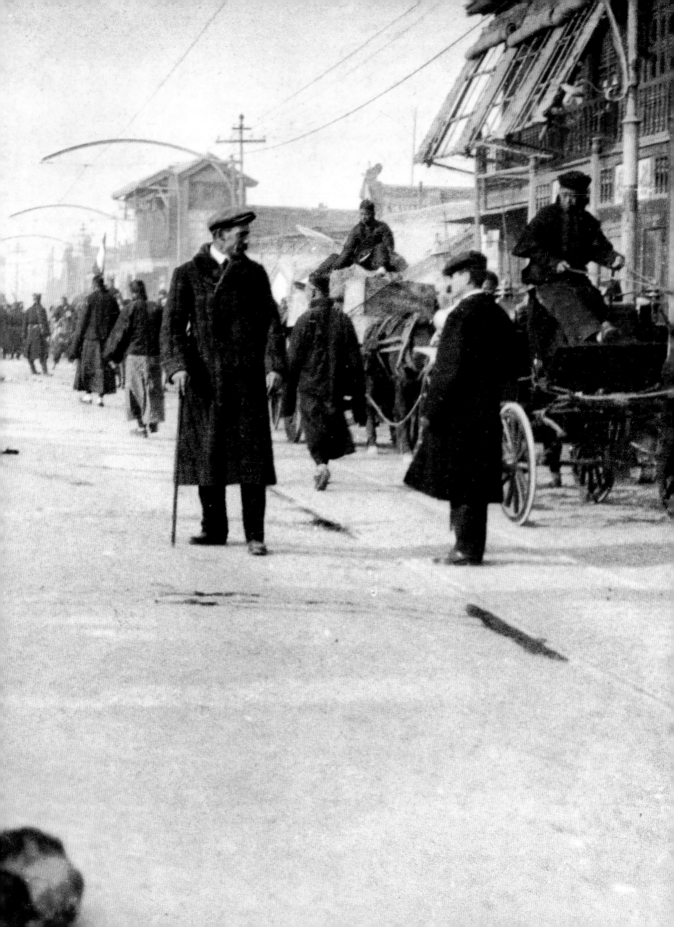

Terra Nova

Antarctica, the fiercest continent on earth, was the object of Captain Robert Falcon Scott's *Terra Nova* expedition, which set sail from Cardiff, Wales, in June 1910, with a 65-strong crew of officers, sailors and scientists. Explorers had been visiting the southern ice desert for nearly 100 years: Scott himself had travelled there with colleagues including Ernest Shackleton aboard the *Discovery* between 1901 and 1904. Yet no one had ever reached the South Pole. Scott was determined that he should be the first.

The party arrived at Cape Evans, McMurdo Sound, on 4 January 1911. Very shortly after they disembarked, expedition photographer Herbert Ponting captured this image, looking out from a grotto formed inside an iceberg towards geologist Thomas Griffith Taylor and meteorologist Charles Wright. (The *Terra Nova* is anchored in the background.) The picture was made from one of more than 1,700 glass photographic plates Ponting exposed in Antarctica before he departed for Britain in March 1912, intending to prepare his photos for a fundraising tour on which Scott was to be the star lecturer.

Yet when Ponting and *Terra Nova* departed, Scott was nowhere to be seen. He and four colleagues had reached the South Pole on 17 January, only to discover that the Norwegian explorer Roald Amundsen had beaten them there by a month. On their return journey Scott and his friends had all died, frozen and malnourished, in the ice. And they would not be the last people to perish in a freezing wilderness that year.

'Had we lived, I should have had a tale to tell of the hardihood, endurance, and courage of my companions which would have stirred the heart of every Englishman. These rough notes and our dead bodies must tell the tale...'

Robert Falcon Scott, last journal entry, 29 March 1912

RMS *Titanic*

Fifty-three metres high, 269m long, with nine decks and a cruising speed of 21 knots, the transatlantic passenger liner RMS *Titanic* was the biggest ship on the oceans when she set out from Southampton for New York City on 10 April 1912, on her maiden voyage.

Less than a week later she was the largest ship at the bottom of the sea. Ship's time was 11.40pm when the *Titanic* collided with an iceberg several hundred kilometres south of Newfoundland, causing a breach in the hull.

Lifeboats were launched, but there were too few for the 1,316 passengers and nearly 1,000 crew. Within three hours of striking the iceberg the *Titanic* broke apart and sank. Although 705 people were rescued by the RMS *Carpathia*, which answered distress calls, the majority were drowned.

The newsboy pictured here is Ned Parfett: he is selling the *Evening News* outside the London offices of the White Star Line shipping company, which built and operated the *Titanic*. The company was cleared of negligence in two official inquiries into the sinking, both of which heaped blame on the *Titanic*'s captain, Edward Smith, for navigating too fast through icy seas. But the White Star Line's chairman, J. Bruce Ismay, who was on board and who – unlike Smith – survived, was pilloried by the public.

Parfett, meanwhile, lived only six and a half more years. He was blown to pieces in France in the autumn of 1918, fighting in a war that made the loss of life aboard the *Titanic* seem almost incidental.

'As needless a sacrifice of noble women and brave men as ever clustered about the Judgment Seat in any single moment…'

Senator William Alden Smith, 1912

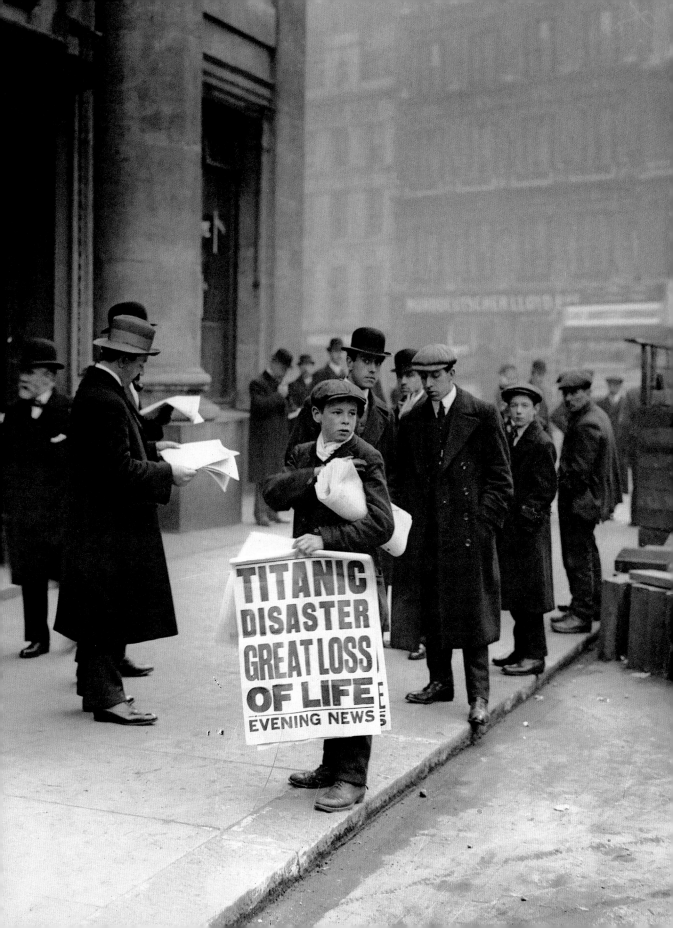

The Rite of Spring

It was not only shipwrecks that could shock the world: on 29 May 1913 the *bien pensant* theatregoers of the Théâtre des Champs-Élysées in Paris were provoked to the point of riotousness by the first performance of a modernist ballet called *The Rite of Spring* (*Le Sacre du printemps*). The music was by Igor Stravinsky, the choreography by the great dancer Vaslav Nijinsky, and the performance organized by Sergey Diaghilev's Ballets Russes. Their combined work was influenced by traditional Russian folk ritual and folk music, yet as the costumes pictured here suggest, it was also of the Modernist *avant garde*: the emerging school of art, music and literature that went out of its way to be discordant, difficult and confusing.

The premiere was a débâcle, as a perplexed audience began first to laugh, then to jeer and finally to throw things at the orchestra. The house lights were turned on in an effort to dampen protests and the performance was completed, but press reports were damning. 'The Russians, who are not entirely acquainted with the manners and customs of the countries they visit, did not know that the French people protested readily enough when the last degree of stupidity was reached,' concluded *Le Figaro*.

The Rite of Spring was performed for another week and transferred to London for a short run, after which it was shelved for many years, and only revived with new choreography; Ninjinsky's steps were lost and only rediscovered in the 1980s.

'That is all we get after a hundred rehearsals and one year's hard work… I sprang a surprise on Paris, and Paris was disconcerted.'

Igor Stravinsky, 1913

Suffragettes

Demands for women's suffrage, or voting rights, reached a militant crescendo between 1912 and 1914, particularly in Britain and America where peaceful demonstration and political organization gave way to violent protest: arson, bomb threats and acts of vandalism ranging from smashing windows and cutting telegraph wires to slashing pictures in art galleries.

The most spectacular of these occurred at Epsom racecourse in Britain on 4 June 1913. Emily Davison, a member of the Women's Social and Political Union or WSPU (nicknamed 'Suffragettes'), ran onto the course during the day's headline race, the Derby, intending to pin a flag to King George V's horse, Anmer, as it thundered by. But Davison failed to attach the flag and was trampled, dying four days later.

This photo shows Davison's fellow Suffragette Emmeline Pankhurst being arrested on a march to Buckingham Palace in May 1914. Pankhurst was seized by Chief Inspector Francis Harry Rolfe and taken away to Holloway Gaol, shouting 'Arrested at the gates of the palace! Tell the King!'

Prison was a familiar destination for Pankhurst and her fellow Suffragettes: many had been incarcerated multiple times under the controversial 'Cat and Mouse' Act (1913). This law thwarted hunger strikes by freeing imprisoned women when they were frail from malnourishment and returning them to the cells when they had regained sufficient strength.

Shortly after this arrest, however, Pankhurst and the WSPU agreed a truce with the government and halted militant activity. A national war was looming. The world was about to change forever.

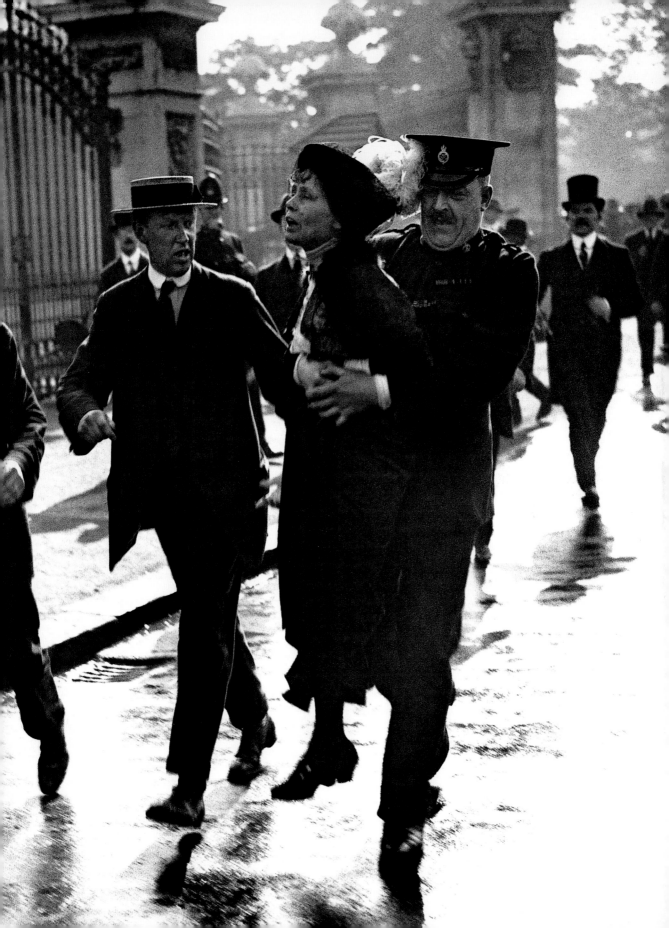

Franz Ferdinand

Archduke Franz Ferdinand was an Austrian aristocrat of high breeding and conventional tastes. Born into the large Habsburg family and sent to become an army officer in his youth, in 1896 he became crown prince and heir presumptive to the dual monarchy of Austria-Hungary. This was a status of some importance, but it still allowed him time to travel around Europe indulging his two great obsessions: buying antiques and shooting wild animals.

Franz Ferdinand's only truly unconventional deed was to marry a princess's lady-in-waiting, Sophie Chotek, rather than a princess. It is likely that the couple would have been obscure in the pages of history had he and Sophie not been gunned down in the street in Sarajevo, capital of Austrian-occupied Bosnia and Herzegovina, in the late morning of Sunday 28 June 1914. The assassin was a Yugoslav nationalist and student called Gavrilo Princip, and the unintended consequence of his gunshots was to start the most terrible war the world had ever seen.

The chain of events that followed Ferdinand's death were an object lesson in the failure of the system of 19th-century alliances designed to keep the peace in Europe. In retaliation for the murder, Austria-Hungary invaded Serbia, so Serbia's Slavic ally, Russia, mobilized troops. Austria-Hungary's ally, Germany, declared war on Russia, so Russia's ally France also mobilized troops. Germany declared war on France as well, and invaded through neutral Belgium. Defending Belgium's honour, Britain joined the fight, and by the start of August 1914 the whole of Europe was at arms. Over the coming years, the Ottoman Empire, Japan and the United States also engaged. The Great War, later known as the First World War, had begun.

'The lamps are going out all over Europe, we shall not see them lit again in our life-time.'

British Foreign Secretary Sir Edward Grey,
3 August 1914

The Western Front

The earliest fighting in the First World War took place in Africa between troops in the European powers' many colonies. But the most notorious theatre of conflict opened in September 1914, when British and French armies lined up to halt German troops along the so-called 'Western Front'. Both sides dug hundreds of miles of trenches across a vast, snaking line that began near Ostend, on the North Sea coast of Flanders, and ended at the Franco-Swiss frontier, near Basel.

Life in the trenches on the Western Front was a defining ordeal of the Great War. Defences of barbed wire, sandbags and machine-gun emplacements covered improvised quarters that were often wet, muddy and cold: miserable conditions in which disease spread and conditions like 'trench foot' – infection and ulceration of perpetually damp and dirty feet – were common. New weapons and tactics including poison gas, howitzer guns and aerial bombardment added to the grimness of trench life. And periodically both sides would launch offensives in which troops were ordered to clamber 'over the top' and advance on foot into machine-gun fire. The huge battles that resulted from strategic attempts to break the stalemate – such as Verdun (1916), the Somme (1916) and Passchendaele (1917) – generally proceeded with catastrophic loss of life.

This British sergeant is pictured in a trench at Ploegsteert Wood in Flanders in early 1917. By this stage, 'Plugstreet' had seen the worst of its fighting and was generally used to rest and revive troops before they were sent back into action.

The Indian Army

After his exploits in Sudan and the Boer War, Lord Kitchener had spent the first decade of the 20th century reforming the Indian army, which he oversaw as commander-in-chief. When the World War broke out its vast manpower – more than one million men – was ready to be deployed in support of the British Empire.

Close to home, this meant patrolling the frontier regions around Afghanistan and Burma. But the majority of Indians who served in the Great War found themselves scattered to the ends of the earth: the largest number were deployed to protect oilfields and shipping interests in Mesopotamia, Palestine and Sinai from the Ottoman Empire.

More than 100,000 Indians went to Flanders and France to fight on the Western Front. (Here, four infantrymen of the 129th Duke of Connaught's Own Baluchis are manning a barricade during the battle of Messines in October 1914.) Other expeditionary forces saw action in East Africa and on the ill-fated Gallipoli campaign.

From 1911 onwards Indian soldiers had been eligible for the Victoria Cross – the highest award for gallantry in military service to the British crown. During the course of the war more than a dozen were awarded to members of the Indian army. The first of them was won by Khudadad Khan Minhas, a sepoy (equivalent to private) infantryman who manned a machine gun at the First Battle of Ypres, firing at German lines until he was injured and everyone else around him was dead.

'This is not war. It is the ending of the world. This is just such a war as was related in the *Mahabharata*...'

An anonymous Indian sepoy writes from his hospital bed in 1915

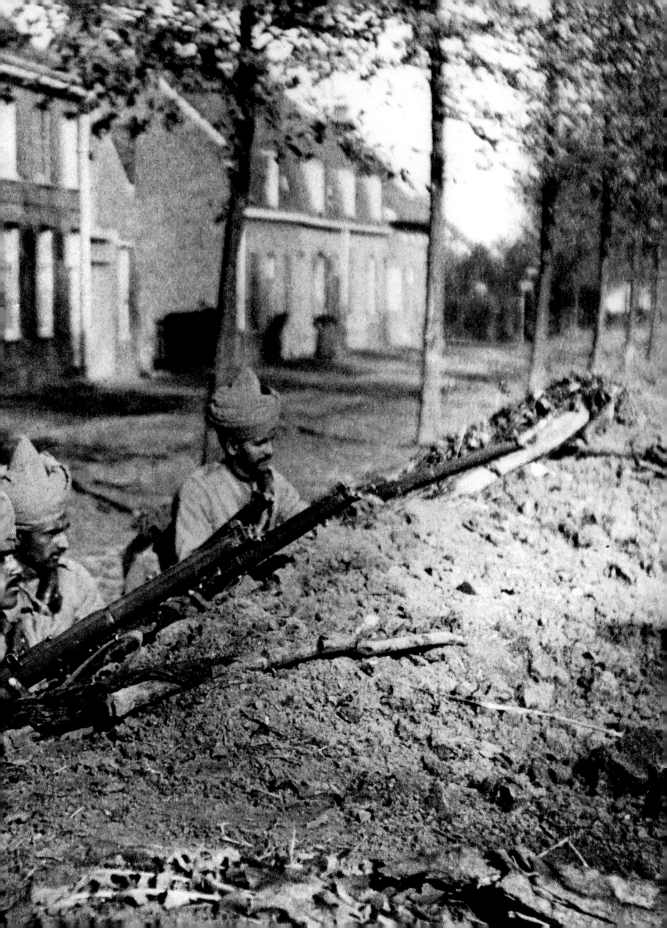

The Red Baron

At the outset of the Great War aircraft were not expected to play a combat role. Not only was the technology new, international law had also forbidden the use of planes to launch weapons. Within weeks of war being declared, however, pilots had begun to influence its course, with reconnaissance flights providing valuable intelligence about troop movements.

By July 1915 Germany had developed and launched single-seater Fokker EI fighter biplanes armed with machine guns that could be fired through the blades of the propellers. Two months later the British brought out competing planes, and by January 1916 the French were also equipped.

Aircraft needed airmen and none was more famous than Manfred von Richthofen, a Prussian cavalry reconnaissance officer of aristocratic birth who transferred to the German flying service in 1915. With 80 confirmed kills he became the most successful flying ace of the war, his noble blood and deadly accuracy behind the controls of a crimson Fokker Dr.I triplane earning him the nickname 'The Red Baron'. Richthofen was also awarded the Blue Max – then Germany's highest military decoration.

This distinctive soft-focus postcard portrait of the Red Baron is by German photographer Nicola Perscheid. Not long after it was taken, Richthofen was shot through the chest during a dogfight over the River Somme against two Canadian pilots flying for Britain's newly founded Royal Air Force. He landed his plane and died, after muttering a phrase that seemed to include the word *kaputt*.

War in the East

The trenches dug on the Western Front were mirrored in Eastern Europe by combat lines that stretched hundreds of miles from the Baltic to the Black Sea. Across this frontier the armies of the Central Powers – Germany, Bulgaria, Austria-Hungary and the Ottoman Empire – fought the Russian Empire, along with Romania and the Allied Powers.

But much further east Japan was also involved in the war, having entered in support of Britain in September 1914 by invading the German-held Chinese port of Tsingtao. This photograph, sometimes thought to show a scene from the Eastern Front, was in fact more likely to have been taken near Tsingtao. It shows a large artillery piece being unearthed by German infantry for use in the heavy fighting that took place around the coastal fort.

The piece being salvaged is identified in the inscription on the shell-case as a 28cm howitzer L/10. These weapons had been developed by the German arms manufacturer Krupp in the 1890s and were deployed in the Russo-Japanese War of 1905, when they proved effective in both attacking ships and firing on ports. Requiring a crane to load, they were capable of firing shells weighing more than 200kg over a distance of around 8km. And this was far from the most powerful such device used in the war. The German army's gigantic 'Paris Gun' had a range of 190km, while their 'Big Bertha' howitzers fired shells weighing more than 800kg.

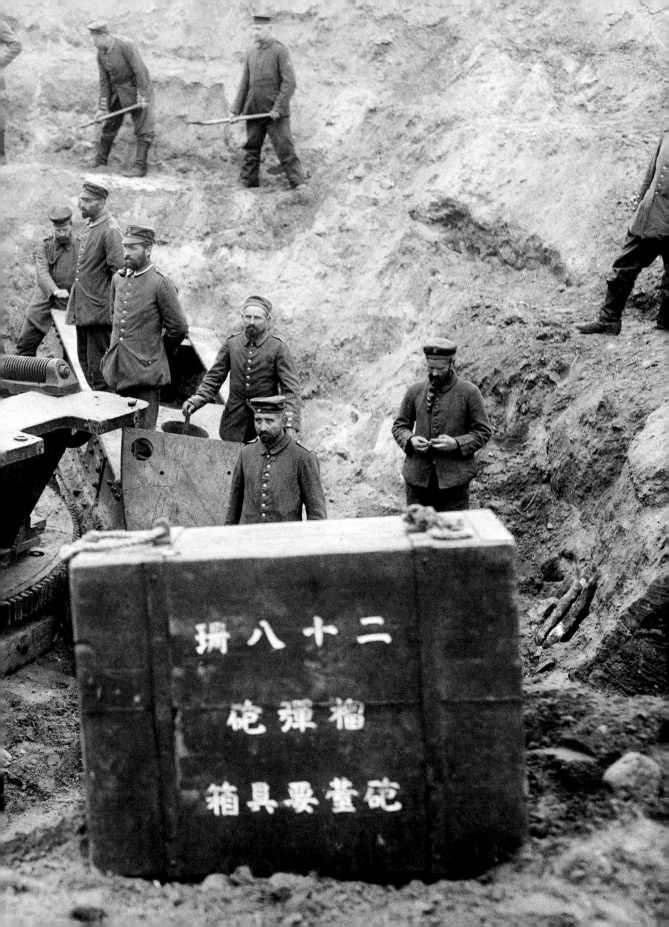

'Men, I am not
ordering you to attack –
I am ordering you to die.'

Colonel Mustafa Kemal Atatürk
at Gallipoli, 1915

Gallipoli

Stalemate on the Western Front, together with
Russian concerns about an attack by the Ottoman
Empire through the Caucasus, led the Allies to
hatch a plan in 1915 to invade Turkey and seize the
Dardanelles Straits. This tiny seaway ran to the
south of the Gallipoli Peninsula; it allowed ships to
navigate from the Mediterranean to the Black Sea,
and controlled access to the Ottoman capital of
Constantinople. It was therefore a vital strategic point
and its capture would be a major boon.

In February 1915 a large armada of British and
French ships approached the Dardanelles, ordered
there by the First Lord of the Admiralty, Winston
Churchill. They were forced back, bombarded by
artillery and tormented by Ottoman sea mines.
Nevertheless, on 25 April a land invasion began,
which ultimately involved nearly half a million Allied
troops. Many of them – including those pictured here
– were drawn from the Australia and New Zealand
Army Corps, or ANZAC.

But like the naval assault, the land invasion
of Gallipoli was a costly failure, which resulted in
a casualty rate of more than 50% among the Allied
troops before the decision was taken to evacuate,
and a quarter of a million on the Ottoman side. In
Britain the scale of the calamity nearly brought down
the government. (Churchill was demoted from the
Admiralty and resigned.) The Ottomans, however,
had a major victory to celebrate. The prestige of
the victory gave succour to the emerging Turkish
nationalist movement which would eventually sweep
to power under Mustafa Kemal Atatürk, who became
the first leader of the Republic of Turkey in 1923.

War at Sea

HMS *Audacious,* pictured here during a storm, was a ghost ship. She had been ordered in 1910 as one of four vessels known as King George V-class dreadnought battleships: heavily armed and capable of carrying enough fuel to sail for thousands of miles.

She was commissioned in October 1913 and on the outbreak of the First World War the following year was refitted in readiness to take on the Imperial German navy. Unfortunately, she did not last long. HMS *Audacious* was sunk by a German mine off the coast of Ireland in October 1914, and her somewhat demoralizing loss was kept a secret by the British Admiralty and the press until the end of the war.

Yet while HMS *Audacious* spent the war underwater, many other ships did see combat action, most explosively at the Battle of Jutland, which took place in waters off the North Sea coast of Denmark over 36 hours between 31 May and 1 June 1916.

Jutland was the largest battleship engagement in history, involving 250 combat ships in total, 25 of which were sunk. Who won, if anyone, was difficult to assess. The German Imperial High Seas Fleet under Vice-Admiral Reinhard Scheer caused more damage than the Royal Navy Grand Fleet under Admiral Sir John Jellicoe. But the Royal Navy's superior size meant that, proportionally, it came away in better shape, having proven its ability to maintain a blockade on Germany and survive even the heaviest attacks.

'There was a terrific flash and shock and I was knocked endways … my eyes full of water and dust … Realized it was pretty hot and we were getting heavily hit…'

Lieutenant Humphrey T. Walwyn describes combat aboard HMS *Warspite* at Jutland, 31 May 1916

Women at War

The giant battleships of the Great War were the product of industrial economies bent towards the purpose of war. And since the war moved millions of working-age men out of the workplace and into the firing line, women took on new, traditionally male jobs: manufacturing weapons, ammunition, ships, planes and trains; working as farm labourers; delivering mail; working as special police officers; manning telephone switchboards; teaching schoolchildren and filling office-based clerking roles.

These women, photographed c.1916, are working in the Elswick munitions factory in Tyneside, England – the headquarters of the world's biggest arms manufacturer, Armstrong-Whitworth. This vital work could be dangerous: handling explosives had grave consequences for workers' health. Besides the obvious risk of accidental explosions, chemical compounds like TNT left workers with yellow staining on their skin and even liver damage from prolonged exposure. After the war, however, the movement for female suffrage was strengthened in the light of women's contribution to the war effort.

Some nations allowed small but significant numbers of women to enlist in branches of the armed forces. The United States opened the Navy, Marines and the Army Nursing Corps to women. In Britain the Women's Army Auxilliary Corps employed women as cooks, clerks and medics. German women could enlist as military nurses. In Russia, several women's battalions were formed towards the end of the war, following the tsar's abdication, one of the most prominent being the 1st Russian Women's Battalion of Death, commanded by the peasant soldier Maria Bochkareva.

'If the women in the factories stopped work for twenty minutes, the Allies would lose the war.'

Marshal Joseph Joffre, French general

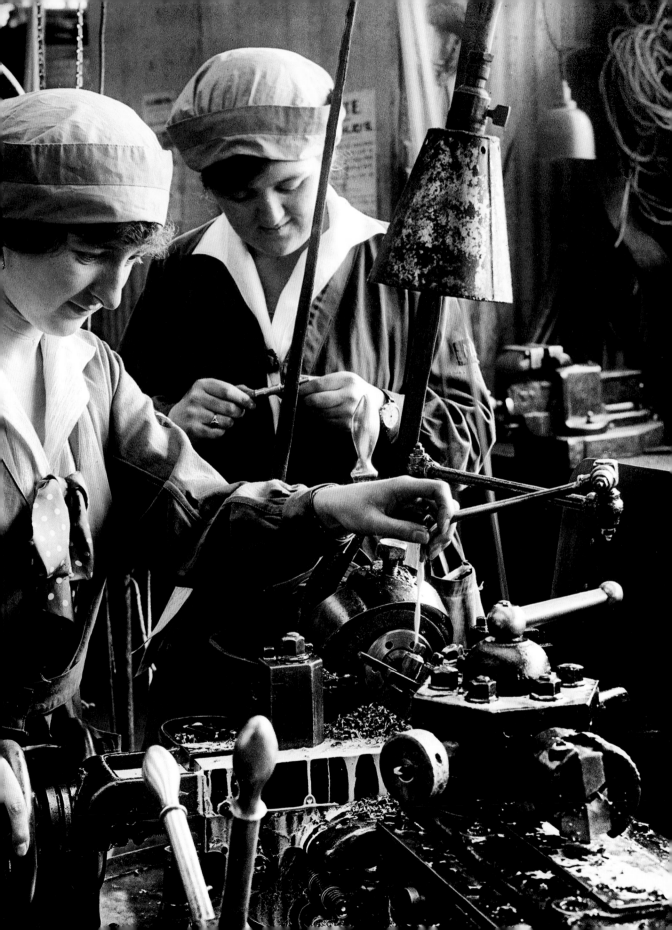

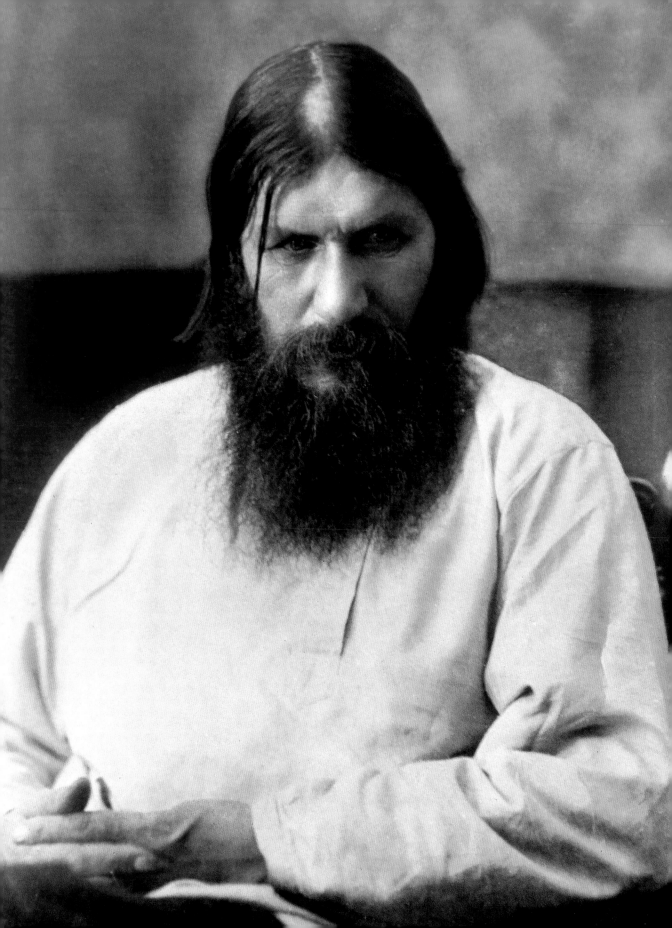

'The Mad Monk'

In 1915 one of the most powerful women involved in the war was the Russian tsarina Alexandra, who had been left in St Petersburg to oversee government while her husband, Tsar Nicholas II, took personal command of the faltering Russian campaign on Europe's Eastern Front. This in turn brought to prominence one of the strangest characters in Russian history: the tsarina's personal guru Grigori Rasputin.

Rasputin was a mystic and a wandering pilgrim from Siberia whom the royal family credited with the power to cure the heir to the crown, 11-year-old Alexei, who suffered from haemophilia. Besides his supposed healing powers, Rasputin was also an extremely persuasive and charismatic individual and the tsarina, like many other women at court, was held rapt by his magnetic personal charm and wild appearance.

Predictably, Rasputin upset many male, conservative figures in Russia with his avowedly louche lifestyle, which included heavy drinking and casual sex. And when Rasputin's influence began to tell over Russian politics his career was cut short. On 30 December 1916 he was murdered by a group of nobles (possibly acting with the help of British secret agents) at the Moika Palace in St Petersburg, home of the wealthy aristocrat Prince Felix Yusupov.

According to Yusupov's later admission, Rasputin was very difficult to assassinate, surviving poisoned cakes and wine and a gunshot to the chest before finally being gunned down in the snow and dumped in a freezing river. His influence over the royal family was at an end – but far greater problems loomed for Russia and the Romanov dynasty.

'Better one Rasputin
than ten fits of hysterics
every day.'

Tsar Nicholas II, 1912

'We are slowly but surely killing off
the best of the male population
of these islands...'

Former British foreign secretary
Lord Lansdowne, November 1916

The Somme

The year 1916 was one of the deadliest in the history of warfare. On the Eastern Front the Brusilov Offensive (or 'June Advance') made crushing gains for the Russian Empire. Meanwhile, on the Western Front, two huge battles took place between Allied and German forces, lasting most of the year and resulting in as many as two million casualties on all sides. They were the battles of Verdun and the Somme.

'Somme. The whole history of the world cannot contain a more ghastly word,' wrote the German officer Friedrich Steinbrecher. For five months millions of men clashed over a 24km front, one tiny portion of which is pictured here (pp. 254–5). The waste of human life was illustrated from the first day, 1 July 1916, when the British army lost nearly 60,000 men, many of them sent over the top of the trenches to walk headlong into automatic fire.

Fighting continued for another 140 days, with shells tearing the woods of the Somme Valley to ribbons, aircraft strafing and bombing enemy positions, and tanks rolling into combat for the first time. Offensives were brought to a close in November, by which time the British and Allied troops had advanced just 11km. Neither side could claim victory, although the British commander-in-chief Sir Douglas Haig justified the massive casualties (some 600,000 killed or wounded on the Allied side alone) by the fact that their efforts had sustained the French in fighting a similarly bloody battle in Verdun. The slaughter on the Somme had achieved little, and the war was set to continue into another bloody year.

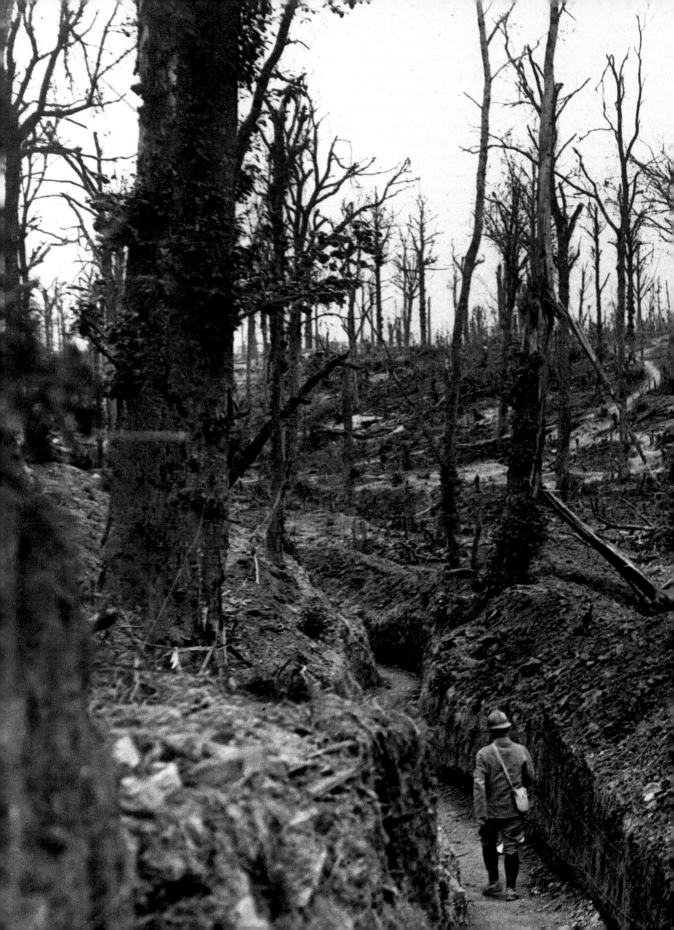

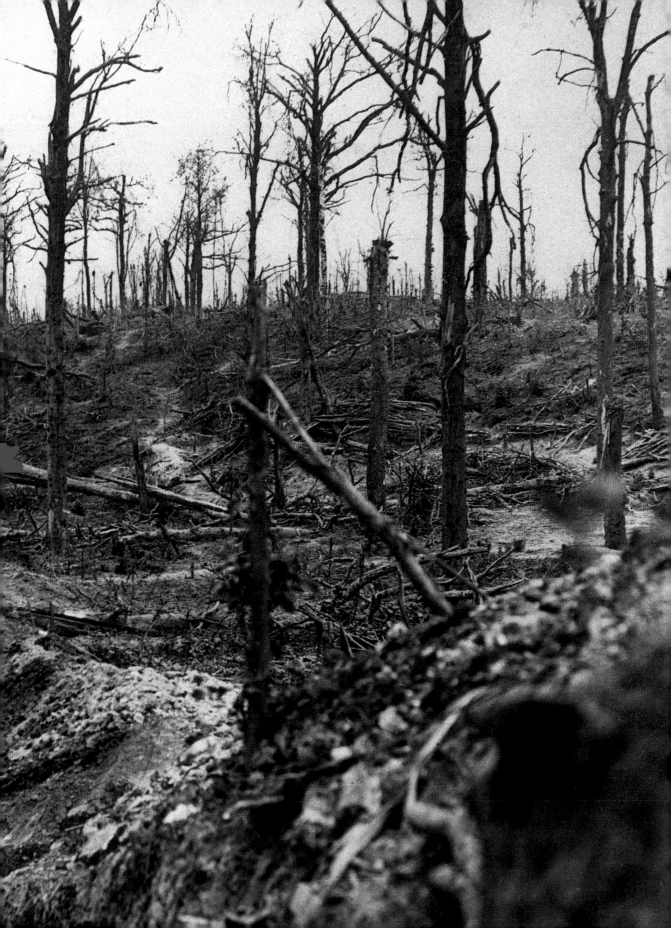

Cambrai

Tanks had been deployed at the Somme, but they were first used en masse on 20 November 1917, during a surprise attack by British forces on German lines near Cambrai in northern France. Covered by artillery fire, several hundred Mark IV British tanks equipped with machine guns and 6-pounder naval guns began a 10-day attack on German positions, crushing barbed wire and protecting infantry advancing behind. They made gains of a few kilometres before a German counter-attack drove them back again at the end of the month.

Cambrai was an indecisive battle in the history of the war – but its contribution to the history of warfare was immense. Huge, heavy mechanized vehicles running on caterpillar tracks would transform battlefield tactics forever. This stereoscopic card from 1917, purporting to show a tank in action at Cambrai, suggests that they were also the object of grim fascination among the noncombatant public.

In the context of the overall war, however, it was not so much machinery as allies that decided the outcome of the grinding conflict in the West. As British tanks rolled over German positions at Cambrai, a new belligerent was mobilizing for war. On 6 April 1917, the United States Senate and Congress had voted overwhelmingly to join the fight against Germany. American neutrality had been tested to breaking point by relentless U-boat attacks on Atlantic shipping and the 'Zimmerman telegram' of January 1917, which revealed that Germany was inciting Mexico to invade the USA. This was the beginning of the endgame.

'As they advanced in masses, with very small intervals between them, they reminded one of Hannibal's battle elephants or the sickle chariots of the Pharaohs.'

The German General Baron Armand Léon von Ardenne, *Berliner Tageblatt*, November 1917

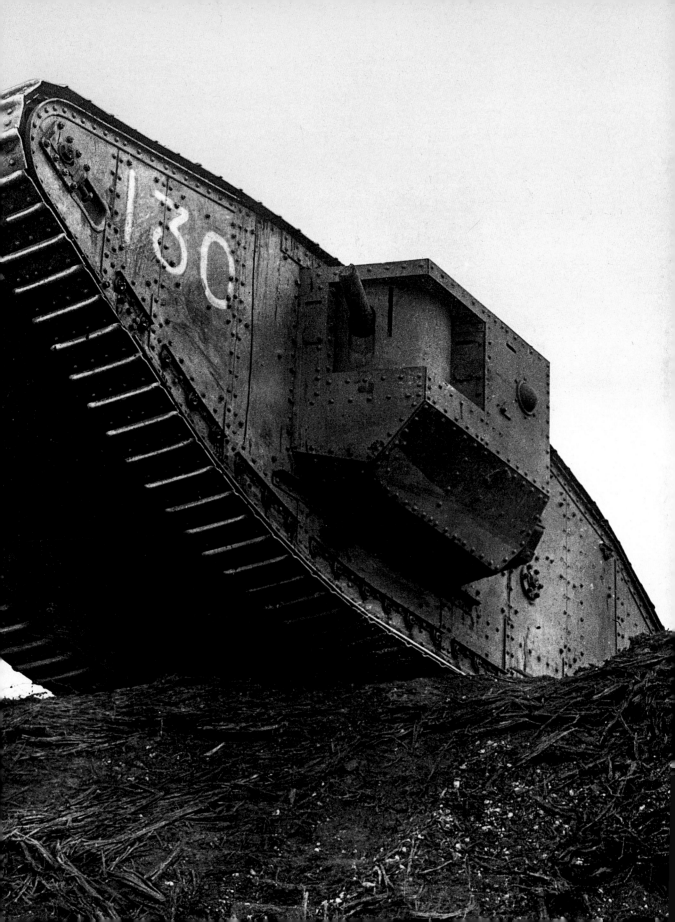

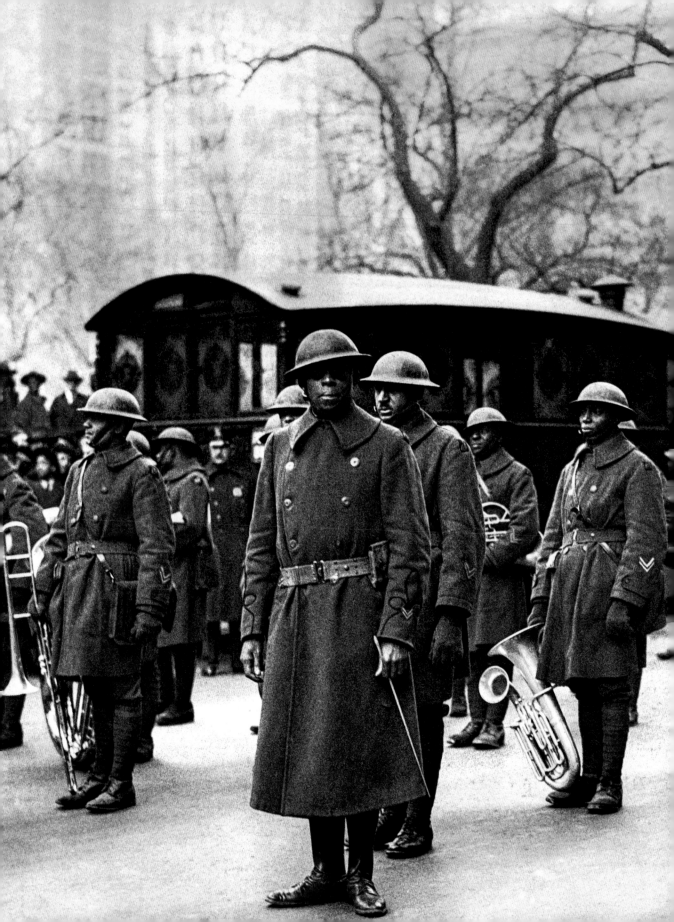

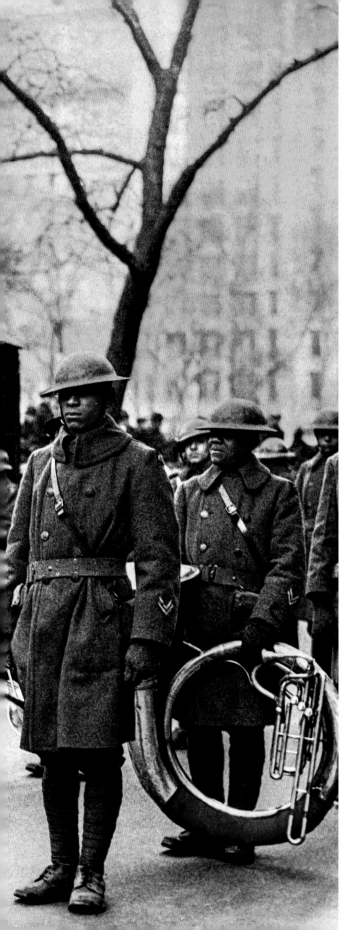

Hellfighters

Although the United States had provided money, supplies and munitions to the Allied powers, few Americans had wished to join the First World War – least of all the 28th president, Woodrow Wilson, who was among the chief advocates for US isolationism. But by the spring of 1917, public opinion had shifted. War was declared on Germany in April and on Austria-Hungary in December of the same year, although the USA never formally joined the Entente or declared war on the Ottoman Empire or any other of the Central Powers.

Once committed, the USA rapidly expanded its military forces, conscripting four million men, who began to flood into France by the spring of 1918. The soldiers pictured here are the all-black 369th Infantry Regiment, known as the 'Harlem Hellfighters', famous for their fierce spirit and superb marching band. The Hellfighters fought with distinction on the Western Front alongside French troops. Their most distinguished members were Privates Henry Johnson and Needham Roberts, both awarded the French Croix de Guerre for bravery while fighting a German patrol in the Argonne Forest. The Hellfighters are seen here on their return to New York in 1919.

The sheer numbers of US troops who appeared in France in 1918 finally achieved the goal that had eluded the Allies for four years: overwhelming the Central Powers with their capacity to absorb losses. In this respect American manpower was critical to the success of the Hundred Days Offensive of July–November 1918 that eventually pushed Germany and her allies out of France and forced the Armistice that ended the war.

Death of the Romanovs

The importance of American entry into the Great War was magnified by the withdrawal of Russia in 1917, following two revolutions that ended with the monarchy destroyed, the royal family murdered and power in the hands of the Bolsheviks, a hardline Marxist party.

Despite the success of the Brusilov Offensive of summer 1916, in February 1917 riots and food shortages caused by the war persuaded Tsar Nicholas II to abdicate in favour of a liberal provisional government.

This left the tsar, tsarina and their five children in limbo. They were not granted asylum in Britain and France, so were sent by the provisional government to Tobolsk in southern Siberia until they could be exiled elsewhere. Two months later, however, the provisional government fell, brought down in the October Revolution, when Bolsheviks led by Vladimir Ilyich Lenin swept into power. Lenin removed Russia from the Great War with the Treaty of Brest-Litovsk (March 1918), but the country was immediately consumed by civil war in which the Bolsheviks faced a coalition of enemies, including pro-monarchists.

The new regime moved the Romanovs to Yekaterinburg, where, on the night of 16–17 July 1918, all were shot, beaten and bayonetted to death in this cellar room in Ipatiev House. The bodies, and those of their four remaining servants, were then mutilated and burned, and the remains hidden in a pit, where they lay undiscovered for more than 60 years. Their miserable deaths gave only a small hint of the brutality that awaited Bolshevik Russia.

'We do not know whose finger it was. I think it must belong to the Empress … It was lying there in the ashes, as were the false teeth.'

Eyewitness report given to
British military intelligence, 1920

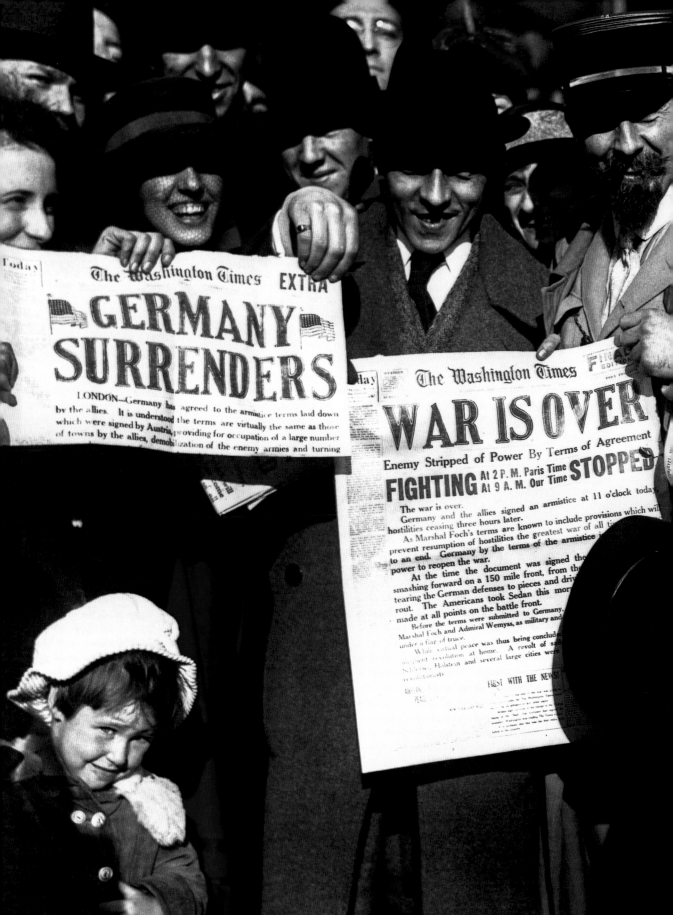

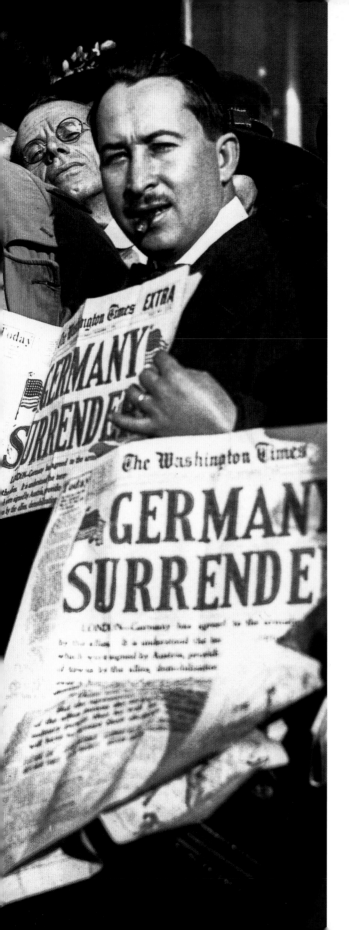

Ceasefire

By late October 1918 the military situation had become impossible for all the Central Powers, and each in turn sought an armistice – a ceasefire to allow for negotiated peace – beginning on 29 September with Bulgaria. These newspapers in Washington DC are reporting Germany's surrender, which was formalized at 11am (Paris time) on 11 November, when terms were signed in a railway carriage in a forest clearing near Compiègne in northern France.

Kaiser Wilhelm II had abdicated two days previously; the terms of the armistice now included the withdrawal of German troops from all occupied territory, the abandonment of German weapons, aircraft, ships and vehicles, and the handover of prisoners. These heavily one-sided terms formed the basis of a vengeful peace agreed in 1919 under the Treaty of Versailles, which confiscated German industrial territory, put heavy restrictions on the size of the German military and imposed an impossibly high bill of reparations (132 billion marks) to be paid to the Allied Powers in acknowledgement of Germany's 'war guilt'.

In retrospect, the peace terms agreed with Germany and the other Central Powers (who agreed to separate postwar treaties) were harsh, muddled and counterproductive. They attempted to square France's desire permanently to neutralize Germany and her allies with the idealistic wish of US President Woodrow Wilson to create a world peace based on fairness, friendship and national self-determination. The job of policing this new world order was assigned to the League of Nations – an international body established in January 1920. The task would very quickly prove impossible.

'This is not a peace. It is an armistice for 20 years.'

Allied supreme commander
Marshal Ferdinand Foch, 1919

Spanish Flu

Around 17 million people died in the course of the Great War, but that figure was more than doubled as the war ended by the outbreak of the deadliest disease pandemic in human history. 'Spanish flu' was an influenza strain that caused extreme muscular pain, headaches, soaring temperature and a racking cough so bad it could cause bleeding in the lungs.

The outbreak was first detected in Kansas, in the United States, and spread worldwide from the early months of 1918, gaining its nickname when the Spanish press reported the severe illness of King Alfonso XIII. Spain's monarch survived his brush with the flu; millions would not.

Desperate measures were taken to isolate victims and control public health, with volunteers from the International Red Cross (including the nurse pictured here) supplementing overworked hospital staff. But even in countries such as the USA, which had been spared the worst effects of the Great War, it proved very hard to contain the spread. Weakened European nations were far more vulnerable; President Woodrow Wilson fell sick during the Paris peace conference of 1919.

In terms of absolute numbers of fatalities, Spanish flu was deadlier than the Plague of Justinian, the Black Death or the AIDS epidemic. Historians continue to debate the exact number of people killed, but by the time it came under control, between 50 and 100 million individuals had succumbed – around 3 to 6% of the world's population. It had been a miserable decade indeed.

1920s

The Roaring Twenties

'You ain't heard nothing yet...'

The first words ever spoken in movies,
The Jazz Singer (1927)

n the cafés of Chicago and the ballrooms of New York a new sound was emerging, blown from the trumpet of a kid from New Orleans called Louis Armstrong. By day 'Satchmo', as he was nicknamed, recorded with bands like the Hot Five, Hot Seven and Little Symphony. By night he brought the house down in packed theatres and ballrooms.

Jazz – a daring musical form that had drifted up from the steamy South, rooted in the African-American experience of the decades after the US Civil War – was the soundtrack to the 1920s. For some it was the noise of a carefree new world; for others a decadent cacophony that typified a world abandoning its moral compass.

To Louis Armstrong, it was simple. When he played, people couldn't help but listen. Many legendary sayings about jazz in particular and music in general would be attributed to Armstrong during his 40-year career. One of his best was: 'Hot can be cool, and cool can be hot, and each can be both.

'But hot or cool, man, jazz is jazz.'

Armstrong's jazz career was just beginning in the 1920s, and he was destined for great things: playing and creating music for an extraordinary five decades. His singing voice was – and remains – unmistakeable, a rich glorious gravelly sound

that was so compelling whether Armstrong was performing conventional lyrics or working on 'scat' – an improvised nonsense style made up of pure rhyme and scattergun sound. And of course there was also his brilliance as a player – powerful lungs and a divine gift for blowing into brass combining to make him the most recognisable and widely imitated musician of his moment. Although Louis Armstrong was still learning his craft in the 1920s, he was nevertheless a musical great who lived his life suffused with the spirit of that era.

In the Western world, the 1920s was a revolutionary, iconic decade. It was known variously as the Roaring Twenties, the Golden Twenties and *Les Années folles* ('the crazy years'). Economies and societies began to recover from the damage inflicted by the Great War. New technologies such as the motor car, air travel, radio and cinema changed the way that people travelled, communicated and lived.

Daring attempts were made to climb the world's tallest mountains and fly across oceans. Women were granted the right to vote. Writers and artists experimented with new styles, which did not merely lament the damage wreaked by the war of the previous decade, but also set out bold new visions for the future.

1920

[Jan] League of Nations, founded to promote and keep international peace, meets for the first time

[Feb] Austrian war veteran Adolf Hitler takes control of the German Workers' Party, renaming it the NSDAP or Nazi party

[Nov] Bloody Sunday in Dublin: assassinations carried out by the Irish Republican Army are met with a civilian massacre by British crown forces

1921

[Mar] Famine begins in Volga region of Russia, leading to deaths of at least 5 million people

[Mar] Kronstadt naval base rises in rebellion against Russia's Bolshevik government. Rebels crushed by the Red Army

[Apr] War reparations of 132 billion gold marks imposed on Germany by Allied powers

1922

[Jan] Italian reconquest of Tripolitania and Cyrenaica begins

[Aug] Michael Collins, revolutionary and leader of the National Army, shot dead during the Irish Civil War

[Oct] Vladivostok falls to Red Army troops, effectively ending the Russian Civil War in favour of the Bolshevik revolutionaries

[Oct] Benito Mussolini leads Italian fascists in the 'March on Rome', and is subsequently appointed as prime minister

1923

[Oct] The Walt Disney Company is founded in Los Angeles

[Nov] By now hyperinflation caused by inability to pay war reparations has rendered German currency completely worthless

[Nov] Munich Beer Hall Putsch carried out by Adolf Hitler and other leaders of the Nazi Party

1924

[Jan] Vladimir Ilyich Lenin dies. Joseph Stalin begins his rise to total power in the USSR

[Jun] British mountaineer George Mallory dies attempting to scale the summit of Mount Everest

[Oct] *Daily Mail* publishes the Zinoviev Letter – a forgery implicating the British Labour party in communist collaboration

Yet, at the same time, beneath the optimism of this brave new world, fresh horrors were being spawned. The Bolshevik Revolution in Russia had created civil war, famine and tyranny. Benito Mussolini's Blackshirts marched on Rome and carried out a coup in the name of the violent doctrine of fascism. Germany's defeat in the Great War and the severe peace imposed at Versailles created economic meltdown and stirred extremist parties such as Adolf Hitler's NSDAP (Nazi Party). The crude division of the Middle East which followed the Ottoman Empire's collapse incited Arab resentment and insurgency. Britain's failure to reach a satisfactory settlement in Ireland caused a civil war that created more Irish questions than it answered.

Mexico's long-running problems showed no signs of abating with a war between Catholic peasants and a resolutely anti-clerical government. And even America, the birthplace of Twenties optimism, bubbled with reactionary resentment, including a rebirth of the Ku Klux Klan and gang warfare caused by a disastrous experiment with the prohibition of alcohol. Then, as the decade drew to a close, the Wall Street stock exchange blew up, and the Golden Twenties gave way to the gloom of a Great Depression.

1925

[Apr] F. Scott Fitzgerald publishes *The Great Gatsby*

[Jul] Great Syrian Revolt begins, with the aim of removing French rule from Syria and Lebanon

[Jul] Adolf Hitler publishes the first volume of *Mein Kampf*

1926

[May] General Strike called in Britain, resulting in nine days of mass walkouts in protest against industrial pay and conditions

[Aug] Violence between Catholics and anti-clerical protestors in Guadalajara signals the beginning of the Cristero War in Mexico

1927

[May] Charles Lindbergh completes the first solo flight across the Atlantic, flying from New York to Paris

[Oct] First feature-length 'talkie', *The Jazz Singer*, released in US cinemas, marking the end of the silent movie era

1928

[Feb] First separate Winter Olympic Games held in St Moritz, Switzerland

[Jul] John Logie Baird makes first colour television transmission

[Sep] Ahmet Zogu declares Albania a monarchy and announces himself as King Zog I

[Oct] Haile Selassie is crowned king of Ethiopia

1929

[Feb] St Valentine's Day massacre takes place in Chicago, a bootlegger slaying widely thought to have been ordered by notorious gangster Al Capone

[Feb] Leon Trotsky exiled from the USSR

[Oct] Wall Street Crash wipes 25% off the value of the New York stock market, leading to the Great Depression

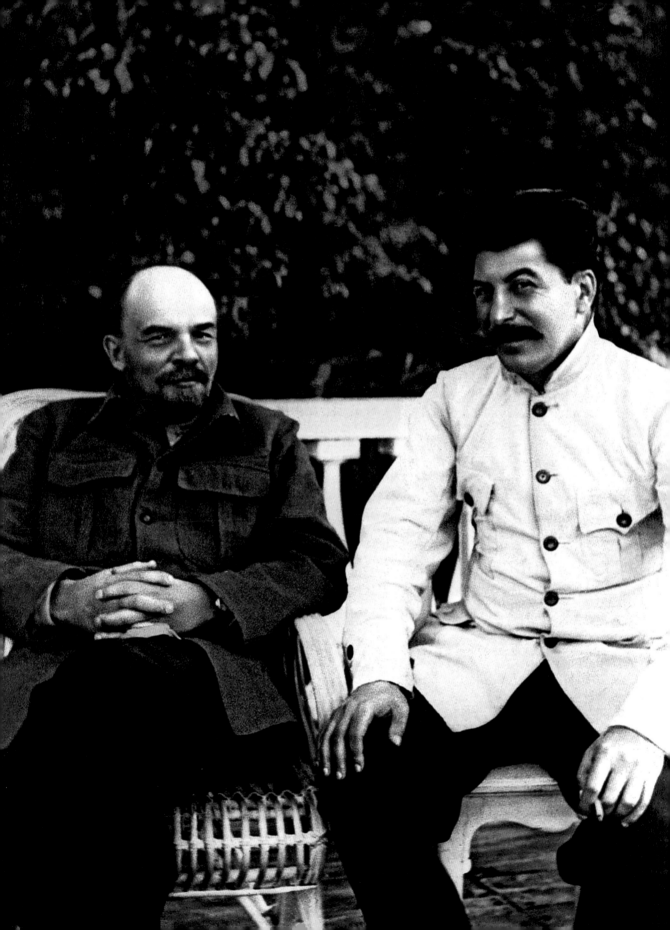

Lenin and Stalin

The Bolshevik Revolution of 1917, which led to the Romanovs' violent deaths, was masterminded by Vladimir Lenin (left) and he duly took power in its aftermath, as leader of Russia and then, from 1922, of the Soviet Union. This new Russia was a one-party state ruled by diktat from the centre and guided by communist theory as divined by Lenin from the writings of Karl Marx.

In late 1921, however, the 51-year-old Lenin's health was faltering badly. He suffered the first of three strokes in the spring of 1922, which left him unable to speak or walk. He died in January 1924: his body was embalmed and put on public display in Moscow, where it can still be visited in his mausoleum in Red Square. Before his death Lenin appeared to favour Leon Trotsky to succeed him, and explicitly recommended that the brutal and blunt Georgian Joseph Stalin be demoted from high office. But in the event Stalin (pictured here with Lenin at the latter's *dacha* in Gorki in 1922) seized power, manoeuvring a diffident Trotsky firstly out of power and then out of the USSR.

Stalin's consolidation of power during the 1920s and 1930s was ruthless and increasingly bloody. He purged the party of his enemies, many of whom would be shot dead after public show trials. His extremist economic policies brought starvation and misery to the country. By the mid-1930s Stalin had transformed himself from a party apparatchik into an unquestioned and feared dictator.

'Comrade Stalin... has unlimited authority concentrated in his hands, and I am not sure whether he will always be capable of using that authority with sufficient caution.'

Lenin, 1922

The Red Army

The Russian Civil War directly followed the Bolshevik Revolution of 1917, and it lasted until 1922, by which time the Red Army, organized by Leon Trotsky, had crushed the White Army's broad coalition of monarchists, foreign expeditionary forces and anti-communists of various other stripes.

The Red Army had been created out of workers' militias and the fragmented rump of the old tsarist army in 1918; it was motivated to fight partly through ideology and partly through discipline rooted in terror. Summary executions punished those who resisted conscription, those who did not fight with sufficient spirit, and those who ran away.

This photograph, taken in Moscow at the end of the Civil War, shows young boys in Red Army uniforms. Who these children are is not known, but a typical experience was that of the popular Soviet children's author Arkady Gaidar. A passionate Bolshevist as a teenager, he joined both party and army at the age of 14, fighting in Ukraine, Poland and Mongolia before retiring in 1924 to work as a journalist and novelist. By this time the war was over and he was still only 20 years old.

The formation of the Red Army was critical to the survival of the Bolshevik Revolution and the course of Russian history; its role would be decisive in the outcome of the Second World War. The army's founding figure, Trotsky, did not live to see this. After being exiled he was murdered in Mexico City in 1940.

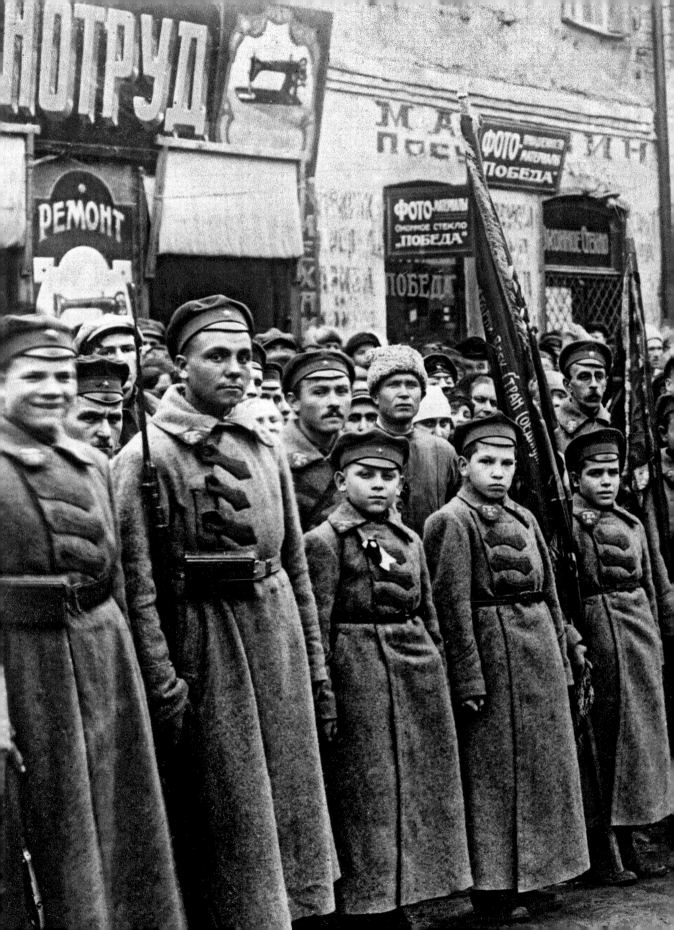

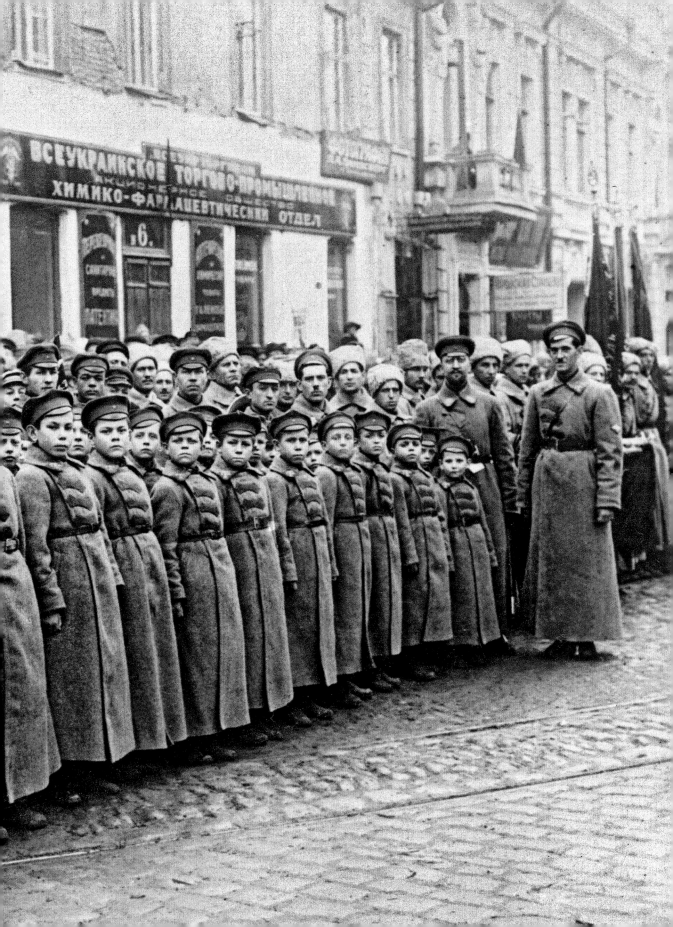

The Kronstadt Rebellion

Among the many desperate battles in the Russian Civil War, one of the most damaging was the rebellion of thousands of sailors, soldiers and disgruntled workers from Kronstadt – a fortress town and naval base on an island that controlled seaward access to Petrograd (formerly St Petersburg) across the frozen Baltic.

By the spring of 1921, years of fighting combined with a wholesale attempt to reorganize the Russian economy according to Bolshevik principles, had led to food shortages, industrial collapse and an increasingly mutinous mood among peasant farmers and city workers alike.

In early March, striking workers in Petrograd allied themselves with the troops of Kronstadt's fortress and the crews of two large battleships, the *Sevastopol* and *Petropavlovsk* (pictured here). They called for sweeping reforms across Russia, including increased rations and an end to political repression.

The result was a battle in which tens of thousands of Red Army troops besieged Kronstadt. Hundreds of rebels were killed, and thousands were either captured or fled to Finland.

The Kronstadt rebellion was doubly embarrassing to the Bolsheviks because of the role the sailors there had previously played in the 1905 Revolution against the tsar, during which the crew of the battleship *Potemkin* had rebelled against their officers. So although the 1921 insurrection was put down, it led to a brief reassessment of the Bolsheviks' dogmatic economic policies, and the progress to full communist control of the economy was relaxed.

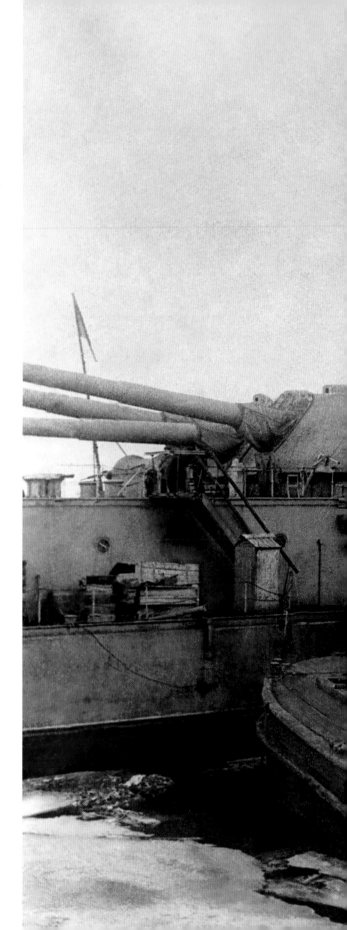

'Dictatorship is trampling the masses under foot. The Revolution is dead; its spirit cries in the wilderness...'

Revolutionary Alexander Berkman loses his faith after Kronstadt, 1924

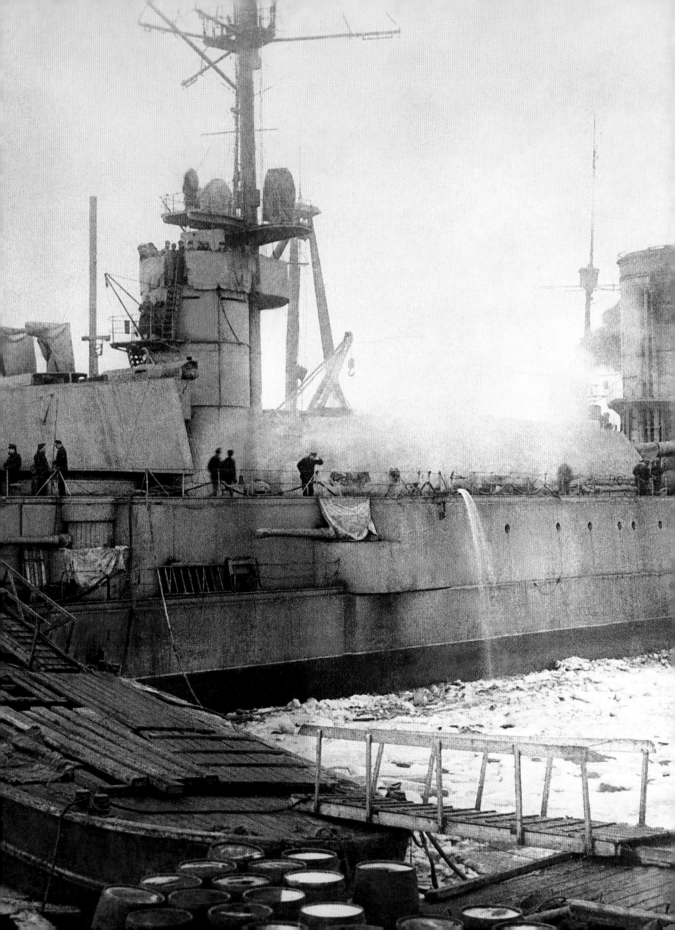

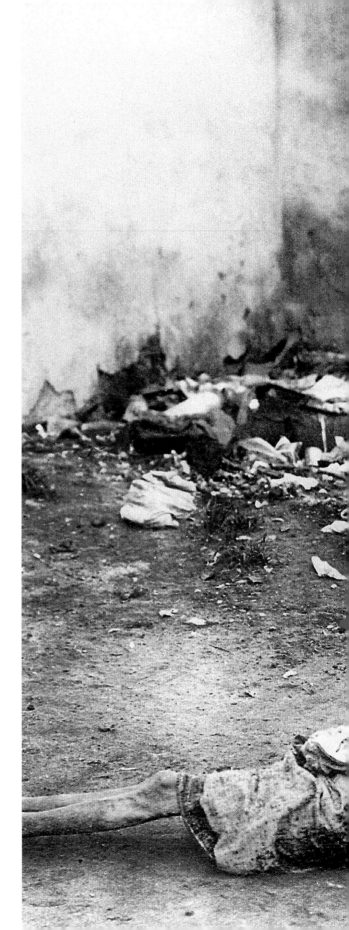

The Great Famine

War, dearth and drought: in 1921–2 this apocalyptic
combination inflicted on central Russia one of the
most dreadful famines ever experienced, killing
vast numbers of people across an area north of the
Caspian Sea roughly the size of Great Britain.

The exceptionally dry summer of 1921 produced
almost no rainfall, causing crops to wither in the
ground. When the harvest came, many regions
experienced almost total crop failure. On farmland
that was largely still cultivated by peasant agriculture
this would have been a disaster in any year; in the
early 1920s it was made many times worse by the
ruinous demands that had been placed on the
countryside during the civil war. Repeated grain
seizures to feed the Red Army meant that there were
no reserves to fall back on. Within months, Russia
was in the grip of a human catastrophe.

This photograph of a starving family was by no
means untypical as food became so scarce that dying
people ate anything they could find – ranging from
roots, bark and acorns to flour made from animal
bones, and even human corpses. Refugees roamed the
countryside and epidemic disease soared.

Lenin's government officially refused outside
help, but this was provided anyway: the International
Red Cross, International Save the Children and
American Relief Administration poured aid into the
country, bringing an end to the famine in 1923. By
this point between five and eight million people
were dead.

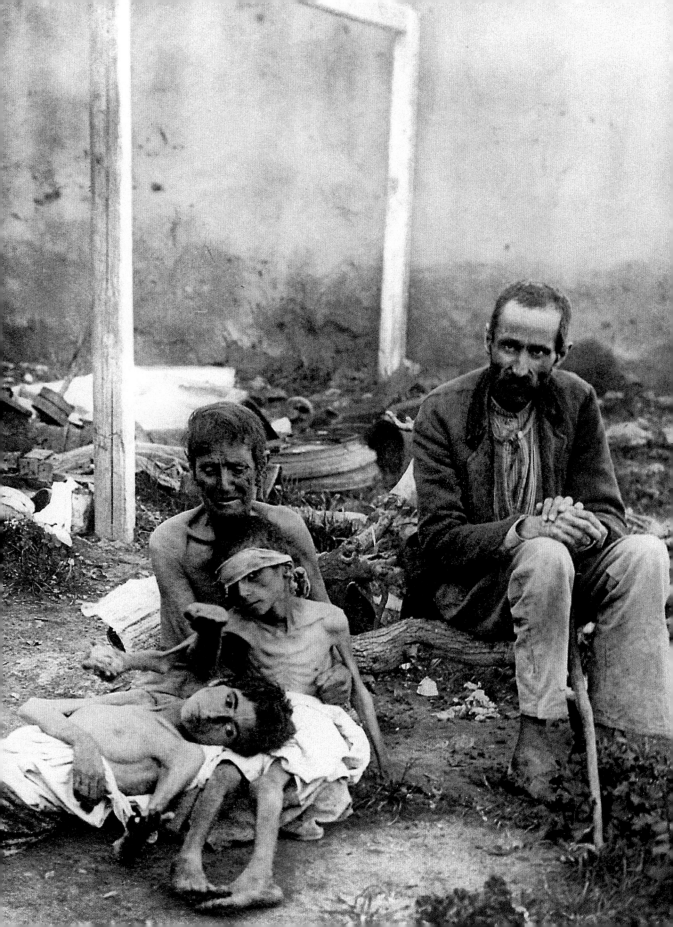

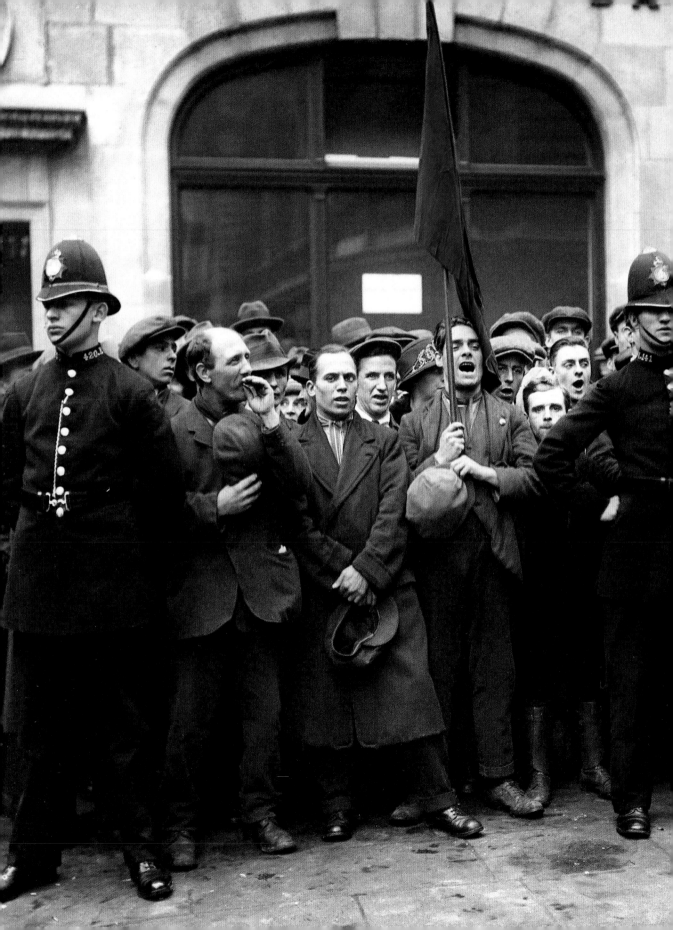

'The Red Flag'

With the triumph of the Bolsheviks in Russia, communist parties across Europe and America were inspired to take up the revolutionary cause. In the UK the Communist Party of Great Britain (CPGB) emerged in 1920, subsuming elements of other left-wing workers' parties but – crucially – not the Labour Party, which had begun to make headway in parliamentary elections since the turn of the century.

In 1924 the CPGB was falsely accused of trying to encourage criminal revolutionary activity. The charge was based on a forged letter, printed in the *Daily Mail*, purporting to be from the senior Bolshevik Grigory Zinoviev, president of the Communist International organization.

The 'Zinoviev letter', urging British communists to prepare for revolution, appeared just four days before the UK general election of 29 October and was used by the *Daily Mail* to accuse the minority Labour government of complicity with the revolutionary cause. Animosities between middle- and working-class people in Britain hardened as a result, a process that intensified in 1926, when a General Strike was staged across the country but failed to produce any improvement in working conditions.

Here demonstrators are pictured singing the socialist anthem 'The Red Flag' in London. Although membership of the CPGB was relatively tiny – numbering in the low thousands – and its performance in elections dismal, the profile and reach of the movement was still significant. By the end of the decade, however, its influence had waned somewhat, and despite a revival in the late 1940s and early 1950s, communism never gained a serious foothold in Britain as it did elsewhere in the world.

'Moscow issues orders to the
British Communists…
Everything is to be made ready
for a great outbreak of the
abominable class war.'

The *Daily Mail*, the Zinoviev letter, 25 October 1924

Ireland Divided

While industrial relations troubled the British mainland, in Ireland a full-blown revolution was afoot. In 1916 republicans rebelled against British rule and declared an Irish Republic. After the First World War, the Irish Republican Army (IRA) fought a fiercely contested guerrilla war with the British Army, the Royal Irish Constabulary (RIC) and unruly and violent auxiliaries recruited to assist crown forces. After two years of fighting this war ended in 1921; negotiations with Britain led to the signing of a treaty which left Ireland partitioned between Northern Ireland and a newly created Irish Free State.

Michael Collins, pictured here striding through Portobello Barracks in Dublin on 7 August 1922 following a memorial mass for Free State soldiers killed in an ambush, was one of the key architects of that treaty: a staunch republican and a ruthless, highly adept soldier. For Collins, the Anglo-Irish Treaty was a stepping stone on the way to full Irish independence. Many of his republican comrades, however, disagreed.

Antagonism between pro- and anti-treaty factions exploded in June 1922 and Collins, who had been appointed to lead a provisional government, was now forced to take military command of the army of the Irish Free State in a civil war that ranged many of his former allies against his own nationalist forces, bolstered by Irish veterans of the British army in the First World War. One of the first orders given under his command was for troops to start shelling Dublin's legal courts, which had been occupied by anti-treaty forces. Collins was assassinated in an ambush by anti-treaty forces in County Cork on 22 August 1922, just 15 days after this photo was taken.

'I tell you this, early this morning I have signed my death warrant.'

Michael Collins, December 1921

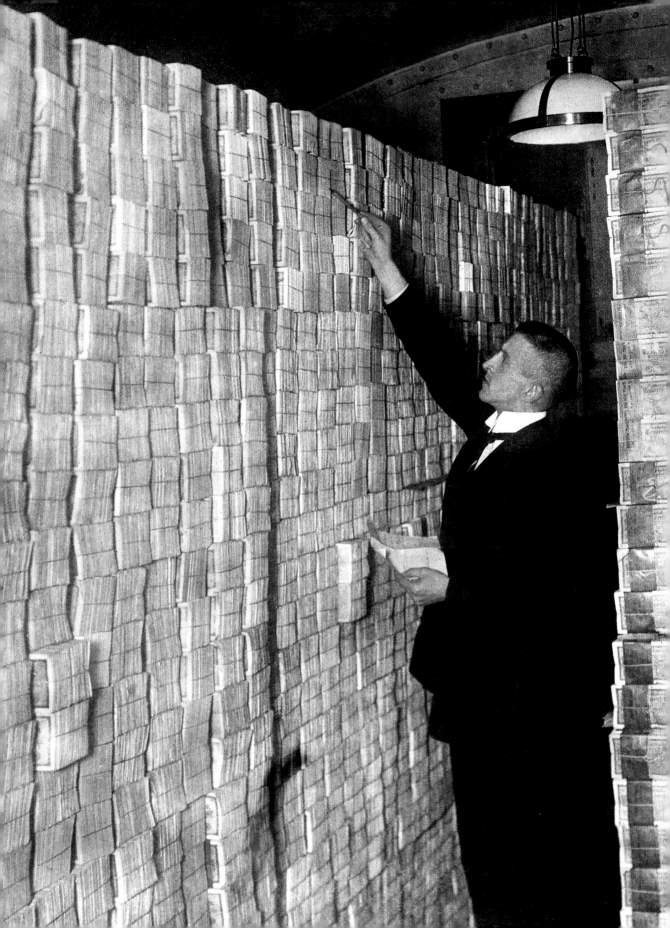

Hyperinflation

Following the losses of the Great War and the humiliation of the Treaty of Versailles, Germany was rocked again during the 1920s: not by civil war but by economic tremors. The massive bill for reparations imposed at Versailles was far beyond the nation's ability to afford. As a means of paying its war debt, the Weimar government began printing paper marks in vast quantities. This photo taken after the autumn of 1922 by the French photographer Albert Harlingue shows a basement piled high with bundles of thousand-mark notes.

Shortly after the end of the war, one US dollar was worth around 50 marks. Thereafter German currency steadily began to lose value. By late 1921 one dollar was worth 300 marks; by Christmas 1922 the exchange rate had passed 7,000 marks to the dollar. Uncontrollable hyperinflation had set in: a year later a dollar was worth more than four billion marks, and reparations were being taken in raw materials seized by French and Belgian troops from German industrial lands in the Ruhr.

The German economy was eventually restored to normality by the Dawes and Young Plans of 1924 and 1929, which poured US investment into the country. But the experience damaged the credibility of the Weimar Republic and the standing of the Allies who had imposed the peace. The absurd sight of wages paid in wheelbarrows or loaves of bread changing hands for hundreds of thousands of marks was not easily forgotten. To make things worse, the conditions that created hyperinflation were also helping to foment extremist political movements. Germany's future had unwittingly been forged among walls of worthless cash.

'The policy of reducing Germany to servitude for a generation… should be abhorrent and detestable… even if it did not sow the decay of the whole civilized life of Europe.'

John Maynard Keynes, *The Economic Consequences of the Peace* (1919)

Adolf Hitler

As Germany laboured beneath the burdens of war reparations the NSDAP – *Nationalsozialistische Deutsche Arbeiterpartei* or Nazi Party – was just one of many small, fairly insignificant political parties in Germany. But it was under new leadership.

Adolf Hitler was born in Austria in 1889, and had served in the Bavarian army during the Great War. He harboured the same resentments of the peace process as many other Germans – but he combined them with an often incoherent set of other reactionary hobby-horses, most notably virulent racism, anti-Semitism and anti-Marxism, a strong, chauvinistic nationalism, and a vague commitment to state control of major industry and the press.

Together these could be called fascism, but the Nazi Party was less an expression of any one political philosophy than the vehicle for Hitler's depraved ambition and patchwork of populist prejudices. A hectoring but charismatic public speaker, he had a gift for telling audiences what they wanted to hear, in simple, defiant language that was readily understood by ordinary Germans. He was also an enthusiastic propagandist and a ruthless party leader (Führer) who encouraged the development of the Nazis' paramilitary wing (known as the *Sturmabteilung*, or SA) and militaristic youth movement (the Hitler Youth).

With national confidence low, Hitler soon found a willing audience for his explosive oratory and new party. During the early 1920s, when this photograph was taken, the Nazis rapidly grew their membership and profile in Bavaria. By 1923 Hitler was ready to make his first grab for power.

'…The keynote of his propaganda in speaking and writing is violent anti-Semitism.'

The New York Times reports on Hitler's political platform, December 1922

'Either the German revolution begins tonight or we shall be dead by dawn!'

Adolf Hitler at the *Bürgerbräukeller*, 8 November 1923

The Munich Putsch

Hitler's rising confidence led in the autumn of 1923 to a battle on the streets of Munich, known as the Beer Hall Putsch. Convinced that the time had come for him to seize control of Bavaria and then Germany, Hitler colluded with the prominent Munich politician Gustav Ritter von Kahr to launch a rebellion, march to Berlin and instal the war veteran General Erich Ludendorff as Germany's new leader.

At the crucial moment in early October, however, Kahr lost his nerve and abandoned the plot. Frustrated, on the night of 8 November Hitler, along with his associates Rudolf Hess and Hermann Göring and 600 SA stormtroopers, surrounded a beer hall – the *Bürgerbräukeller* – where Kahr was giving a speech. They burst in, Hitler firing a revolver and declaring the Bavarian government to be deposed.

A tense night followed, but in the morning as the plotters marched into the streets of Munich it became clear that they did not have a clear plan or sufficient numbers to go very far. A small street battle broke out between the police and around 2,000 rebels, in which the Nazi putschists were scattered.

This photograph by Hitler's friend and official photographer Heinrich Hoffmann, often dated to 8 November, actually shows an SA exercise several weeks after the putsch. By this time Hitler had been arrested. He was subsequently jailed for attempted treason, but served little more than a year of his sentence, enjoying comfortable prison conditions in which he dictated to Hess *Mein Kampf* ('My Struggle'), a notorious memoir-cum-manifesto expressing his bombastic, hate-fuelled ideas.

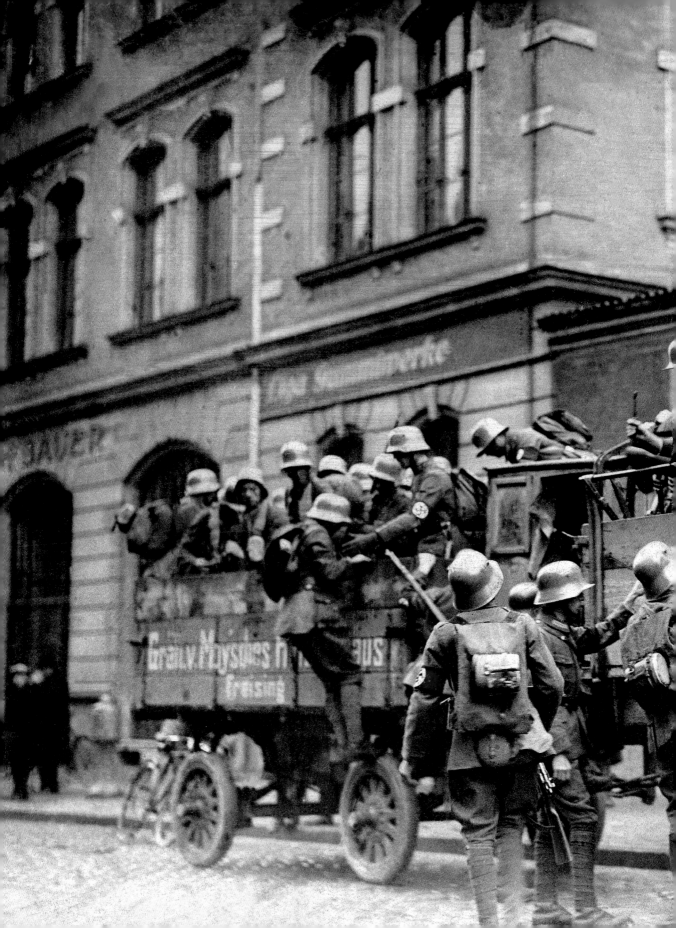

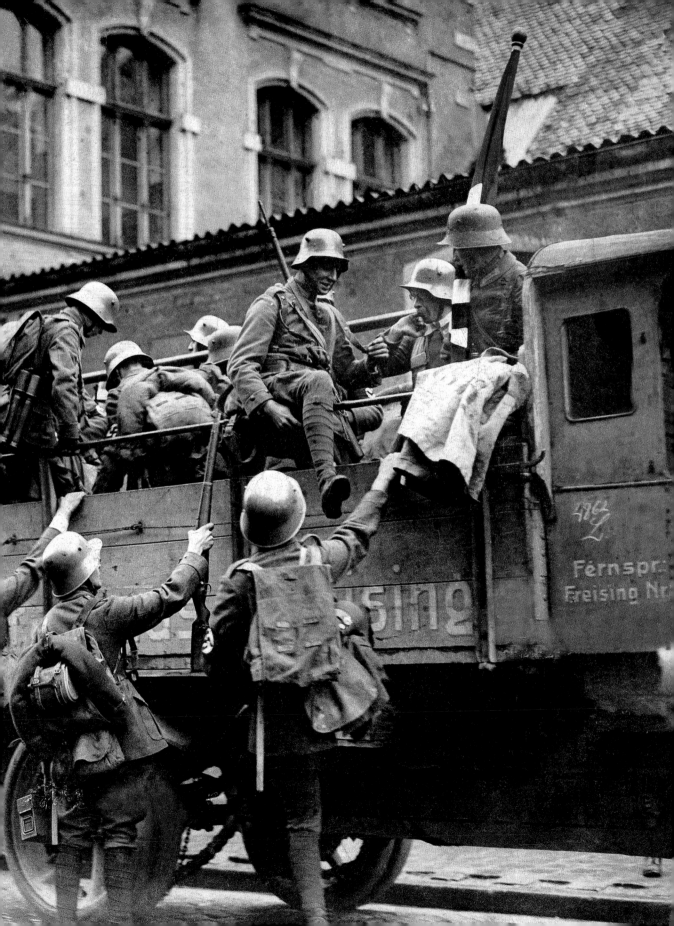

Il Duce

Hitler's aborted Munich coup was inspired in part by the success of another bombastic European leader: Benito Mussolini, a 39-year-old journalist and one-time socialist who in October 1922 had led his fascist Blackshirts in a 'March on Rome', where they deposed the prime minister and installed Mussolini as Italy's political leader. From this position, endorsed by King Victor Emmanuel III, Mussolini set about transforming Italy from a parliamentary democracy into a totalitarian state over which he ruled with absolute power as *Il Duce* ('The Leader').

The fascist doctrines that Mussolini developed were based on traditionalist social values, a strong state, racial theory, aggressive nationalism and a desire to acquire *spazio vitale* (living space) by conquering lands historically associated with Italy: Dalmatia, Slovenia, Albania and Savoy. Reviving the Roman Empire was his broadest goal, and his means were violence and coercion. His paramilitary Blackshirts beat up his enemies and enforced the will of their leader. The country was transformed into a police state. Mussolini's cult of leadership was expressed in pompous, militant speechmaking, macho posturing and his acquisition of titles and offices.

Mussolini's grandiose foreign ambitions became evident almost as soon as he took power. In 1923 Italy invaded Corfu, ignoring League of Nations protests. And in North Africa, where Italy controlled Libya, land confiscations and round-ups of natives began in 1923. The dangerous nature of Italian fascism was evident from the start – but it was not clear who was prepared to stand up to the posturing *Duce*.

Libya

Italy had been engaged in a sporadic war of
conquest in North Africa since before the First World
War, attempting to assert control over the regions
of Tripolitania and Cyrenaica. Recapturing territories
in the Maghreb, of the sort that had once been held
by the Roman Empire, appealed to Mussolini's
inclination for the grandiose. So Italian troops
supported by tanks, aircraft and local camel corps,
such as those pictured here, raced across the deserts,
making rapid territorial gains before their advance
was checked by a guerrilla movement led by a
legendarily tough soldier and Quranic scholar called
Omar Mukhtar, who had spent much of his life
combating French and British imperialism in Chad
and Egypt.

The fighters Omar Mukhtar commanded were
loyal to the Senussid tribal dynasty and his movement
became known as the Native Resistance. After several
years of bitter desert warfare, a fragile truce was
brokered between Italy and the Senussids in 1929.
But this collapsed within a year.

As the 1930s dawned Mussolini approved a
change of tactics under the pitiless General Rodolfo
Graziani, who was authorized to crush the resistance
by any means necessary and establish a unified Italian
colony under the ancient name Libya – which would
incorporate Tripolitania, Cyrenaica and the southern
region of Fezzan. Tens of thousands of native-born
Libyans were rounded up and placed in concentration
camps. The 70-year-old Omar Mukhtar was captured
and hanged in 1931 and the 'Pacification of Libya',
as it became known, was complete three years later.

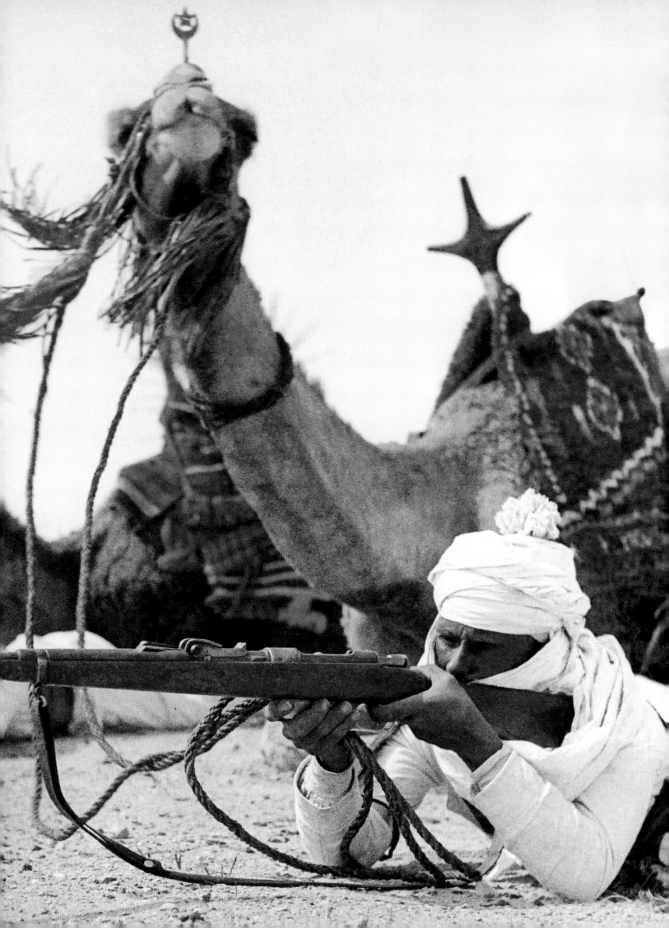

The Great Syrian Revolt

Ottoman defeat in the First World War had left an empire to be carved up between the victorious Allied powers, which was largely done according to the vision of the Sykes–Picot Agreement of 1916, which placed a greater emphasis on the survival of European colonies than on the needs of the inhabitants of the region. Former Ottoman territories in the Middle East were divided into mandates or 'spheres of influence' for Britain and France.

The French sphere covered much of Greater Syria, including Lebanon, but almost as soon as occupying troops arrived in 1920 they were faced with a series of revolts in favour of Syrian independence under the rule of Faisal ibn Hussein, the third son of the grand sharif of Mecca.

Although this rebellion was put down and Faisal chased into exile, resistance to the French continued throughout the 1920s. In 1925 another revolt exploded under the Druze leader Sultan Pasha al-Atrash, who encouraged all Arabs in Syria – Druze, Sunna, Shia, Alawite and Christian – to join his cause.

Uprisings occurred in the cities of Hama and Homs, and some of the fiercest fighting took place around Damascus, which was vigorously and repeatedly shelled, reducing parts of the city to the smoking rubble that can be seen in this photograph. It took until the spring of 1927 for order to be fully restored. Independence from French rule was only achieved following the end of the Second World War in 1945.

'Religion is for God and homeland is for all.'

Saying attributed to Sultan Pasha al-Atrash, 1925–7

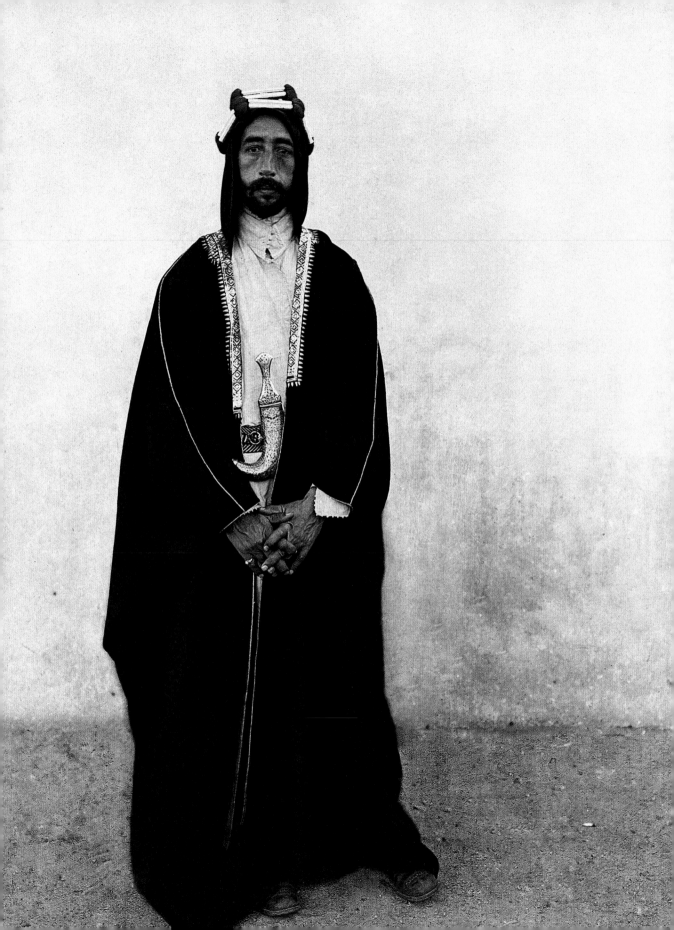

King Faisal

When Faisal ibn Hussein, pictured here, was hounded from Syria by the French in 1920 it was only the latest adventure in a life that had been packed with incident. Born in 1883, he was the third son of Hussein ibn Ali, who had declared himself king of the Arabs during the Great War and revolted against the Ottoman Empire. The vision shared by both Hussein and his son Faisal was that of a single nation constructed from the Arab areas under Ottoman rule, in which common Arab values transcended religious differences and the sectarian rivalries of Sunni and Shia Islam.

One of Faisal's chief motivations for joining his father in rebellion against the Ottomans was the promise of British backing for the pan-Arabist project once the war was over – a hope that was encouraged by his friend T. E. Lawrence (aka Lawrence of Arabia). At the end of the war, when it became clear that the Middle East was instead to be split into imperial mandates in accordance with the Sykes–Picot Agreement, Faisal was bitterly disappointed. However, following the failure of his attempt to rule Syria, he accepted an offer from the British government to take power in Mesopotamia as King Faisal I of Iraq. He did not give up on his vision of pan-Arab unity, but by the time of his early death, aged 48, which occurred during a visit to Switzerland in 1933, he had brought Iraq out of British oversight and into full nationhood.

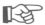

The Cristero War

The Mexican Revolution of the 1910s had come to a temporary end in 1917, but peace was shattered in the 1920s, as a struggle between government and church from 1926 to 1929, known as the Cristero War, pitted pro-church peasant rebels against the military power of the federal army. The ensuing violence made the sight of bodies piled up in fields – as captured here by the American photographer James Abbe – all too familiar.

The catalyst for war was the decision of President Plutarco Elías Calles, elected in 1924, to enforce anti-Catholic provisions in the constitution. Churchmen were banned from holding political roles, were not permitted to criticize the government and had their property rights severely curtailed. Church schools and bell-ringing were banned. Priests were forbidden to wear clerical dress in public.

Outraged by this frontal assault on traditional religious life, people in central Mexico began to band together under the slogan ¡Viva Cristo Rey! ('Long live Christ the king!'). At first the Cristeros (soldiers of Christ) engaged in peaceful demonstration and civil disobedience, but by the beginning of 1927 running battles had broken out between armed peasants and government agents. Eventually foreign diplomacy, led by the US ambassador Dwight Morrow, and the election in 1928 of a more conciliatory president, Emilio Portes Gil, brought the crisis to a close. By that stage, however, the Cristero War had taken the lives of around 100,000 people.

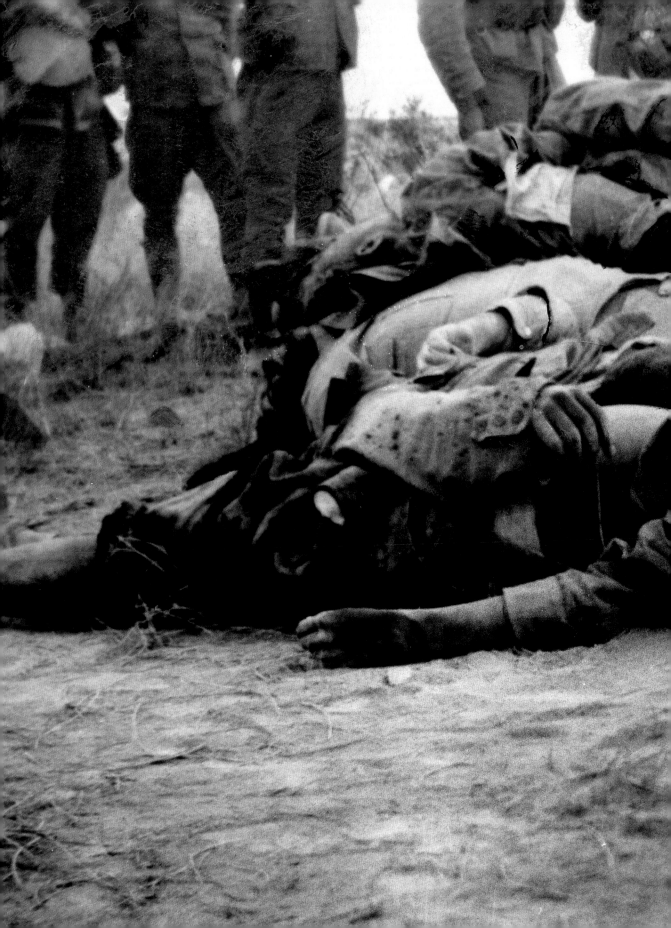

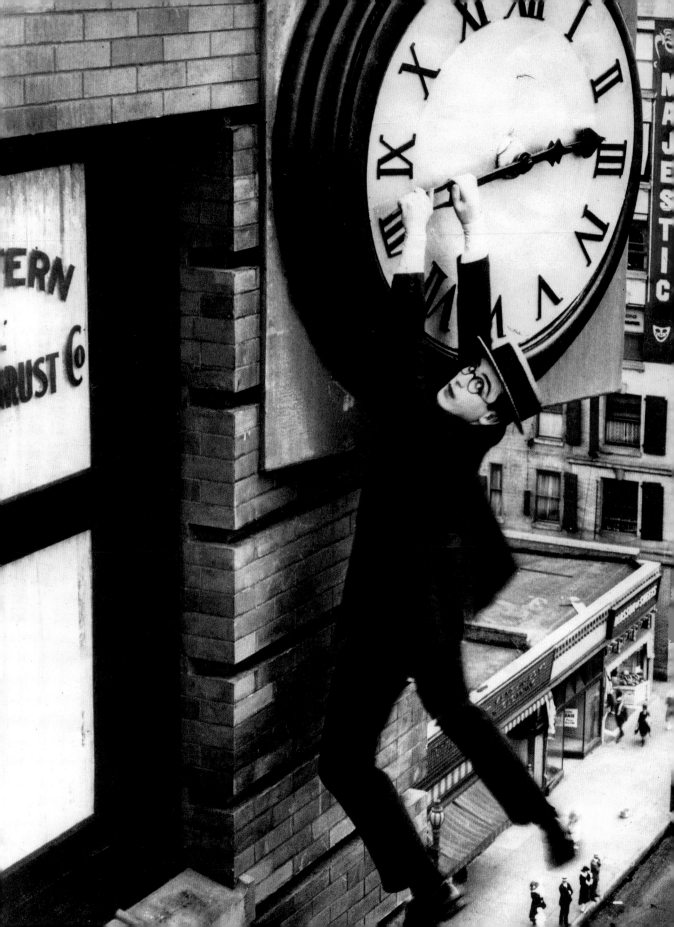

Safety Last!

A new type of hero and heroine emerged in the 1920s: the silent-movie star. Actors like Greta Garbo, Charlie Chaplin, Louise Brooks, Buster Keaton, Douglas Fairbanks and Harold Lloyd became tremendously popular in Europe and America, appearing in feature-length black-and-white films produced in Los Angeles (rather than New York where the industry had been based during the previous decade). Audiences flocked to pictures such as *The Gold Rush, Ben-Hur, The Ten Commandments* and *The Hunchback of Notre Dame*, in which directors became increasingly creative and daring with their development of plot and character.

The 1920s also saw a vogue for recurring comedic heroes such as Chaplin's 'Little Tramp' and Lloyd's 'glasses' man – pictured here in an iconic still from *Safety Last!*, a romantic comedy released in 1923. Lloyd was one of the highest-earning stars of the decade, thanks in part to his business savvy: he produced as well as starred in his own films. But his success also owed much to the sheer appeal of his characters, the audacity of his stunts and his disdain for personal safety. By the time he was ascending skyscrapers for the action sequences in *Safety Last!* he had already lost his right thumb and forefinger to an accident in which he was filmed lighting a cigarette from the smouldering fuse of a prop bomb.

The silent-film boom did not last long: in 1927 the first feature-length 'talkie', *The Jazz Singer*, was released, beginning a rapid transition to soundtracked films, which by the end of the decade was complete.

'My humour was never cruel or cynical. I just took life and poked fun at it.'

Harold Lloyd, reflecting on his career, 1971

Flappers

The 1920s were transformative years for many women round the world, nowhere more so than in the United States. A booming economy, successful suffrage movement and a sense that women had contributed handsomely to the war effort coincided with the rise of a generation of women with fresh ideas about sex, marriage, education, work and the definition of public decency and decorum.

The so-called Roaring Twenties were in a large part defined by images of 'flappers' – young women who dressed provocatively, smoked, drank, danced as they chose, listened to jazz music and generally flouted convention. And their progressive impulse was reflected in American law: the 19th Amendment was ratified in time for women in all states to participate in the 1920 presidential election.

But liberality came unevenly. This photograph shows women on a beach by the Potomac River in Washington DC being inspected for compliance with bathing regulations. Many state park superintendents upheld ordinances insisting that necklines for swimwear plunged no lower than armpit level, while hemlines were to be at most four inches (10cm) above the knee.

This lag between attitudes and laws was typical of the story of women's rights at virtually every level. And as it was with swimsuits, so it was with the law: a significant minority of Southern states refused ratification of the 19th Amendment in 1920. Indeed, it took another 50 years for Georgia, Louisiana and North Carolina to formally approve this most basic sign of women's equality, while Mississippi symbolically ratified the Amendment in 1984.

Prohibition

Set against the permissiveness of the flapper generation was a new conservatism in American society, represented most clearly by Prohibition: a nationwide ban on the manufacture and sale of alcohol mandated by the 18th Amendment and enforced by the Volstead Act, which came into effect on 16 January 1920.

The Temperance Movement – a pious, largely Protestant group with a moral objection to drinking on the basis that it led to social evils, including violence, destitution, corruption and idleness – had been prominent in the United States since well before the Civil War. Newcomer members of the Union such as Kansas, North Dakota and Oklahoma outlawed alcohol as part of their state constitutions. But lobbying during the Great War by groups such as the Anti-Saloon League converted an issue of local preference into a national crusade against the demon drink.

The effects of Prohibition were roughly opposite to those intended. Arguments that outlawing alcohol production would increase the availability of grain for more wholesome uses were offset by a severe decline in government income from taxing alcohol consumption. Americans' thirst was intensified, not subdued, by enforced sobriety. While restaurants like this one in New York City advertised their dry status, speakeasies (illegal bars) thrived by the thousand. A lucrative black market sprang up in illegal distilling and bootlegging, controlled by murderous gangs such as Al Capone's Chicago Outfit.

Public outrage was now fuelled not by popular inebriation but by rampant criminality and bootlegger slayings, like the Saint Valentine's Day Massacre of February 1929. In 1933 Prohibition was officially abandoned: an experiment in high national morality that ended in unvaliant failure.

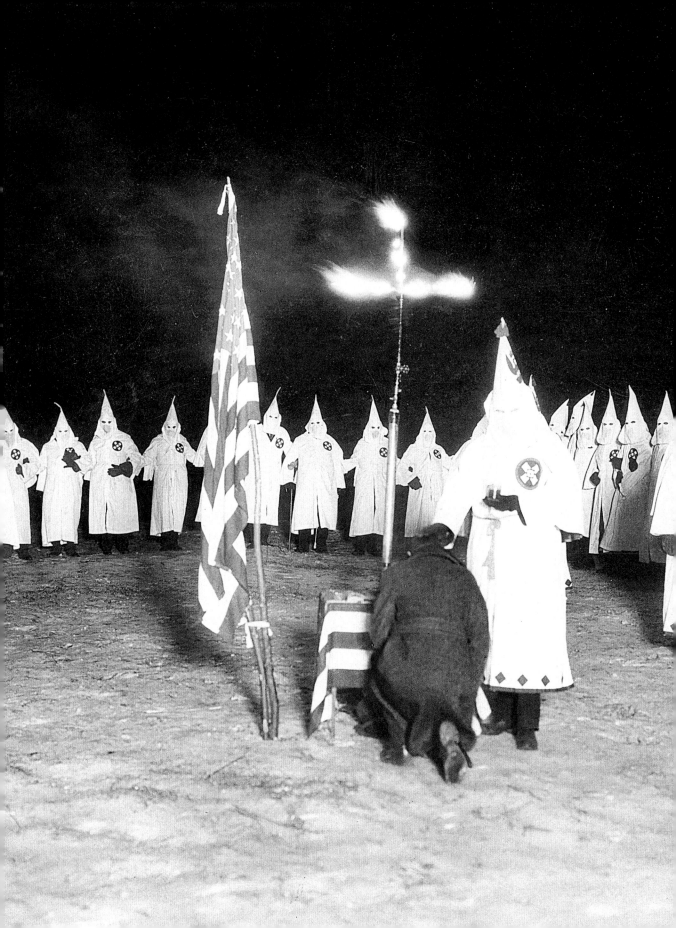

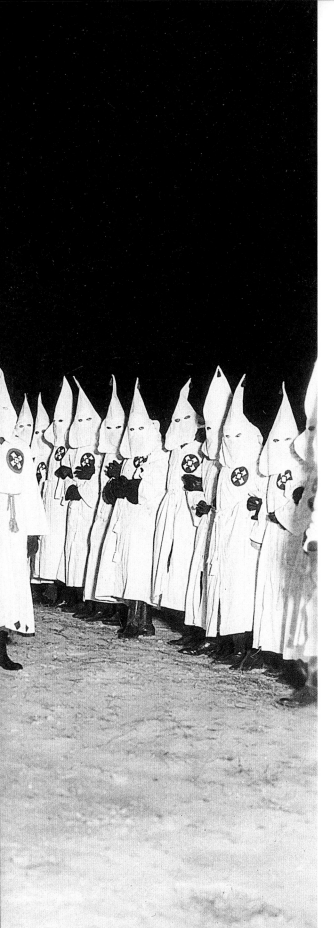

The Ku Klux Klan

Among Prohibition's staunchest supporters were the Ku Klux Klan. This nativist, white supremacist organization, first established in the South during post-Civil War Reconstruction, was revived in the 1920s, drawing together middle-class white Americans beneath a banner of stiff-necked Protestant bigotry, anti-progressive sentiment, intimidation and cod-spiritual ritual.

The second coming of the Klan was inspired by the 1915 silent film *Birth of A Nation*, which romanticized the role of the first Klan in defending American virtue. An incompetent Alabaman physician called William J. Simmons decided to refound the order with himself as Imperial Wizard. Despite slow beginnings, the revived Klan shot to renewed popularity in the 1920s, when its membership peaked at around four million. The Klan's goal was to police a supposed moral decline; Klansmen took aim at illicit drunkenness, bootlegging, sexual promiscuity, criminality and abortion.

Through white-robed meetings, public marches and violent attacks on civilians, Klansmen terrorized those they deemed immoral, as well as black, Jewish, Catholic, Communist, Mexican and Asian Americans. This expanded considerably the brief of the first Klan, who had chiefly targeted black people. Their methods included cross-burning, tarring and feathering, lynching and flogging.

An essential part of Klan activity was the enactment of pompous ceremony, as in this photograph taken by Jack Benton, which depicts the night-time initiation of a new Klansman, conducted before a burning cross and the United States flag. The frisson of combining uniformed ritual with mob rule proved highly seductive to many Americans, who often sympathized with the Klan's means and methods, even if they did not join.

Eventually Klan violence backfired. By the 1930s membership had waned – although the movement would have a third coming in response to the Civil Rights movement of the 1960s.

Attempting Everest

Earth's tallest mountain had been given the English name 'Everest' by Britain's Royal Geographic Society in 1865, after the foul-tempered and unpopular former president of that organization, Sir George Everest (who actually pronounced his name *Eave-rest*). But no known person had ever climbed its 8,848 metres and returned to tell of their adventure. In the early 1920s three expeditions set out to remedy that, travelling from British India into the little-known Himalayan range via Tibet and seeking a passage through merciless terrain, painful altitude and terrible weather to the top of the world.

In 1921 an exploratory expedition travelled through the ancient fort-town of Tingri (also known as Gang-gar, meaning 'high encampment'), where this photograph was taken of the military governor with his mother and wife. The following year a direct assault on Everest was attempted, which ended in disaster when an avalanche killed seven Tibetan and Nepalese porters. In 1924 a third mission also failed, again fatally. The casualties this time included the British climbers Sandy Irvine and George Mallory – the latter the only man to have been present on all three expeditions, and a late convert to the idea that Everest could only be scaled using supplemental oxygen canisters. When asked the purpose of undertaking a suicidal climb up such a forbidding mountain, Mallory coined the famous phrase: 'Because it is there'. His body was eventually found, well preserved on the mountainside, in 1999.

'We must… pit our skill against the obstacles wherever an opportunity of ascent should appear until all such opportunities were exhausted.'

George Mallory records his impressions of Everest from near the town of Tingri, June 1921

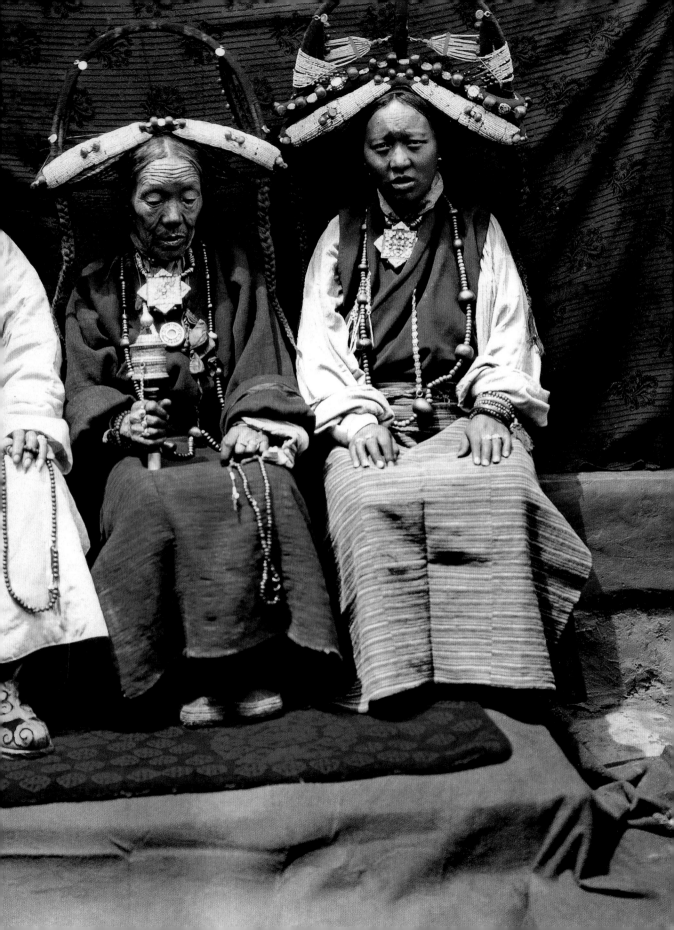

Flying the Atlantic

The Everest of air flight was the transatlantic crossing.
In 1919 a pair of British aviators named John Alcock
and Arthur Brown had flown from St John's in
Newfoundland to County Galway in Ireland in a
biplane bomber repurposed from the Great War.
Then in 1927 Charles Lindbergh, a 25-year-old US Air
Mail pilot, travelled solo from New York to Paris.

The journey earned Lindbergh lifelong
international fame; but his was soon surpassed by that
of Amelia Earhart, pictured here. She was the first
woman to fly across the Atlantic, as a passenger in a
three-person flight in 1928, and four years later the
first to make the journey on her own.

Earhart was every inch an American woman
of the 1920s, cultivating boyish looks and chasing
celebrity, declining to change her surname when she
married, and serving as president of The Ninety-
Nines, an organization dedicated to promoting the
cause of women in the air.

But Earhart's most enduring deed was her
disappearance. In 1937 she and her navigator Fred
Noonan embarked on a 47,000km circumnavigation
of the globe aboard a customized Lockheed Electra
10E. They set out east from Oakland, California and
had flown the majority of their route when they took
off on 2 July 1937 from Lae in New Guinea, across the
Pacific towards the minuscule Howland Island.

A series of navigation errors meant they never
arrived. Their fate is still uncertain: either the
Lockheed ran out of fuel and ditched into the sea, or
(less likely) they landed elsewhere and starved or were
captured and killed. The mystery continues to invite
fevered speculation and conspiracy theory to this day.

'Hooray for the last grand
adventure! I wish I had
won, but it was
worthwhile anyway.'

Earhart in a letter addressed to her father in
case of her death aboard her first
transatlantic flight, 1 June 1928

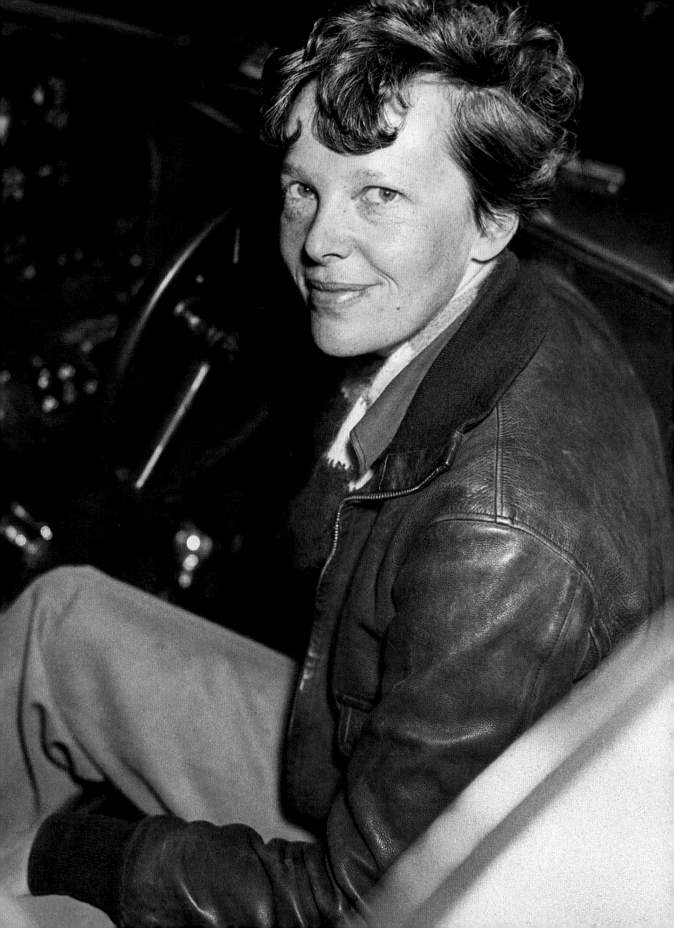

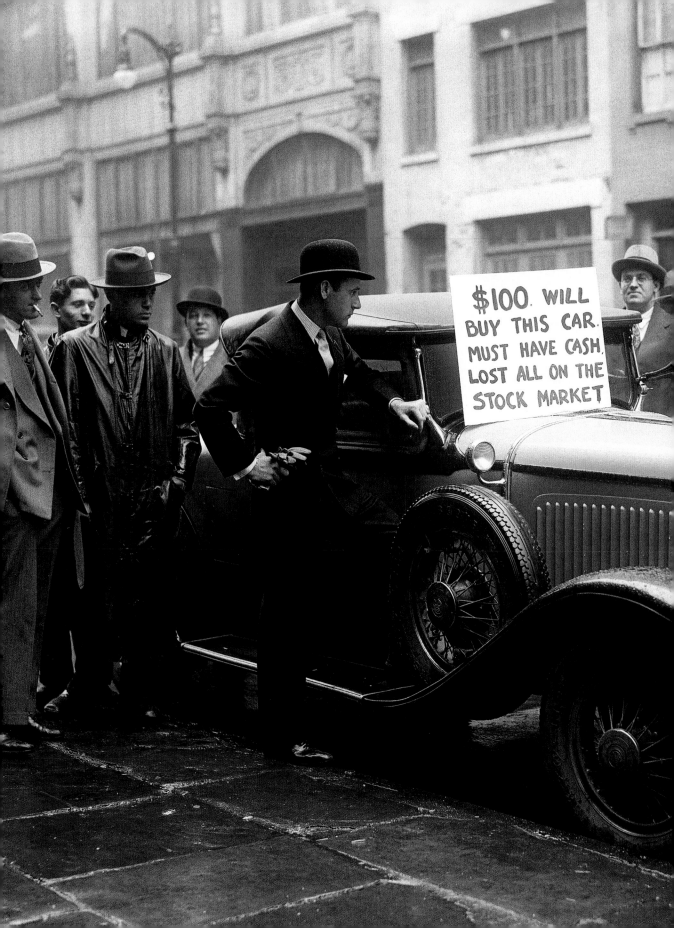

The Wall Street Crash

A decade after the end of the Great War the world economy was beginning to recover, and despite civil wars and social unrest in many parts of the world, optimism for the future was building. The US president Calvin Coolidge famously began his 1928 State of the Union address by speaking of 'tranquillity and contentment' at home and problems abroad 'yielding to the touch of manifest friendship'. Americans, he said, 'can regard the present with satisfaction and anticipate the future with optimism'.

Then, between Monday 28 October and Tuesday 29 October 1929, the New York stock market shed around 25% of its value during the worst financial crash in history. Panicked traders sold and sold, and sold, wiping out life savings in an instant and wrecking the security of millions of people in a blind stampede of money gone mad. Fights erupted on trading floors and ruined investors, such as this broker, Walter Thornton, hit the streets to sell their assets for whatever they could muster.

The Wall Street Crash lasted for another fortnight, but its effects would continue for years. Businesses folded, millions of jobs were lost, and financial collapse spread like a virus across almost every major world economy. The Roaring Twenties ended with a shriek of terror, plunging the world into a Great Depression from which it would take a generation and another global war to recover.

The Road to War

'We have... blundered in the control of a delicate machine, the working of which we do not understand.'

John Maynard Keynes, 'The Great Slump of 1930'

'Mama's been shot!' yelled one of Florence Owens' many children, when they spotted their mother's photograph in the *San Francisco News* on 11 March 1936. Florence, 32, had not been shot. An ink-blot resembling a bullet-hole had merely formed in the middle of her forehead on that copy of the newspaper. But the portrait – which had been taken a few days earlier at a roadside camp for pea-pickers off Highway 101 in California – would turn her image into an icon.

Few people would ever know Florence's name, yet her vacant stare into the middle distance, coupled with the apparent despair of her faceless daughters Katherine and Norma, seemed to capture the worst fears of ordinary people throughout America and the entire world during the 1930s.

Work was scarce. Families were destitute. Severe economic recession had been tough on all Americans. On the American plains, over a thousand kilometres east of California, successive droughts had turned millions of acres of farmland into near-desert – the so-called Dust Bowl. The future, if there was one, seemed terribly bleak.

The picture was taken by Dorothea Lange, a 40-year-old photographer who had been sent out into the American wilderness by President Franklin D. Roosevelt's Resettlement Administration – a federal agency set up to offer solace and redress to those who had lost their homes and jobs during the savage economic downturn that followed the Wall Street Crash of 1929.

Florence Owens was typical of the times. She was descended from displaced Native Americans, and spent much of her adult life bearing ten children by four different men, and hauling them about the country in search of hardscrabble labour picking vegetables. On the day she encountered Lange, her family had stopped at the pea-pickers' camp because Florence's partner's car, a Hudson sedan, had broken down. (Not, as Lange claimed in her notes, because they had sold the tyres.) Just like millions of other Americans, they were dirty, hungry and broke.

They were not, perhaps, as hopeless as the image implied; in later years Owens and her children would express some resentment of the story their faces were used to sell. Nevertheless, to the wider public this image (one from a set of six, shot quickly on a Graflex camera) spoke of a society in which the American dream appeared to be on the verge of collapse.

Lange's boss, Roy Emerson Stryker, described it as the 'ultimate' photo of the age.

1930

[Feb] Communist party of Vietnam established

[Mar] Indian lawyer and civil rights leader Mohandas Gandhi begins his 'Salt March' from Ahmedabad to Dandi

[Oct] Revolution in Brazil overthrows Washington Luís and installs Getúlio Vargas as president

1931

[Mar] USA adopts *The Star-Spangled Banner* as its national anthem

[Aug] Disastrous river flooding in China causes millions of deaths

[Oct] *Cristo Redentor*, a massive statue of Christ with his arms outstretched, is officially unveiled on a mountaintop above Rio de Janeiro

1932

[Mar] Start of the Holodomor – man-made famine in Ukraine and other parts of the USSR, killing millions of people

[Jun] Chaco War begins between Bolivia and Paraguay over the disputed territory of Gran Chaco

[Sep] House of Saud completes conquest and unification of the Arabian peninsula and establishes the kingdom of Saudi Arabia

1933

[Jan] Adolf Hitler appointed German chancellor by President Paul von Hindenburg

[Mar] Franklin D. Roosevelt inaugurated as president of the USA. He institutes the New Deal to counteract effects of the Great Depression

[Dec] Prohibition in the USA formally ends

1934

[Jun/Jul] Night of the Long Knives – a series of murderous purges of elements within the Nazi Party

[Aug] Death of German President Hindenburg. Hitler becomes Führer of Germany

[Oct] Mao Zedong's 'Long March' begins as several thousand Communist troops retreat 9,000km through the Chinese interior to escape capture by Nationalists

The age Stryker spoke of was one of gathering gloom. Crisis and catastrophe were the twin themes of international politics. The Wall Street Crash wreaked havoc across America and tipped the global economy into a Great Depression, worse even than the Long Depression which had blighted economies and societies across the world at the end of the previous century. The severity of the downturn in pure economic terms was one thing; its effects on national and international relations were worse still. In Western Europe fascism was on the march; in Germany, Italy and Spain fascists ended the decade in charge of the national governments. The German situation was the most alarming of these: Adolf Hitler's Nazi party swept to power in 1933, began rearming Germany in anticipation of a new European war, and stirred the worst instincts of the German people to support oppressive and, later, murderous policies against Jews and other minorities.

In the Far East, a civil war in China was interrupted only when China and Japan went to war over the contested region of Manchuria. In the Soviet Union, Joseph Stalin's ruinous collectivization programme starved millions to death. South America was gripped by national wars and revolution. In India, peaceful protest against British rule was met with often-brutal reprisals. Whether any or all of this would have occurred had the American stock market not exploded in 1929 is somewhere between debatable and unknowable. What is certain is that during the 1930s the world was heading for a reckoning which would surpass even the horrors of the 1910s.

None of this, probably, was on Florence Owens' mind as she stared past the lens of Lange's Graflex. Her immediate concern was feeding her older children, suckling the baby she held at her breast and getting the Hudson's radiator mended. But from the moment Lange's shutter clicked, millions people have looked at her careworn face, and read back their own doubts, torments and concerns.

1935

[Jan] Italian colonies of Tripoli and Cyrenaica are conjoined to form Libya

[Feb] Adolf Hitler commences German re-armament in defiance of the Treaty of Versailles

[Apr] Dust Bowl storms hit the American prairies

1936

[May] Italian troops take Addis Ababa after invading Ethiopia on Mussolini's orders in 1935

[Jul] Civil War breaks out in Spain, attracting international intervention on both the Republican and Nationalist sides

[Aug] Summer Olympic Games held in Berlin. African American sprinter Jesse Owens wins four gold medals

1937

[May] The *Hindenburg*, a German Zeppelin airship, catches fire and crashes as it approaches its landing station in New Jersey

[Jul] Marco Polo Bridge Incident near Beijing brings about the start of the Second Sino-Japanese War, which lasts until 1945

[Dec] Rape of Nanking begins: Japanese soldiers commit numerous atrocities in the capital of Republican China

1938

[Mar] Germany annexes Austria

[Sep] British prime minister Neville Chamberlain hails his Munich Agreement with Hitler as having achieved 'peace for our time'.

[Nov] *Kristallnacht*, a night of violent assaults on Jewish shops and businesses, takes place in Germany

1939

[Mar] German troops invade Czechoslovakia, ignoring the Munich Agreement

[Apr] Italy invades Albania; King Zog and the royal family flee into exile in England

[Sep] Hitler orders the invasion of Poland. Britain and France declare war on Germany. The Second World War begins

The New Deal

The Great Depression was in its way as grave a crisis as the United States had faced since the Revolutionary and Civil War eras. Those two periods had produced the most celebrated presidents in US history. The 1930s would bring to the fore a leader of comparable distinction, when the 1932 election produced a landslide victory for New York's Democratic governor, Franklin Delano Roosevelt, who swept the Republican incumbent, Herbert Hoover, from office on the promise of a 'New Deal' for Americans.

Roosevelt, known as FDR and pictured here at his inauguration on 4 March 1933, was a bona fide American aristocrat. He was an alumnus of Harvard College and Columbia Law School and a distant cousin of the 26th president, Theodore Roosevelt – whose niece, Eleanor Roosevelt, he had married in 1905. But his New Deal was an avowedly populist programme designed to reform the American financial system, promote economic recovery and provide relief in the form of income subsidies, employment in public works and social security payments for those worst affected by the Depression.

The success and long-term effects of the New Deal are still hotly debated by US historians, in part because the transformative nature of Roosevelt's presidency drew up new dividing lines in American politics and society. What is generally beyond doubt, however, is Roosevelt's status as a great American statesman. Despite struggling for many years with the crippling after-effects of polio, he was the only US president to serve more than two terms, being elected four times and dying in office during the Second World War in April 1945.

'The New Deal is plainly an attempt to achieve a working socialism and avert a social collapse in America…'

H. G. Wells, *The New World Order* (1940)

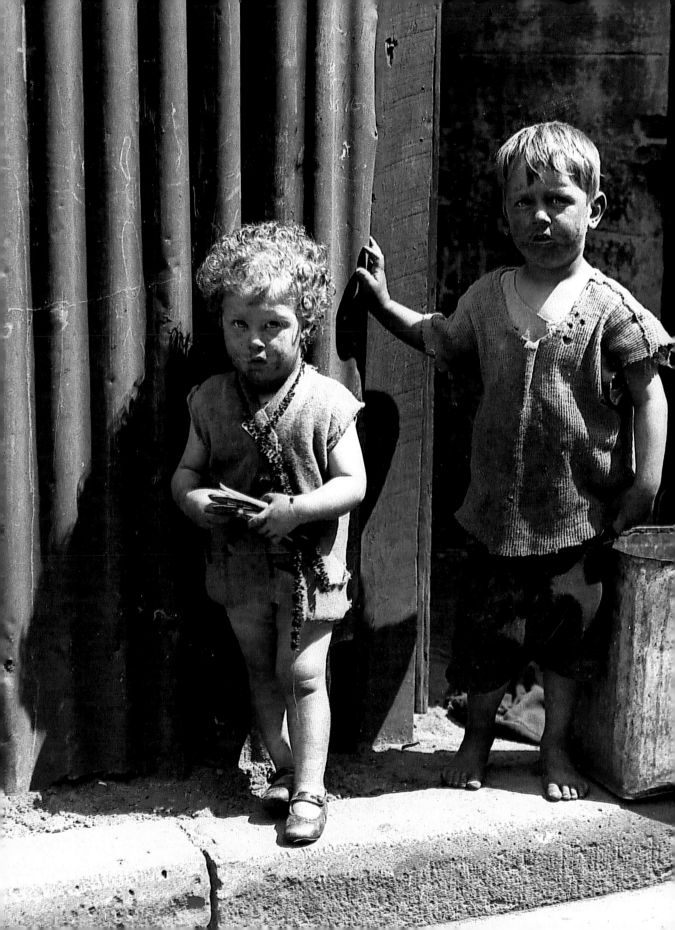

The Great Depression

The Great Depression spread like a plague across the world, with poverty, destitution and homelessness trailing in its wake. The speed of its advance and the damage it wreaked stoked civil unrest, rioting, social upheaval and great lurches towards the political extremes.

Outside China, Japan and the Soviet Union, whose closed economies were relatively sheltered from trade and outside influence, very few nations escaped the infection of financial losses and economic collapse. National incomes plummeted, with GDP falling in some regions by a half or more. Banks failed. Deflation set in. Governments fell. Countries dropped out of the gold standard, which had formally regulated the value of money and influenced exchange rates between currencies for more than a century.

All of this financial disruption was translated directly into human misery. In 1932 in Australia, where these children were photographed, unemployment peaked at 29%. This was a severe hardship but by no means the worst in the world. In some parts of Britain's industrial north seven in ten adults lost their jobs.

The combination of economic turbulence and drastically reduced living conditions for millions of people led many governments to seek radical solutions, and electorates to seek radical governments. Nowhere would this have more doleful consequences than in Germany, still fragile after the crisis-strewn years of Weimar government and, in the view of many on the extreme right, ripe for a return to militarism and autocracy.

Der Führer

Throughout the 1920s the NSDAP or Nazi Party
had been somewhere between a thuggish fringe
movement and a bad joke. Yet by the spring of 1933 its
leader, Adolf Hitler (pictured here addressing troops
at a rally in Dortmund), had become Germany's
dictator.

Hitler's rise to power rested on his ability to
bind together nationalists' resentment of the Treaty
of Versailles with ordinary Germans' dissatisfaction at
the hardships of the Great Depression, all swept along
by a hysterical anti-Semitic and anti-communist
rhetoric which blamed the nation's problems on the
enemy within.

From 1929 both the Nazis and the Communists
made steady gains in German elections. Both
increased their presence in the Reichstag (German
parliament) while at the same time flooding the
streets with their paramilitary thugs. In the end,
though, the Nazis prevailed both at the ballot
box and in the brawl. Through a combination of
Hitler's personal appeal, the violent tactics of the
Sturmabteilung (SA) 'Brownshirts' under Ernst
Röhm, and a vigorous propaganda operation overseen
by Joseph Goebbels, by November 1932 they had
become Germany's largest political party.

The ageing German president Paul von
Hindenburg was persuaded to appoint Hitler
chancellor on 30 January 1933; less than two months
later Hitler awarded himself dictatorial powers
under the Enabling Act. The following summer
Hindenburg died, and all German military forces
took an oath declaring their personal loyalty not to
their nation but to their Führer. The remilitarization
and Nazification of German public life had begun.

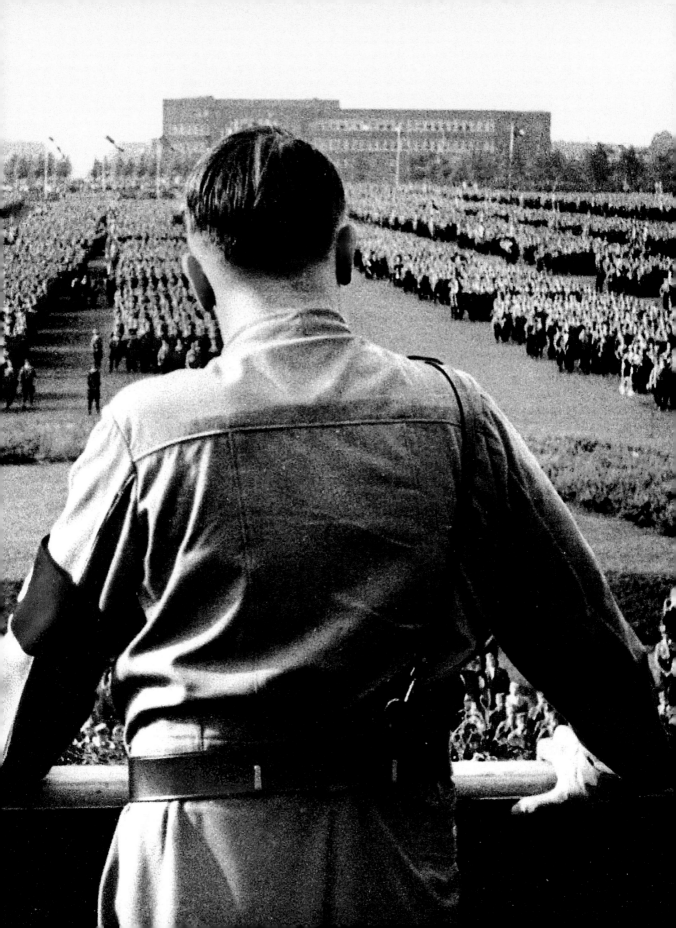

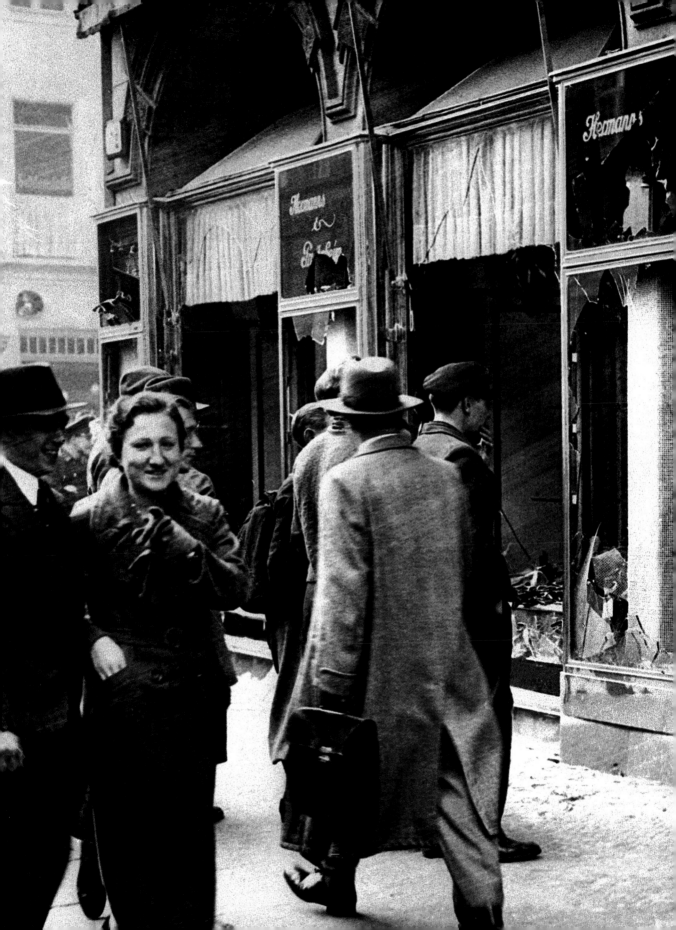

Kristallnacht

Hitler had never bothered to conceal his disdain for Jewish people: *Mein Kampf* was littered with grotesque anti-Semitic passages. On his elevation to Führer, the harassment, persecution and, later, mass murder of Jews became a central goal of Nazi policy.

As soon as Hitler took power in 1933 Jews were banned from professions ranging from medicine and law to film and journalism. Jewish children were removed from German schools. Jews were forbidden to own farmland. The Nuremberg Laws, passed in 1935, stripped Germany's Jews of their citizenship and basic rights. Mixed marriages between Jews and gentiles were outlawed and Jews were forbidden to fly the German flag. All of this was supported by relentless anti-Jewish propaganda.

On the night of 9–10 November 1938, against a background of forced Jewish expulsions from Germany, SA paramilitaries co-ordinated a wave of pogroms across the Reich, smashing, burning and vandalizing synagogues and Jewish shopfronts such as the one pictured here in Berlin (pp. 322–3).

Thousands of businesses were wrecked, some beyond repair. This was *Kristallnacht* – the night of broken glass – and it marked an escalation in the brazen violence of Nazi anti-Semitic policy. In the aftermath, addressing foreign media, Goebbels claimed that the pogroms had been spontaneous popular demonstrations in protest at the murder in Paris of a diplomat called Ernst vom Rath by a teenager called Herschel Grynszpan – a Polish Jew who had been forced out of Germany by the anti-Jewish climate. This was patently untrue. And Nazi persecution of the Jews was soon to become even more spiteful and severe.

'All the great men of Germany... have all had faults. Hitler's followers are not spotless. Only he is pure.'

Leni Riefenstahl, 1938

Nazi Sympathizers

When *Kristallnacht* took place the German dancer, actress and film director Leni Riefenstahl was travelling in the USA. Quizzed by a newspaper reporter about Adolf Hitler, she gushed admiration, calling him 'the greatest man who ever lived'.

A supremely gifted and technically groundbreaking director, Riefenstahl was captivated by the Führer. She was handsomely patronized by the Nazi Party, who commissioned her to make films about the 1933 and 1934 Nuremberg Rallies, called *The Victory of Faith* and *Triumph of the Will*. (This photograph shows her during filming for the latter.) In 1936 she made *Olympia*, portraying the Berlin Olympic Games.

Riefenstahl was not the only prominent figure in Germany to sympathize with the Nazis. While many intellectuals, such as the Jewish physicists Albert Einstein and Max Born, fled the Reich in fear for their lives, other artists and writers – including Riefenstahl and the philosopher Martin Heidegger – openly associated with and supported the party and its policies. There was no real question of what these were: anti-Semitic policies at home coupled with rapid rearmament and naked military aggression abroad, as Hitler took over Austria and Czechoslovakia between 1938 and 1939, before setting his sights on the rest of Europe.

The final film Riefenstahl made about the Nazis covered the invasion of Poland in 1939, ostensibly as war journalism. She survived the Second World War, avoiding prosecution (although not condemnation) for her complicity with the party, and died in 2003.

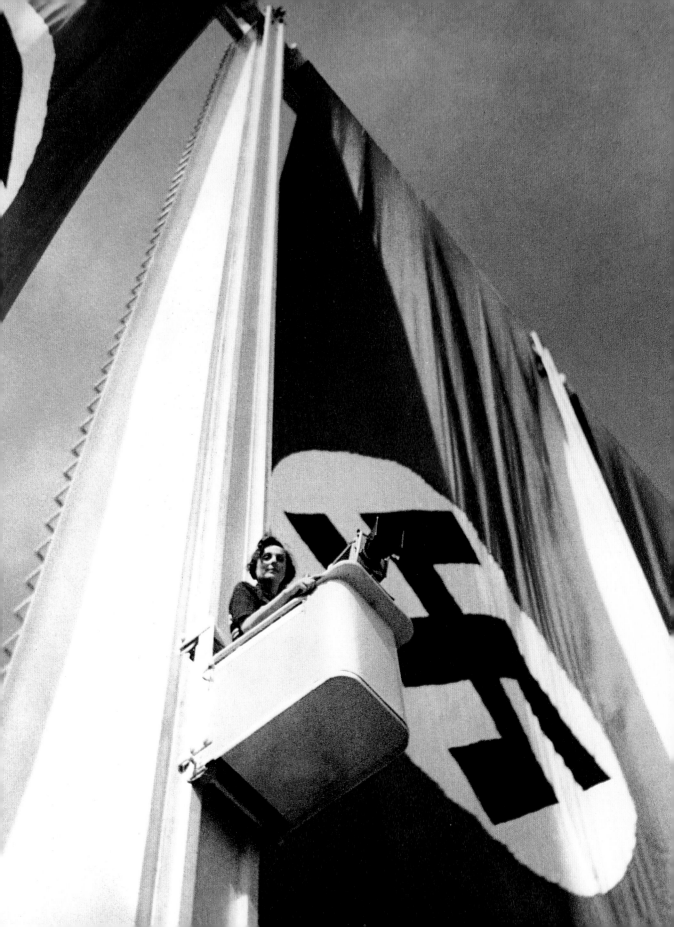

Abyssinia

Benito Mussolini, like Adolf Hitler, nursed dreams
of conquest and nationalist glory. In 1935 he took a
provocative step towards precisely this by invading
Abyssinia – or the Empire of Ethiopia – which
shared a long boundary with the colony of Italian
Somaliland and was the only African nation other
than Liberia to have retained its independence during
the 'Scramble for Africa'. The pretext was a border
spat at Walwal in December 1934. Mussolini ordered
a major troop build-up on the Ethiopian border,
which in October 1935 duly became a full invasion.

The Ethiopian Emperor Haile Selassie appealed
numerous times to the League of Nations for support.
The only result was an active demonstration of the
League's unfitness for purpose. Leading members
Britain and France – neither blameless in Africa and
both perturbed more by Hitler's rapid rearmament
– ultimately preferred appeasement to action.
The League imposed a set of toothless sanctions,
which Mussolini ignored. Ethiopia was left to fend
for herself. This photograph shows a desert chief
preparing for battle against an Italian army that
would deploy tanks and mustard gas.

Italian units seized the capital Addis Ababa in
May 1936. Haile Selassie left his kingdom to seek
refuge in England, where he lived for five years until
restored to his throne in 1941. Fascism, he said then,
was a 'cruel and godless dragon, which has newly
risen and is oppressing mankind'.

'The Abyssinian warrior…
will attack without fear or
trembling, even when he is
to advance against tanks.'

General Eric Virgin, Swedish military advisor
to Haile Selassie, 1935

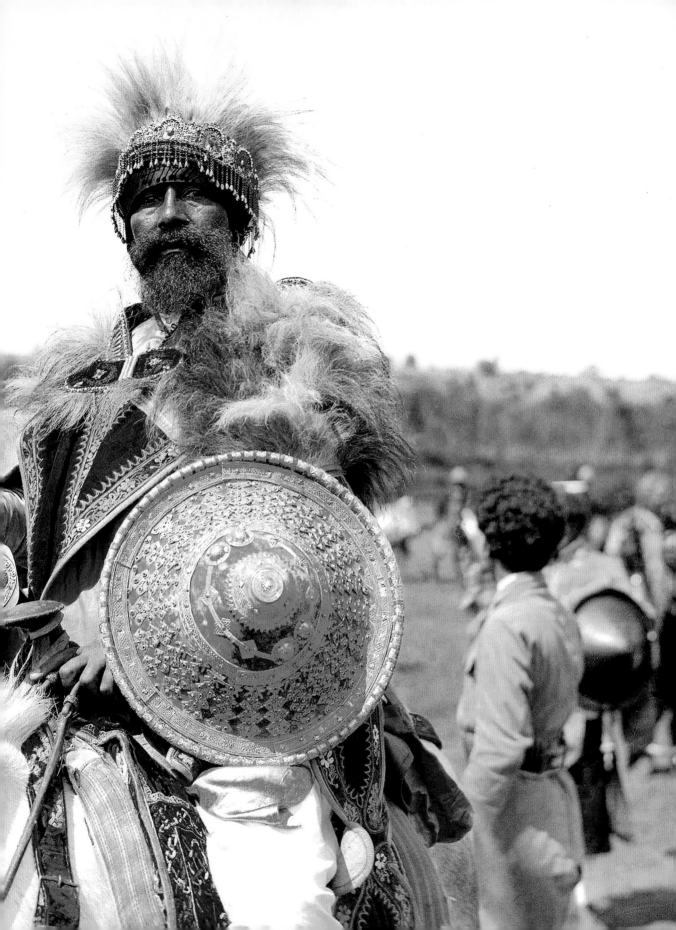

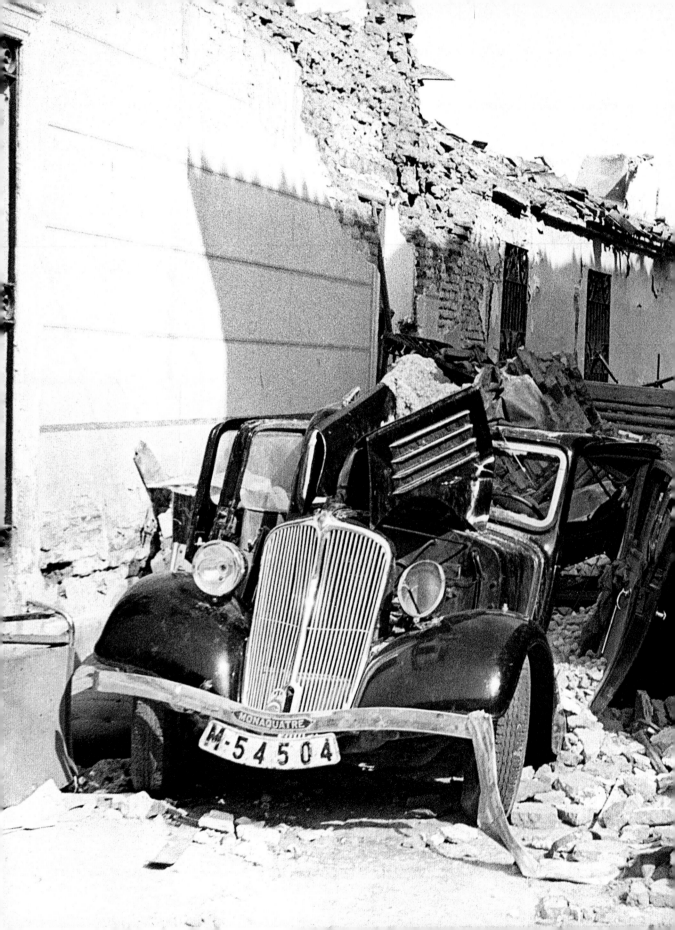

The Spanish Civil War

Following shortly after Italian aggression in Abyssinia, in July 1936 war broke out in Spain. On the surface the Spanish Civil War was a contest between an elected 'Popular Front' government comprising moderate socialist and other left-wing elements (known as Republicans), and a coalition of conservative and hard-right groups, including nationalists, monarchists and fascists (known as Falangists), led by General Francisco Franco.

Yet the war was in reality a proxy conflict in which each side was supported by international powers. Franco was backed by Hitler and Mussolini. The Republicans were supported covertly by France, and openly by the USSR, Mexico's left-wing revolutionary government, and 'International Brigades' comprising volunteers from Britain, Canada, the United States, Poland, Yugoslavia and elsewhere.

For three years there was skirmishing in the countryside and urban street fighting – this photograph shows the aftermath of a battle in Torrijos, near Madrid. Nationalist execution squads were active as Franco overwhelmed the south and west of Spain in July 1936 – and the Republicans would retaliate in kind. The domestic conflict was complicated by the involvement of massive military power from abroad, including the 'Condor Legion' – a German land and air unit.

Hermann Göring's Luftwaffe (the German air force) used the Spanish Civil War as a testing ground for warplanes including Stuka dive-bombers. Their most notorious mission was the terror-bombing of Guernica, memorialized in a famous painting by Pablo Picasso. The Spanish Civil War ended in 1939 with Franco victorious and much of Spain in ruins.

'If you had asked me why I had joined the militia I should have answered: "To fight against Fascism," and if you had asked me what I was fighting for, I should have answered: "Common decency." '

British author and journalist George Orwell, *Homage to Catalonia* (1938)

King Zog

In the second tier of Europe's strongmen during the 1930s was Ahmet Zogu, who in 1928 had promoted himself from president to king of Albania, taking the regnal title Zog I.

Although an authoritarian ruler, Zog committed himself to a programme of modernization in his kingdom, cancelled Islamic law, reformed the Albanian currency and opened his borders to Jews fleeing Nazi Germany and occupied Austria.

Yet Zog's relatively enlightened absolutism did not survive the decade. Albania's tiny economy was gutted by the Great Depression and he fell back for financial and political support on the friendship of fascist Italy. Mussolini exploited Zog's weakness to turn Albania into a client state, opening up the country to Italian immigration, dictating Albania's economic policies and demanding extensive control over the institutions of state.

When Zog baulked at the lopsidedness of this alliance, Mussolini sent in the Italian army. In 1939 Zog, his wife, the Hungarian-American countess Geraldine Apponyi (pictured here, centre) and their newborn son Leka fled the country with as much gold bullion as they could carry. They travelled through Europe – this photograph was taken in Sweden – before settling in London at the Ritz Hotel. Zog never returned to his kingdom, although he conspired with the British double agent Kim Philby against the communist regime that ruled there from 1946 until 1992. Zog died in Paris in 1961. He was 65 years old: quite an achievement, given his habit of smoking 200 cigarettes a day. Queen Geraldine died in 2002.

'The true Albanian is at
heart a monarchist.'

Zog I, as dictated to Herman Bernstein,
American ambassador to Tirana, 1933

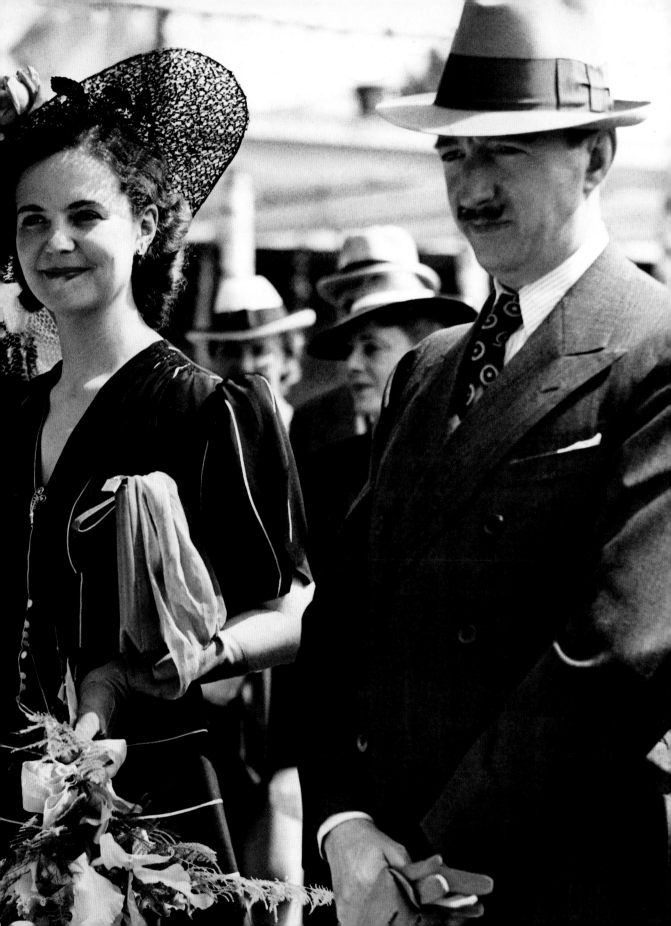

Cristo Redentor

As fascist Europe descended into godlessness, in
Brazil a monumental effort was being made to keep
the faith. Following concerns that Christianity would
wane following the separation of church and state
with the founding of the First (or Old) Brazilian
Republic in 1889, designs had been drawn up for a
gigantic statue in the then-capital, Rio de Janeiro,
which would greet the Catholic citizens every time
they looked to the city's skyline.

The result was *Cristo Redentor* – Christ
the Redeemer – a 38m high, 1,145-ton Art Deco
sculpture of Jesus, erected on the towering summit
of Corcovado mountain. The statue was designed by
the Brazilian architect Heitor da Silva Costa and the
French engineer Albert Caquot and executed by the
French-Polish sculptor Paul Landowski, who created
it in clay portions in his Paris workshop before the
real piece was built from reinforced concrete over a
steel frame. To soften the harsh concrete façade, *Cristo
Redentor* was finished with a mosaic of tiny pieces of
soapstone quarried near Ouro Preto.

Here the statue is shown nearing its completion:
the official unveiling took place on 12 October 1931.
Yet when *Cristo Redentor* was revealed, it looked out
upon a country in some turmoil. In 1930 the Republic
collapsed following a military coup and the populist
Getúlio Vargas was installed as interim president.
Initially Vargas imposed sweeping reforms aimed at
modernizing Brazil's economy, but in 1937 he seized
dictatorial powers and established the *Estado Novo*
(New State) – a totalitarian regime that lasted
until 1945.

'The statue of the divine saviour
shall be the first image to
emerge from the obscurity in
which the earth is plunged...'

Heitor da Silva Costa, *c.*1922

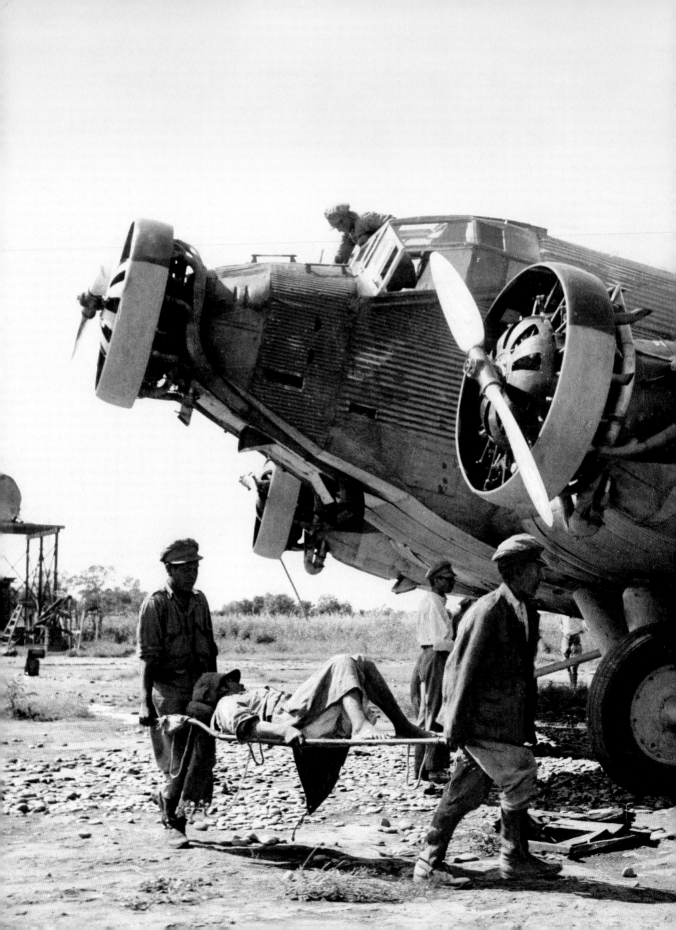

The Chaco War

Elsewhere in South America, Bolivia and Paraguay collided over part of the Chaco Boreal (also known as the Gran Chaco) – a large, hot area of lowland where oil had been discovered and which, more importantly, granted access to the Atlantic Ocean via the Paraguay River. Since both Bolivia and Paraguay were landlocked and had lost territory during wars fought on the continent during the 19th century, control over the Chaco had – over several decades – become a matter of increasing national importance, ultimately leading to the outbreak of war in 1932.

The aircraft pictured here is a Junkers Ju-52, a German-built aircraft mainly used to transport cargo (although several had been deployed in the bombing of Guernica during the Spanish Civil War). Four of these found their way into Bolivian hands during the Chaco War, in which they were mostly used to transport supplies to the front and to evacuate injured personnel, as in this photograph. The war marked the first use of military aircraft in South America along with tanks and heavy artillery.

The war lasted until the summer of 1935, by which time Paraguay controlled the majority of the Chaco Boreal, despite the fact that when fighting began it had been the poorer and militarily less powerful of the two countries. The death toll from disease and from fighting in snake-infested swamp and jungle was high – around 100,000 people were killed during the course of the conflict, and thousands more permanently displaced from their homelands.

Mao and Zhu

When the 1930s dawned, China was in the grip of a long-running civil war. Many factions were party to the conflict, but pitched against one another at the ideological and military centre of the war were nationalists led by Generalissimo Chiang Kai-shek and an insurgent Chinese communist movement whose most prominent leader was Mao Zedong. During a long life Mao devoted himself first to revolutionary struggle and then, from 1949, to the brutal and murderous transformation of China into a communist state under his own leadership.

Mao (left) is pictured here during the late 1930s with Zhu De, a warlord who had travelled extensively throughout Germany and Russia during the previous decade, returning to China determined to incite revolution. Zhu was instrumental in the foundation of the Chinese Workers' and Peasants' Red Army – usually shortened to the Chinese Red Army.

Mao and Zhu formed a close military and political partnership built on a personal relationship so close that they were known jointly as 'Zhu-Mao'. Their alliance lasted on and off for half a century, from their first contact as fellow Soviet revolutionaries in Jiangxi Province in the late 1920s, until 1976, when the two men died within weeks of one another.

During that time their policies brought about as many as 70 million deaths in China – many through the civil war in which they were leading protagonists, and even more as a result of the reform-and-repress strategies pursued by Chairman Mao following his rise to leadership of communist China after the Second World War.

'Year to year in bloody battles caught /
Each village wall now wears the bullet mark.'

Mao Zedong's poem 'Dabodi', 1933

'Last night up to 1,000 women and girls are said to have been raped... If husbands or brothers intervene, they're shot.'

John Rabe, Nanking, 1937

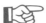

Manchuria

Manchuria was the great chunk of northeast China bordering the Sea of Japan: rich in coal, mineral deposits and farmland. Japan had long held an interest in the territory, contesting control with China and Russia.

In September 1931 Japanese officers in Kwantung (an area of the Liaodong Peninsula leased to Japan since 1905) staged a faked bombing of a railway line, known as the 'Mukden Incident'. On the pretext of punishing the Chinese, Japan then embarked on an all-out invasion of Manchuria.

The following year, defying League of Nations protests and then withdrawing from their membership of the League altogether, the Japanese declared Manchuria to be an independent state called Manchukuo. Puyi, the last of the Qing emperors of China, who had been deposed in the revolution of 1912, was installed as a puppet leader.

For five years a war proceeded by relatively small-scale skirmishing between Chinese and Japanese troops, but in 1937 it erupted into major violence, as Japanese troops flooded into Manchuria and launched attacks on Chinese cities including Beijing and Shanghai. Hundreds of thousands of soldiers were sent to fight, including these men (overleaf), photographed as they set out from Tokyo at the start of this new phase of the war.

Dreadful atrocities were widespread, including most notoriously the 'Rape of Nanking', during which as many as 300,000 civilians were killed in a massacre that included sexual assault, gang rape, torture and cannibalism. The tone had been set for a vicious war that would continue until 1945.

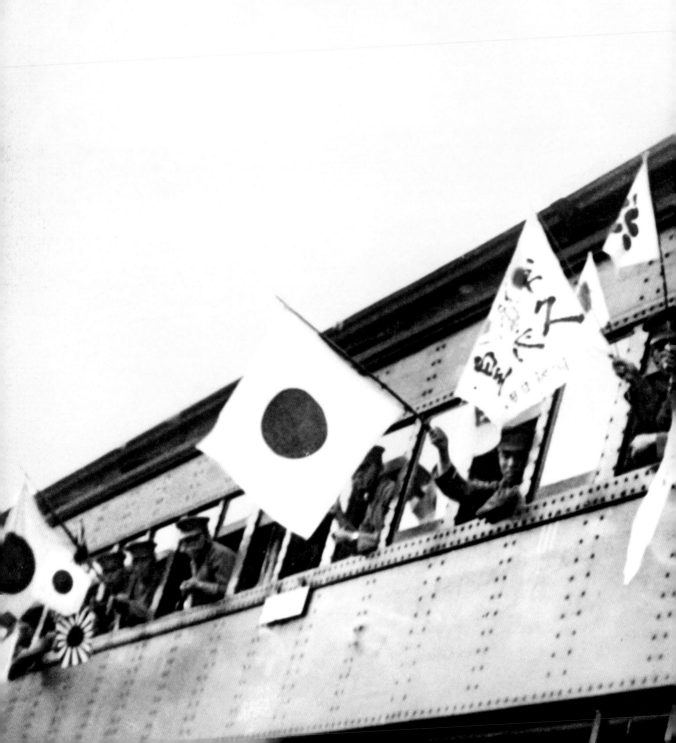

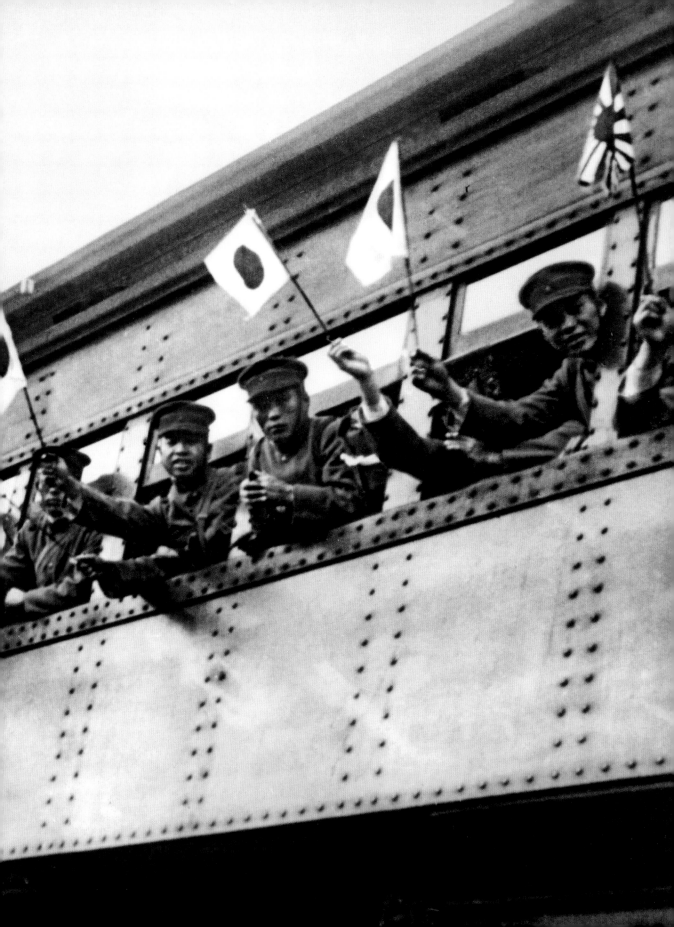

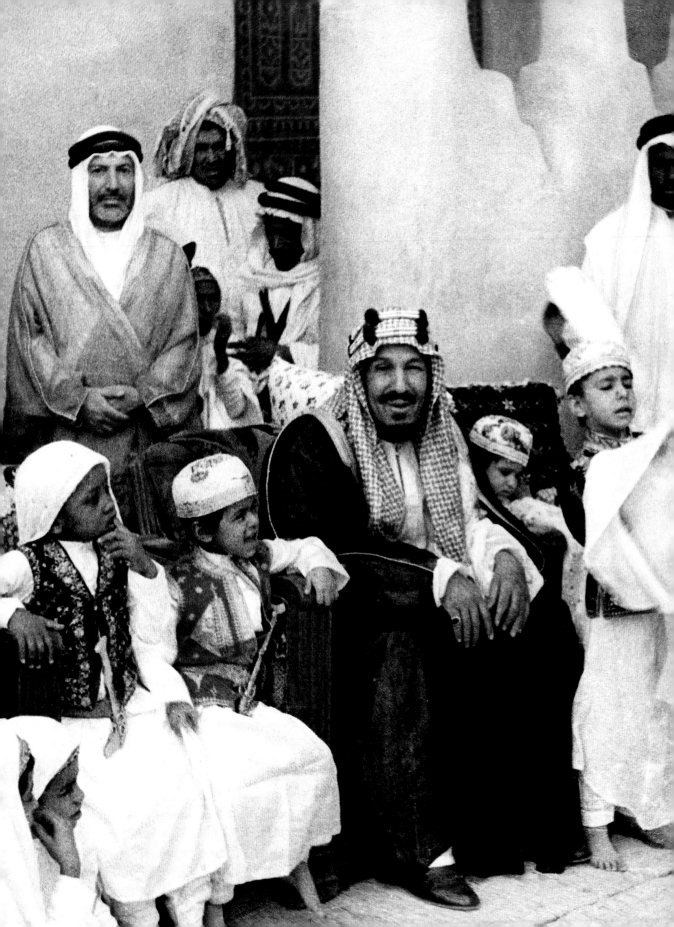

The House of Saud

In the Middle East, the 1930s witnessed the birth
of a new kingdom. For many years the Arabian
Peninsula had been fractured and fought over by
rival tribes, emirs and sheikhs. In 1932, however, the
House of Saud completed its conquest of the majority
of Arabia, uniting the Nejd (the interior of the
peninsula, with its capital in Riyadh) and the Hijaz
(the western coastal area which included the holy
cities of Mecca and Medina).

The new kingdom of Saudi Arabia came into
being on 23 September 1932 under the rule of the
tall, thick-set and forthright 57-year-old Abdulaziz
Ibn Saud. Six years later its fortunes changed in a
dramatic fashion when American scientists discovered
what proved to be the world's largest oilfields beneath
the desert sands at Dammam in the Eastern Province
of the new kingdom. Saudi Arabia and Ibn Saud now
became critical players in global affairs. Not only were
they the gatekeepers to the most holy sites in Islam,
they were also heavily courted by world leaders who
required access to their natural resources in an ever-
more industrialized world.

Ibn Saud (seated, centre) is photographed here
with various members of his huge family. Through his
many wives, the king fathered around 100 children,
including at least 45 sons, six of whom ruled over the
kingdom between the time of Ibn Saud's death in 1953
and the present day.

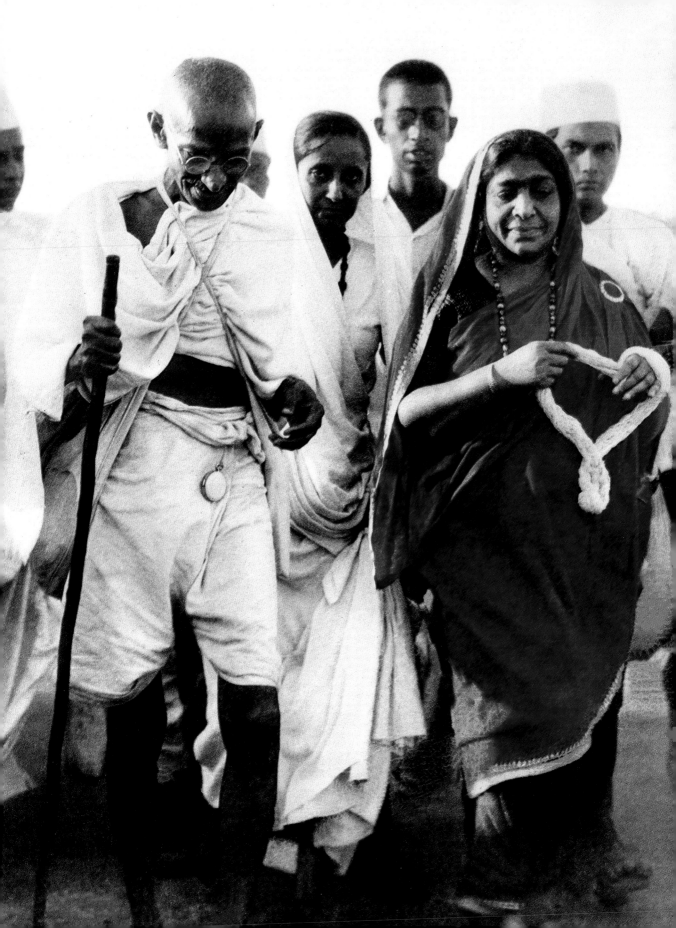

The Salt March

'Satyagraha' was the name that the Indian lawyer and civil rights leader Mohandas Gandhi gave to the tactics deployed in his campaign against British rule in India – and to an earlier campaign he led for Indian rights in South Africa. In Sanskrit its literal meaning was 'polite insistence on the truth', but it was used to describe civil disobedience on a grand scale. In 1930 Gandhi focused it on a single, simple commodity: salt.

Under British rule, salt was manufactured and taxed by the government, and sold to Indians at a steep mark-up. To defy the salt laws, Gandhi reasoned, would hurt Britain economically without the need for violence. On 12 March he left his religious retreat at Ahmedabad to begin a walk of more than 320km to India's western coast, where he intended to make his own illegal salt from the sea.

By the time Gandhi reached the salt flats at Dandi a month later, tens of thousands of people were following him. Gandhi was arrested and jailed for several weeks, but the symbolism of his protest was obvious; it sparked further salt rebellions and other forms of civil disobedience across India. Britain's response – a violent crackdown – only emphasized to the outside world the injustice of their imperial rule.

Gandhi's supporters called him 'Mahatma', meaning 'great-souled'. He is pictured here during the Salt March with the poet and activist Sarojini Naidu, one of his long-time supporters and a towering figure in India's independence movement.

'We have resolved to utilize all our resources in the pursuit of an exclusively nonviolent struggle.'

Mohandas Gandhi to his followers
on the Salt March, 1930

'Now we are able to carry on a determined offensive against the kulaks, [and] eliminate them as a class…'

Joseph Stalin, 29 December 1929

Collectivization

In the Soviet Union, one of the communist government's key ideological and economic aims was to transform farming. Peasant families working their own land were thought to be insufficient to sustain Stalin's ambitious programme of industrialization. As individuals pursuing their own betterment they also offended the first principles of Soviet thinking.

During the 1930s farms across the USSR were forcibly collectivized: grouped together to create huge agricultural communes known as *kolkhozy* and *sovkhozy*. These were set targets by the government, which greedily helped itself to the harvest. In 1929 less than 5% of farms in the USSR were collectivized; ten years later, more than 95% were.

There was widespread resistance to collectivization, which many peasants viewed as a return to the tsarist serfdom abolished in 1861 – justifiably, since they were compelled to work, forbidden to leave and the government seized the fruits of their labour. Peasants went on strike, hiding and hoarding grain and even killing their animals to deny the government a profit.

The Stalinist response was slaughter and starvation. The *kolkhoz* pictured here was near Kiev, in Ukraine, whose fertile wheat fields had once been nicknamed 'the bread-basket' of the USSR. The 1932–3 Soviet collectivization turned Ukraine into a famine zone. Government propagandists railed against *kulaks*, a supposed class of traitorous, bourgeois-minded peasants. Rations were cut and even stopped altogether, and mass deportations to labour camps began. Around four million Ukrainians died in a terror famine now called the 'Holodomor'.

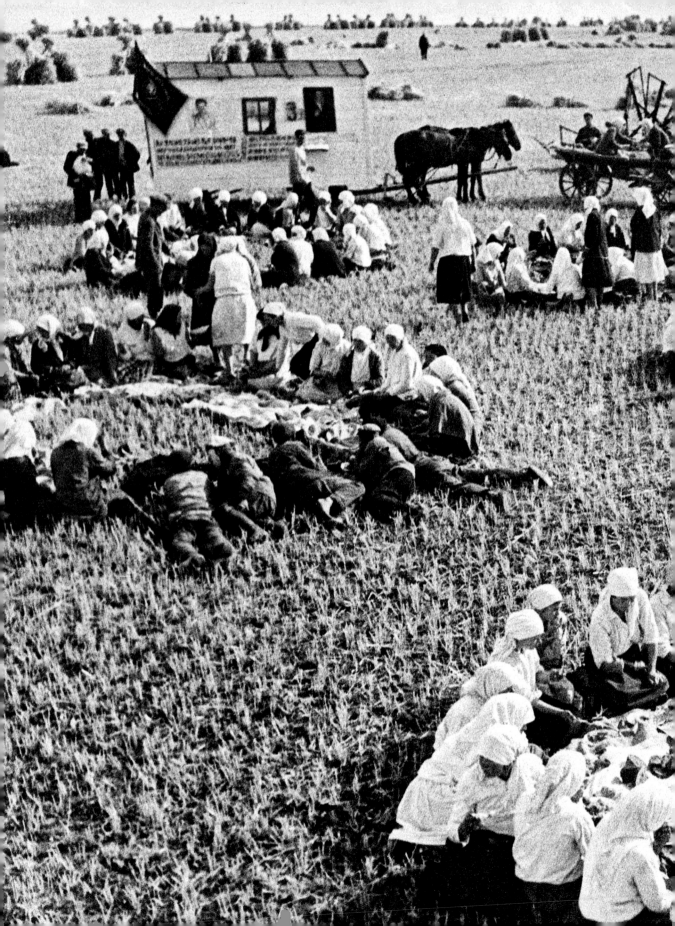

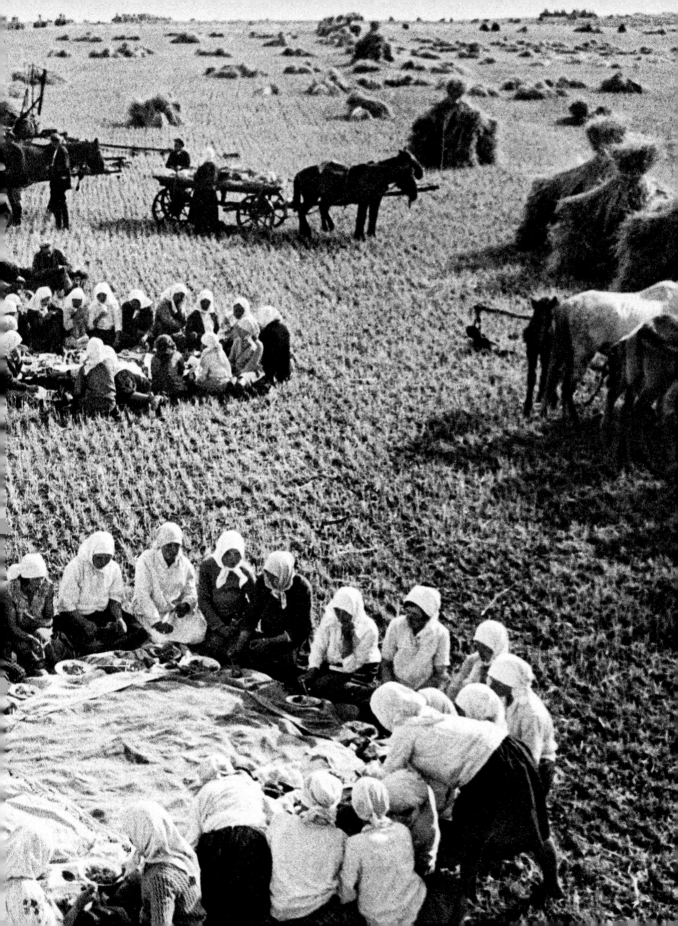

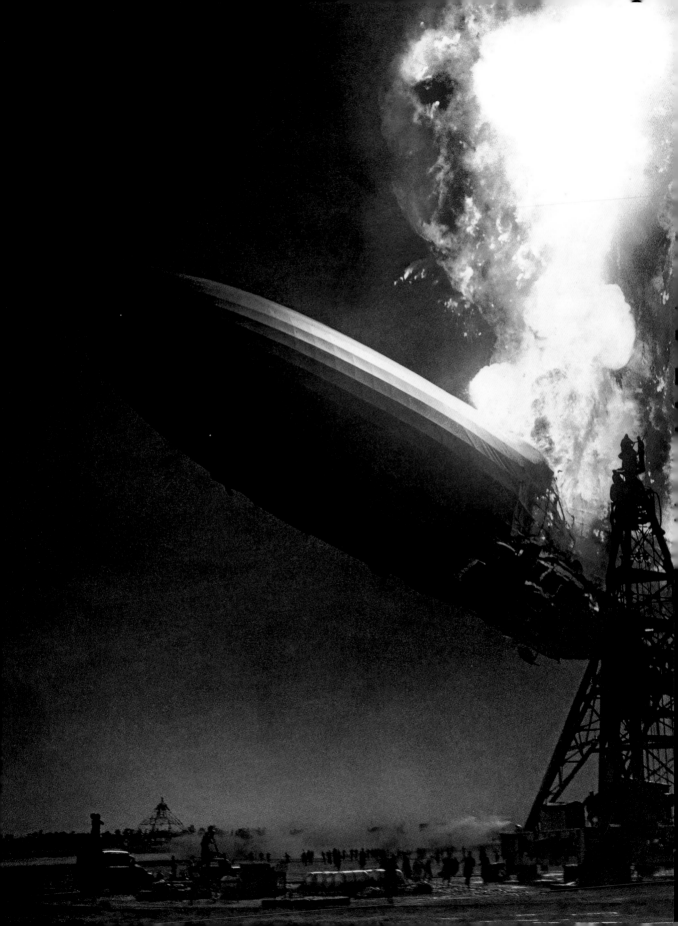

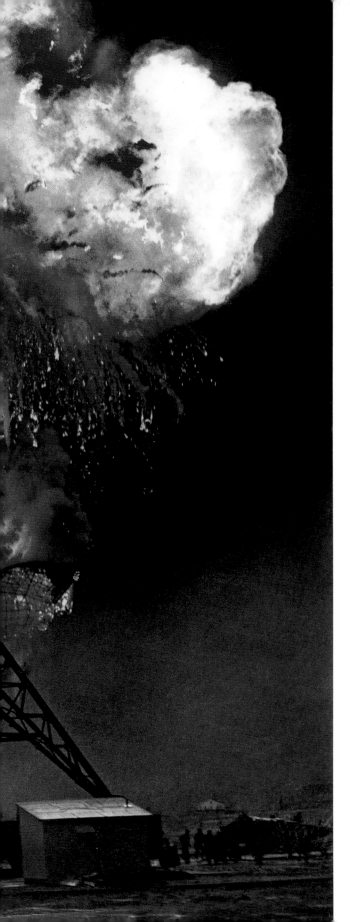

The *Hindenburg* Disaster

The German airship LZ 129 *Hindenburg* had crossed the Atlantic in three days, carrying 36 passengers and around twice as many crew, when it came in for landing several hours late at Naval Air Station Lakehurst in New Jersey on the evening of 6 May 1937. Dozens of reporters and cameramen were watching, expecting to capture the smooth landing of a masterpiece of modern engineering, albeit one with Nazi swastikas emblazoned on its tail.

Instead, they watched in horror as the *Hindenburg* burst into flames, pitched sickeningly backwards and crashed to the ground. Those on board jumped from high in the air to escape the flames and smoke. It took less than a minute for the massive, luxuriously fitted airship to be destroyed, killing 13 passengers and 22 crew.

This was far from the only such disaster during the airship age: four years earlier the USS *Akron* had broken up in a violent thunderstorm over the Atlantic. But the *Hindenburg* disaster was the first to be captured in gruesome detail by America's national media. The reputation of rigid airships lifted by large hydrogen- or helium-filled cells went up in flames in a matter of seconds.

This, compounded with the rise of passenger planes, led to a swift end to the age of commercial airship flights. However, they continued to be manufactured in the United States for military use. As was becoming increasingly clear, fighting craft of all sorts were going to be necessary in the violent decade ahead.

'It's a terrific crash, ladies and gentlemen. It's smoke, and it's in flames now; and the frame is crashing to the ground… Oh, the humanity!'

Herbert Morrison, WBC radio live report, 6 May 1937

'Peace for our Time'

Crowds cheered as the British prime minister Neville Chamberlain stepped out of his aeroplane at Heston Aerodrome in Middlesex on 30 September 1938. He had returned from a four-power conference in Munich with Adolf Hitler. The German Führer's forcible annexation of Austria, forays into the Rhineland and threats to invade Czechoslovakia had shaken Europe. Squashing Hitler's ambition seemed to threaten open war in Europe so Chamberlain had chosen to appease Hitler by acquiescing to his demands. The Munich Agreement therefore sanctioned German annexation of the Sudetenland, a border area of Czechoslovakia with a large ethnic German population.

'The settlement of the Czechoslovakian problem… is in my view only the prelude to a larger settlement in which all Europe may find peace,' Chamberlain said to the crowds at Heston. He then produced a sheet of paper detailing a commitment made between himself and Hitler not to take Britain and Germany into war against one another. Later, having returned to 10 Downing Street, Chamberlain declared that he had achieved 'peace for our time'.

Chamberlain was dead wrong. Hitler did not immediately wish to fight Britain, but he had vanishingly little desire for European peace. Six months later, on 15 March 1939, German troops invaded the remainder of Czechoslovakia. In April and May 1939 he made non-aggression pacts with Stalin's Russia and Mussolini's Italy. In September he invaded Poland. Chamberlain's appeasement had failed. Hitler's intentions were unmistakable.

A second world war was about to begin.

'I do not care whether there is a world war or not… I am prepared to risk a world war rather than allow this to drag on.'

Adolf Hitler, September 1938

348

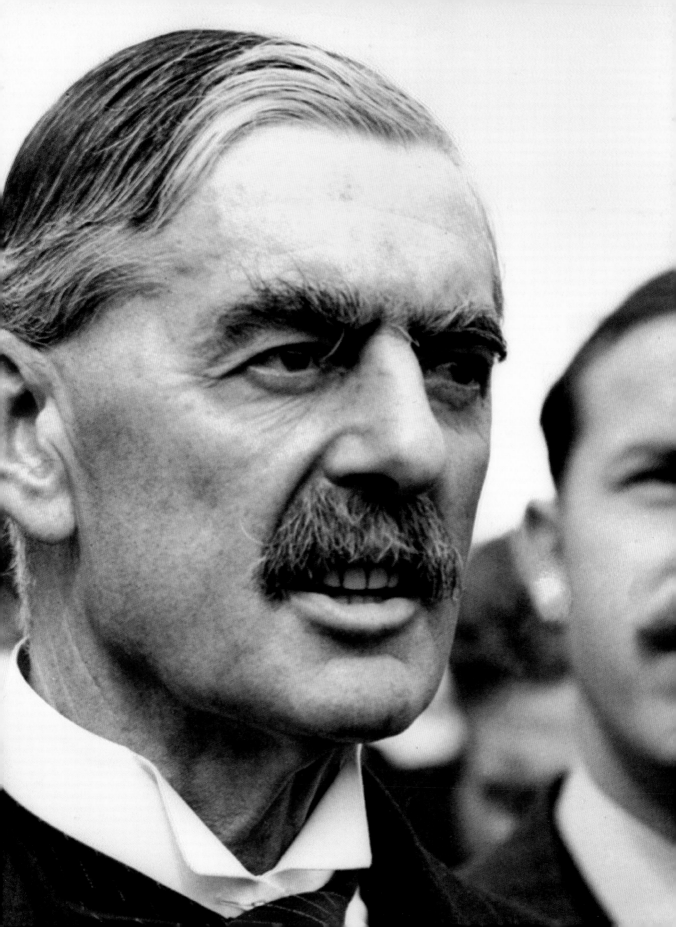

Destruction & Salvation

1940s

'…If the British Empire
and its Commonwealth last for
a thousand years, men will still say,
"This was their finest hour." '

Winston Churchill, speech, 18 June 1940

'The whole fury and might of the enemy must very soon be turned on us,' warned Britain's newly appointed prime minister Winston Churchill, as he stood in the House of Commons in London on 18 June 1940 and assessed the bleak military situation in Europe. France had fallen, scattered and swept away by Adolf Hitler's German war machine. Britain was to be next, according to Churchill. The fate of the free world, he said, now depended on British resistance. If Hitler advanced any further then the civilized West would 'sink into the abyss of a new Dark Age made more sinister, and perhaps more protracted, by the lights of a perverted science'.

As always, Churchill was leaning upon his matchless oratorical gifts to deliver a message that was, if hyperbolic, nonetheless true. Europe was ablaze, and the flames were spreading fast. A second world war had begun and it would prove to be even more devastating than the first.

There were many causes of the Second World War: lingering German resentments over the faulty peace that followed the Great War of 1914–18; the catastrophic effects of the Great Depression; the consequent rise of fascist parties in Europe, especially the Nazis in Germany, the manifestation of Adolf Hitler's personal psychopathology.

A European war to check Hitler spread to North Africa and the Middle East, and became tangled up with a Pacific war to check Japanese aggression. The United States entered both theatres from 1941 after Japanese warplanes bombed Pearl Harbor in Hawaii. Anglo-American and Soviet invasions ended the war in Europe by May 1945, while the war in the East was terminated after the USA dropped atomic bombs on the Japanese cities of Hiroshima and Nagasaki.

In total, more than 50 million people died during the Second World War, and the conflict shaped global politics and cultural attitudes in ways still felt today. The close of hostilities ushered in another terrifying conflict: a series of proxy wars and a nuclear arms race between communist Russia and a free West, led by the USA, known as the Cold War.

Churchill's remarks to the House of Commons in June 1940 came three weeks before the beginning of one of the war's most famous battles. It is now known as the Battle of Britain: the first campaign in any war to be fought entirely in the skies. Aeroplane technology had advanced rapidly since the Great War, and for three and a half months the German

1940	1941	1942	1943	1944
[May] German troops invade France, skirting the Maginot Line and taking Paris by mid-June	[Jun] Germany invades its erstwhile ally, the USSR: the campaign is codenamed Operation Barbarossa	[Jun] Battle of Midway takes place in the Pacific Ocean, inflicting fatal damage on Japanese naval capability	[Jan] German troops at Stalingrad surrender to their Soviet enemies following a gruelling winter siege	[Jun] D-Day landings on 6 June begin Allied assault on Europe with a massive amphibious assault on beaches in Normandy
[May] Dunkirk evacuations begin, lifting 338,000 mostly British troops from the French coast to escape German military advance	[Dec] Japanese bombing raid on US naval base at Pearl Harbor, Hawaii, provokes the USA into joining the Second World War on the Allied side	[Aug] Guadalcanal campaign begins: Allied forces attempt to drive the Japanese out of the Solomon Islands	[Apr] Jewish insurgents trapped in a sealed-off section of Warsaw commence the Warsaw Ghetto Uprising	[Oct] Japanese air force begin to deploy kamikaze suicide attacks at the naval Battle of Leyte Gulf
[Jul] Battle of Britain begins, as the British Royal Air Force competes for supremacy with the German Luftwaffe		[Oct/Nov] British victory over German and Italian troops under Erwin Rommel at the Second Battle of El Alamein in Egypt	[Jul] Largest tank battle in history fought between German and Soviet forces at Kursk	

Luftwaffe, commanded by Hermann Göring, attempted to knock out Britain's capacity to defend itself by air, so that a seaborne invasion (codenamed Operation Sealion) would be possible.

The objective of the Royal Air Force was survival, and by the end of the summer that aim had been achieved. The principal planes used for the defence of the realm were the Hawker Hurricane and Supermarine Spitfire single-seater fighter planes.

Churchill is pictured here on 31 July 1940, when the Battle of Britain was at its height. He was inspecting defences near the coastal town of Hartlepool, County Durham, in the northeast of England, when he was handed a Tommy Gun. The resulting photograph would become one of the most enduring images of Britain's belligerent, nattily dressed, cigar-chomping prime minister, who seemed all at once to take on the trappings of an imperial bulldog and Prohibition-era Chicago gangster. It was taken by Captain W. G. Horton, a career photographer for *The Times* newspaper who, in his British army posting, was officially assigned to Churchill for the duration of the war.

Churchill was acutely aware throughout the war of the value of being both seen and heard by the British population. His stirring speeches in parliament were re-recorded for broadcast to the nation, and the War Office made sure Horton captured reel after reel of footage of him walking among the ordinary people. Often these people were suffering terribly, not least when, at the end of the summer of 1940, the Battle of Britain gave way to what is generally called the Blitz – in which German air attacks concentrated on a night-time terror bombing campaign aimed at civilian targets in London and port cities around the United Kingdom.

In the years before the Second World War broke out, Churchill (a veteran of the Boer War) had often seemed a man out of step with the times: an imperial relic of the 19th century whose habits and attitudes were entirely unsuited and even offensive to the new world. Yet in the fight against fascism – as close a thing to a genuine struggle between good and evil as history ever produced – he found and seized his moment. In that sense at least he deserves to be considered a great man of modern history.

1945

[Jan] Nazi SS leader Heinrich Himmler orders evacuation of concentration camps where the regime had been murdering millions of Jews and other ideological enemies

[Apr] Mussolini killed by Italian partisans; Hitler commits suicide. Allied victory in Europe declared in early May

[Aug] USA drops two atomic bombs on Japan, largely destroying Hiroshima and Nagasaki and forcing Japanese surrender

1946

[Mar] Winston Churchill describes the Cold War in a speech referring to an 'iron curtain' descending across Europe

[Oct] Nuremberg Trials end with the hanging or imprisonment of numerous high-ranking Nazi officials

[Dec] First Indochina War breaks out between French colonial forces and Communist Vietminh, led by Ho Chi Minh, president of North Vietnam

1947

[Mar] US President Harry S. Truman announces the Truman Doctrine, the basis for American assistance to democracies threatened by communist insurrection

[Aug] India partitioned to create an independent India and a Dominion of Pakistan, causing mass displacement and violence

1948

[Apr] Marshall Plan comes into effect, providing billions of dollars of US loans and aid to rebuild Europe

[May] David Ben-Gurion declares Israel an independent Jewish state, leading to war with the new nation's Arab neighbours

[Jun] Berlin airlift begins, to supply food, fuel and other provisions to free West Berlin, isolated behind communist lines

1949

[Jul] Ban on mixed marriages in South Africa marks the beginning of racist system of apartheid

[Aug] USSR tests its first atomic bomb

[Oct] Communist leader Mao Zedong announces the creation of the People's Republic of China

Blitzkrieg

Britain and France declared war on Germany in
September 1939, after Hitler invaded Poland. There
followed a six-month 'phoney war', as all sides
mustered their strength. Although Hitler regarded his
enemies with contempt – 'they are worms', he said –
the German military was smaller than the combined
Allied forces.

Moreover, France was stoutly defended. A chain
of concrete fortifications, weapons outposts and
walls known as the Maginot Line stretched along her
eastern border with Germany, from the foothills of
the Alps to the forests of the Ardennes.

Yet in the spring of 1940, Germany attacked and
the Maginot Line failed. Having first sent armies to
take Norway, between 10 and 27 May Hitler ordered
a lightning advance of German troops into France
through northwest Europe. German *Blitzkrieg*
tactics involved assaults by fast-moving armoured
and motorized infantry supported by Stuka dive
bombers. The Germans outflanked the French
fortifications, conquered Belgium, the Netherlands
and Luxembourg and drove British and French forces
rapidly towards the Atlantic coast. On 10 June the
fascist leader of Italy, Benito Mussolini, also declared
war on France, and four days later Paris surrendered.

This photo shows German troops storming
the Maginot Line in 1940, armed with pistols and
flamethrowers. The grinding trench warfare of the
First World War had not materialized, but in its
place had come something equally traumatizing: the
Blitzkrieg of a relentless military machine directed
with ferocious intent.

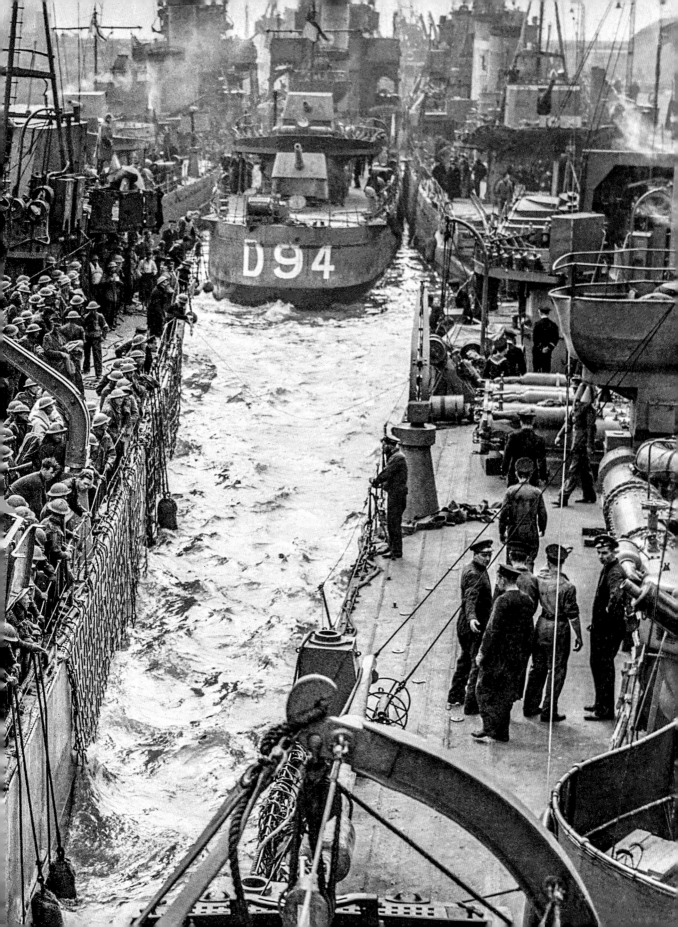

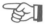

Dunkirk

In the spring of 1940 German armies threatened to wipe out the entire British Expeditionary Force that had been despatched to the Franco-Belgian border to fight alongside their French allies. Hundreds of thousands of men had fallen back towards the coast, and by the end of May they were trapped on the beaches around the town of Dunkirk. A scramble began to evacuate more than 400,000 British, French and Belgian troops to England.

The mission was codenamed Operation Dynamo, and was commanded from Dover Castle by Vice-Admiral Bertram Ramsay. Under RAF air cover around 900 ships and boats – ranging from destroyers to civilian lifeboats – were sent across the Channel to scoop up as many men as they could while Dunkirk's defences held.

Conditions on the beaches were dreadful, with men lining up among the sand dunes for up to a week, while Luftwaffe aircraft strafed them with machine-gun fire. Ramsay had expected to save 45,000 lives at most. Yet between 26 May and 4 June, 338,000 people were rescued.

One typical rescue vessel can be seen in the background of this photograph (pp. 356–7), published on the front page of the *Daily Sketch* tabloid newspaper on the morning of 3 June 1940. The British destroyer HMS *Whitehall* is marked with her pennant number D94. Although damaged by German gunfire, she delivered nearly 3,000 people to safety in four Channel crossings and spent the rest of the war patrolling the North Sea, destroying German U-boats.

The Blitz

The Battle of Britain during the summer of 1940 failed to destroy the RAF and Churchill adamantly refused to come to terms with the Nazis. Wary of invading Britain by sea, Hitler therefore turned to an air assault known as the Blitz, which targeted civilian and industrial targets in London, in towns on Britain's southern and western coasts, and in cities as far north as Hull, Liverpool and Glasgow.

Eighteen thousand tons of bombs were dropped on London, which was attacked on 57 consecutive nights during the autumn and winter of 1940. Many children were evacuated to the countryside to escape the destruction that left large swathes of the old City and working-class East End reduced to smoking ruins. This staged photograph from the Blitz emphasizes the plight of children during the bombing campaign. Despite the popular use of garden bomb shelters ('Anderson' shelters) and the conversion of basements and even the London Underground into makeshift bunkers, there were high numbers of casualties: more than 40,000 civilians were killed and nearly a million homes were destroyed by incendiaries and explosives.

The wail of air-raid sirens and staccato sound of anti-aircraft guns taking aim at German bombers formed a nightly ritual that drew to an end only in May 1941. By that time, Hitler had lost hope of, and interest in, defeating Britain on its own shores, and had turned his attention elsewhere, to a new and even deadlier front of the war in Eastern Europe.

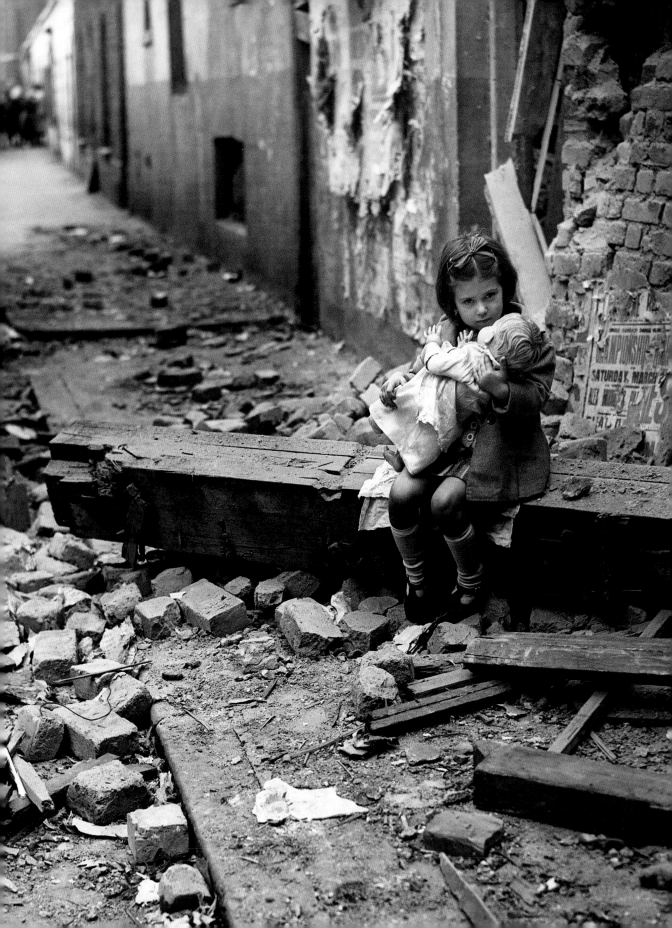

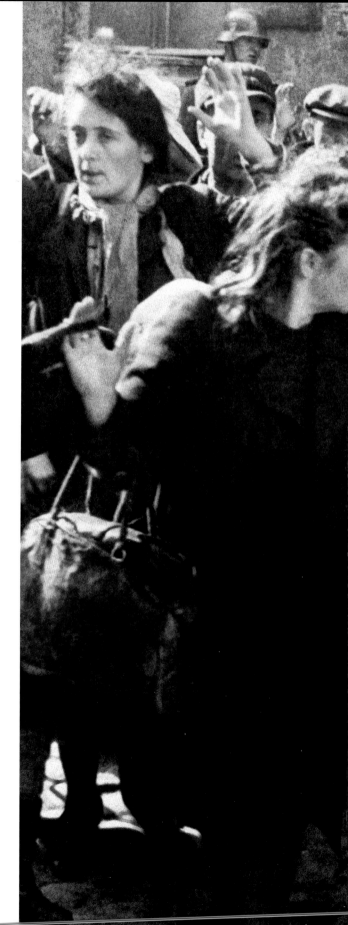

The Warsaw Ghetto

After German armies invaded Poland in autumn
1940, its capital city of Warsaw fell under Nazi
rule. This was disastrous for Warsaw's large Jewish
population.

After compelling Jews to identify themselves
with white armbands and blocking Jewish bank
accounts, the Nazi governors in Poland began to
relocate Jews from the suburbs and countryside to
the city centre. A 3m-high wall was built to seal off a
ghetto containing over 400,000 people within little
more than 3.4 sq km. Conditions were appalling,
with starvation rations set at 150kcal a day and typhus
rampant. Then in 1942 the Germans began herding
citizens onto trains heading east to Treblinka, where
they were exterminated en masse by shooting and in
gas chambers.

This photograph was taken in 1943 during the
Warsaw Ghetto Uprising. On 19 April rebels armed
with petrol bombs and pistols set upon Nazi troops
sent to round up victims for Treblinka. The uprising
lasted nearly four weeks until, in May, the ghetto
was destroyed with fire and explosives and the last
remaining inmates shot or deported. The identity
of the child pictured here is uncertain; the soldier
with the rifle is known to be one Josef Blösche, a
notoriously brutal member of the paramilitary Nazi
SS (*Schutzstaffel*), responsible for the execution of
hundreds of Jews in Warsaw.

His picture was included in the notorious
Stroop Report: an account of the uprising, prepared
by General Jürgen Stroop, who was hanged for war
crimes in 1951.

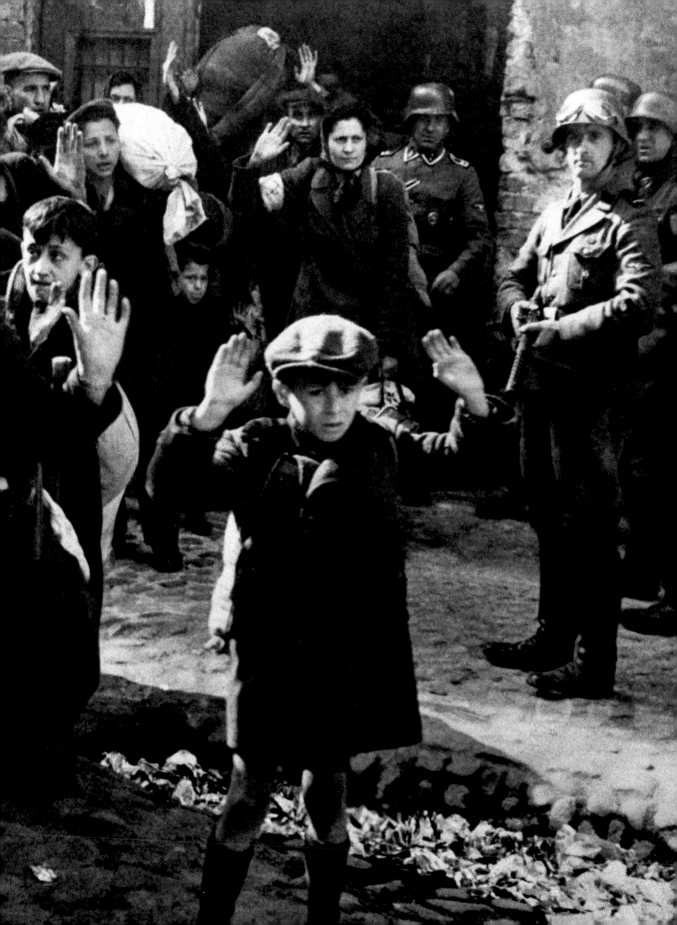

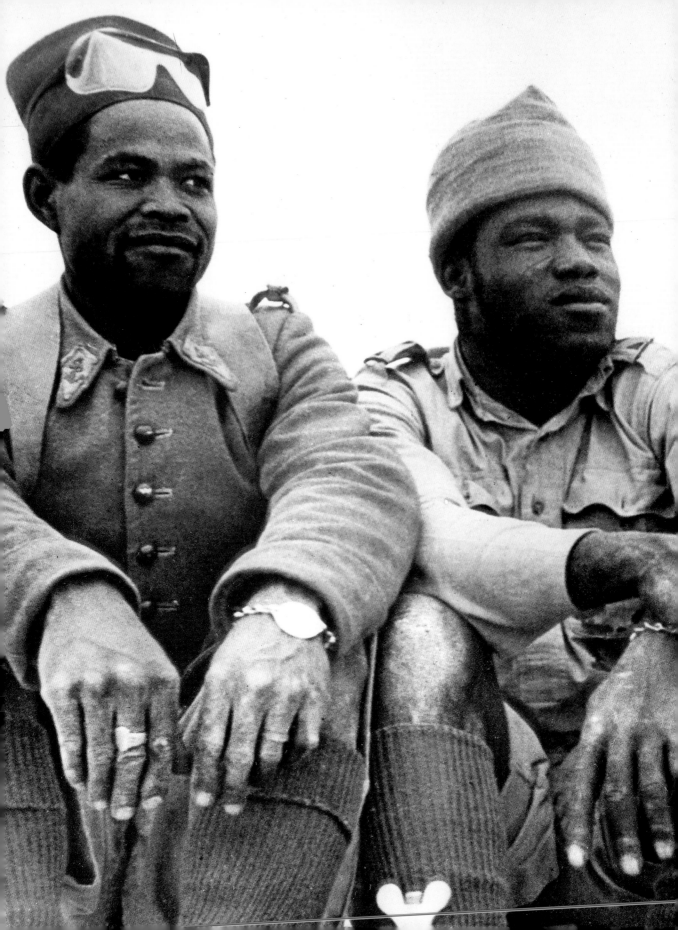

The War for North Africa

While Hitler's armies swarmed across Europe, a second field of conflict had emerged in the deserts of North Africa. Mussolini's Italian forces, which had invaded the British protectorate of Egypt from their adjoining colony of Libya in late 1940 – and been swiftly overwhelmed – were bolstered and eventually supplanted by Germany's Afrika Korps, led by the formidable general Erwin Rommel, nicknamed 'The Desert Fox'.

The war for North Africa lasted from June 1940 until the early summer of 1943, ranging from Egypt and Libya in the east to Morocco in the west. Although led by British armies, an array of other nationalities drawn from the British and French empires and beyond took part in the grinding campaigns. This photograph shows three members of the Free French foreign legion who took part in fighting around the Libyan oasis of Bir Hakeim during the early summer of 1942; the men are from Senegal, Madagascar and French Equatorial Africa.

General Bernard Montgomery's dramatic, and morale-raising, victory at El Alamein in October–November 1942 (the second battle fought at this location) brought Rommel's successful desert campaign to an end. The fighting would drag on for another six months, until the Axis forces were defeated and destroyed in Tunisia in May 1943. The Allies would push on to invade Italy, but by this stage the Japanese had bombed Pearl Harbor, the United States had entered the war and Hitler had invaded the Soviet Union. North Africa was only a part of an increasingly uncontrollable and truly global conflict.

'Our mandate from the prime minister is to destroy the Axis forces in North Africa… and it will be done!'

Lieutenant General Bernard Montgomery, 1942

The Eastern Front

The Soviet Union began the Second World War
on a spree of conquest almost as greedy as Hitler's.
Between 1939 and 1941 Joseph Stalin's armies invaded
eastern Poland, Latvia, Lithuania, Estonia and
Romania. During the Winter War of 1939–40 they
invaded Finland. This photograph shows a Soviet
infantryman on exercise in around 1940.

 The initial burst of Russian aggression in the east
was done under the protection of a non-aggression
pact with Hitler. But on 22 June 1941 the Führer
abandoned his promises and launched Operation
Barbarossa: a three-pronged German attack on the
USSR, spearheaded by *Panzer* (i.e. tank) divisions,
which blasted towards Leningrad in the north, Minsk
and Kiev in the centre and Odessa in the south.

 The Soviets lost around five million men in
three months. Yet if there was one thing the USSR's
enormous population could absorb, it was losses in
manpower. That, along with Stalin's insistence that
all men from his generals downwards fight to the
death or face execution for treachery, meant that
although the Soviets were battered back hundreds of
kilometres inside their own borders during Operation
Barbarossa, Moscow held out.

 As the bitter Russian winter set in, the German
Blitzkrieg stalled. The lightning victory Hitler had
sought was not forthcoming; indeed, over-ambition
in the east had dragged Hitler, like Napoleon
Bonaparte before him, into a sapping conflict that
would in the end prove to be his unmaking.

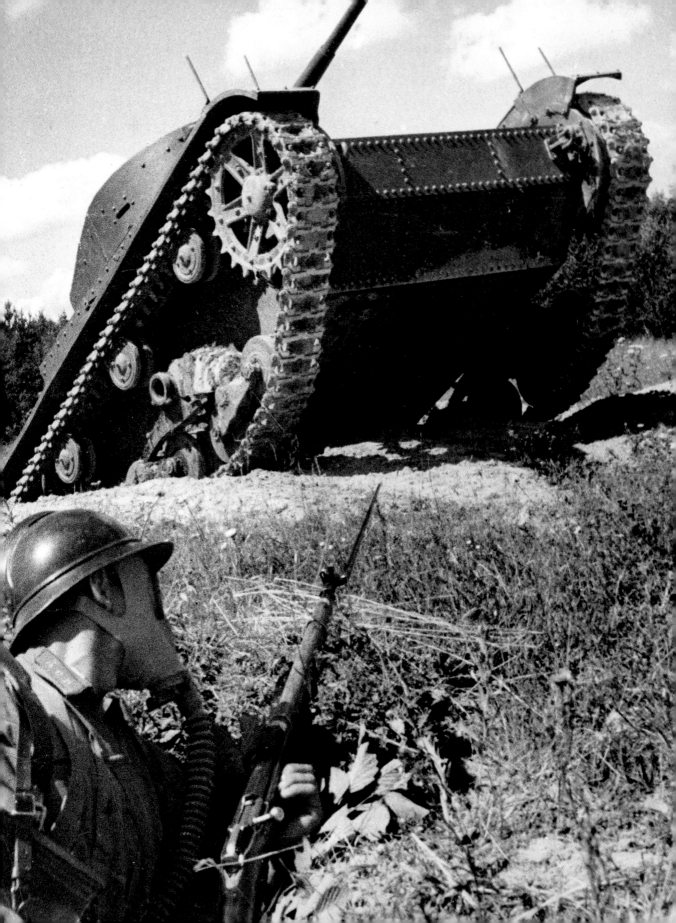

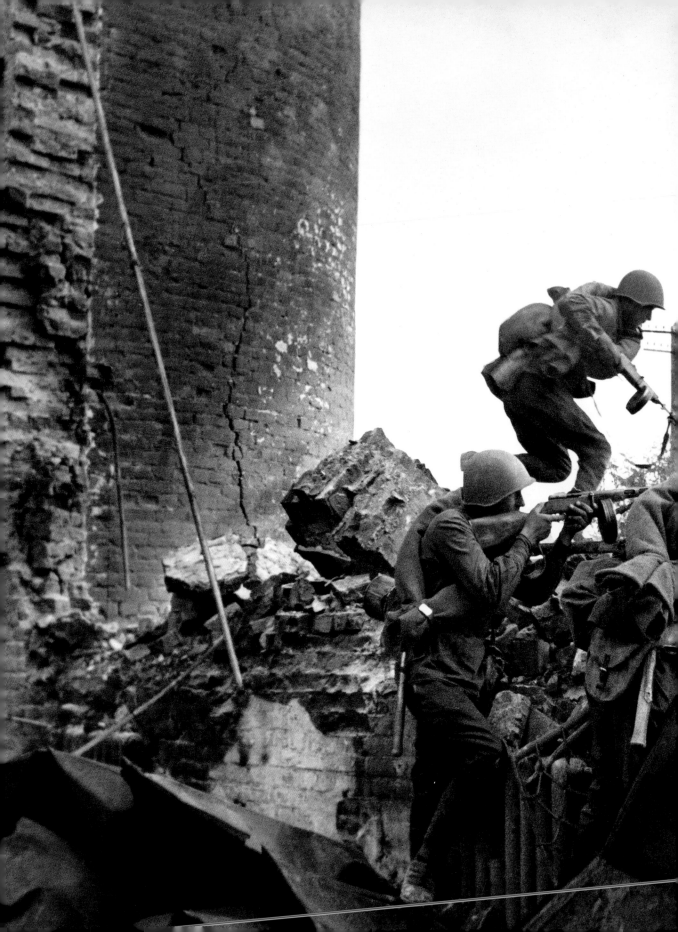

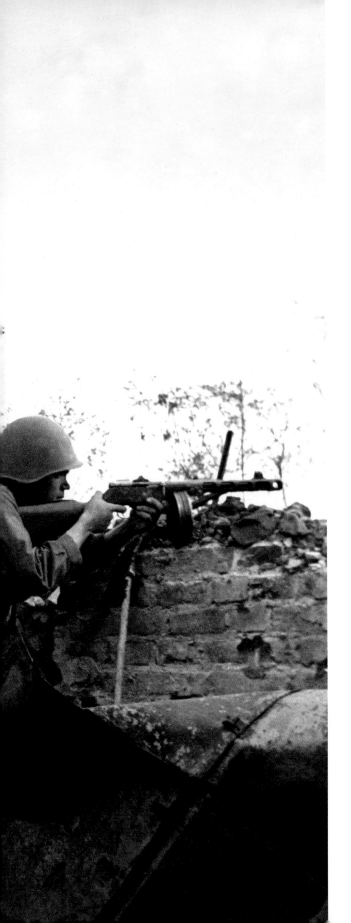

Stalingrad

In summer 1942, Hitler recommenced his assault on the Soviet Union. As part of a drive towards the oilfields of the Caucasus, the German Sixth Army advanced southeast and overran Stalingrad, an industrial city on the River Volga. In response, Stalin sent Marshal Georgy Zhukov, his finest general, aided by General Aleksandr Vasilevsky, to save the city.

On 19 November simultaneous Soviet operations, codenamed Mars and Uranus, respectively tied up German divisions near Moscow and trapped around a quarter of a million German troops around Stalingrad, cutting them off from the rest of the German and Axis forces. Throughout the winter of 1942–3 the Soviets allowed their enemies inside the Stalingrad pocket to freeze, starve and die of epidemic disease in their thousands, as Nazi attempts to relieve the siege by airdrops from the Luftwaffe faltered.

On 10 January Zhukov's assault began, with an artillery bombardment followed by a head-on attack across the icy countryside around Stalingrad, then street-to-street through the shattered city. The Red Army soldiers seen here fighting with PPSh-41 Schpagin submachine guns (nicknamed 'daddy' in Russian as a pun on their initials) were part of this Operation Koltso (meaning 'Ring'), which choked the Germans into submission.

Much to Hitler's fury, the Sixth Army's commander, Friedrich Paulus, surrendered on 31 January 1943, having lost 800,000 men killed or wounded and another 90,000 taken prisoner. Zhukov had lost even more, but he had saved Stalingrad, inflicting a humiliating defeat on Germany that turned the tide of the war.

'This victory meant that our Motherland had withstood one of the most difficult tests in its history.'

General Aleksandr Vasilevsky, after the defence of Stalingrad

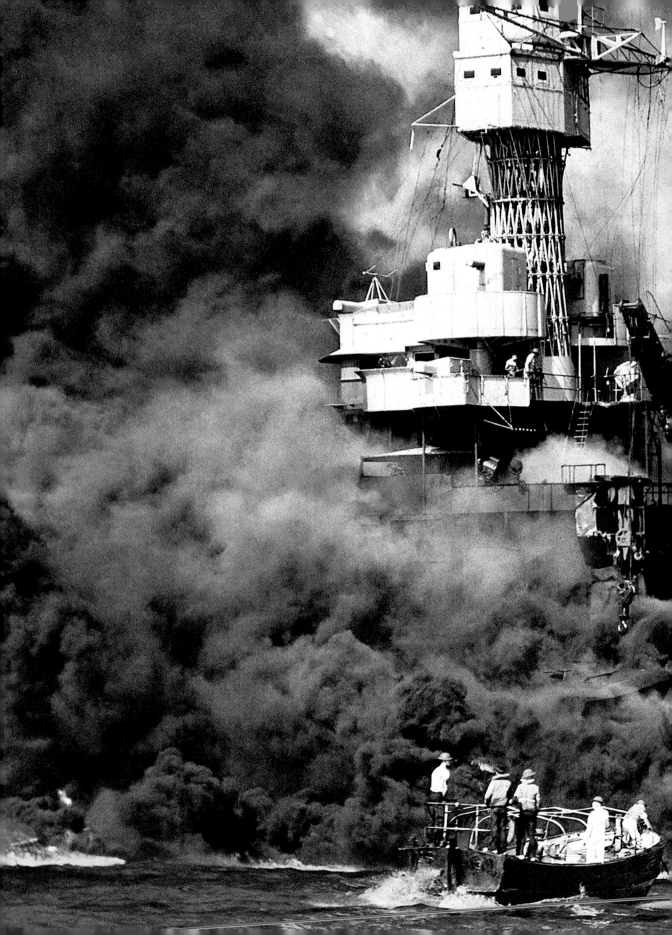

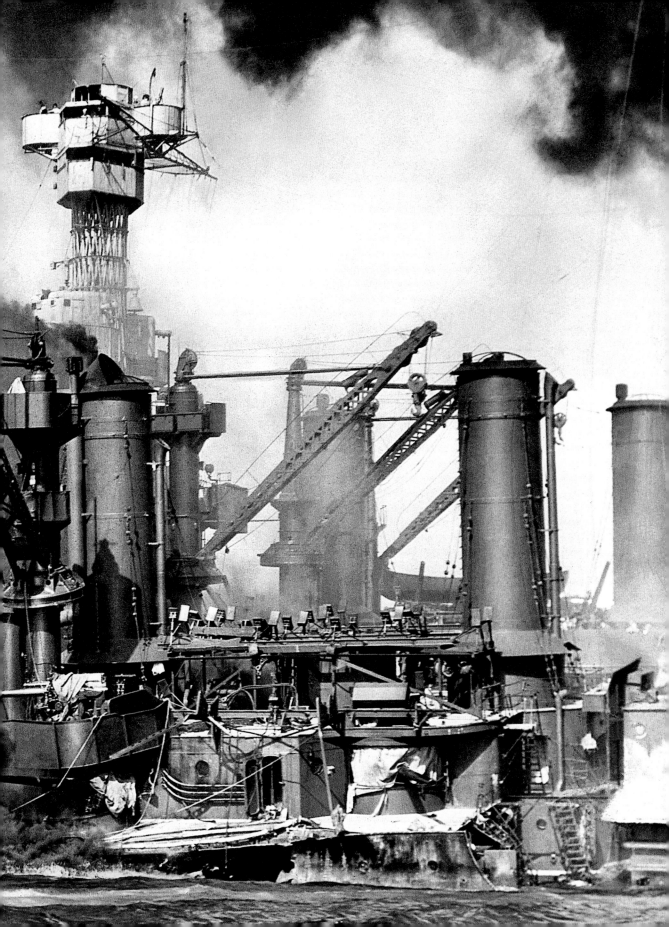

Pearl Harbor

'Air raid Pearl Harbor. This is not drill.' Terse but
chilling, this message alerted American servicemen
on the naval base at Pearl Harbor, Hawaii, to the
devastating and unanticipated attack that is pictured
here (pp. 368–9). It was 7 December 1941 and the
skies were screaming with the engines of more than
350 fighters and bombers of the Imperial Japanese
Navy Air Service.

By the time the assault was over at 10am, Japan
had destroyed or damaged more than a dozen US
naval ships and 360 aircraft; 2,403 Americans were
dead and 1,178 wounded. Elsewhere in the Pacific
near-simultaneous Japanese attacks were occurring
on US positions in the Philippines and Guam, on
British targets in Malaya and Hong Kong, and on
the kingdom of Thailand. US President Franklin
D. Roosevelt addressed the nation, describing the
Pearl Harbor raid as 'a day that will live in infamy'.
It was certainly a day that shaped history. After more
than two years of official neutrality (during which
it had been supporting the Allies with money and
supplies) the United States declared war on Japan on
8 December, followed by Germany on the USA on
the 12th.

America swung onto a war footing and turned
the full might of its massive industrial economy
behind the Allied cause. Pearl Harbor had come
nowhere near destroying American military
capability; it had only succeeding in provoking
a dangerous and effective enemy.

Guadalcanal

In the first half of 1942 the Japanese made rapid gains
throughout the Pacific, invading Singapore, New
Guinea, the Solomon Islands and Burma and sending
bombing raids as far afield as Darwin in Australia.
But after defeat in the huge naval Battle of Midway
on 4–7 June 1942, they began to falter. Their armies
were overstretched and their Allied enemies – the
United States, the British Empire, the Soviet Union
and China – had regrouped.

The counter-attack began in August as
Allied forces spearheaded by US Marines invaded
Guadalcanal in the Solomon Islands. Their main
goal was to prevent the Japanese from establishing
a strategic airbase at a location later known as
Henderson Field. Midnight landings at Guadalcanal
and the nearby Florida Islands on 6–7 August took
the Japanese by surprise. But there was no swift
victory; rather, a gruelling campaign of land, naval
and air warfare, much of which was undertaken in
thick tropical jungle. It took until February 1943 to
force a Japanese withdrawal.

This photograph, showing US infantry (who
took over from the Marines in December 1942)
bathing in a river, was taken by a team sent to
Guadalcanal by the American photographic weekly
Life magazine (launched in 1936), which included
the 25-year-old Ralph Morse. In the humid jungle
conditions Morse and his colleagues kept their
film rolls and caption notes dry by storing them
in condoms bought from military bases they flew
through on their way to the war zone.

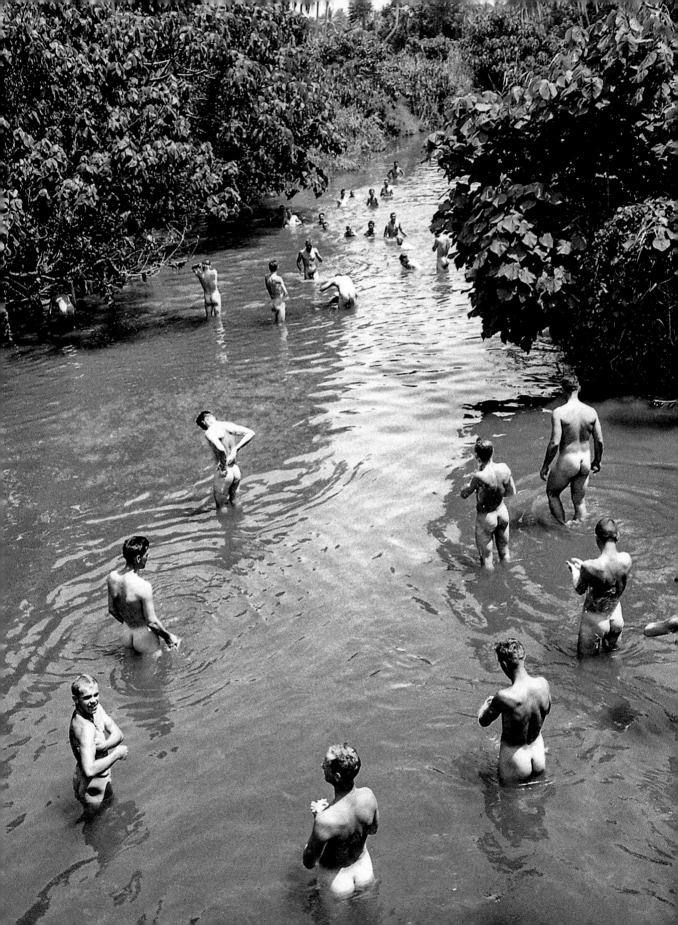

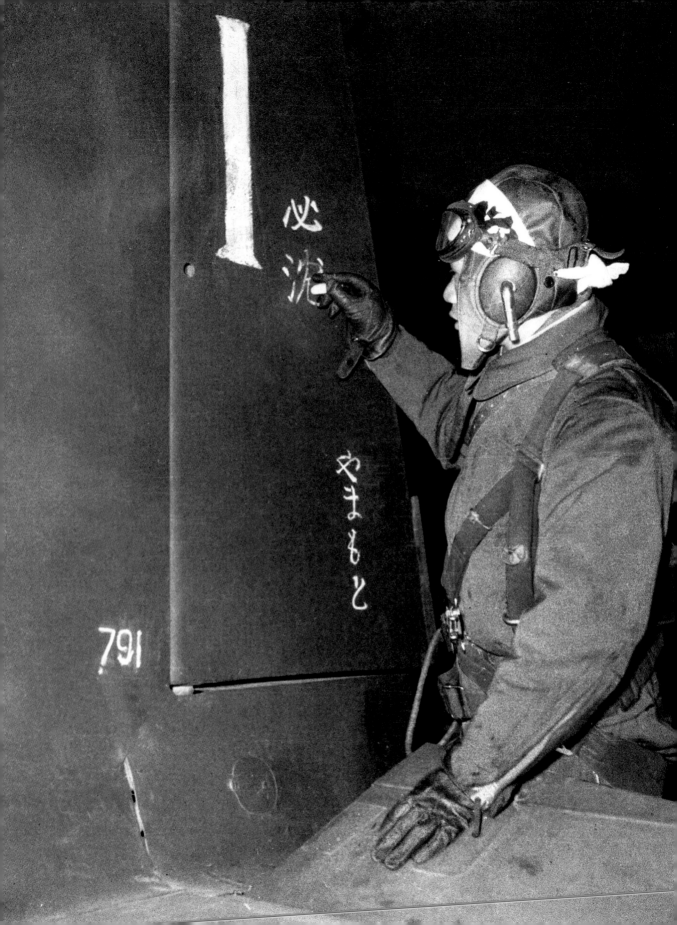

Kamikaze

The Guadalcanal campaign marked the beginning of a steady reversal of fortunes between the Japanese and Allied forces in the Pacific. At a summit held in Cairo in November 1943, US President Roosevelt, Britain's Prime Minister Winston Churchill and the Chinese Generalissimo Chiang Kai-shek issued a joint declaration of their intention to 'persevere in the serious and prolonged operations necessary to procure the unconditional surrender of Japan'.

In October 1944, at the Battle of Leyte Gulf off the Philippines (a massive clash won by the Allies, and often called the largest naval battle in history), a deadly new Japanese tactic was used for the first time: *kamikaze* attacks. The word translates as 'divine wind', a poetic name for suicide bombing. Japanese pilots flew planes loaded with explosives into enemy shipping, killing themselves but offering the possibility of far greater destruction and a much higher success rate than assault by missiles not flown by fanatical human beings. Nearly 4,000 kamikaze pilots died during the short period of the war in which the tactic was used.

The slogan being painted on the tail of this plane is a stark warning. 'You must sink,' it says, 'for Yamamoto.' This was a message not of simple loyalty, but of revenge. On 18 April 1943 Japan's naval commander Admiral Yamamoto had been killed, after an aircraft in which he was flying was shot down by US air force fighters as it passed over the island of Bougainville, east of New Guinea.

'In southern seas
Seeking enemy ship
Diving straight in.'

Haiku written the night before an attack by
kamikaze pilot Corporal Bunroku Fujita,
25 May 1945

'The tide has turned!
The free men of the world are
marching together to victory!'

US General Dwight D. Eisenhower,
6 June 1944

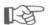

D-Day

By late 1943 the war was turning decisively in favour of the Allies. At another conference held in November–December of that year in the newly occupied Iranian capital, Tehran, the Allied leaders agreed the time was ripe to reopen hostilities in France.

On the morning of 6 June 1944 a massive armada of troop carriers and warships approached five stretches of beach in Lower Normandy, which the Allies had codenamed Utah, Omaha, Gold, Juno and Sword. With protection from heavy aerial bombardment, 132,000 men began to pour off landing craft and fight their way onto the beaches. Although they faced stiff resistance, an elaborate campaign of misinformation and fake preparations to invade either Norway or the Pas-de-Calais had led Hitler to order build-ups of his own forces in the wrong locations.

This photograph (overleaf), taken for the US Navy, shows members of the US 4th Infantry Division, and some of the 327th Glider Infantry Regiment, 101st Airborne in transit to Utah Beach on D-Day. Glider infantrymen were trained to land light, engineless and disposable aircraft behind enemy lines, but thanks to a shortage of tow-planes during the build-up to D-Day these airmen were deployed from the sea.

Nearly 10% of the participants in the D-Day landings on 6 June were killed or wounded during the course of the day's fighting, but the Allied strategic objective – to take the beaches, establish a bridgehead and set the stage for the reconquest of northwest Europe – had been secured.

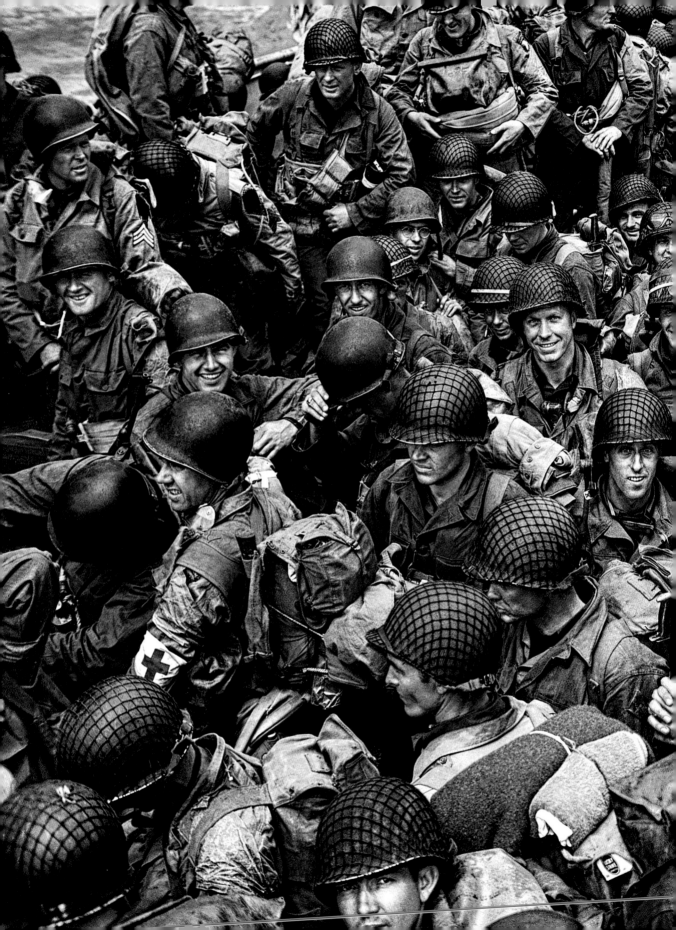

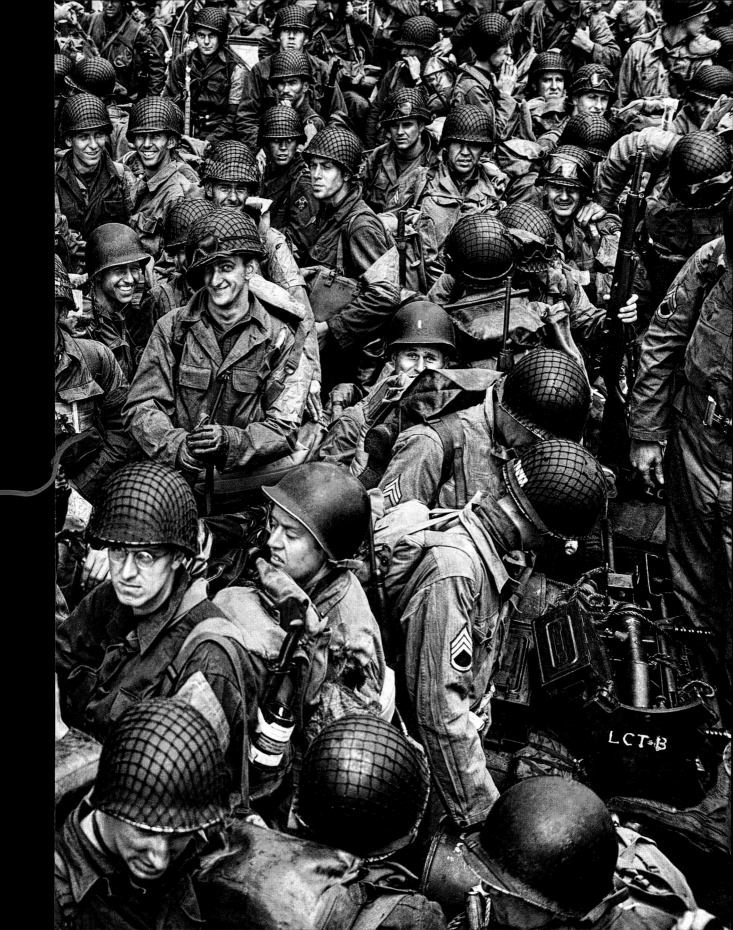

Liberation

In the spring of 1945, the inmates of Buchenwald sent out a Morse-code message on a shortwave radio they had built in secret. 'To the army of General Patton. This is the Buchenwald concentration camp. SOS. We request help. They want to evacuate us. The SS wants to destroy us.'

Since 1937 Buchenwald had received almost 250,000 prisoners, selected for death under the Nazis' murderous ideological policies. They included Jews, Soviet prisoners of war, gay men, Jehovah's Witnesses, Slavs, Poles, the disabled and those suffering from mental illness. More than 50,000 had died there: hanged, shot, starved, worked to death or subjected to cruel medical experiments. Now, as the Nazi state crumbled, the SS were herding inmates on forced 'death marches' towards the German interior, partly to cover their tracks and partly to retain slave labour.

This photograph barely hints at the horrors US soldiers found on 11 April 1945, when they liberated Buchenwald. Thousands of inmates were crammed into tiny bunks, thin as skeletons, malnourished and diseased. (One of those photographed here is the 16-year-old Elie Wiesel.) Dead bodies were piled up like logs. Sickened and angered, the liberating forces compelled residents of the local town, Weimar, to tour the camp. Many passed out, overwhelmed by the sight, the stench and the evil that lay, undeniable, before them.

Overall some 15–20 million people – including six million Jews – eventually fell victim to Nazi ideological murder, in a genocide often called the Holocaust or *Shoah*.

'From the depths of the mirror, a corpse was contemplating me.'

Elie Wiesel, *Holocaust Memoir*, translated into English as *Night* (1956)

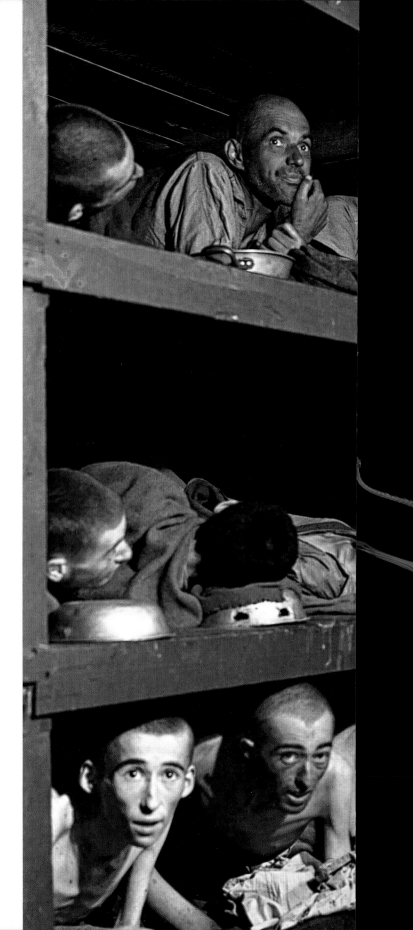

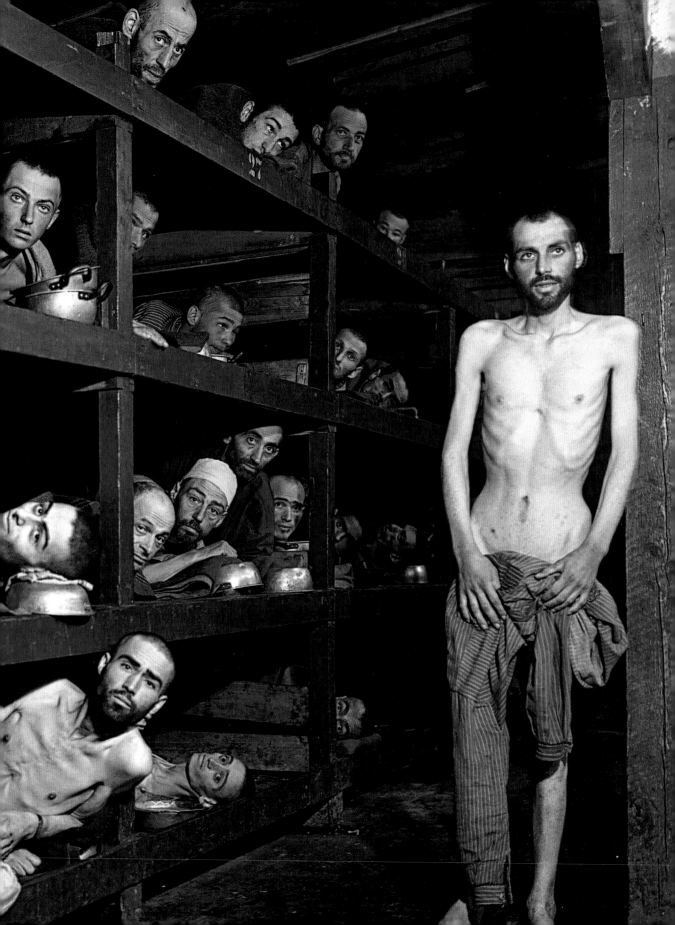

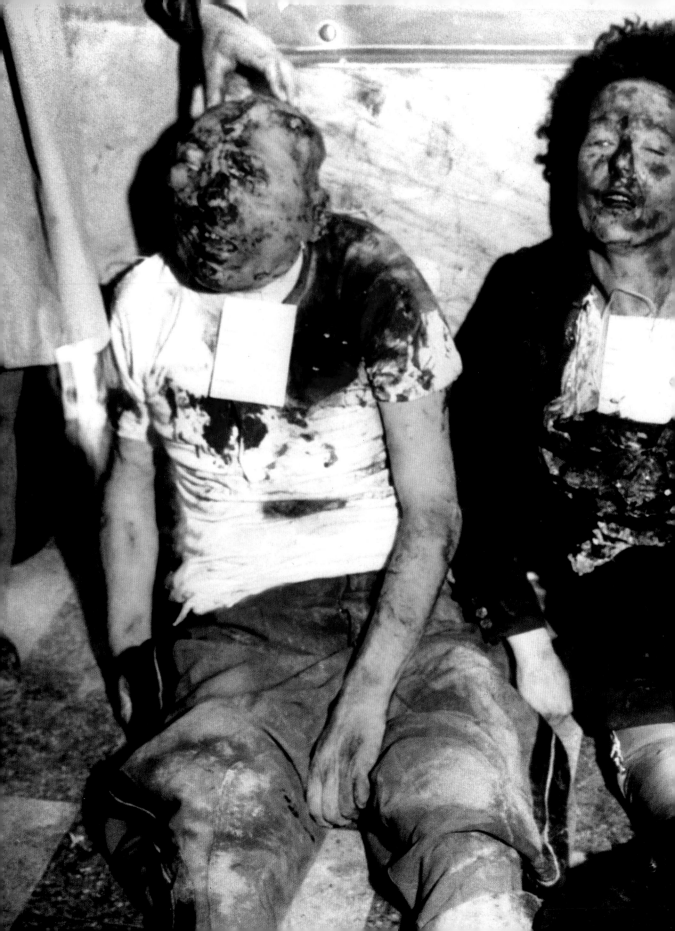

Mussolini's Death

After victory in North Africa, the Allies invaded Sicily
during the summer of 1943 and fought their way up
the Italian peninsula to Rome, which had fallen on
4 June 1944, two days before D-Day. Italy's fascist
dictator Benito Mussolini, or *Il Duce*, as he styled
himself, who had held power since 1922, had been
removed from office and imprisoned following the
fall of Sicily.

Later in 1943 he was sprung from confinement
in a ski resort in the Apennine mountains by a
Nazi paratrooper raid, but there was no question of
Mussolini regaining power over the whole of Italy,
which had by now switched sides to fight with the
Allies. Instead he was installed, on Hitler's say-so, as
the puppet leader of a rump state in northern Italy
known as the Italian Social Republic.

As the Nazi war effort fell apart in 1945 Germany
was no longer in any position to prop up Mussolini.
In late April of that year he fled his base in Milan,
pursued by partisan anti-fascist groups who had
put out orders for leaders of the extreme right to be
punished for their deeds. On 27 April Mussolini
and his mistress, Claretta Petacci, were captured by
partisans on the roads near Lake Como. The next
afternoon the pair were summarily shot dead, then
taken to Milan and ritually abused by crowds, who
kicked and beat their corpses then hung them up on
meathooks outside a petrol station.

Potsdam

Two days after Mussolini died, Adolf Hitler and his wife Eva Braun killed themselves in Berlin. The city capitulated to Stalin's Red Army on 2 May; on 7 and 8 May ('VE Day') General Alfred Jodl and Field Marshal Wilhelm Keitel signed instruments of unconditional surrender, acting with the approval of Hitler's successor, the head of the German navy Karl Dönitz. The war in Europe was over.

On 17 July 1945 an Allied conference opened at the Cecilienhof Palace in Potsdam on the outskirts of Berlin. It was the third wartime summit attended by the 'Big Three' – the leaders of the Soviet Union, the United States and Britain. The leaders who initially assembled at Potsdam, photographed here, included Winston Churchill (accompanied by Labour Party leader Clement Attlee), the new US President Harry S. Truman (Roosevelt had died in April 1945) and Joseph Stalin.

The major topics discussed at Potsdam were reconstructing Europe, dismantling and dividing Nazi Germany, the trial of surviving Nazi leaders, and ending the war with Japan. Britain, the USA and China issued a declaration calling for Japan's unconditional surrender, threatening 'utter destruction' otherwise. In that regard, Truman spoke cryptically of US plans to end the war in the Pacific, which involved a powerful new weapon. He did not reveal its nature, but it would become dreadfully plain within days of the conference, which concluded on 2 August.

'We have discovered the most terrible bomb in the history of the world.'

President Truman's private notes from the Potsdam conference

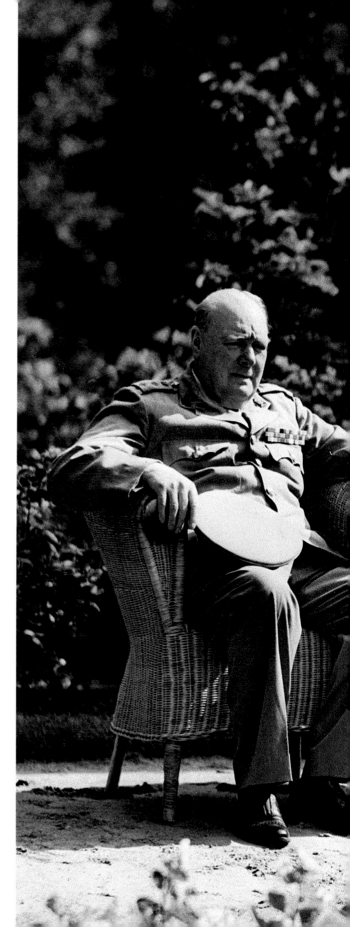

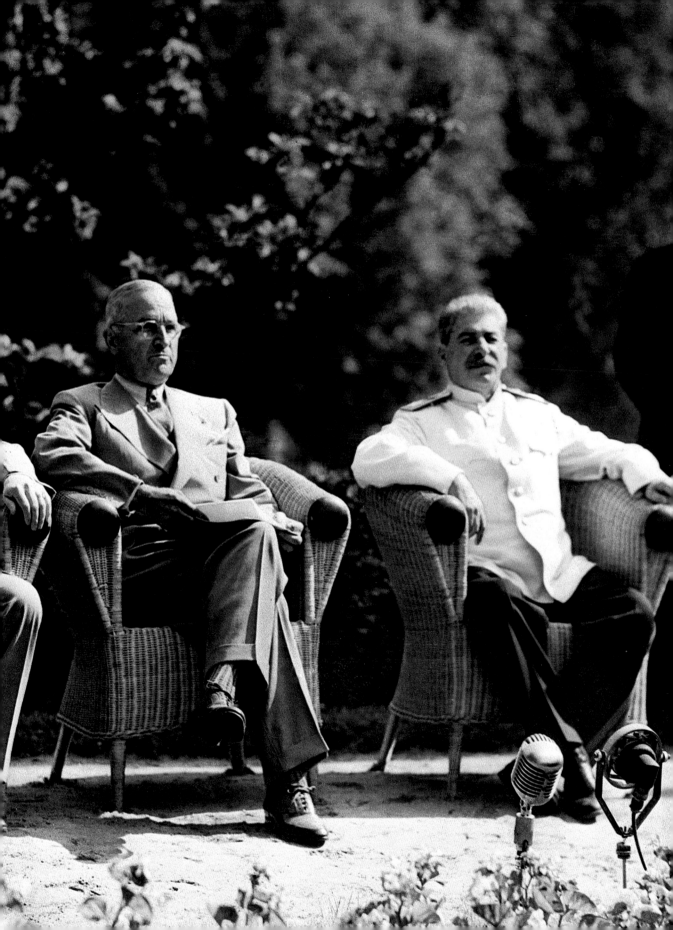

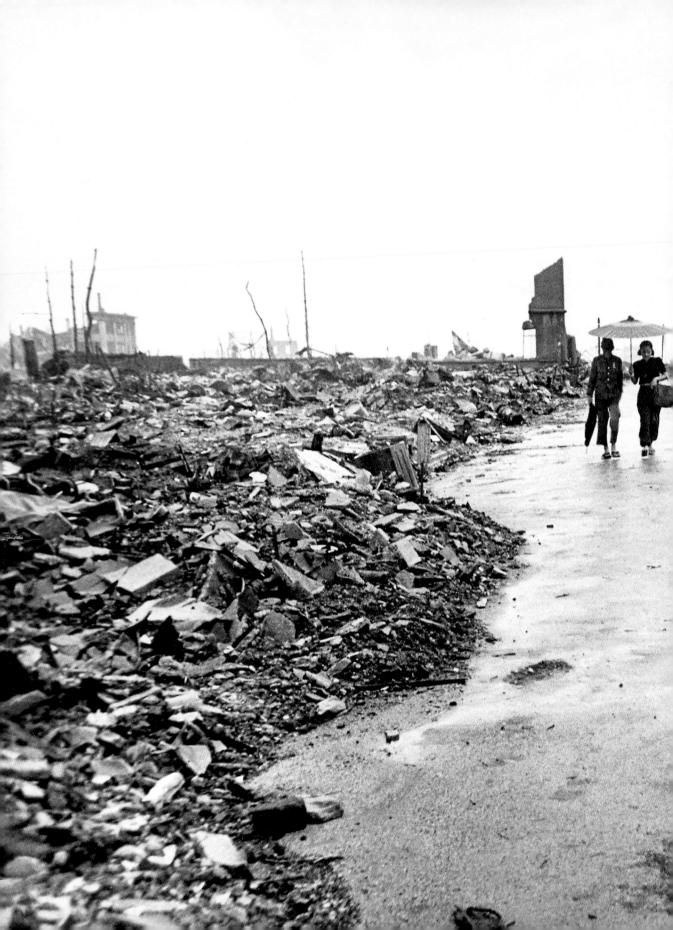

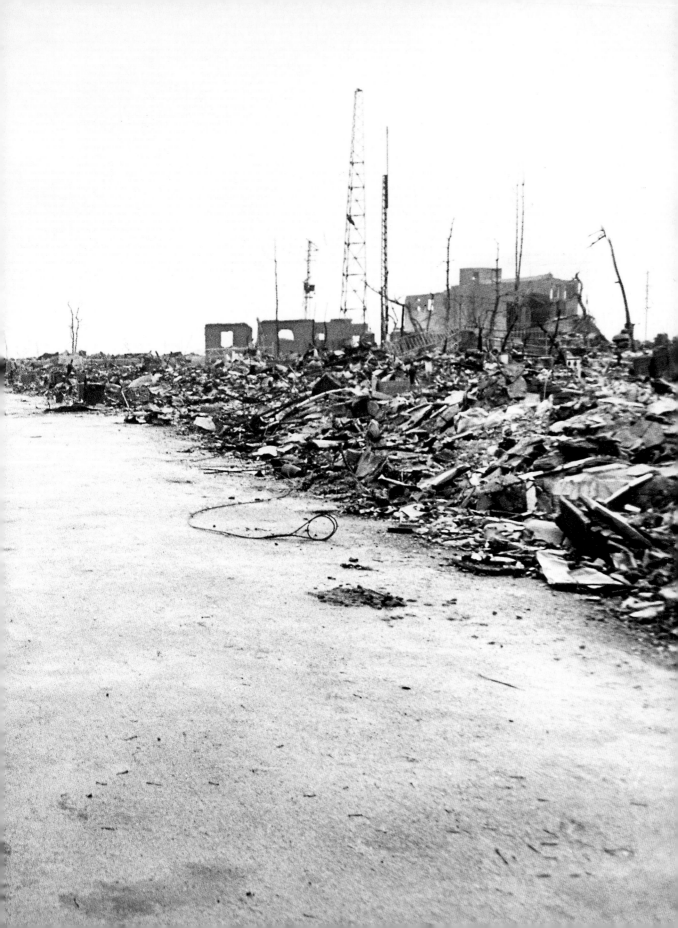

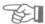

Hiroshima

During the war American scientists working at a secret New Mexico facility on a programme known as the Manhattan Project had developed two forms of atomic bomb. President Truman favoured testing these weapons on an enemy. Japan's failure to surrender at the end of the war gave him his opportunity.

During the spring of 1945 dozens of Japanese cities, including Tokyo, had already been devastated by Allied firebombing. On 6 August a bomb of an altogether different magnitude was dropped on the city of Hiroshima from a B-29 Superfortress heavy bomber called *Enola Gay*. The 4,000kg uranium bomb, codenamed 'Little Boy', detonated during the morning rush hour, evaporating 12 sq km of the city and killing 120,000 people between the initial blast and the end of the year. This photograph (pp. 382–3), taken by *Life* magazine's Bernard Hoffman in September 1945, shows what little was left of a once busy city.

Still the Japanese did not surrender. Truman ordered a second strike. On 9 August another B-29, *Bockscar*, dropped a plutonium bomb, codenamed 'Fat Man', on the city of Nagasaki, killing another 40,000. The prospect of further nuclear attacks, allied with the threat of the Soviets approaching with conventional weapons, finally convinced the emperor to sanction surrender. On 15 August Hirohito addressed the nation by radio for the first time in his life. 'Should we continue to fight,' he said, 'not only would it result in an ultimate collapse and obliteration of the Japanese nation, but also it would lead to the total extinction of human civilization.'

VJ Day

The photographer Alfred Eisenstaedt was walking through the throngs of people partying in the streets of Manhattan during the early evening of 14 August 1945. News had just reached New York of the Japanese surrender on the other side of the world (and the international dateline) and the city was in ecstatic uproar. In Times Square, Eisenstaedt saw a sailor careering down the street, 'grabbing any and every girl in sight'. Running ahead of the sailor, Eisenstaedt saw him throw his arms around a white-clad nurse. He pulled his camera from his shoulder and clicked the shutter four times.

A week later the best of the four frames was published in *Life* magazine. 'In New York's Times Square a white-clad girl clutches her purse and skirt as an uninhibited sailor plants his lips squarely on hers,' read the caption. The photograph rapidly became one of the most popular and iconic in American history – although the names of the kissers have never been agreed upon.

Eisenstaedt's photograph captured perfectly the mood of VJ Day. The journalist Don Iddon, writing for the *Daily Mail*, wired to London his reports of a city in joyous uproar. 'Sirens hooted from ships in the harbour, crowds danced through the streets … Times Square became the throbbing centre of the demonstration, in the biggest, wildest and most tumultuous turn-out in the city's history… Some servicemen were jolting civilians by light-heartedly firing their revolvers in the air and setting off firecrackers and kissing screaming girls.'

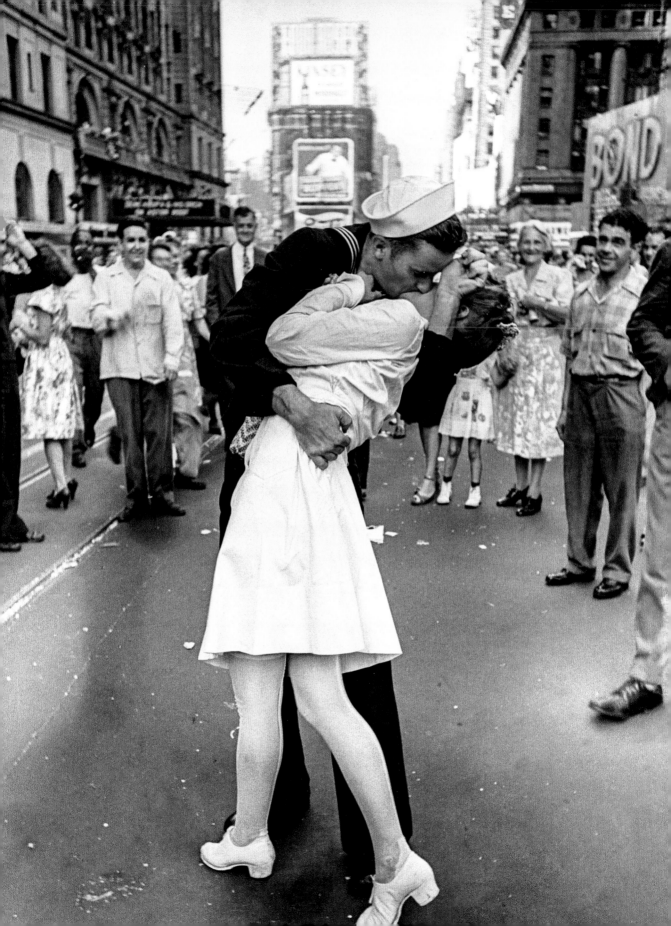

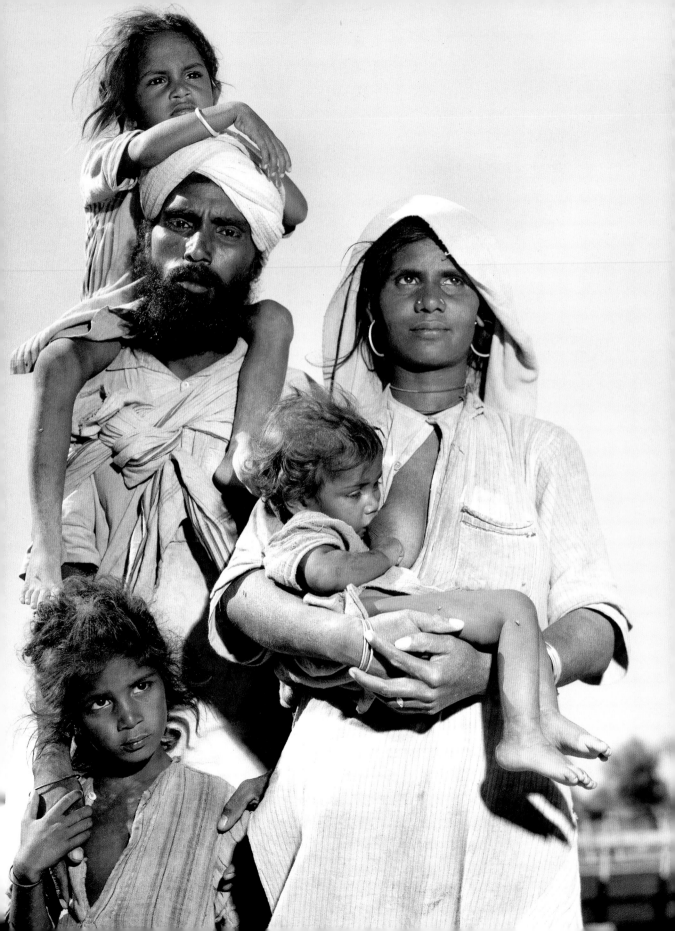

Indian Partition

Britain had emerged victorious from the Second World War but the damage wreaked on her possessions in the Far East, along with the efforts demanded of the colonies to help defeat the Axis Powers, meant that empire was unsustainable, unaffordable and ripe for breaking apart.

It began in India, where an independence movement had been building for decades. Britain had promised to grant self-government in 1942. Once the war was over, it was impossible to delay any longer. The question was how to achieve an orderly transition in a country riven with deep religious divides, most notably between Hindu, Muslim and Sikh communities.

The solution agreed on by the British viceroy Louis, Lord Mountbatten, the leader of the Indian Congress, Jawaharlal Nehru, and Muslim leader Muhammad Ali Jinnah was partition. On 14–15 August 1947 a large swathe of northwest India and a smaller portion in the northeast was carved off to form the Dominion (later, Islamic Republic) of Pakistan.

Partition was conceived with good intentions, but it was a disaster, bringing upheaval and bloodshed on a devastating scale. Planning was rushed and 15 million people (including the Sikh family photographed here) were displaced as minorities suddenly stranded on either side of the so-called Radcliffe Line fled rape, murder, 'ethnic cleansing', rioting and the wholesale destruction of towns and cities. Partition quickly created a chaos as bloody and horrifying as the civil war it was intended to prevent.

The Berlin Airlift

The end of the war also brought partition to Germany. After being defeated from both east and west, the Reich was divided into four zones, overseen respectively by the Soviet Union, the United States, Britain and, later, France.

Germany's capital, Berlin, lay deep inside the Soviet-controlled eastern sector, isolated from the British zone by 160km. But the city's status meant that it too was divided between the victorious powers. West Berlin, under Allied occupation, effectively became an island within Soviet territory.

By 1948 it was clear that tensions between the free West and the USSR were to form the basis for the next phase of global political hostility, known as the Cold War. In an attempt to force the Western Allies out of Berlin and extend Soviet control over as much of Germany as possible, Stalin ordered a near-total blockade of West Berlin's road, rail and air routes.

In response, the Allies agreed to supply West Berlin by cargo plane. (This photograph shows Berliners at Tempelhof Airfield watching an American C-47 coming in to land.) Envisaged as a short-term solution, the airlift lasted from 26 June 1948 until September of the following year. Aircraft from the US, Canadian, British, French, South African, Australian and New Zealand air forces dropped hundreds of thousands of tons of vital goods and supplies on the isolated city. Eventually the USSR backed down. But Berlin's fate was far from settled, and the Cold War had only just begun.

'From Stettin in the Baltic to Trieste in the Adriatic, an iron curtain has descended across the Continent.'

Winston Churchill, speech at Fulton, Missouri, 5 March 1946

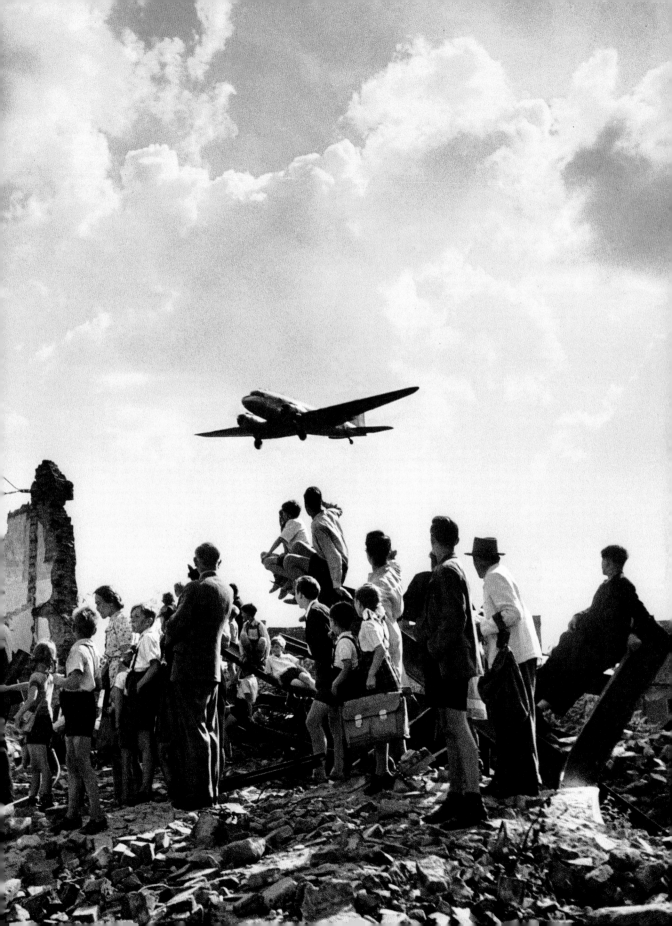

'Vehemence and hatred
between the Jews and
Arabs increase daily . . . '

Robert Kennedy reports from Palestine,
Boston Post, 5 June 1948

The Arab–Israeli War

The British Mandate of Palestine was another land
dismembered following the Second World War. In
1947 the United Nations (the successor to the League
of Nations) approved a plan to partition Palestine
three ways. Separate Jewish and Arab states were
planned, while the area surrounding and including
Jerusalem and Bethlehem was to be placed under
international supervision.

The result of this partition, as with so many
others, was misery and violence. When the
Zionist leader David Ben-Gurion declared Israel's
independence in May 1948, Arab armies from Egypt,
Jordan, Syria, Lebanon and Iraq, supported by
smaller contingents from Saudi Arabia and Yemen,
invaded Palestine. The soldier pictured here is part of
the Arab Legion, the British-trained (and led) army
of Jordan.

The Arabs began the war with superior
forces, but Israel was secretly armed and supplied
by Czechoslovakia and rapidly expanded both its
military capability and its territory. By the time
armistice agreements were put in place in 1949, Israel
controlled almost all of the land intended for division
between the two peoples. Only a large pocket of
land west of the River Jordan up to and including
East Jerusalem (the 'West Bank') and a sliver of
coastal territory around Gaza (the 'Gaza Strip') lay
under Egyptian and Jordanian control. Hundreds
of thousands of Palestinian Arab civilians had been
displaced and many were now refugees.

To Israel a great 'war of independence' had been
won. Arabs described their defeat and the exodus that
followed as the *Nakba*, or catastrophe.

Changing Times

'Some people tap their feet,
some people snap their fingers,
and some people sway back and forth.
I just sorta do 'em all together...'

Elvis Presley, interview, 1956

The age of rulers with royal blood had long been waning, and the world was hungry for a new kind of king. It found one in the American rock 'n' roll star Elvis Aaron Presley, born in Tupelo, Mississippi, in 1935, and destined during his relatively short career for worldwide fame on a scale achieved by few entertainers before or after him.

Elvis was raised a poor, lonely, God-fearing mother's boy, who found solace and joy in the rich, soulful music of the segregated American South: gospel, blues, jazz, soul and country. In 1948 his father, a labourer and petty criminal, moved the family to Memphis, Tennessee, which would be Elvis's home for the rest of his life. There he learned to play piano and guitar, entered singing contests and started to dream of a recording career.

In 1953 the 18-year-old Elvis began recording demo records under the watch of the Memphis-based producer Sam Phillips. The following summer Phillips's label, Sun Records, released two of his songs to local radio stations and by the end of the year Elvis was touring the United States. His 'rockabilly sound' found instant popularity in Memphis and beyond, while his sexually charged stage persona exerted a powerful effect on young women in particular: his fans' wild response to his gyrations while performing

was a cause of major moral concern to older, conservative Americans.

In the summer of 1955 Elvis signed a management contract with Andreas Cornelis van Kuijk, a Dutch-born promoter better known by the name 'Colonel Tom' Parker. Aggressive and rapacious, Parker determined to squeeze from Elvis's act every possible iota of attention, fame and wealth. The two men made a formidable partnership, and from 1956 Elvis poured forth an apparently ceaseless (and extremely profitable) stream of smash-hit records, including classic recordings such as 'Heartbreak Hotel', 'Hound Dog' and 'Jailhouse Rock'. He signed multi-picture deals with Hollywood studios to appear in motion pictures such as *Love Me Tender* (1956). These, together with his personal appearances on the newly popular mass medium of television, propelled Elvis to international celebrity. Four years after his first recording he was the most famous – and controversial – musician in the world.

Then, in 1958, he stopped performing. Military conscription in the USA had been signed into law in 1940 and would last until 1973; Elvis was therefore liable for service in the armed forces. In March 1958, amid frenzied media attention, he formally joined the US army and was stationed at Friedberg in West

1950

[Jan] President Truman orders development of the hydrogen bomb, escalating a nuclear arms race in the Cold War

[Jun] North Korean forces invade South Korea, beginning the Korean War. Hostilities continue until a truce in 1953 permanently divides the peninsula

1951

[Apr] Treaty of Paris establishes the European Coal and Steel Community, forerunner of the EEC and EU

[May] Tibetan delegates sign Seventeen Point Agreement affirming Chinese sovereignty over Tibet

[Oct] Winston Churchill returned as British prime minister following a six-year period in opposition

1952

[Feb] King George VI dies and Elizabeth II becomes queen of the United Kingdom and head of the Commonwealth

[Oct] State of emergency declared in Kenya in response to Mau Mau uprising against British colonial rule

1953

[Jan] North Sea flooding causes extensive damage in Britain and the Netherlands

[Mar] Joseph Stalin dies after a night of heavy drinking. By 1956 he has been replaced as leader of the USSR by Nikita Khrushchev

[Aug] Elvis Presley records his first songs at Sun Records' studio in Memphis, Tennessee

1954

[Apr] Geneva Conference ends with partition of French Indochina, creating two Vietnamese states divided at the 17th parallel.

[Jun] Military coup in Guatemala, backed and aided by the American CIA, deposes President Jacobo Árbenz in favour of a military junta

[Nov] Algerian National Liberation Front (FLN) announces a struggle to secure independence from French rule

Germany with the 3rd Armored Division. He would serve his two years in some comfort: living in hotels rather than a barracks and enjoying the company by night of numerous young female admirers, including a 14-year-old called Priscilla Beaulieu, whom he married in 1967.

This photograph dates from the end of Presley's military service – by which time he had been promoted to sergeant and, as denoted from the badges on his dress greens, had attained 'expert' and 'sharpshooter' status with a variety of weapons, including pistols and carbine rifles. He was discharged from service on 5 March 1960 and returned to the USA, free to perform once more. He continued to live up to his nickname as 'the king of rock 'n' roll' – but his later years saw a decline into ill-health and drug addiction, ending on 16 August 1977 when he died of a heart attack on a bathroom floor in Graceland, his palatial home in Memphis.

Elvis's deployment to Germany at the height of his fame spoke to a number of important trends during the 1950s. He was a screen icon and a hip-twisting sex symbol to a generation of young people with scant regard for the pieties of the pre-war age. He was also a very visible illustration of conflicts new and old that haunted the world. In occupied Germany he lived on the front line of the Cold War, an all-consuming struggle between the two new superpowers – the USA and Soviet Union.

The Cold War was not altogether cold during the 1950s, as the Korean War and conflicts in Latin America and the Caribbean would demonstrate. Coups and proxy battles that cost thousands of lives were accompanied by nuclear testing and a race to send men into space – all played out against the backdrop of witch-hunts and purges on both sides.

Meanwhile, the 'old' empires broke up in often painful fashion, a process that sparked chaotic realignment and brutal conflict on every continent in the world. Yet alongside all this came the rise of new technologies and a consumerist boom. Television, radio and newspapers thrived, making stars of people like Marilyn Monroe and Elvis Presley, who restored the world to colour after so many decades in the dark.

1955

[May] Warsaw Pact announced to coordinate military defence between USSR and satellite communist states

[Sep] Argentinean president Juan Perón removed from power by military coup

[Dec] Montgomery bus boycott begins in Alabama after African–American Rosa Parks refuses to vacate her seat for a white passenger

1956

[Jun] Playwright Arthur Miller called before House Un-American Activities Committee on suspicion of communist ties. He marries Marilyn Monroe eight days later

[Jul] Egypt's President Nasser nationalizes Suez Canal, leading to the Suez Crisis

[Nov] Soviet tanks crush a Hungarian uprising against communist rule

[Dec] In South Africa, Nelson Mandela and dozens of anti-apartheid activists are charged with treason

1957

[Mar] European Economic Community (EEC) established by the Treaty of Rome to promote economic integration between members

[Oct] François 'Papa Doc' Duvalier assumes office as president of Haiti

[Oct] USSR successfully launches *Sputnik 1*, the first artificial orbital satellite

1958

[Jan] Mao Zedong unveils the Great Leap Forward, a programme of economic reform in China which contributes to a famine in which 45 million people die

[Mar] Elvis Presley accepts conscription into the US Army, and is sent to serve at Friedburg in occupied West Germany

1959

[Jan] President Fulgencio Batista flees Cuba, leaving the country in the hands of revolutionaries Fidel and Raul Castro and Che Guevara

[Jan] Former French resistance leader Charles de Gaulle becomes president of the French Fifth Republic

[Mar] Tibetan uprising against Chinese rule begins; 14th Dalai Lama escapes into exile

Struggle for Tibet

The subject of Tibetan independence – or not – from Chinese rule is one of the most sensitive issues in modern history. Following the Chinese Revolution that overthrew the Qing dynasty in 1911–12, Tibet operated in fact, if not in law, as an independent government. But after the Second World War was over, in 1949 China fell to a communist revolution and troops of the Chinese People's Liberation Army (PLA) soon entered eastern Tibet. The Tibetan government was compelled to travel to Beijing and sign a treaty in 1951 that effectively ensured the status of the region as a part of China.

This photograph was taken by the British photographer Bert Hardy, and published in 1951 in *Picture Post* – a weekly publication similar to the blockbusting American *Life* magazine. It shows a Tibetan mother with her child on the road between Tibet and Kalimpong in West Bengal.

Women and children on the roads became a common sight in Tibet for the rest of the 1950s, as fighting broke out from 1956 onwards, culminating in a popular uprising in the Tibetan capital of Lhasa in 1959. Fearing kidnap, the young Tibetan spiritual leader and head of state known as the 14th Dalai Lama fled over the Himalayas to take sanctuary in India; he remains in exile from his country today. In 1989 he won the Nobel Peace Prize for his efforts to broker a peaceful settlement to the Tibetan question.

'In Tibet . . . they believe the more difficult the journey, the greater the depth of purification.'

Heinrich Harrer, *Seven Years in Tibet* (1952)

'Classes struggle, some classes triumph, others are eliminated. Such is history . . .'

Mao Zedong, 1949

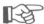

Khrushchev, Mao and Ho

As the Cold War intensified during the 1950s, the two most powerful men on the communist side were the leaders of the Soviet Union and China respectively. Two of them are photographed here: Nikita Khrushchev and Mao Zedong, shown dining in Beijing in 1959 alongside North Vietnamese president Ho Chi Minh (overleaf). His country would be drawn into an agonizing ideological proxy war – between communist North and US-backed South – that began in 1955 and would last for 20 years.

Khrushchev's rise to become the leader of the USSR began when Joseph Stalin died on 5 March 1953 from a massive stroke brought on by a night of heavy drinking. Stalin's immediate successor was Georgy Malenkov, but after a period of political dogfighting he was removed and by 1956 Khrushchev was pre-eminent, and working to pursue policies of 'de-Stalinization'.

Mao had consolidated his power somewhat earlier, after emerging victorious from the Chinese Civil War of 1945–9, which firmly established the Communist Party of China as the ruling party in the state, leaving the Kuomintang to rule over a rump republican state based on the island of Taiwan. By the time this picture was taken Mao had begun to implement his 'Great Leap Forward' – a disastrous and tyrannical attempt to modernize Chinese industry and agriculture which caused 45 million deaths in the Great Chinese Famine.

Despite the apparently cordial scene, tensions between Khrushchev and Mao often ran high, as their views diverged on what communism was and how it should develop during the 20th century.

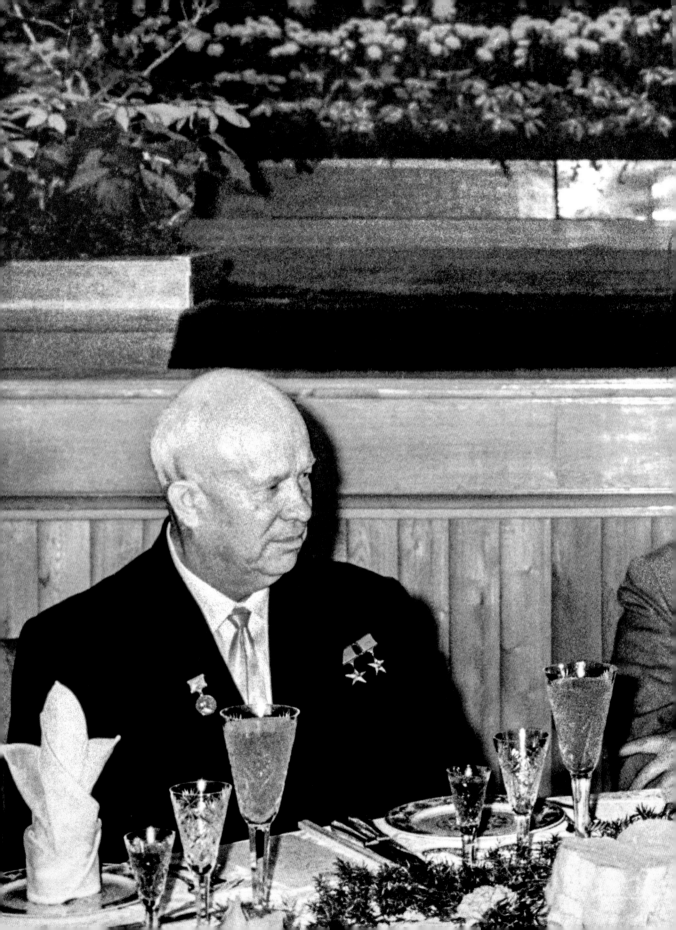

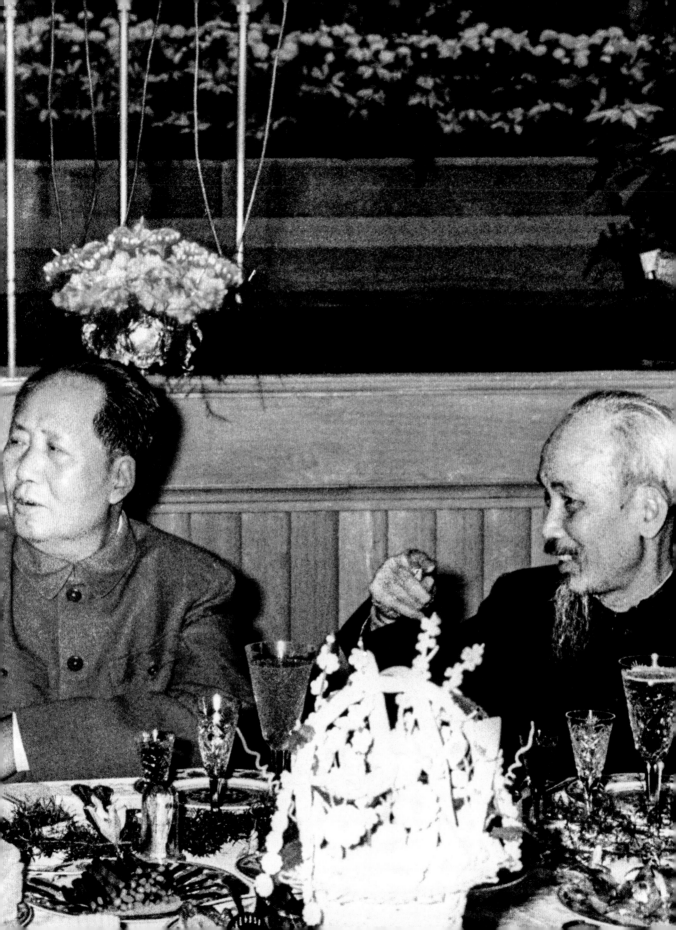

The Korean War

On the eastern side of China an even bloodier conflict was brewing, as the first major proxy encounter of the Cold War period broke out in Korea.

Japanese rule over Korea, imposed in 1910 shortly after the assassination of Queen Min, ended following Allied victory in the Second World War. Korea was liberated from the north by the Soviet Union and from the south by American troops, so that by 1948 it was ruled by two different governments, divided at the 38th parallel. Each was backed by a rival superpower.

On 25 June 1950 North Korean forces invaded South Korea and swept towards the tip of the peninsula, reinforced from October by a massive influx of Chinese troops. This photograph dates from around that time, and shows South Korean troops capturing an injured North Korean fighter during the Battle of P'ohang-dong.

The North Koreans and Chinese were eventually driven back by a coalition of United Nations, US and South Korean forces. By 1951 a grinding stalemate across the parallel had begun, during which the peninsula was battered by bombing raids, naval shelling, fighter-jet skirmishing, infantry battles and guerrilla warfare, while the controversial US general Douglas MacArthur was lobbying for nuclear strikes against North Korea and China. The death toll was grim: perhaps one million soldiers and 2.5 million civilians perished. A truce was agreed at the village of Panmunjom in 1953, but for the rest of the century the demilitarized zone at the 38th parallel remained one of the most tense international borders in the world.

'If we lose the war to Communism in Asia, the fate of Europe will be gravely jeopardized.'

General Douglas MacArthur, speech, 23 August 1950

'I am not a liberator. Liberators do not exist. The people liberate themselves.'

Ernesto 'Che' Guevara, 1958

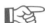

Fidel and Che

The spectre of communism crept within 300km of the American coastline during the 1950s when the two men pictured here (overleaf), Fidel Castro and Ernesto 'Che' Guevara, led a revolution against Cuba's dictatorial president Fulgencio Batista.

Castro (born in 1926) was a lawyer-turned-revolutionary who founded a paramilitary army with his brother Raúl in 1952 to fight against Batista's US-backed authoritarian police state. The brothers were jailed for attacking government barracks on 26 July 1953, but they were released in an amnesty in 1955 and continued their struggle.

That year in Mexico City they met Guevara, an Argentinian medical student whose own anti-capitalist leanings had been hardened by his experience of US interference in South American states. Guevara sailed to Cuba with the brothers and together they set up a tiny but dedicated guerrilla army based in the mountains, which frequently bested the Cuban national army in battle. When Batista fled the country in January 1959, the Castros and Guevara were triumphant.

Initially Fidel denied that he had led a communist revolution, but from 1961, following the failure of a US-sponsored counter-revolutionary invasion at the Bay of Pigs, Cuba aligned with the USSR. In 1962 it was the focus of the Cuban Missile Crisis, which almost began a nuclear war.

Guevara, addicted to revolution, left Cuba in 1965 to foment trouble in the Congo and later Bolivia, where he was captured and shot dead. Fidel, however, led Cuba until 2008.

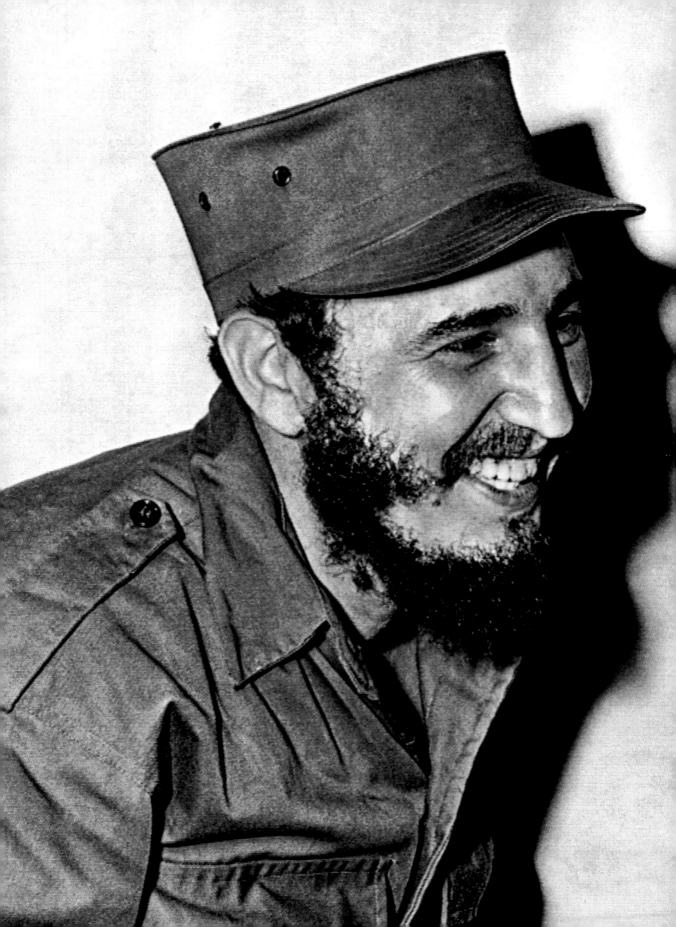

The Guatemalan Coup

An important part of Che Guevara's political education took place in Guatemala, which he visited in 1953–4 at a time when the nation was boiling with revolutionary tension agitated by America's Central Intelligence Agency (CIA).

In 1951 Guatemala elected as its president Jacobo Árbenz Guzmán, who began a series of reforms in which land not being used for industry or agriculture was seized and redistributed to indigent peasants. In the United States this caused serious consternation, prompting fears of the imminent arrival of communism in the Americas, while also threatening the assets of the politically influential, multinational corporation United Fruit, which suffered land confiscations and lobbied hard for US intervention. In 1954 a CIA-trained army of revolutionaries launched a coup, deposed Árbenz Guzmán and installed Carlos Castillo Armas as a dictator.

The CIA supported the coup with heavy-handed propaganda and psychological operations. This photograph shows the pro-Armas fighter Maria Trinidad Cruz kneeling in front of a tomb. According to news reports in the USA, the tomb was her husband's: the Associated Press agency reported he had been killed by firing squad while 'battling Reds'.

The after-effects of the Guatemalan coup were long and profound. It worsened an already unstable political situation, contributing to a civil war that lasted from 1960 until the 1990s. In Latin America at large, it fuelled growing anti-US sentiment. The USA had interfered in Venezuela, Nicaragua, Panama, Mexico and Haiti earlier in the 20th century; Guatemala seemed to be yet another example of unwelcome US imperialism.

'Our only crime consisted of decreeing our own laws and applying them to all without exception . . .'

Jacobo Árbenz Guzmán,
radio broadcast, 19 June 1954

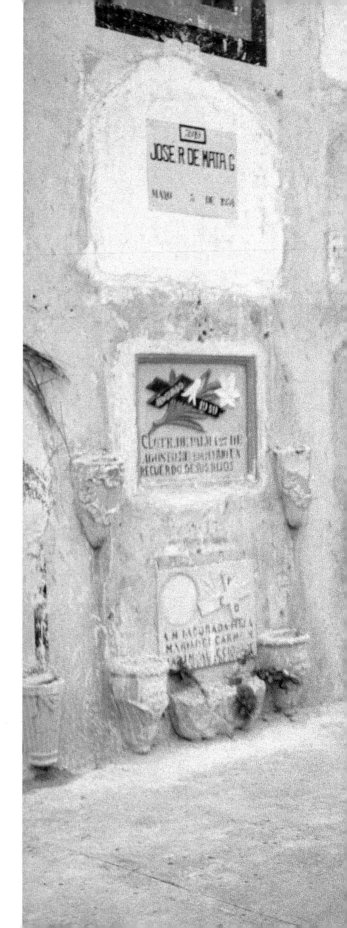

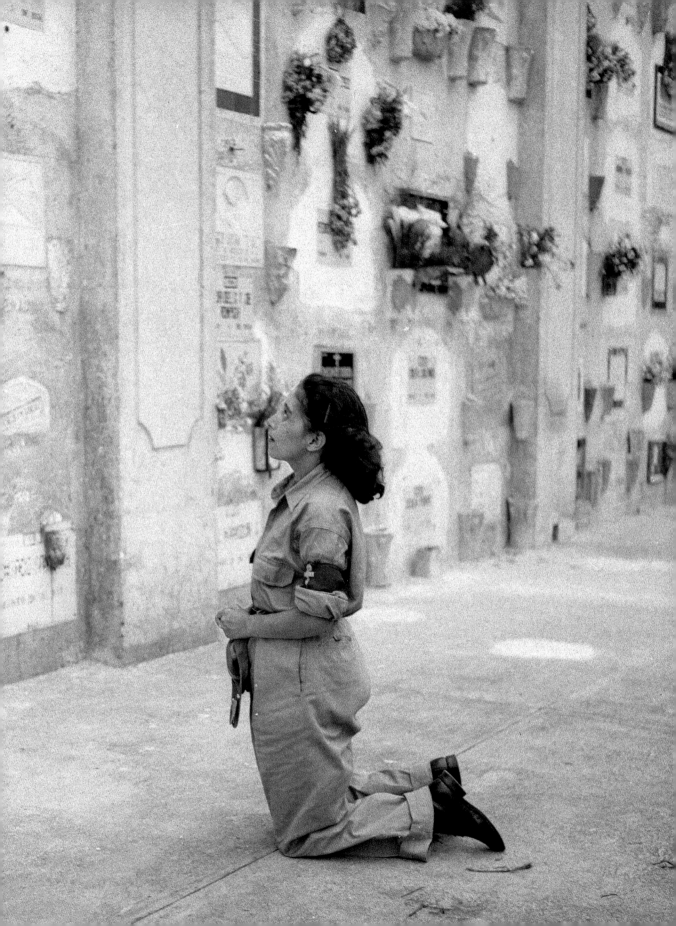

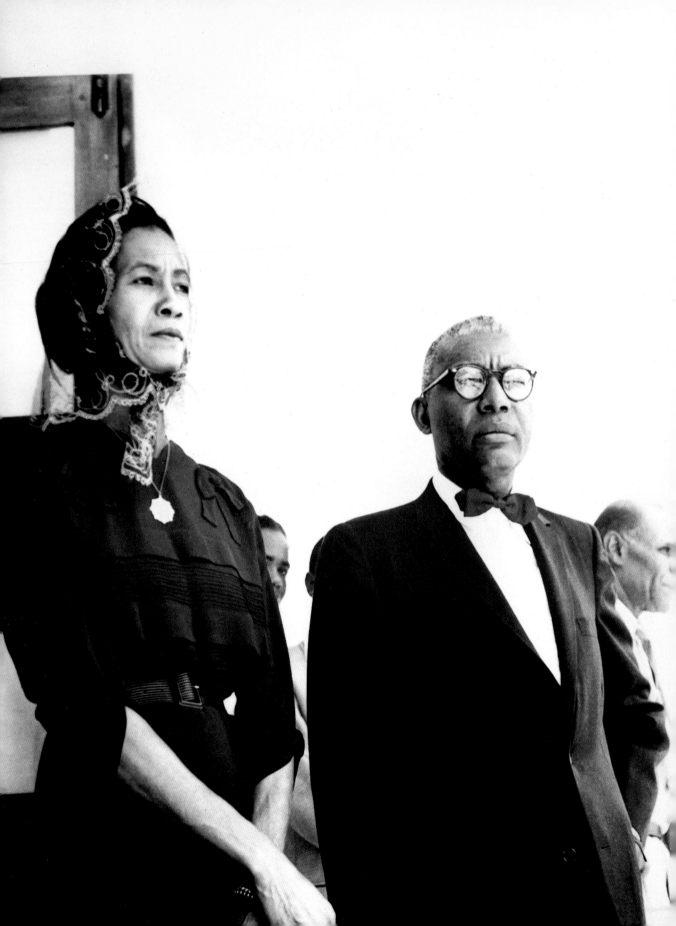

The Duvaliers

François Duvalier, pictured here with his wife Simone
Duvalier (née Ovide), was born in 1907 and therefore
grew up during the period between 1915 and 1934
when the United States occupied Haiti. Although he
trained as a physician – his patients gave him the
nickname 'Papa Doc', which stuck – Duvalier made
his name in politics. He rose to prominence in a
US-sponsored campaign to combat the bacterial
infection yaws, and served as health minister in 1949.
After a period in the wilderness during the military
rule of Paul 'Bon Papa' Magloire, in 1957 Papa Doc
was elected president.

Duvalier was schooled in both medical ethics
and the supernatural religious beliefs of Haitian
Vodou, and he was a prominent advocate for black
nationalism in a country where black rights had long
been trampled. But in his 14 years as president he and
Simone ('Mama Doc') oversaw a bloodthirsty
despotism. Duvalier persecuted his enemies, real and
perceived, with a private militia, the *Tonton Macoute*,
named after a child-eating bogeyman from Creole
folklore, which combined jackboot secret police
terror tactics with macabre, ritualistic torture.

As eccentric as he was brutal, Duvalier enjoyed
posturing on the foreign stage: when US President
John F. Kennedy was assassinated in 1963 he claimed
that he had cursed him with *Vodou*. The following
year, Duvalier entrenched himself, through flagrantly
rigged elections, as president for life. This turned out
to mean until 1971, when he died from heart disease
and was succeeded by his son Jean-Claude Duvalier,
known as 'Baby Doc'.

Marilyn Monroe

On 21 June 1956, eight days before she was due to be married, the actress Marilyn Monroe (born Norma Jeane Mortenson) spoke to reporters outside her house in New York.

For Monroe, speaking to pressmen was nothing new: she was one of the most famous actresses in America, whose short but sensational career included roles in smash-hit movies such as *The Seven Year Itch* (1955), provocatively revealing magazine photo-shoots and a notoriously titillating performance of the song 'Happy Birthday' at President Kennedy's 45th birthday party. Even her death was a bombshell: she was found naked and face down on her bed in August 1962 after a barbiturates overdose at the age of 36.

On this occasion, however, the questions related to a political sensation. Monroe's fiancé was the playwright Arthur Miller (her previous husbands were a merchant sailor called James Dougherty and the baseball legend Joe DiMaggio), and Miller was due that day to testify before the House Un-American Activities Committee – a Congress-based panel investigating citizens with alleged ties to communism.

This was part of a broad-ranging effort to root out 'enemies within', nicknamed 'McCarthyism' after the firebrand US Senator Joseph McCarthy who was convinced that subversives and traitors were present throughout the US government, military and entertainment industries. Those found guilty could be fined, jailed, have their passports removed or be 'blacklisted' – prevented from working.

Miller was fined and blacklisted after refusing to testify when in front of the committee, but he and Monroe were married all the same. They divorced in 1961.

> 'She was a whirling light to me
> . . . street-tough one moment,
> then lifted by a lyrical and
> poetic sensitivity . . .'

Arthur Miller remembers Marilyn Monroe
in his autobiography, 1987

Elizabeth II

Born in the same year as Marilyn Monroe, 1926, but destined for a much longer life in the public eye, Elizabeth II became queen of the United Kingdom and its various dependent states following the death of her father George VI on 6 February 1952.

This picture was taken ten and a half months later, on 25 December, when the Queen delivered her first Christmas broadcast by radio from the Sandringham estate in Norfolk, continuing a tradition begun by her grandfather George V 20 years earlier. Sixty-five years later, in 2017, the Queen was still making Christmas broadcasts, now on television. By this time she had become the longest-reigning monarch in British history.

Elizabeth's reign saw the steady loosening of ties between Britain and its former imperial colonies, as well as partial devolution between England, Scotland, Wales and Northern Ireland. At the time of writing she had been served by 13 prime ministers, from Winston Churchill to Theresa May.

Her exceptionally long marriage to Prince Philip, the duke of Edinburgh, produced a large royal family. At times this was a source of disquiet and scandal – particularly during the troubled marriage of her eldest son and heir, Charles, and his wife Diana Spencer, who died in a car accident in 1997. Overall, however, Elizabeth's reign was characterized by the queen's personal devotion to the nation, and by the continuing popularity of monarchy in an age when elsewhere in the world royalty was in retreat.

'Pray that God may give me wisdom and strength… that I may faithfully serve Him and you, all the days of my life.'

Queen Elizabeth II, radio broadcast,
25 December 1952

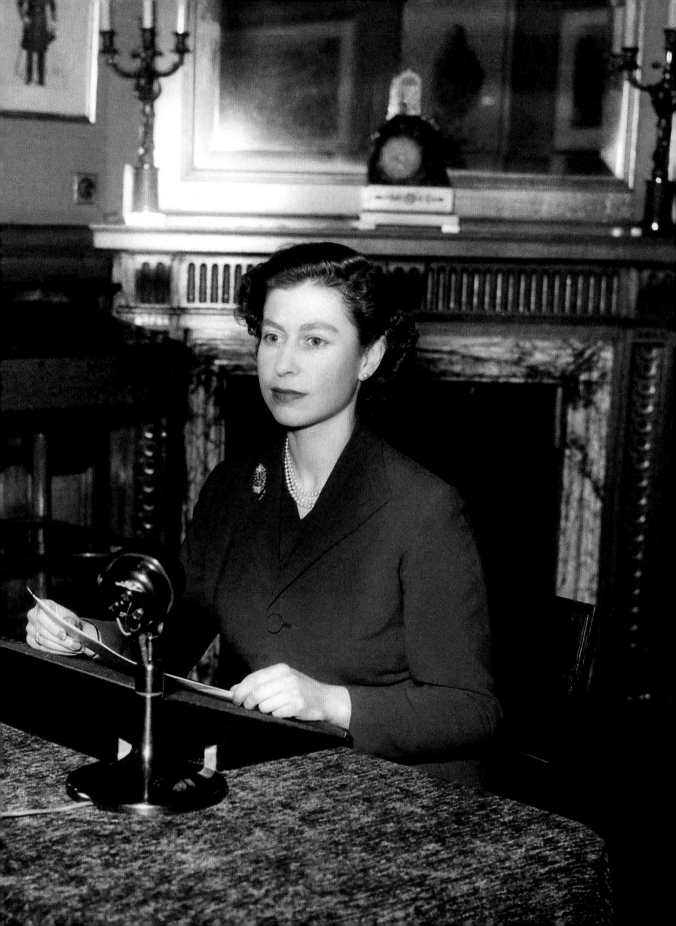

'I've just never seen great powers make such a complete mess and botch of things…'

Dwight D. Eisenhower, October 1956

The Suez Crisis

Britain's standing as a world superpower had been tested to destruction by two world wars. The starkest illustration of its denuded state came early in Elizabeth II's reign, in a war over the Suez Canal.

In July 1956, Egypt's nationalist president Gamal Abdel Nasser unilaterally nationalized the canal, provoking an armed invasion of the Sinai Peninsula on 29 October by forces from the infant state of Israel (whose shipping had been blocked from using the canal). Fighting quickly escalated: Britain and France also intervened, launching bombing raids in an attempt to force Nasser to reopen the canal. By 5 November British and French paratroopers were fighting on the outskirts of Port Said. (This photo shows British frogmen searching for enemy weapons caches hidden in the waters of the canal.)

Yet this aggressive intervention backfired spectacularly. International pressure bore down heavily on the Israelis, British and French from all sides. Nikita Khrushchev, who backed and armed Egypt, threatened Soviet nuclear strikes on Western Europe. US President Dwight D. Eisenhower – who could not tolerate a Franco-British invasion of Egypt at the same time as he was forcefully condemning a Soviet invasion of Hungary – threatened serious damage to the UK's finances. On 21 November United Nations peacekeeping forces arrived in Egypt, and two days later the British and French pulled out, humiliated. The British prime minister Anthony Eden resigned, citing ill health. The crisis was a sign of just how far the old imperial powers had fallen.

The North Sea Flood

In 1953 a different body of water caused serious loss of life, as violent storms in the North Sea caused flooding in the Netherlands, Belgium and the United Kingdom. The combination of high tides and appalling weather meant that during the weekend of 31 January to 1 February sea levels rose by as much as 5.6m, washing over coastal walls, bursting dykes and causing widespread damage to thousands of hectares of land and tens of thousands of homes.

This photograph by the Italian photojournalist Mario De Biasi shows dead livestock in the Netherlands: it has been estimated that 30,000 animals were killed during the flooding. The human cost was also terrible: more than 2,500 people lost their lives (including 133 passengers and crew of the *Princess Victoria* car ferry, which sank off Northern Ireland in the North Channel). Most of these deaths were recorded in the Netherlands, where 70% of the land lies at less than 1m above sea level. The 1953 flood is known there as the *Watersnoodramp* ('flood disaster').

Major public works were undertaken on both sides of the North Sea to try to prevent a recurrence of the disaster. The Netherlands built the Delta Works – a series of sluices, dams and barriers designed to control the flow of water through the myriad river estuaries of the Dutch coastline. In Britain, the government eventually commissioned the Thames Barrier to protect London against high waters, and a second barrier at the confluence of the River Hull and the Humber Estuary.

'They have been engaged for centuries in a battle with the sea, and they have suffered one of the greatest reverses.'

Clement Attlee MP on the North Sea flood victims, 19 February 1953

The Hungarian Revolution

At exactly the same time as the Suez Crisis was rocking both the eastern Mediterranean and the Western alliance, Hungary was descending into open rebellion. Since the end of the Second World War the country had been controlled from Moscow, and operated as a repressive communist regime patrolled by Soviet troops and a widely loathed secret police (the AVH).

After Stalin's death in 1953 hopes for a more liberal future blossomed in Hungary. In October 1956 a progressive leader, Imre Nagy, took power as prime minister, against a background of civil unrest and attacks on symbols of communist tyranny. But when Nagy announced on 1 November that Hungary would leave the USSR-led mutual defence system known as the Warsaw Pact, Khrushchev took pitiless action. Tanks rolled into Budapest three days later, backed by artillery and aircraft bombing raids. Despite the resistance of people like the young man shown here in a photograph by Mario De Biasi, Soviet troops crushed protests and killed around 3,000 people, a large proportion of them civilians.

A new leader, János Kádár, was installed and in 1958 Nagy was secretly tried for treason, found guilty and hanged. Tens of thousands of other Hungarians were also arrested and imprisoned, while many more fled the country and sought political asylum elsewhere. The uprising had been squashed, and a stern message sent to other nations on the Soviet side of the 'Iron Curtain'. Freedom was not an option.

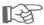

New Alliances

The age of European empires was over, but the idea of peacekeeping through large supranational alliances found new form after the Second World War. Besides the United Nations, founded in 1945 to arbitrate in global disputes, a series of other important economic and defence treaties were created during the 1950s, all dividing ultimately along Cold War lines.

This photograph (taken on 18 November 1957 by Manuel Litran for the French magazine *Paris Match*, overleaf) shows a reception in Luxembourg being addressed by René Mayer, a senior official in the European Coal and Steel Community (ECSC). This organization, whose founder members were Belgium, France, Italy, Luxembourg, the Netherlands and West Germany, was intended to harmonize industrial output and reduce economic tensions that could spiral into military conflict. The organization was the blueprint for and forerunner of the European Economic Community (EEC, established 1957) and European Union (EU, established 1993), which bound a widening pool of member nations in increasingly close economic and political alliance.

Across the Iron Curtain the USSR organized its own equivalent alliance. The Council for Mutual Economic Assistance (or COMECON) tied together the Soviet sphere of influence – Eastern Europe and various other communist states – between 1949 and the collapse of the Soviet Union in 1991.

Besides these economic umbrella organizations, two rival military alliances were also created in the 1950s: the North Atlantic Treaty Organization (NATO), a US-led defence pact established in 1949; and the Warsaw Pact, its Soviet equivalent, agreed in 1955.

The Algerian War

Integration in Europe coincided with a wave of decolonization beyond, as the Old World powers were shaken loose from places that had once been the bedrocks of empire. One of the bitterest struggles was fought in Algeria from 1954 until 1962, in a vicious war between French forces and the Algerian National Liberation Front (FLN), which brought down the French Fourth Republic, freed Algeria and created many long-term problems on both sides of the Mediterranean.

France had ruled Algeria since conquering it between 1830 and 1848, and despite promises during the Second World War to restore autonomy to the region, once the war was over little was done. On 1 November 1954 the FLN announced that it was beginning a struggle to secure independence. A guerrilla war began, to which France eventually committed half a million troops.

One of the most serious challenges for France's socialist prime minister Guy Mollet and every other French leader – including, from 1958–9, the veteran general-politician Charles de Gaulle, who headed the new Fifth Republic – was balancing the interests of the settlers with those who supported liberation. This photograph (taken by François Pages for *Paris Match*) shows riots in Algiers as French-Algerian settlers (known as *pieds noirs*) took to the streets on 7 February 1956 to protest against colonial policy.

De Gaulle was the subject of several assassination attempts by right-wing paramilitaries, but doggedly pursued a course of Algerian self-determination. Independence was overwhelmingly approved by a referendum in 1962, and nearly 900,000 settlers fled Algeria.

'In this admirable country in which a spring without equal covers it with flowers and its light, men are suffering…'

Albert Camus, Algerian-born French philosopher and novelist, 1958

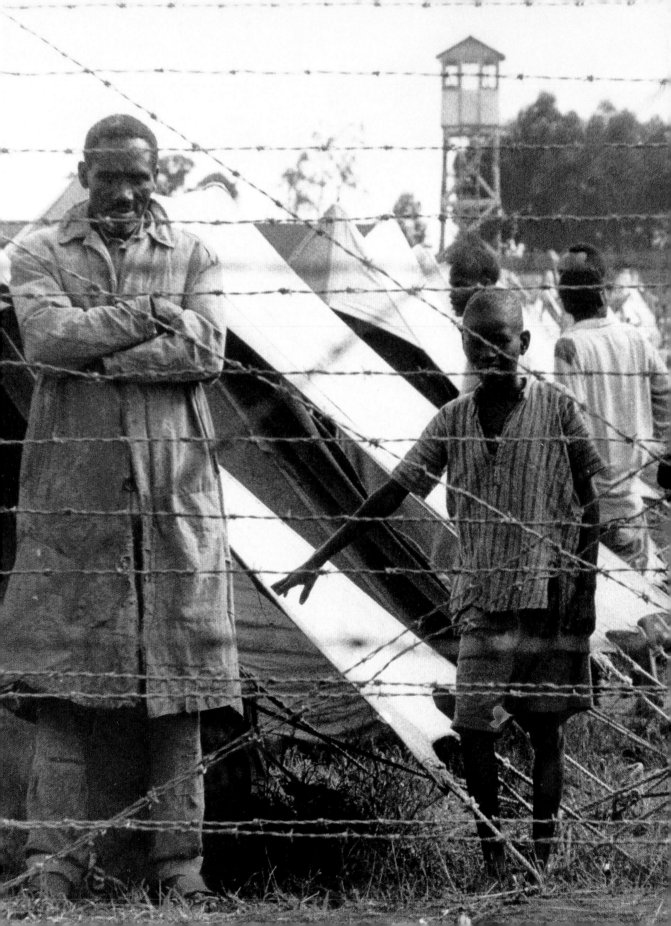

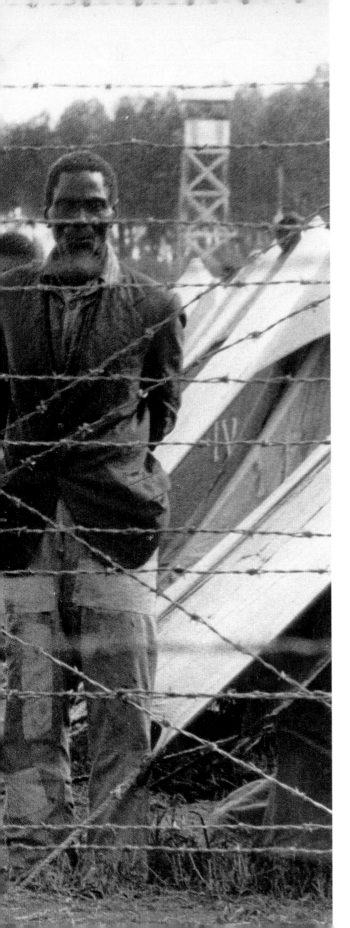

The Mau Mau Uprising

While the French fought in Algeria, opposition to British colonial rule in Kenya took the form of a rebellion by a militant nationalist alliance, drawn predominantly from the Kikuyu people.

British colonial rule in East Africa, which began with land seizures during the 1890s, was exploitative and harsh. Kenya's fertile highlands were parcelled up and granted exclusively to white settlers, while Africans were denied land, mistreated and made to work for low wages.

In 1952 a sworn, secret society nicknamed Mau Mau (the etymology is obscure) began to attack white farms, massacre settlers and kill Africans they considered hostile to their cause. Mau Mau violence could be spectacularly brutal, and the British military reaction was accordingly swift, severe and very often merciless. This photograph was taken around 1954 at Langata Camp: one of numerous concentration camps where hundreds of thousands of Kikuyu suspected of having taken the Mau Mau oath were imprisoned. Political brainwashing, beatings, rape, burning and castration were common.

The ferocity of Britain's response to the Mau Mau uprising meant that by 1956 the rebellion had been more or less stamped out. But many suspects remained imprisoned for several years – including the academic and activist Jomo Kenyatta, who was accused of masterminding the rebellion. Only in 1963–4 did Kenya finally achieve its liberation, becoming an independent republic with Kenyatta as its first president. In 2013 the British government agreed to pay out millions of pounds in compensation to surviving Mau Mau torture victims.

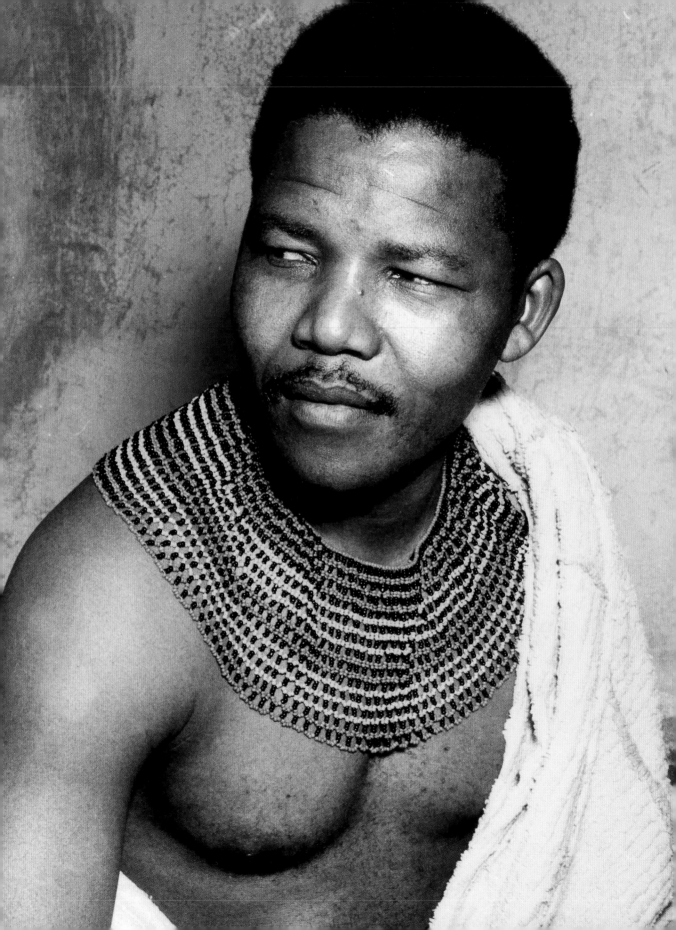

Nelson Mandela

South Africa had been granted independence in 1910 and complete freedom from British legislative oversight under the 1931 Statute of Westminster (which also applied to Canada, Australia and New Zealand). But it was hardly a free country. A wave of racist legislation passed by the Afrikaner-dominated National Party in the late 1940s and early 1950s created a system of apartheid (literally 'separateness' in Afrikaans) in which the rights of non-white South Africans were severely curtailed: public places were divided by race, interracial sexual relations and marriages were banned, and large swathes of the population were forcibly resettled in segregated neighbourhoods.

The struggle against apartheid was long and hard. Its most famous hero was a lawyer and activist from a distinguished family of the Xhosa-speaking Thembu people called Nelson Mandela, pictured here in traditional dress during his youth. From the 1940s Mandela was a member of the anti-apartheid African National Congress (ANC).

In December 1956 Mandela and dozens of other prominent anti-apartheid activists were arrested in Johannesburg and charged with treason. The trial took more than four years to reach a verdict, but in March 1961 Mandela and his co-defendants were all found not guilty.

This was not the end of Mandela's troubles, though. In 1962 he was arrested once more, tried this time for sabotage and sentenced to life imprisonment. He served 27 years in jails including Robben Island, only being released in 1990. Over the next four years apartheid was dismantled, culminating in 1994 in Mandela's election as South Africa's president in multi-racial elections. He served until 1999 and died in 2013, by which time he had acquired iconic status worldwide.

> 'I hate race discrimination... in all its manifestations. I have fought it all during my life... and will do so until the end of my days.'

Nelson Mandela, courtroom statement, 1962

The Nuclear Arms Race

The inherent peril in the Cold War was that both sides possessed weapons capable of destroying the human race. The Soviet Union successfully tested its first atomic bomb (codenamed *First Lightning*) in Semipalatinsk, in modern Kazakhstan. An arms race was under way, joined by the UK, France and China.

This photograph shows the detonation of an underwater plutonium implosion bomb nicknamed 'Helen of Bikini'. This was the so-called 'Baker' test of Operation Crossroads, carried out at Bikini Atoll in the Marshall Islands on 25 July 1946. These remote western Pacific islands became a favourite location for US nuclear testing throughout the 1950s: Bikini's native residents were removed from their homes permanently as ever-more destructive and contaminating devices were deployed.

In the 1950s the US tested its first hydrogen bombs, including the 'Castle Bravo' device (1954), which produced an unexpectedly powerful blast yield of 15 megatonnes – approximately 1,000 times larger than the 'Little Boy' explosion that vapourized much of Hiroshima during the Second World War. This was beaten by the explosion over the Arctic Circle of a 50-megatonne hydrogen bomb by the USSR in 1961: 'Tsar Bomba' created a mushroom cloud seven times the height of Mount Everest and broke windows hundreds of kilometres away.

In 1962, nuclear war was narrowly averted during the Cuban Missile Crisis, resolved after negotiations between US President John F. Kennedy and USSR premier Nikita Khrushchev.

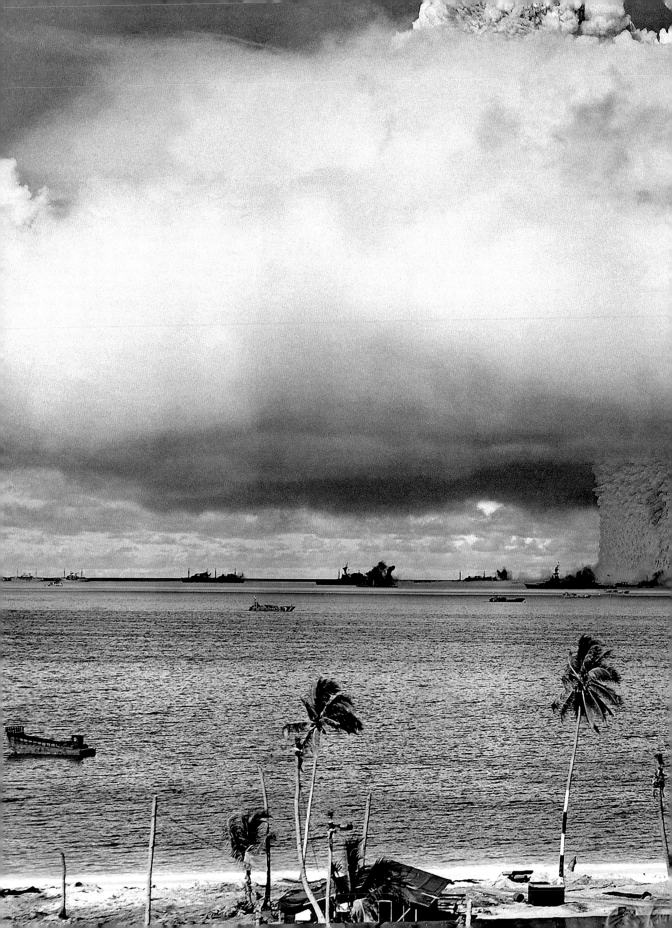

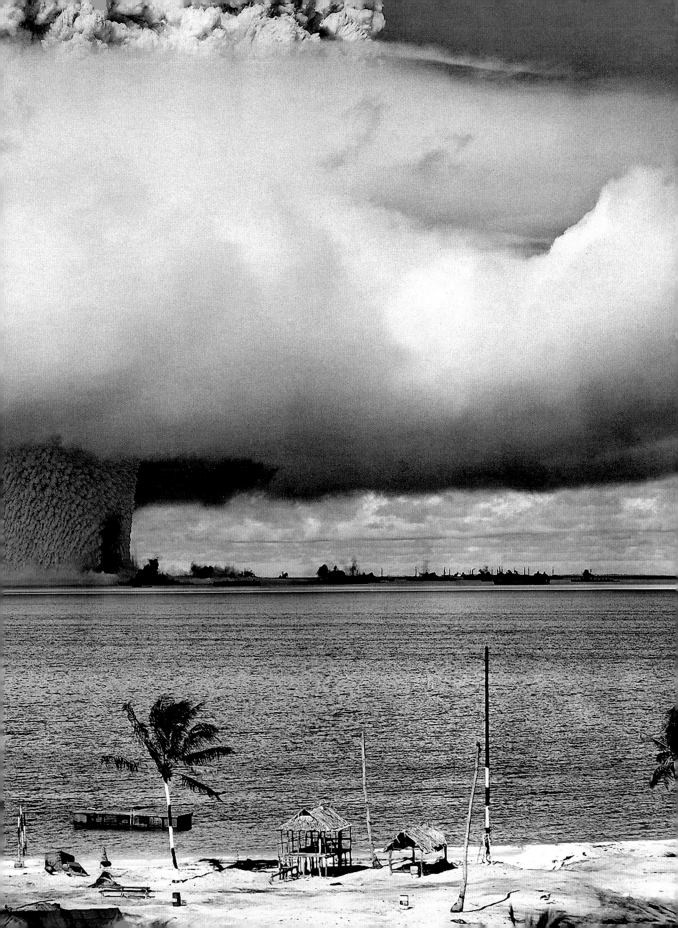

The Space Race

The last great arena of competition between the Cold War superpowers was space. As both sides developed rockets capable of delivering nuclear missiles, they realized that the same technology could be adapted for manned flight outside the earth's atmosphere.

This photograph of a Soviet cosmonaut, held in the US Library of Congress, is dated November 1959. This was the period when the Soviet Union was selecting a pool of men to train for spaceflight as part of the *Vostok* programme, which triumphed on 12 April 1961 when Yuri Gagarin became the first man to leave the earth, on an orbital flight lasting an hour and 48 minutes. This followed the successful launch of the unmanned satellite *Sputnik 1* in 1957, and *Sputnik 2* in the same year, which carried a dog called Laika.

The first US space programme, overseen by NASA from 1959, was called *Mercury*. It lagged behind the Soviet mission, only putting an astronaut – John Glenn, later a US senator – into orbit in 1962. But from that point, fortunes began to reverse: the United States scored the greatest victory of all on 20–21 July 1969 when Neil Armstrong and Buzz Aldrin became the first men to set foot on the moon during the *Apollo 11* mission.

In total, 12 people walked on the moon between 1969 and 1972, when the *Apollo* missions ended. Changing priorities in space exploration and the vast cost of manned lunar missions mean that no one has been back since.

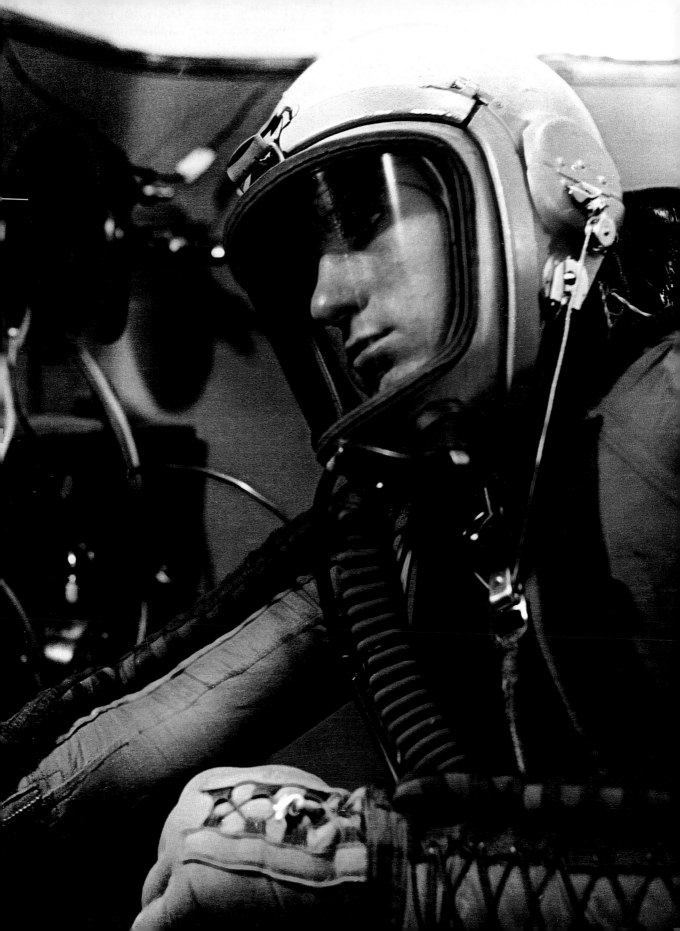

Index